watercolour CHALLENGE

PRACTICAL PAINTING COURSE

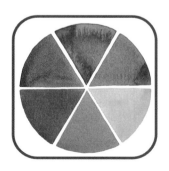

First published in 2001 by Channel 4 Books,
an imprint of Pan Macmillan Ltd, Pan Macmillan,
20 New Wharf Road, London N1 9RR, Basingstoke and Oxford.

Associated companies throughout the world

www.panmacmillan.com

Designed and edited by Eaglemoss Publications,
based on the partwork *Watercolour Challenge*.
Copyright © Eaglemoss Publications 2001

9 8 7 6 5

A CIP catalogue record for this book is available from the British Library.

ISBN 0 7522 2032 2

Artists' materials and equipment for many photographs supplied courtesy
of Winsor & Newton.
Colour reproduction by Chroma Graphics (Overseas) Pte Ltd.
Printed and bound in Great Britain by Bath Press

This book accompanies the television series *Watercolour Challenge*
made by Planet 24 for Channel 4.
Series Producer: Jill Robinson

Contents

Introduction

Watercolour is a beautiful, flexible and thrilling medium that has something to offer everyone. Layers of translucent washes applied over white paper give it a jewel-like brilliance, which is unmatched by any other medium. No wonder it is the preferred choice for many artists, whether they are professional or amateur. It can be used for any style of painting, from meticulously rendered illustrative styles to expressive works that exploit the spontaneity of wet-in-wet washes. The materials used are compact and portable, making watercolour perfect for quick landscape sketches made on the spot, and it can also be used for larger 'exhibition' paintings completed at leisure in the studio.

Because watercolour is technique-based, it is difficult for a complete beginner to handle the medium without some tuition. *Watercolour Challenge: Practical Painting Course* provides a comprehensive and structured introduction to the basics, and progresses to advanced techniques that will delight and surprise even the most experienced practitioner. The approach is simple and direct, and assumes no previous knowledge. Each topic opens with a short explanation that is accompanied by examples showing the concept or technique in practice and an exercise allowing you to develop the relevant skills. 'Key Points' boxes provide a synopsis for the beginner and a useful aide memoire for more experienced painters, while 'Tips' and 'Expert Advice' features offer shortcuts and handy hints gleaned from the professionals.

So what exactly is watercolour? Watercolour paint consists of dry pigments ground with water and bound with a watersoluble gum so that it adheres to a support, which is usually paper. You will find watercolour paint in a solid form in pans or half-pans, or in a moist form in tubes. Both versions are diluted with water in palettes to create a solution or 'wash' that is then applied to the support, usually with a brush, although, as we will see, other tools can be used as well. The ability to mix, apply and control washes is the basis of all successful painting in watercolour.

There are two types of watercolour paint: traditional watercolour, which is transparent, and an opaque form called 'body colour' or gouache. *Watercolour Challenge Practical Painting Course* is concerned primarily, though not exclusively, with transparent watercolour. Gouache can be used alone or it can be combined with watercolour.

The difference between traditional watercolour and other paint media (including gouache) is its transparency. It is this quality that gives pure watercolour its special luminosity. However, the transparency of the medium does dictate and limit the way the paint can be used. You cannot, for example, overpaint a dark colour with a light one, and the only white available in a pure watercolour is the white of the paper. This means that you must plan ahead and allocate all your white and light areas at the very beginning – unlike oils and acrylics, where you can add pale colours and highlights at the end. In watercolour you should apply your lightest tones and colours first, gradually working towards the darkest tones, a process described as working 'light to dark'. If this seems daunting or confusing, don't worry, this practical guide explains these concepts clearly and succinctly, while the accompanying exercises show you how to reserve your whites and build tones.

Acquiring and inventing a repertoire of watercolour tricks and techniques is all part of the fun and, like a good vocabulary, it will allow you to express yourself quickly, effectively and entertainingly. Later chapters introduce a large number of mark makers, ranging from basic and exotic brushes to sponges, pens and even household materials, such as cling film and foil. You will also learn about the additives that change the way the paint behaves, the various ways of protecting the white areas in your painting and the almost infinite ways of creating textures and interesting surfaces.

But no matter how experienced you are, watercolour remains an unpredictable medium. Papers can reveal flaws, paint dry unevenly, and wet colours bleed, creating accidental blendings of colour or variegated areas known as 'backruns' or 'cauliflowers'. One of the keys to successful watercolour painting is learning to cope with these unforseen happenings. Although watercolour has a reputation for being unforgiving, you will find that there are many ways of dealing with mistakes. Often these so-called errors can be incorporated into your work as 'happy accidents' creating a freshness and spontaneity that is the characteristic of the very best watercolour work.

Buy the best materials you can afford, learn to enjoy the fluidity of the medium, and practise, practise, practise. Above all, enjoy yourself!

CHAPTER 1
PAINT BASICS

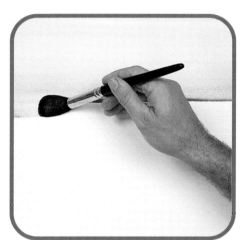
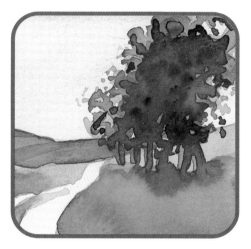

Anyone can paint in watercolour once they have taken the time to master a few basic techniques. The first things the beginner needs to know are how to mix and lay a wash, the difference between wet in wet and wet on dry, and the concept of working light to dark. Once you have become familiar with them, you will begin to enjoy the medium.

When you start, make sure that you have plenty of paper and give yourself time to work though the useful exercises that accompany the explanation of each topic. More than any other medium, watercolour is about having good timing and understanding the way materials respond to each other. You can read all the books in the world, but it is only by putting brush to paper and being prepared to take risks, that you will become completely familiar with the medium, learn to handle paint with confidence, and, most importantly, discover your personal style.

Mixing & laying a wash

Learning how to work with washes is an essential watercolour painting skill that needs practice to perfect. The term 'wash' describes both the diluted paint in solution and the dried film of colour on the paper.

Washes are the basis of pure transparent watercolour. You can apply them over any sized (sealed) area, and build up colour by overlaying a series of transparent washes. There are three types – flat, graded and variegated. Flat washes (overleaf) are the simplest: as the name implies, they are areas of uniform colour, laid over part, or all, of the paper. Graded washes (see page 17) vary in intensity from light to dark, or vice versa, while variegated washes (see page 19) are laid by dropping one wet colour into another.

▶ *Tubes are useful for large-scale working. Simply squeeze a dab of paint directly from the tube into a saucer and then mix the wash in the same way as if using a pan.*

How to mix a wash

▼**1** Load a brush with clean water and then transfer some to a mixing saucer. You need two jars – one filled with clean water so that the colours don't get contaminated and the other to clean the brush.

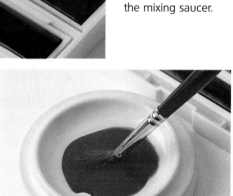

▶**2** Moisten the paint in the pan by working the brush carefully over the surface of the pan. Once the brush is loaded, transfer the paint you need to the mixing saucer.

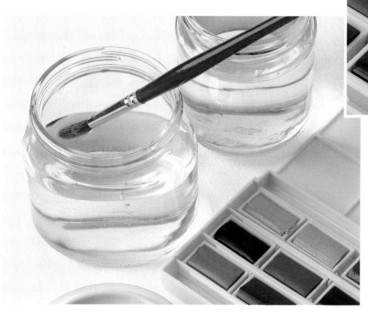

▶**3** Mix the colour with the water. To darken the wash, add a little more paint. To lighten it, add more water. Clean your brush first before using it to transfer water from the mixing jar to your palette.

◀ *With pan colours, you can see all your colours at a glance. Pans are also more convenient than tubes for working outdoors.*

▶**4** Test the intensity of the wash on a scrap of paper (and allow it to dry) before you start painting with it. Doing this is important, since watercolour always looks lighter when it is dry than it does when wet.

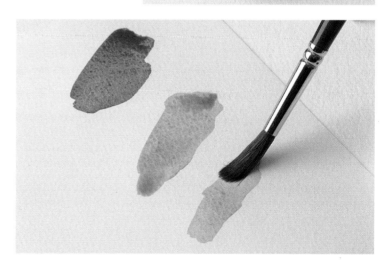

Laying a flat wash

To make sure the wash is laid evenly, paint straight through from start to finish before any area has time to dry. Use a large brush if you are laying a large area such as a sky. It holds more paint and means you can cover large areas of paper faster.

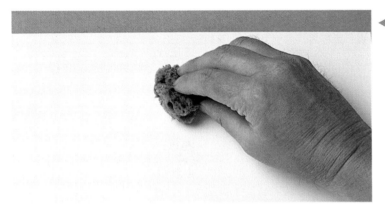

◀**1** The paper needs to be wetted slightly before you start to paint. Use a dampened natural sponge, starting at the top edge and working across and down the paper. Don't press down too hard, or you may flood the paper.

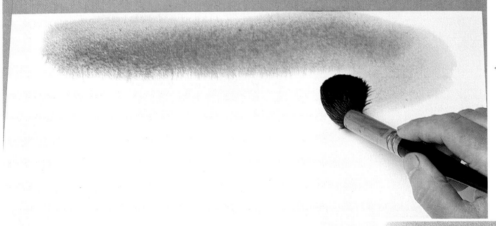

◀**2** Apply the wash before the paper dries. Load the biggest brush you've got with paint – in this case, the colour is Winsor Blue – and draw it across the top of the paper from left to right. When you reach the end, draw the brush back below the previous band, picking up the wet edge of the first stroke. If you require more wash, load the brush again at the end of a stroke.

Tip

To lay washes over large areas of paper it makes sense to use a large wash brush such as a mop. You need to cover the paper with your wash as quickly as possible.

▶**3** Continue until the wash is fully laid. Then put the board on to a level surface and leave to dry. This takes about an hour, depending on the type of paper and the drying conditions.

Wet on dry

One of the basic techniques in watercolour is painting wet on dry. This method of applying washes gives you maximum control of the paint so it is particularly useful for rendering details accurately.

Artists use the term 'wet on dry' to describe watercolour applied to a dry surface. This can be either pristine paper or another earlier wash that has already dried.

BUILDING UP THE LAYERS

Wet-on-dry washes are not difficult to control and therefore the technique is relatively easy to master. Once the paint is on the paper it stays where you have put it without running, and it dries to produce a crisp-edged shape.

Laying new washes over earlier ones that have been allowed to dry is the classic way of building up watercolour to achieve a greater depth of colour than is possible with just a single wash. It's important, though, not to overdo this – otherwise the colours become muddy. A maximum of three or four layers of colour is generally enough.

The paint must be left to dry between washes. This can be time consuming at best and impossible at worst – if, say, you are working outdoors and it is damp. A hair drier can help speed up the process, but don't use one while the paint is still fluid. If you do, the drier may blow rivulets across the paper.

Taking a closer look

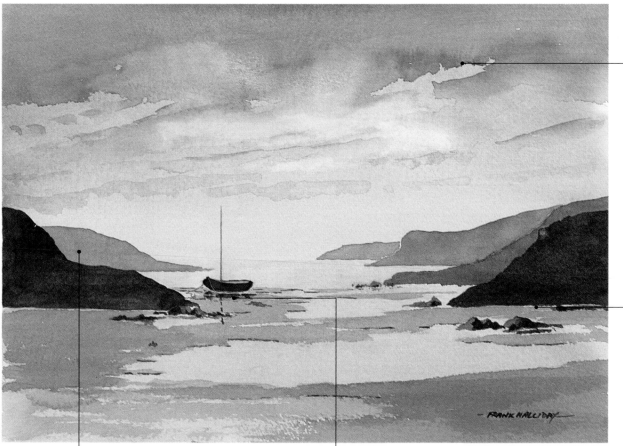

**Last light
by *Frank Halliday***

The sky wash has dried with a crisp, jagged edge. Notice how the pigment has collected at the edge of the shape.

The total control provided by wet-on-dry washes allowed the artist to leave thin lines of white paper to express sunny highlights.

The farther headland, painted first, was left to dry completely. Then the nearer headland was put in with a stronger wash.

The fine details of the boat and the dark edges of the pools were painted with the very tip of the brush.

Perfecting the technique

If you try working wet on dry with different papers and brushes, you'll be amazed by the results.

The type of paper, the wetness of the wash and the way it's applied all influence the effects you can produce when working wet on dry.

To explore the possibilities, practise on HP (hot pressed), NOT (cold pressed) and Rough papers (see page 267), working with round and flat brushes. Experiment with a variety of non-brush marks, too: use sponges, spatter the paint, or apply a fluid blob and tilt the paper to make it run and spread. Not only will the paint stay where you want it and dry with crisp edges, you will also produce an exciting variety of effects.

Try this!

Experiment with wet on dry on a spare piece of paper and see how the tones darken and the colours modify as you build up layers of wash.

◄ **1** Paint a rectangular shape on dry paper. Notice the crisp edge that forms and see how the pigment tends to migrate to the edge of the painted shape. Allow to dry completely before continuing.

► **2** When the first wash is dry, apply a second overlapping wash in the same colour. Note how a crisp edge forms again and the tone builds up.

► **3** This time let the first wash dry, then paint an overlapping wash of a different colour. Note how laying one colour over another creates a new colour.

In practice

Flower study

Try painting this flower and notice how working wet on dry gives you control over your washes, while the crisp edges that the technique produces serve to enhance the final image.

◄ **1** Use a No.9 round brush and a pale wash for the first petal shapes on dry paper. Leave to dry. Strengthen the wash slightly and add the next layer of petals. Leave it to dry again. With wet on dry, you can paint exact shapes while leaving areas of the paper white for highlights.

▲ **2** Mix a darker wash for the mid-tone areas on the petals. When the paint is dry, mix more colour into the wash and add the darker areas. Leave to dry.

► **3** Strengthen the wash still more and paint the areas of deepest shadow. Finally, again when the the paint is dry, use the tip of the brush to paint the stamens.

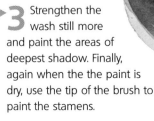

Wet in wet

Painting wet in wet produces instant, unpredictable results that create some of the most exciting and beautiful effects in watercolour.

In the wet-in-wet technique, paint is applied to a wet or damp surface. This can be paper moistened with water or another wash of colour that is still wet. It's simple – but it calls for quick, confident work. If you overwork the washes they lose their freshness.

WORKING QUICKLY

To paint wet in wet, dampen the paper and apply fairly wet washes to it in quick succession. The colour runs as it touches the wet surface, and dries with soft, blurred edges. You can use wet in wet to create modulated tones by dropping a dark wash into a lighter wash of the same colour, or by laying different tones of a colour alongside each other so they bleed. You can make variegated washes (see page 19) by doing the same with different colours.

KEEPING CONTROL

Wet-in-wet effects depend on how damp the paper and paint are and on the texture of the paper. The wetter the surface, the less control you have. On a saturated surface the paint forms rivulets that instantly run and merge with the surrounding areas. If the paper or underlying wash is only slightly damp, washes are easier to control – so you can you work in a detailed way without losing freshness and fluidity.

Taking a closer look

Harvest moon by *Richard Allen*

A darker wash added to the top of the sky created a graduated blend from top to bottom that helped give the painting a sense of recession.

The trees on the horizon were added while the sky and grass washes were still wet. This allowed the paint to flare into the sky – the colour softened as it spread and dried.

The white area of the moon was reserved with masking fluid, then left to dry before applying the first washes.

A final wash, added to the field in the front and blended in with a dry brush, helped advance the foreground still more.

The colours of the hedges and trees are stronger the nearer they are. The darkest hedgerow is in the foreground.

Different methods

Experiment with combinations of wet in wet and wet on dry.

Accidental blendings of colour and watermarks (backruns, see page 93) often occur to good effect with wet-in-wet painting. Also, different pigments (coloured particles in the paint) behave in different ways – for instance, cerulean granulates in a way that is excellent for a textural effect in a sky or water scene.

Wet in wet is perfect for cloudy skies, large background effects in landscapes, and for blending subtle colours. You can combine wet in wet with wet on dry by using wet-in-wet washes to create interesting colour blendings and then adding crisp details wet on dry.

Try this!

Use this exercise to experiment with wet-in-wet washes. Modulate tones by applying successive washes of one colour, or create variegated washes with different colours.

1 Moisten the paper. Load the brush with wash and paint a rectangle on the wet paper. Watch how the paint flares out to make blurred edges. The degree of flaring depends on the type of paper and how wet it is.

2 Lay another patch of wash and while still wet, add a second wash in the same colour. The paint blurs and blends, modulating tones where the washes overlap.

3 Finally, lay another wash and, while it is still wet, apply a second wash in a different colour. See how the colours blend and mix where the washes overlap, creating variegated effects.

In practice Sky at sunset

Practise handling wet-in-wet washes with this simple study of a glowing sunset sky. Paint the crisp-edged skyline wet on dry once the wet-in-wet washes have dried.

1 Wet a rectangle on the paper, leaving the sun dry. Load a brush with pale grey wash and apply it to the paper in diagonal bands, guiding the brush around the dry sun. Notice how the bands of wash bleed into the paper, forming soft, blurred edges, while the sun's edge remains crisp.

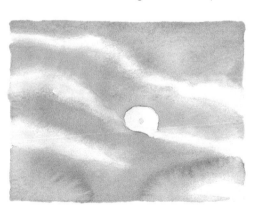

2 Before the first wash dries, apply a darker wash, again guiding the brush around the white sun. Watch the paint flare and spread into the first wash, creating varying tones. In areas where the first wash has dried a little, see how the second wash forms slightly crisper edges. Leave to dry.

3 Use clean water to moisten the areas where you want the pink glow to penetrate the clouds. Apply a thin red wash to these areas and let it dry. Then fill in the red sun wet on dry, and paint the dark grey skyline silhouetted against the evening sky.

Graded washes

Large areas of a picture – skies, for example – often require flat washes with some kind of added interest. Graded washes of one colour, but graduated intensity, are a good solution.

In a graded wash the colour moves through regular tonal gradations from dark to light down the paper – or vice versa. The wash is applied on wet or dry paper with broad brush-strokes advancing back and forth down the page. As the wash progresses you lighten or darken the tone by adding more water or paint. The resulting wash is useful for describing skies, where the colour is most intense overhead and pales towards the horizon.

Speed is the key to applying a seamless graded wash. Work fast so the paint doesn't have a chance to run back, or dry into hard lines. Keep the paint fluid so each brushstroke blends into the one below. Work on stretched paper (see page 268) secured on a board, and use a large brush.

(see page 268)

Key points

● Tonal changes are controlled by diluting or strengthening washes as you work.

● Working quickly is the key to graded washes, thus avoiding hard edges between the bands of tone.

● Keep washes fluid so that each successive brushstroke blends with the previous one.

● Large areas such as sky and water can be treated by laying a graded wash and then working over it.

● Use stretched paper – it's easier to work with because it dries flat.

Laying a graded wash: blue sky

A graded wash takes a few seconds to complete. This exercise shows you how to paint a graded blue sky wash. Practise until you have the confidence to work quickly and keep the wash going without stopping.

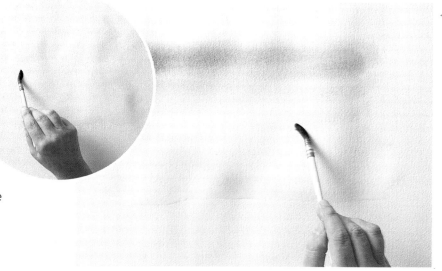

▶**1** Dampen the paper with clean water and a large wash brush, wetting the whole area the wash is to cover.

◀**2** Load the brush with ultramarine wash. Paint a broad band across the top of the paper. Work from left to right and don't lift the brush until the end of the stroke. Pick up more water on the brush to dilute the wash and make a return stroke, picking up the wet lower edge of the first brushstroke.

◀**3** Continue working back and forth down the paper in this way, diluting the wash with more water for each band of colour. At the bottom the wash should be very pale. Note that you sometimes get a vertical, rather than a horizontal, effect (see below) – excellent for a rainy sky. This is a random effect, depending very much on the type of paper you choose, how damp it is and even on the pigment used.

Sunset sky

A graded wash also works well in exactly the opposite way – starting out lighter at the top of the picture area and darkening towards the bottom.

1 Make two washes of alizarin crimson – one watery, one stronger. Load a mop brush with the watery wash and work back and forth across the damp paper in bands.

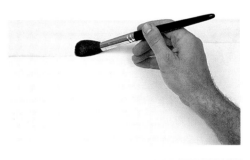

2 Introduce the darker wash about one third of the way down the paper, keeping the brush going all the time and overlapping each stroke a little. Recharge your brush every third stroke, so the wash gradually becomes darker.

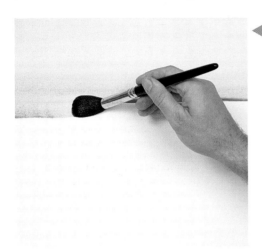

3 Keep the wash going to the bottom of the paper, picking up more of the darker wash every three strokes. Aim for a soft transition from lighter to darker all the way down. Leave to dry. You should end with a softly graded wash that could be the start of a sunset sky picture.

Taking a closer look

The warm tone of the underlying graded wash enriches, informs and gives an overall harmony to the colours and tones in this painting.

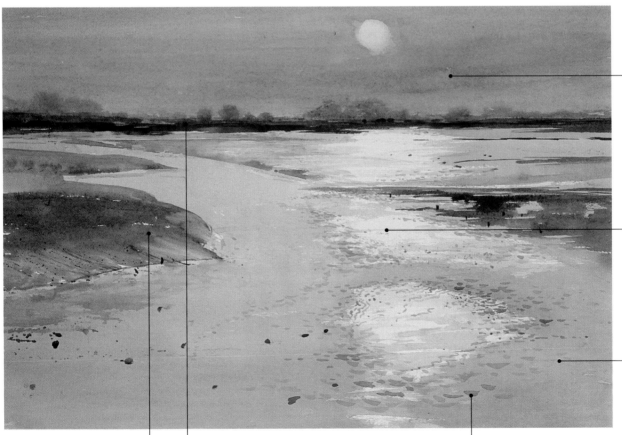

Evening light by Charles Bartlett

Starting at the top with a deep pink, the artist gradually carried his wash down the whole of the paper surface, lightening the colour gradually to a soft pink at the very bottom.

Both the sun and the bright areas of highlight – the reflections on the water – were masked out before the initial wash was started.

The greeny-grey wash describing the sand is warmed and made richer by the pale pink of the underlying graded wash.

For the mud flats the artist laid down a mid-tone wash, then flooded in a range of darker tones which dried with a crisp edge.

The far shoreline was laid in wet in wet – its soft, blurred outline suggests distance.

Touches of a dark pinky brown, laid wet on dry, give texture to the foreground sand.

Variegated washes

Variegated washes exploit the unique ability of watercolour to mix and blend colours on the painting surface, producing spontaneous and sometimes unexpected results.

Variegated washes are much more random than graded washes. They are created by applying different colours or shades to wet paper, and they produce subtle and unpredictable results. As you apply fluid washes on to dampened paper the colours instantly bleed and flare into each other where they meet, creating more colours and shades. Variegated washes can be applied loosely, with different colours or shades dropped into a wet area to create modulated and marbled effects. These are suitable for stormy skies or general underpainting (blocking in the main areas of colour in the early stages) for foliage or landscapes. You can also apply variegated washes in a more controlled way, applying different colours in loose bands (see overleaf).

Key points

- Use the wet-in-wet technique to apply variegated washes, then add detail wet on dry.

- Several colours and shades are used in a variegated wash.

- Washes flare out into neighbouring colours, making more colours and shades.

- Sunrises, sunsets and stormy skies are perfect for variegated washes.

- Underpaint with variegated washes for foliage and landscapes.

In practice **Moonlit sky**

Plenty of practice will enable you to handle variegated washes confidently and quickly. Try painting the moonlit sky below and you'll see that it's not just a case of applying the washes. As the paper dries the colours continue to merge and blend, creating more colours and unexpected shapes. You must work very quickly.

1 Reserve the moon with masking fluid. When this is dry, dampen the paper with clean water then load a No.6 round brush with colour and flood in the first wash. Watch the edges soften and bleed into the wet paper.

2 Work fast so the first wash doesn't dry out. Drop in a second colour and see how the colours merge into each other with soft, blurred edges.

3 Now swirl in a third colour in different areas. Notice how the areas of new colour bleed into the existing wash, modulating the previous tones and colours.

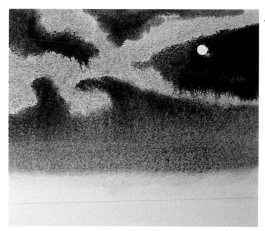

4 Apply a fourth colour to the bottom of the picture to represent the landscape for your moonlit scene. Watch how the washes continue to change as the paper dries.

Interesting effects

Variegated washes create an almost limitless variety of effects. Experiment to find out the possibilities.

You need to apply a variegated wash with speed and confidence. Mix your colours first so you can work quickly, and at all costs avoid the temptation to overwork the washes. If you do too much with such washes, they lose most of their characteristic freshness and spontaneity. As with other washes, tilting the board encourages the paint to flow down the paper. Remember, too, that washes applied to damp paper dry much lighter – take this into account when you mix your colours, and watch how the pigments react.

Expert advice

● Different pigments behave differently in very wet washes, giving some interesting textures. Generally, for example, cobalt blue and ultramarine blue produce flat, even areas of colour, while some, such as the Winsor blue used here, granulate to create a mottled effect. All these different effects can add interest and texture to your final image.

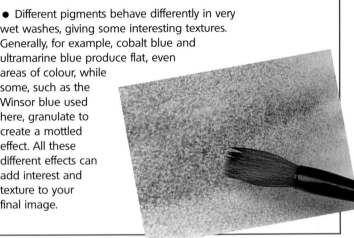

Taking a closer look

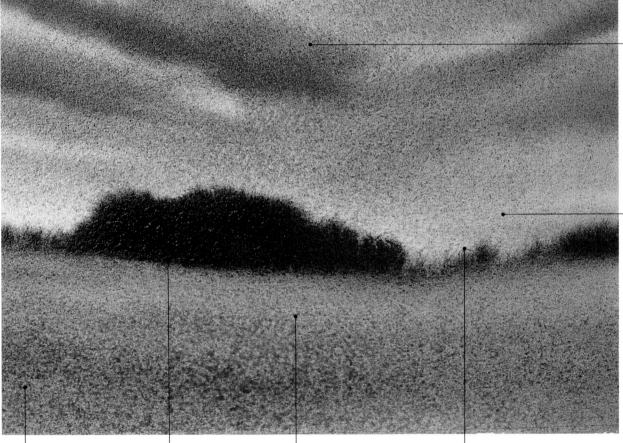

Stormy sky (detail) by *Richard Allen*

The artist began this painting by dampening the entire picture area, and stroking in a strong red wash across the horizon. He then applied a blue-grey wash to the sky, adding extra colour to describe the dark clouds.

Dramatic colours in these variegated washes express a turbulent sky. Wet-in-wet colours bleed into one another, creating strange shapes and new colours.

The wash used for the grass has been darkened towards the foreground to create a sense of recession.

The dark trees and bushes have been put in with plenty of paint and very little water so the colour wouldn't bleed too far into the sky.

Very wet washes give some interesting textures. Notice how the Winsor blue in the grass has granulated to create a mottled effect.

The lighter areas have been created by lifting out wet paint with a dry brush.

Layered washes

One way to make the most of the characteristic transparency of watercolour is to build up layers of transparent washes.

Tone, or value, describes the lightness or darkness of a colour, or an area of a subject. To depict form, it's essential to create a range of light and dark tones. In watercolour you can do this by adding more paint to a wash to darken it, or by adding more water to lighten it. You can build up areas of tone by overlaying washes of the same colour; and you can make effective use of the transparency of the medium to create new colours by overlaying one colour with another. You can darken a wash by adding black, grey or a complementary. (Complementaries are pairs of colours found opposite each other on the colour wheel.)

ADJUSTING THE DILUTION

When creating darker tones by adding more paint, or paler tones by adding more water, experiment with different dilutions to establish the range of tones you can produce from a particular colour. With practice you will be able to predict the results.

Key points

● To render forms accurately you need to create a range of tones.

● Lay overlapping washes to build up a range of tones.

● Overlap washes of a single colour to create tones ranging from light to dark.

● Overlap washes of different colours to create new colours.

● Adjust the dilution of the paint to create the same tonal effects, working from light to dark or dark to light.

Try this!

Try the exercises here to build up a range of tones. Experiment with different colours – not simply with the ones used here. This helps you familiarize yourself with the paints in your box.

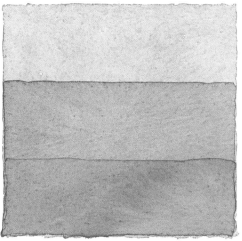

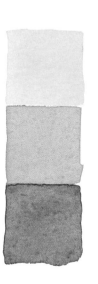

◀ LAYERING ONE COLOUR
Lay a flat wash of Prussian blue in a square and leave it to dry. Lay a second wash over the first, starting a third of the way down the first one. Leave to dry. Then lay a third wash over the previous two, starting it two-thirds of the way down. Once this, too, has dried, three different tones are clearly visible.

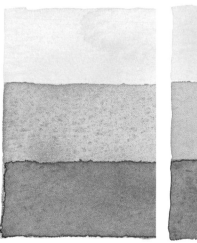

▲ ADDING MORE PAINT
The more paint you add to a mix, the darker will be the resulting tone. Lay down a band of dilute Prussian blue. Add more paint to the wash and lay another band under the first. Add more paint and lay down a third band – the darkest wash of all. Notice that the result is quite similar to that achieved by layering one colour (see far left)

▶ LAYERING THREE COLOURS
Paint a rectangle of cadmium yellow pale. Lay cadmium green pale over the bottom two-thirds of the square. Leave to dry. Finally lay a band of Prussian blue over the bottom third of the square.
 Notice how each colour modifies the one before – and how the tones build up. Allow each wash to dry before you apply the next.

◀ *Here are the colours used to create the yellow and green tones. From the top: cadmium yellow pale, cadmium green pale and Prussian blue. The interesting layer is the bottom one – where the Prussian blue creates a darkish green.*

Overlaying washes

This classic watercolour technique exploits the clarity and luminosity of transparent washes on white paper.

Paints vary in their opacity and in the way they behave in washes. It's worth practising mixing washes and overlaying them in order to get to know how different pigments work.

You must keep the water clean. Have two jars of water to hand – one for cleaning your brush and one for mixing the washes. What the colour looks like on a particular piece of paper is important too – the texture of the paper and how much size (sealing solution) there is on the surface all contribute to the overall effects.

Tip

It's a good idea to work with a limited range of colours. The landscape on this page has been produced using three colours only: Prussian blue, cadmium yellow pale, cadmium green pale. A limited palette produces a harmonious image and you will really get to know the colours you're using.

In practice **A country landscape**

You can create this simple image using a very limited range of colours. Some variations in tones and colours are made by overlaying – and some by changing the mixes.

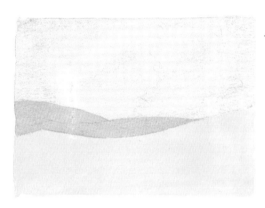

1 Lightly pencil in the three main areas. Lay a pale Prussian blue sky to the edge of the third area. When dry, lay cadmium yellow pale up to the sky. The soft green central area is created by overlaying the blue with yellow.

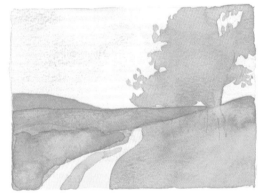

2 Paint the tree and the grass and hillside areas in a wash of cadmium green pale. Notice how this colour, laid over the different underlying washes, already creates a range of different tones.

3 Mix cadmium green pale and Prussian blue to paint in the most distant hillside and to indicate more trees in front of the first tree – add some more tree trunks as you go.

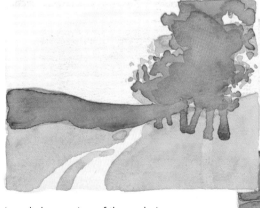

4 Finally mix a darker version of the cadmium green pale/Prussian blue wash and use to add more trees, the shadow underneath those closest to the front of the picture, and the foreground grassy areas. Each wash is modified by the colour underneath and adds tones that help to provide a sense of recession and distance.

Hard & soft edges

In watercolour you can exploit hard and soft edges to express the different natures of objects, and to imitate the effects of distance.

The familiar wet-on-dry and wet-in-wet techniques enable you to create both precise, hard edges and softly blurred ones. You can use these to play up the essential differences between objects. Hard edges are ideal for depicting architectural forms, for example, while soft edges convey the nature of organic elements, such as trees or clouds. Many images, especially landscapes, call for both kinds of edges. You can also use soft and hard edges to indicate spatial relationships, imitating the way the eye sees things. Foreground objects are seen in sharp focus. With distance, edges soften. You can use this distinction to create a sense of recession in a painting. The appearance of the landscape is also affected by the quality of the light. On a sunny day objects are sharply defined with crisp shadows. On an overcast day edges soften, even when viewed close up.

Key points

- Distinguish between objects with hard and soft edges.
- Use hard edges to depict architectural subjects.
- Use soft edges for natural elements such as trees, plants and clouds.
- Paint foreground objects in sharp focus with hard edges.
- Depict distant objects with soft edges.
- Suggest the quality of the light with hard or soft edges.

Taking a closer look

Artists may approach a similar subject in totally different ways, as these two paintings demonstrate. They are both landscapes, but the interpretation is a matter of personal style.

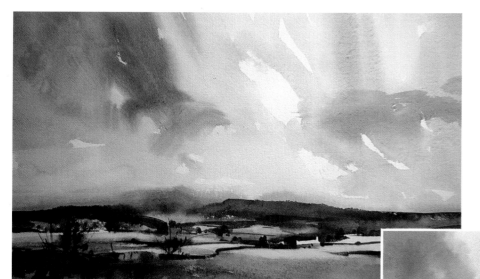

**Welsh border in winter
by *Aubrey Phillips***

◀ *The artist has exploited the softness of wet-in-wet washes to express the icy chill of this winter landscape. The eye is drawn to the hard edges of the white house and snow-covered fields, but the overall effect is fluid and soft-edged – and very bleak.*

**Chalk tracks, Gog Magog Hills
by *Ronald Maddox***

▶ *In this painting the artist has used a distinctive linear approach that emphasizes the undulation of the hills. He has skilfully combined hard edges and converging lines with a bold composition to convey the sense of organic vitality and movement in the landscape.*

Painting hard & soft edges

The contrast between hard and soft edges in a painting adds visual interest and emphasizes textural differences.

Watercolour is ideal for creating subtle gradations of tone and delicate blendings of colour. You can produce these effects by applying paint to wet or damp paper and allowing the colours to run. With experience you will learn just how wet the paper should be, and when you need to add a flow improver such as ox gall. Hard edges can be made by working wet on dry. Straight lines can be achieved by painting up to a pencil line or by using masking tape. You can also paint a straight line using a ruler and lay a wash alongside that before it dries.

Tip

When your subject includes many shadows, give them hard, semi-hard or soft edges depending on the quality of the light and the nature of the object casting the shadow.

Taking a closer look

In this semi-abstract painting hard edges suggest the geometry and solidity of the architectural landscape, while soft edges capture the contrasting softness of foliage and the depth and transparency of light and shadow.

Wet on semi-dry
Colour applied to a semi-dry wash is more controllable than colour applied to a wet area. Dark tones added to the crown of the trees spread gradually, creating shadows with softly defined edges.

Wet on dry
Applying a wet wash over a dry wash gives a controllable edge. The geometric outline of the shaded area is drawn in pencil and a brown wash applied. The colour is taken up the pencil line and dries to give a neat, crisp edge.

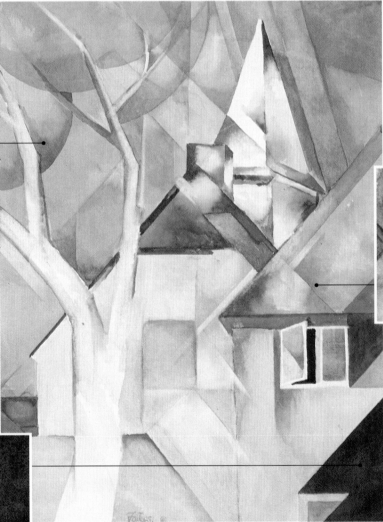

Tree town, Hindon
by *Peter Folkes*

Wet in wet
A pale terracotta wash is laid over the roof. While the wash is wet darker ochres and russets are flooded in, to give subtle gradations of tone.

Lifting out

Colour can be lifted from the paper while the paint is still moist. This is a useful option for creating whites, light areas and textures – and for correcting mistakes.

Watercolour can be lifted out while the paint on the paper is still wet. This means you can rectify mistakes or remove excess paint when you have flooded the paper; or you can create whites and light areas if you didn't reserve them earlier. You can also use lifting out in a positive, planned way to create specific effects, soften hard edges or modify areas of colour. Even dry paint can be lifted effectively by rewetting the surface.

There are various ways to lift out colour, depending on the size of the area to be lightened and the effect you want. The amount of colour you can lift depends on the texture and surface of the paper, how dry the paint is and the pigment's staining power. Smooth HP or NOT papers, especially highly sized (sealed) ones, release colour more readily than Rough. But pigments such as Winsor blue and alizarin crimson nearly always leave a stain on the paper.

Try this!

Lifting out needs a little practice to perfect. To gain confidence, lay a flat wash on a spare piece of paper and experiment with the different techniques below. See what effects you can achieve with each method.

◄ BRUSH *Dab a wet brush gently into dry colour on the paper, then lift out the newly wetted colour with blotting paper. Wipe the brush and repeat. Rinse the brush periodically if you want to lift out a large area of colour. You can do the same with a damp cotton bud.*

▶ BLOTTING PAPER *Fold blotting paper into a wad with a pointed or blunt end, and use the edge on the wet wash to lift out precise areas of colour; or pat the blotting paper flat on the wash to lift out a larger area.*

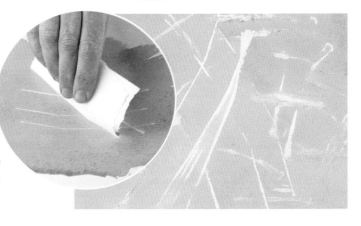

▲ SPONGES *A dampened sponge is an ideal tool for lifting out colour, especially from large areas. It also creates great textures and cloud effects when used to blot a wet sky wash. Try both natural and synthetic sponges, as well as coarser and finer textures. Repeat the sponging several times if you want to lift out more colour. (See also page 73.)*

A variety of effects

Lifting out is a watercolour technique in its own right. You can create striking effects by lifting out wet or dry colour.

Lifting out is useful for creating light areas for specific purposes – to describe dramatic, complex skies, sharp highlights on water, or the bloom on fruit, for example. Hard edges can be softened, and colours diffused and modified. And different techniques can create various effects. Dab a wet sky wash with a dry sponge to suggest the tops of clouds, lift out sun rays with a tissue rolled to a point or depict dappled foliage with a sponge. After lifting out, leave your painting to dry, then work back over the top with a brush to add extra texture.

Tip

Lifting out medium is a soluble gelatin film, applied to the support and allowed to dry. It is more soluble than the paint, so if you work into the wash with a wet brush or sponge, the colour lifts easily and cleanly. However, it doesn't make the watercolour more soluble, so your washes won't turn muddy.

 By the side of the lake

Try this landscape using a variety of lifting-out techniques. You can create eye-catching sky effects, add texture to hillsides and describe realistic foliage. Lift colour from both wet and dry washes, then work back over the top for added textural interest.

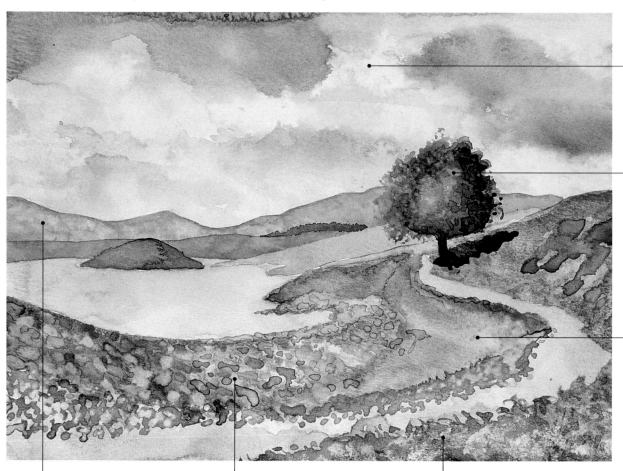

A lakeland landscape by *Kate Gwynn*

Blotting wet washes with a crumpled tissue creates complex cloud effects.

Build up progressively darker washes on the tree, working wet on dry. Lift out colour with a moist sponge to depict the dappled foliage.

Work back over the top of the shoreline with a wet brush to create texture and detail.

Roll tissue into a neat wad and use it to lift out some of the wash on the farthest hills.

To depict the pebble shore, lift colour out of the dry wash with a wet cotton bud or brush. Lift off more colour with dry tissue.

Try a different kind of texture on the grassy banks. Let the wash dry, then moisten it with a wet tissue. Use a dry tissue to lift off wet colour to give a mottled effect.

Scraping back

Scraping back means removing dry paint to reveal the paper beneath. Use the technique to create a range of effects, from very fine details to highlights.

Scraping back creates effects that cannot be achieved by any other means. For example, you can make finer lines than with a brush for delicate highlights. The technique involves removing dry paint so the white of the paper is revealed. You can do this in a number of ways, depending on the result you want. All involve abrading, scratching or cutting the paper surface.

These techniques break the paper surface, changing the way it accepts paint – usually making the paper more absorbent. Painting over a glasspapered area, for instance, makes the paint look darker than usual. Scraping back often results in some damage to the surface, but this can add expressive textures to your work. Use tough paper and work gently to avoid making holes.

Taking a closer look

To get the best out of the scraping-back technique use it sparingly – you don't want to create a whole picture with it! Here the artist has used a knife to scrape back the spiky grasses on the right and glasspaper to give texture to the sky behind the church spire.

**Bulwick
by *Tony Porter***

Diffused sky
Rubbing fairly vigorously with glasspaper lifts the paint completely and is useful for creating a hazy, diffused highlight effect – as here in the sky area.

Spiky grasses
Scratching back with the point of a craft knife creates sharply defined, fine lines that are ideal for stiff dry grasses – the contrast in texture between the grasses here and the softer surrounding brushwork is very marked, and extremely effective.

Scraping into dry

You can scrape back into dry washes in a number of ways to create various effects.

Scraping or scratching back with a craft knife or a razor blade can create different effects, depending on whether you use the point or the flat edge of the blade. Abrading with glasspaper or a hard rubber makes more generalized marks. You can scrape back with anything that works and is to hand. And textured and smooth papers give different results, so try both. Bear in mind that you get a different range of effects again when you paint over scratched or abraded surfaces.

◀ **GLASSPAPER ON ROUGH PAPER**
Rub fine glasspaper gently over a dry wash on Rough paper. Notice that working gently removes paint only from the raised 'tooth' of the paper, causing a speckled effect. When you rub more vigorously the colour is removed completely. The diffused highlight created here is perfect for expressing the sparkle of sunlight on water.

▶ **GLASSPAPER ON NOT PAPER**
This time try using glasspaper on a NOT surface. The paper is smoother than Rough so the effect is less speckled. Notice how the glasspaper causes fine scratches on the painted surface where it is used lightly.

Experimenting with scraping back

Paint some areas of wash on scraps of paper and let them dry thoroughly. Then scrape back in a variety of ways to see what effects you can create.

◀ **USING THE POINT OF A CRAFT KNIFE**
Scratch out fine white lines with the point of a sharp craft knife. Use firm, quick movements but don't dig too deeply into the paper. Notice how the textured surface of the Rough paper breaks up the scratch marks. This method of scraping back is ideal for depicting delicate highlights and fine details such as grasses.

▼ **CUTTING THE TOP LAYER WITH A KNIFE**
A very sharp craft knife can be used to cut out complete strips of wash. Try cutting into the wash, but make sure you cut through the top layer of the paper only. When you have cut the area you want to remove, carefully lift the strip of wash to leave a distinct, hard-edged highlight. You will achieve a graphic effect, suitable for depicting ripples on water for example.

▶ **SCRAPING WITH THE FLAT EDGE OF A KNIFE**
Scrape gently with the flat edge of a knife blade to create more general highlights. Texture is created as the surface of the paper is lifted off completely in some places and roughened in others. Where the lifted surface gathers, it causes tiny shadows which give added depth to the texture.

▶ **USING A HARD RUBBER**
Rub gently over the wash with a hard rubber. The effect is similar to using glasspaper but, since the rubber is less abrasive, the effect is softer and more diffused. As well as exploiting the effect in its own right, you could use this method to corrrect mistakes.

Using gouache

With gouache, the term used for opaque watercolour, you can paint from dark to light as well as from light to dark, create semi-transparent washes – and even cover up mistakes.

Gouache can be diluted for delicate washes, blended by working wet in wet and used to build up layers with flat washes. You can combine it with transparent watercolour, adding small touches for highlights or to cover errors; and the opacity of gouache allows you the freedom to work from dark to light. For more information on gouache, see page 265.

Gouache is occasionally referred to as body colour but the two are not the same. Body colour is in fact transparent watercolour made opaque by adding Chinese white or gouache white. The term is also used to describe highlights rendered in Chinese white on top of a transparent watercolour painting. Body colour has a milky appearance, but gouache looks more solid.

Key points

- Gouache is sold in tubes, pans and pots.
- Gouache is opaque when used thick, semi-transparent when diluted.
- Use gouache in thin, semi-transparent washes, blended wet in wet or in layers.
- Work from dark to light or light to dark – with gouache you can do either.
- Add highlights to transparent watercolour with gouache or body colour.
- Cover up minor errors with gouache.
- Add white paint to gouache to lighten it.

Taking a closer look

Gouache is perfect on tinted or toned paper because you can choose the colour to reflect mood, or as a complementary to the main colours – such as earth red under a green landscape. This gives broken colour effects, depth of colour and some lively optical mixes. This painting is on a ground (surface) toned with watery yellow ochre, sap green and burnt umber which add underlying warmth to the blues of the water.

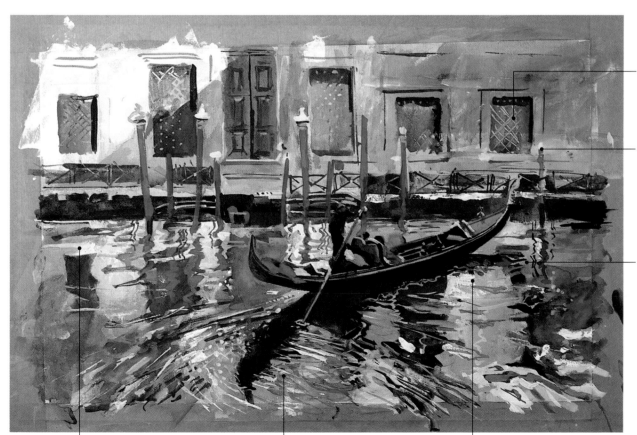

Gondolas in Venice by *Stan Smith*

Gouache left to dry a little can be scraped into with the handle of the brush, creating strong textures.

The bright white tips of the posts in the water are added last – you don't have to mask them out or reserve them as white paper.

Traces of the warmly tinted ground show through here and there under very thin washes of gouache.

White gouache applied in a thin wash stands for the reflection of the building in bright sunlight.

Thinner and thicker applications of gouache in a range of colours give drama, movement and life to the waters of the canal.

White gouache is applied thickly – almost undiluted – to give texture and liveliness to the water.

Additional benefits

Gouache has most of the qualities of transparent watercolour – with the bonus of some special effects of its own.

With gouache you can use most of the techniques of ordinary watercolour – with the added freedom of working from dark to light, exploiting the opacity of the medium and creating some wonderful textures with fairly thick, undiluted paint. In addition you can go for strong, bright energetic colours and a wide range of tinted surfaces.

Use the same brushes and weights of paper you are already using with traditional watercolours – especially NOT papers which have a good all-purpose surface. With gouache you can also try card, board, wood and even fabric supports. If you want to use gouache thick – for texture – then go for bristle brushes.

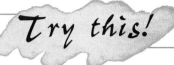

Try this!

With gouache you lighten colours by adding white. Such mixes are called tints – because they are opaque you can use them over darker colours.

◀ **PALE TINTS**
One way to make a tint with gouache is to squeeze a blob of colour from a tube into the well of a palette, dilute it with water and mix in a little white.

For an even paler tint, put some of the mix you have made into a new well, add more white and mix it in. Continue in this way until you reach the tint you require.

Yet another option is to dilute some white gouache with water, then add tiny amounts of colour, just a touch at a time, which will tint the white a little.

In practice

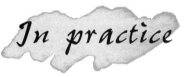

Yachts in watercolour and gouache

Paint this image in traditional watercolour and in gouache – then compare the two. The soft transparency of the first is obvious against the brightness and opacity of the second, but the main difference is in the handling of the whites and highlights.

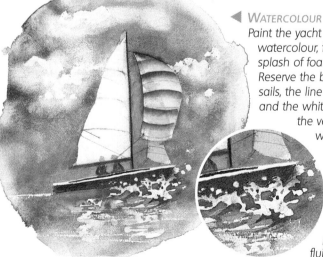

◀ **WATERCOLOUR**
Paint the yacht in traditional watercolour, first masking out the splash of foam against the bow. Reserve the bright white of the sails, the line of white decking and the white reflections under the vessel. Work the sky in wet in wet washes, leaving areas of white paper for the clouds, and lifting out other areas with a damp sponge. Finally, peel off the masking fluid to reveal the foam at the bow.

▲ **GOUACHE**
Paint the same scene, but this time build up the clouds in white gouache over the blue wash of the sky. Paint the sails in white, then add the white water under the boat and the splashing white foam at the bow. Notice the strength and brightness of the colours, compared to those of the first sketch.

Using whites

The white of the paper is the primary white for watercolour, but opaque white paint has many valuable uses for the artist.

For the purist, the only white in watercolour is the white of the paper. However, opaque white, that is semi-transparent Chinese white or white gouache, can make a valid contribution to both watercolour and gouache painting. It's excellent, for example, in situations where highlights are impossible to reserve – a star-studded sky or a field of daisies on a green lawn, say. You can use it to overpaint details wet on dry, or apply it wet in wet in different ways to create numerous effects.

It must always be applied with a light touch to avoid compromising the translucent qualities of watercolour, but the contrast between the transparency of watercolour and the opacity of white gouache, for instance, can be very effective. Used sensitively and for its own qualities, opaque white integrates into a painting, adding special effects without looking like an afterthought.

Taking a closer look

With care, you can use opaque white in several ways in the same image. Here the artist used it wet in wet for softly diffused clouds, and wet on dry to overpaint small details.

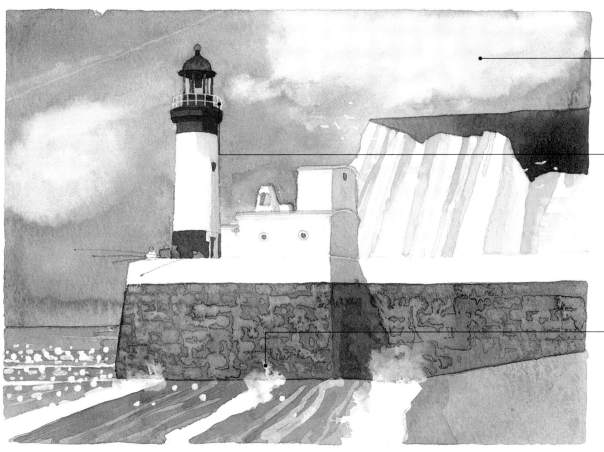

Lighthouse by *Ian Sidaway*

White gouache dropped into wet watercolour mingles with the wash to suggest billowing clouds in a summer sky.

Opaque white on dry washes is ideal for tiny details difficult to reserve – such as the seagulls and the railing on the lighthouse.

Opaque white used wet on dry is useful for water effects. Here smudged-on white gouache depicts misty flying surf. Spattered opaque white conveys the sparkle of sunlight on the water.

Highlights with whites

*You can use opaque white in a number of different ways
to add expressive touches to a painting.*

A spatter of opaque white is an effective way to depict a flurry of snow, the sparkle of sunlight on water or a starry sky – small highlights you can't reserve easily. Even if you have reserved highlights, they may recede as your painting progresses so they're no longer bright enough. You can always use opaque white to brighten them at a later stage. You can also use opaque white to overpaint details, such as daisy petals or the tiny highlight in an eye.

In practice Special effects

*Opaque white is a valuable help in many situations. Below are some suggestions,
working both wet on dry and wet in wet.*

▶ White gouache introduced into a wet watercolour sky wash creates soft cloud effects. Trail the white paint from the brush in some areas and swirl it into the sky wash in others.

▲ A delicate, controlled spatter of white gouache on to a dry wash is perfect for depicting stars in a night sky. You can reserve the white disc of the moon at the start.

◀ There's no better way to suggest falling snow than a spatter of opaque white when washes are dry. Use a small brush and, for a realistic effect, increase the density of the spatter in places to suggest wind-blown flurries.

▲ Overpainting on dry washes enables you to depict brilliant white daisies on a strong green background. You can paint them in as much detail as you like, correcting the image as you work.

▶ Opaque white helps you depict water effects. Here it's smudged in wet in wet for the flying surf, and spattered on to the dry washes to depict the sparkle of sunlight on the surface of the water.

Using toned grounds

In watercolour you can use a tinted or toned ground (or paper) to establish a colour key, set a mood or give an image a sense of unity.

Although most 'pure' transparent watercolours are painted on white or nearly white paper, many artists like to work on a coloured or tinted surface. If you're using watercolour on its own, it's usually best to stick to very pale tints, but if you introduce opaque body colour or gouache you can be much more adventurous. A tinted paper sets the colour key and mood for an image.

Choose a paper to suit the subject, the mood and your style of painting. A yellow ground gives a warm, sunny atmosphere; a blue feels cooler and more restrained. Go for a paper that reflects the local colour of your subject – blue for a seascape, green or ochre for a landscape. For more dramatic effects, try a complementary of the predominant colour – pink for a green landscape, for example (see page 47).

Key points

- White paper gives maximum brilliance to 'pure' transparent watercolour.

- Use lightly tinted supports to set a mood and a colour key.

- Lay a pale colour wash to tone white paper.

- Colours tend to dry duller on tinted papers than they do on white papers.

- A touch of Chinese white gives sparkling highlights on a coloured ground.

- Darker tinted papers can be used for gouache and body colour paintings.

- If a non-watercolour paper is too absorbent, seal it with size.

Taking a closer look

The artist has used pure watercolour with some body colour on lilac grey paper to achieve a rich, intense, layered effect.

Behold the sea
by *Jacqueline Rizvi*

On a mid-tone ground it is possible to work towards both the light and the dark tones in the sky.

Complex layers of colour create an optical mix which gives a sense of depth and luminosity.

The sea is built up from layers in varying degrees of opacity and transparency.

Some tints are made from pure watercolour mixed with a tiny bit of zinc white, while others are thinned with water.

Touches of zinc white are used for the foam on the breakers.

Which paper to choose?

Watercolour papers come in a range of tints. You can also use coloured papers intended for other media; or prepare your own by applying a flat or variegated wash on to white paper.

Although there's a long tradition of artists using tinted papers for watercolour, it is only in recent years that they have become widely available. The first was a range of handmade NOT papers in pale shades of cream, sand, oatmeal, grey and green. Another range – 300gsm (140lb) mouldmade NOT paper – appeared in cream, grey, oatmeal, eggshell (green) and blue. Another interesting paper is handmade in India from cotton rag and reclaimed jute. It has a pleasing buff colour with flecks of jute fibre. Turner's Blue Wove is a modern re-creation

of Turner's Grey – a paper manufactured for J.M.W. Turner.

Another approach is to tone your own paper – this gives more choice of colour and texture. Stretch the paper (see page 268) and lay a flat wash of the appropriate colour with a large wash brush or a sponge. Vary the tones and textures to produce a variegated wash and use brushy marks. Leave the paper to dry, then carry on as usual. For a more permanent toning which won't lift and mix with overlaid washes, use diluted acrylic, which is insoluble once dry.

Toned watercolour papers. The top three are NOT watercolour papers hand-tinted with a flat or textured wash of colour. The bottom three are ready-tinted Bockingford NOT watercolour papers in eggshell, oatmeal and blue.

Try this!

Paint the same landscape on a cool blue ground and on a sunny yellow paper. You'll find you respond to each in different ways – and the moods of the finished images will turn out to be surprisingly different.

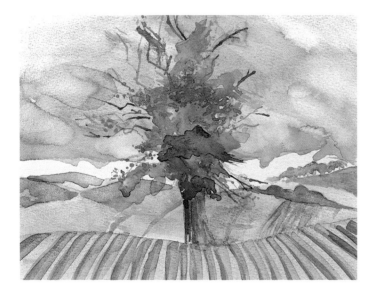

▲ *BLUE GROUND*
The blue tone was created by applying a pale underwash of ultramarine and leaving it to dry before continuing with the painting. The cool colour is less dominant than the yellow, and produces a more sombre mood.

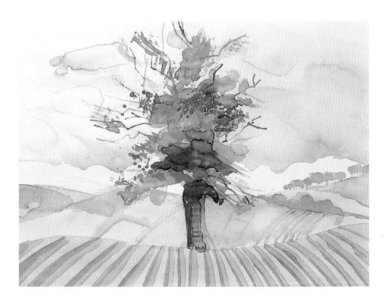

▲ *YELLOW GROUND*
The yellow paper here is a piece of craft paper which was stretched before use. The colour warms and sometimes mutes the transparent and semi-transparent watercolour washes, and gives the image a lively, sunny aspect.

Corrcting mistakes

It's often said that you can't correct mistakes in watercolour – but that's a purist's view. In fact, you may well be able to save your painting.

A common problem is colour runs, caused by very dilute washes or over-wet paper. You can mop up the dribbles with a tissue, a sponge or a rag or, for very small runs, use a cotton wool bud.

If the paper has started to absorb the paint, let it dry, then try rewetting the area with a damp sponge or a cotton wool bud – this is also useful for softening hard edges. Another useful solution is to remove dry paint with sandpaper or a craft knife, then smooth away any roughness as well as loose particles, and repaint. Abrading the paper in this way will remove some surface size, so it will take the new paint in a different way.

Very dark areas can be masked out with body colour, or even patched. When a composition isn't working, use a pair of L-shapes (see page 171) to try out different crops, or add a section of paper, and extend the composition.

Taking a closer look

Compare the two halves of this landscape – one side has been corrected, the other hasn't. On the left there are runs and washes that are too dark. On the right the artist has used washing off and abrading to improve matters.

Path through the park by Kate Gwynn

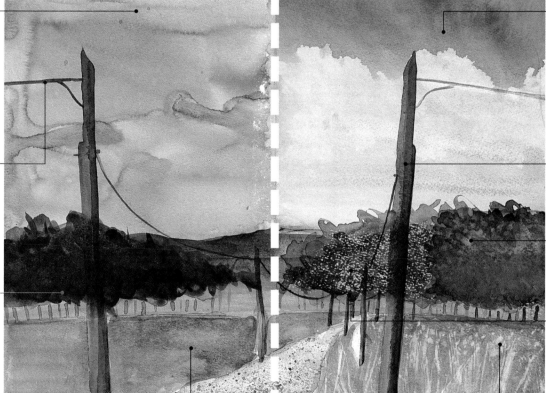

Before

After

The sky wash has run, leaving some unsightly tide marks.

The telegraph cable is too dark, making it look hard and solid.

The foliage is too dark, spoiling the sense of recession.

The grass is dull, and lacks texture.

The sky has been been washed off and repainted. The wash now pales towards the horizon to provide a better sense of perspective.

The artist has used a hard eraser to soften the colour.

The foliage has been rubbed back with sandpaper. This area has been repainted with a paler wash.

The artist has left this area of foliage as broken colour, to suggest a lighter green.

Paint has been lifted with a wet brush to add texture.

Rescuing a lost cause

Even in extreme circumstances, there's a chance you can turn a watercolour disaster into a picture you can hang on your wall.

 In practice Fixing a picture

Try out more radical techniques to rescue a poor composition. The artist here trimmed off part of the painting, patched another area, and overpainted with body colour.

Before

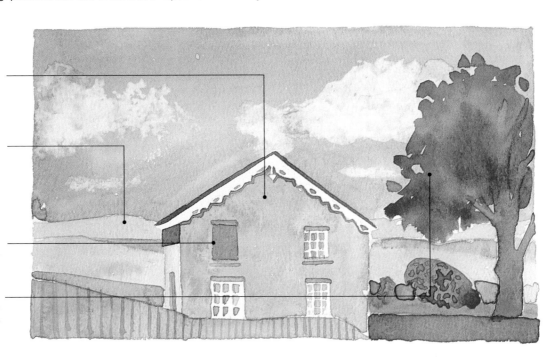

The centrally positioned house makes for a flat, dull composition.

The long horizon leads the eye into the sky, distracting attention from the main focal point.

The white glazing bars have not been reserved.

The foliage and bush are too dark, creating a tonal imbalance.

After

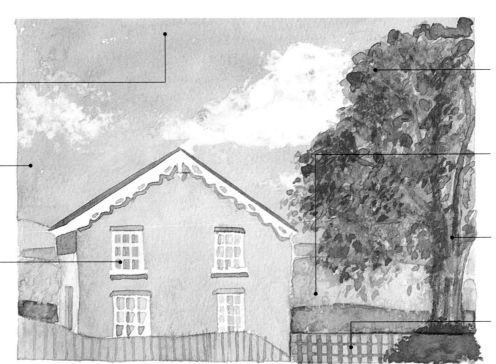

The top of the picture has been trimmed off. Reducing the sky area brings more emphasis to the house and tree.

The side of the picture has been trimmed – moving the house off-centre makes the composition more interesting.

The glazing bars have been overpainted with white gouache.

Washing out and repainting with broken colour suggests the texture of leaves.

The foreground grass and fields are darker, improving the sense of recession.

Shading on the trunk and branches gives more texture and form.

This corner has been patched and repainted for a lighter, more recessive feel.

Line and wash

The crisp vitality of pen and ink combines perfectly with the subtle translucence of watercolour to produce expressive drawings.

Transparent watercolour and pen and ink form a perfect partnership. The sharp and lively quality of pen and ink contrasts with the soft tonal qualities of watercolour to produce drawings of sensitivity and delicacy. It is a traditional and popular combination, especially when a degree of precision is required with colour – for architectural subjects, say, or botanical studies. Use waterproof ink, which won't run when you apply washes on top; the ink lines retain their crispness. You can use watercolour washes to enliven a finished pen-and-ink drawing; or you can start with loose washes and use pen and waterproof ink to add detail and express shape and form. The ink is only waterproof when dry. It can be diluted with water to achieve a lighter tone.

Key points

- Waterproof ink retains its crispness of line when washes are applied on top.

- Draw with pen and ink, then add watercolour washes selectively to highlight chosen areas.

- Apply loose washes first, then draw into them with pen and ink to add detail and form.

- Build up layers of watercolour for added texture.

- Vary the thickness of the line to give vitality to the pen and ink drawing.

Taking a closer look

In this lively drawing the artist has skilfully combined broad washes with pen-and-ink linework. The result perfectly captures both the impressive building and the atmosphere of the busy market.

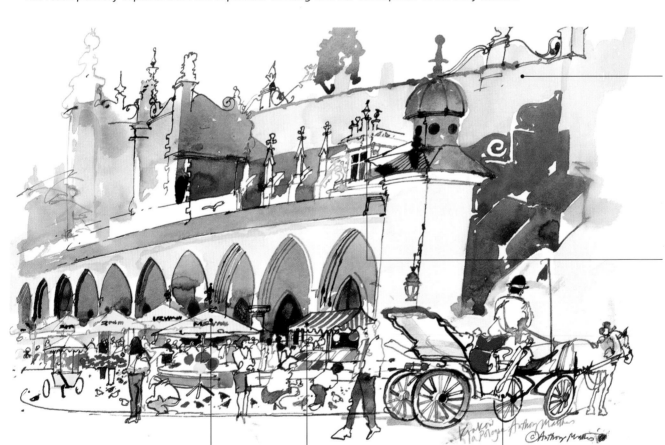

Market place, Krakow, Poland by *Anthony Matthews*

The artist began with broad washes to establish the building. The subtle, muted tones provide plenty of visual information but they don't overpower the scene in front.

Fluid pen-and-ink lines hint at architectural details and sketch in the bustling market scene. In places the artist diluted the waterproof ink to vary the tone and soften the line.

Simple outlines indicate the busy stalls and shoppers. The accents of primary colour contrast with the quiet tones of the building.

The artist used waterproof ink, so he could add accents of colour on top of his linework.

The horse and carriage are depicted with more detail so they advance into the foreground.

Using line and wash

You can employ this technique in different ways to depict even the most intricate forms with freshness and vitality.

With line and wash you have several options. You can first create a pen-and-ink drawing, then introduce colour and shading with watercolour washes. Alternatively, you can start with broad washes to suggest mass and tone, and then use pen and ink to depict outline and form, and to add detail. Whichever way you work, exploit the variety of marks your pen can make so your drawing has vitality, and don't overwork your washes.

Tip

Ink lines are hard to correct, so you may feel more confident if you start with a pencil under-drawing. Map out the basic forms and their relative positions first – but keep things simple and don't include any details.

Try this!

The combination of coloured ink lines and watercolour washes enables you to handle flower studies such as this lily with great sensitivity and attention to detail.

▶**1** Begin with a simple pencil outline to help you to get things right before you start drawing with pen and ink. Check that the proportions and relative positions are correct, and keep an eye on the negative shapes too.

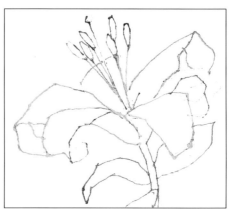

▲**2** Outline the petals and leaves with waterproof coloured inks. Keep your lines fluid and alive – you needn't stick rigidly to your pencil marks.

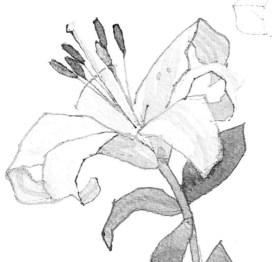

▶**3** Make sure the ink is dry, then use watercolour washes to add colour and tone. Don't just fill in the lines, but really 'feel' the forms with your brush so you follow the curve of the petals and leaves and hint at their texture.

▶**4** When the washes are dry, return to your pen to add textural detail. Observe the flower carefully – subtle lines that follow the shapes of the petals perfectly depict their firm waxiness, and the leaves can be treated in the same way. Add final details to the stamens and a careful spatter to the petals.

The wash-off technique

Used to produce pictures that are dramatic and compelling, this method combines gouache paint with waterproof Indian ink.

In wash-off, a dry gouache painting is covered with waterproof ink, then flooded with water. This washes off the ink on painted areas, with some of the paint, while the ink remains undisturbed in the unpainted areas. The result is a dramatic image characterized by visually powerful areas of solid black.

Some ink remains randomly on the painted areas, enlivening the surface and giving the appearance of a woodcut. To succeed you must follow a few basic rules. Plan your picture before you start so you reserve the black areas as unpainted paper. White areas must be painted white, not reserved.

Taking a closer look

In this bold and dramatic painting the artist exploited the effects of the wash-off technique to produce a striking image of a Venetian square.

The powerful black arch provides a daring frame for the glimpse of the square beyond.

Sharp contrast
The artist contrasted robust black areas with whites and muted tones to create a strong sense of light.

Broken effects
The artist allowed traces of ink to break up the coloured areas and create a visual contrast with the solid black of the arch silhouette. These touches of black help to create textural interest in the aging façade.

View of St Marks Square, Venice
by *Kate Gwynn*

Using the wash-off method

Apply the gouache thickly, or the water won't lift the ink effectively – and ensure it's dry before covering with waterproof ink.

 In practice **Gondolas in Venice**

Work on heavy paper and secure it to a board with gummed paper strips. Simplify your initial painting. Use artists' quality paint – cheaper paints may leave only a faint image after washing off.

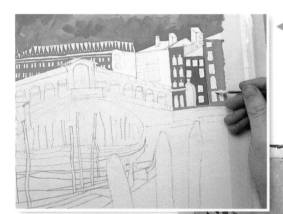

◄**1** Draw the simple outlines in pencil. Block in the sky in thick paint – the surface should be built up above the support. Paint the details, leaving the windows and the gondola hulls blank – to be coloured by the ink. Use loose brushstrokes for the water, leaving areas for the ink to stain. Let the painting dry completely.

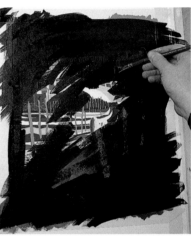

▲**2** Use a flat brush to apply waterproof Indian ink lightly to the entire picture surface. Don't scrub with the brush – you will disturb the paint. The built-up surface of the gouache should be visible through the ink. When the whole picture is covered, leave the ink to dry completely.

▼**3** Hold the picture over a sink and gently pour warm water over it to lift the ink. Pour close to the picture and turn the board so the water flows in different directions. Coax stubborn areas of ink with a cloth (inset), and clarify details with a cotton bud dipped in hot water. Give a final wash with cold water.

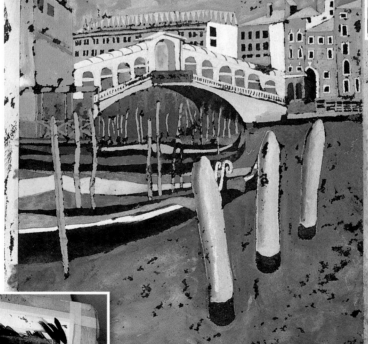

View of the Grand Canal, Venice by *Kate Gwynn*

◄**4** The gondola covers provide a colourful focus that leads the eye to the white bridge. The wash-off has created muted tones that depict the moody sky, the murky water and the faded façades of the buildings. Traces of ink remain to give the image freshness and immediacy.

Blot painting

Use paint or ink blots to trigger your imagination and help you 'find' exciting landscape compositions.

Every child has 'seen' landscapes, faces and animal shapes in clouds and stains on the wall. The blot technique is similar since it involves making random blots and marks on paper, seeing what images they suggest and then developing them into sketches or finished paintings.

This process exploits the mind's tendency to make sense of abstract shapes and is useful for beginners who may feel intimidated by a sheet of blank white paper. The random marks are liberating because they interrupt the stark whiteness of the support and give something positive to work with. Blots can also be useful for more experienced painters who want to stimulate their imagination. Painting from the subject undoubtedly hones your powers of observation, but giving free rein to your fantasies can be equally rewarding.

Taking a closer look

The artist created this Turneresque study by applying Indian red, lemon yellow and burnt umber watercolour paint to the base of an enamel plate and pressing the plate on to a sheet of slightly damp lithography paper.

**Venetian sunset
by Albany Wiseman**

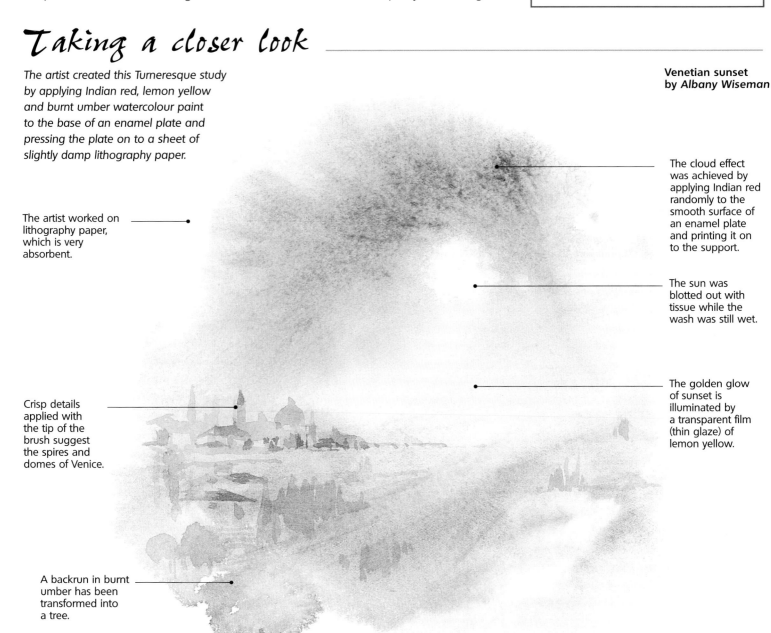

The artist worked on lithography paper, which is very absorbent.

Crisp details applied with the tip of the brush suggest the spires and domes of Venice.

A backrun in burnt umber has been transformed into a tree.

The cloud effect was achieved by applying Indian red randomly to the smooth surface of an enamel plate and printing it on to the support.

The sun was blotted out with tissue while the wash was still wet.

The golden glow of sunset is illuminated by a transparent film (thin glaze) of lemon yellow.

Creating blots

There are several ways of exploiting blots. Experiment and find the system that suits you best.

To begin a blot painting, load a brush with watercolour wash and apply it to paper. While it's still wet, lay another sheet on top and press gently. Lift the top sheet to reveal a similar blot. Study both, turning them round to see if an image suggests itself. Then, while the paint is still wet, use a brush to move it around, or blot with a tissue or a sponge. When dry, elaborate the image with wet-on-dry washes, pencil or coloured pencil.

Another way is to apply colour to the base of a plate – it must be be smooth so its entire surface touches the paper. Dust the surface with talcum powder to remove grease and increase adhesion. Apply colour to the base, 'print' on to the paper and proceed as before.

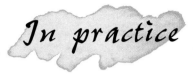

In practice **Different blot combinations**

Explore various techniques, combinations of colours, as well as miscellaneous paper surfaces, and enjoy the variety of textures and images that emerge.

▼ OYSTER SHELL, SEA AND SAND
Sepia tint, raw sienna and cobalt blue were applied to a very smooth, heavily sized paper. The non-absorbent surface produced fascinating runnels and textures which suggested the ripple marks on a sandy beach.

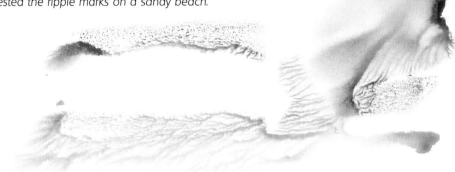

▲ SWAN OUTLINE
This blot of sepia ink looked promising. The artist printed it out on to another sheet by folding the paper over.

▲ DETAILED SWAN
A beak applied with the tip of a brush turned the sepia blot into a convincing swan.

▶ OLIVE TREES
Blobs of cobalt blue, sepia tint and brown calligraphy ink were applied to HP paper and printed off on to another sheet of paper. Tree trunks applied with the tip of a brush were the only addition needed to produce an attractive landscape.

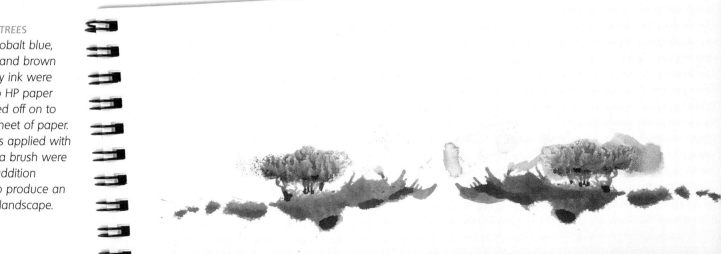

Laying tube paint on paper

Paint squeezed directly from the tube can be used to create images that are vibrant, colourful and spontaneous.

This unconventional technique involves laying down touches of tube colour and then working the paint with a wet brush. Start by wetting the paper evenly with a sponge or a wash brush. Then apply dabs of paint directly from the tube on to the paper, placing the colours so that they will give the mixes required. Work the paint with a wet brush, creating washes and mixes. The paint becomes thin and transparent in some places but remains thick and opaque in others. Although the technique is unpredictable and risky, the results have a marvellous immediacy and vigour.

Taking a closer look

In this sunny painting the artist has applied dots of tube watercolour and worked these up into washes on the paper.

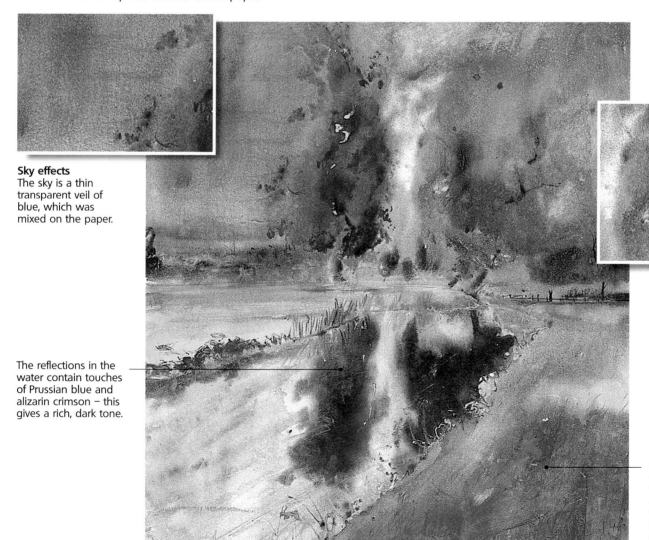

Summer's reflection by *Sophie Knight*

Sky effects
The sky is a thin transparent veil of blue, which was mixed on the paper.

Foliage colour
Spots of cadmium red, lemon yellow and cobalt blue are mixed to give washes of bright green foliage interspersed with touches of the original tube colour.

The reflections in the water contain touches of Prussian blue and alizarin crimson – this gives a rich, dark tone.

Generous quantities of students' quality tube paint were applied directly to the support. Used lavishly, it gives a good intensity of colour.

Using the 'direct' paint technique

Practise this technique using a simple subject, such as a vase of flowers, and a limited palette of colours.

In practice **Vase of flowers**

It's important to keep the paper wet throughout the painting process – spray the painting with a light mist of water at regular intervals.

◀ **1** Wet the paper evenly. Apply blobs of paint in the correct positions. Use alizarin crimson and Prussian blue for the violet flowers and the background; cadmium yellow and lemon yellow for the creamy flowers; and mixes of Prussian blue, cerulean, lemon yellow and cadmium yellow for the greens.

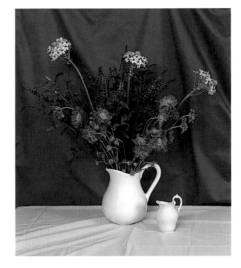

▲ SET-UP FOR THE PAINTING
The artist based her picture on this still life.

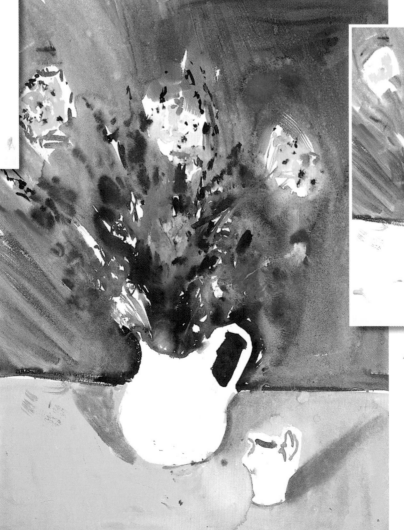

▶ FINISHED PICTURE
Add dots and smears of Prussian blue and alizarin crimson tube colour for the spiky flowers, and emphatic dots of the same colours for the dark tones on the yellow flower heads. Use the same colours for the dark areas in the foliage and to refine the outline of the large jug.

▲ **2** Load a brush with water and mix the background colours. Take the wash around the edge of the flowers, foliage, vase and table cloth. Work into the background flowers, and the foliage. Then block in the yellow foreground using a clean brush, taking the colour around the jugs (see inset).

CHAPTER 2

COLOUR THEORY

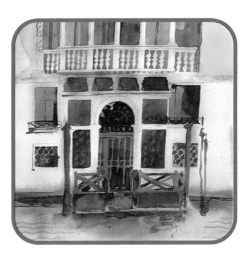

The ability to use and mix colour is one of the keys to successful painting, yet this is often the most difficult skill for beginners to learn. This chapter introduces the basic principles, explains the terminology, illustrates colour in practice and provides useful exercises.

Two main aspects of colour are of importance to the artist: the process that occurs when colours are mixed together, and the powerful effects colours have on each other. The complementary pairs of colours are a good example of this, since when placed side by side they make each other look brighter and more vibrant, but when mixed together they mute one other to produce a lovely range of 'coloured greys' that make a marvellous addition to any painter's palette.

The colour wheel featured in this chapter is a useful aid that will help you understand and remember the most important colour relationships, including the important complementary pairs. Paint your own colour wheel when you have a spare moment – doing so will ensure that the relationships between colours really stick in your mind, and it will also give you some useful practice in laying washes.

Colour basics

You'll discover that using and mixing colours becomes surprisingly simple with the help of the colour wheel.

The colour wheel is a diagram that will help you to understand, and remember, some of the most important colour relationships and the key colour terms. Use it to predict how colours behave when mixed together, and what effects they produce when put together in a painting.

Make a six-colour wheel, annotate it and pin it up where you can see it as you work. It will be an invaluable aid to mixing and using colours.

▶ PRIMARIES AND SECONDARIES
The primary colours are red, yellow and blue. They are unique in the painter's palette because they cannot be mixed from other colours. The secondary colours, mixed from the primaries, are orange, green and violet. They are located between the pair of primaries from which they are mixed. The primaries red and yellow produce orange; yellow and blue give green; blue and red give violet.

Primary red

Secondary orange

Secondary violet

Primary yellow

Primary blue

Secondary green

Warm colours

Cool colours

◀ WARMS AND COOLS
The cool colours – violet, blue and green – are located in one half of the colour wheel opposite the warm colours – red, orange and yellow. Cool colours appear to recede and take up less space than warm colours. They generally have a calming effect. Warm colours appear to come forward in a painting and with their association with fire, sunlight and danger can be used to create a sense of energy and excitement.

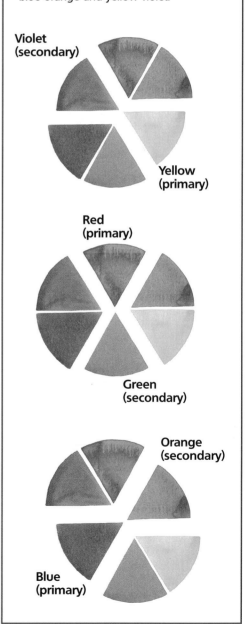

Complementaries

Complementaries are colours that are opposite each other on the colour wheel. A primary is complemented by a secondary. The complementary of a secondary is the primary not included in its mixture. So, for example, primary yellow is the complementary of violet. The colour wheel gives you these complementary pairs: red-green, blue-orange and yellow-violet.

Violet (secondary)

Yellow (primary)

Red (primary)

Green (secondary)

Orange (secondary)

Blue (primary)

Colour in practice

Colour performs many different functions in a painting. Understanding these will help you to use it effectively and creatively, and enable you to evolve your own personal style.

You can use colour very simply to describe the surface appearance of things – the blue of the sky, for example, or the rich brown of a ploughed field. It can also be used to create visual illusions – warm and cool colours can be orchestrated to model three-dimensional form or create the illusion of depth on the flat surface of a painting. Colour can set a mood – bright harmonious colours can be used to suggest energy or happiness, while jarring or discordant colours can evoke unease or anger.

Key points

- Local colour is the actual colour of a surface, unmodified by light or atmospheric effects.

- Colour key is the predominant tone of a painting. A high key painting is light in tone, while in a low key picture the colours are more muted.

- Tone, or value, is the lightness or darkness of a colour.

Taking a closer look

In this exuberant and colourful study, the artist has used a high-key palette, which means that the light tones predominate. Her very personal approach to colour produces images which are accurate evocations of scenes, but which also have a deliciously decorative quality.

**St Amant, Auvergne
by Jenny Wheatley**

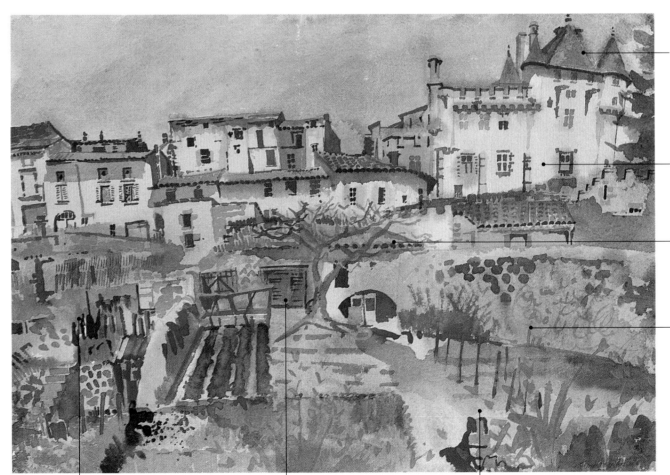

The orange tiles resonate against the complementary blue of the sky.

Primary yellow gives the painting a sunny aspect.

Orange is the local colour of the roof tiles.

Secondary greens introduce a cool contrast into the scene.

Green is the local colour of the foliage.

Touches of hot red in the foreground draw the eye.

Shadows are often violet – the complementary colour of yellow light.

Complementary contrasts

One of the most important colour relationships is that between the complementary pairs of colours. Used together they can inject great vitality and zest into a painting.

When complementary pairs are laid side by side, they have a dramatic and enhancing effect on each other. Reds appear redder when they are placed next to their complementary green, while blues seem more vivid and vibrant when orange is nearby.

The primary colours and their complementaries offer the strongest contrasts in the artist's repertoire. It's worth taking the time to examine the different effects to be achieved. You can use complementary pairs to add life to areas of colour, draw attention to specific places and add impact.

Try this!

At first, some of the effects made by complementary pairs can seem unbelievable. But the fact is that colours react with each other in the eye in certain well-established ways. The two exercises below prove it.

◀ THE AFTER-IMAGE EFFECT
The most dramatic demonstration of the power of the complementary relationship is the 'after-image'.

Stare fixedly for fifteen seconds at the dot in the middle of the coloured squares. Quickly transfer your gaze to the dot in the centre of the grey squares. You'll see the complementary of each colour in the corresponding section. The pale green after-image of the red square will appear in the top right square, with yellow below it, pink in the square next to it, and blue in the top left.

▶ TWO BLUES
Look carefully at the two central blue squares – are they or aren't they the same colour?

They are in fact identical, but the blue in the left square looks more intense because it is surrounded by its complementary orange.

Try your own experiments with other complementaries, using coloured paper. For example, place a red square on a complementary green background, and then see how the same red square looks on a blue background.

Complementary opportunities

You can use the complementary pairs as the basis of a painting or introduce them here and there to add vitality and visual excitement.

Complementary pairs provide the greatest colour contrast, but they also have a natural affinity for one another, so if both are present the eye immediately jumps from one to the other. These characteristics can be used to make links across a painting and to draw the eye to important features.

The way that colours react to each other in practice is affected by many factors, including their size, shape and the distance between them. Small areas of complementary pairs appear to shimmer and can be used to add interest or lead the eye around a painting. If you use the same colours on a large scale discords can result – and these too can be exploited to create a particular mood. By alternating stripes of a pair of complementaries, for example, you can make colours appear to vibrate before your eyes on the paper.

Take a closer look

In this lively painting the artist has freely applied washes of colour on a board with a pleasing neutral tone. His palette is restricted, based on the red-green complementary pairing of a boat and trees in the centre of the painting, and the golds and neutral browns of the dockside buildings. Notice the way the eye dances between the red figure in the left foreground and the green chair on the other side, and is then led back to the red boat.

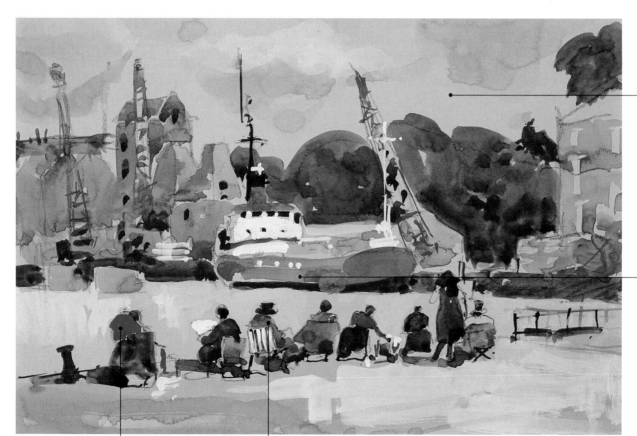

Painters at Mistley Quay by *John Tookey*

The warm grey of the support holds the image together and provides a foil for the brighter colours.

The red of the ship resonates against the green foliage.

This patch of red 'looks for' the green chair on the far side.

The bright blue figure links to the complementary golden ochres of the dockside buildings – notice that in this case a small intense patch of a cool complementary seems to balance bigger areas of the warm colour.

Mixing complementaries

Mixing complementary pairs of colours together produces a range of beautiful greys and browns that gives depth, complexity and harmony to your watercolour painting.

When the complementary pairs of colours are placed next to each other, they have a mutually enhancing effect. An equally important aspect of this relationship is the way the colours behave when they are mixed together. When you mix any primary colour with equal quantities of its complementary secondary, you produce a grey or brown. These greys are called 'neutrals' or 'coloured greys'. By varying the proportions of each colour in the mix you can create a wide range of cool greys and soft browns. These mixed neutrals are much more varied and lively than the greys you can make by adding straightforward black or grey paint to a mix.

Try this!

The best way of finding out what happens when you mix pairs of complementaries is to try it for yourself. This colour wheel is a useful aid to memory.

▶ CREATING NEUTRALS
Make a colour wheel like this one. Paint in the primaries – red, yellow and blue. Then paint in the secondaries – green, orange and violet. To create the neutral colours in the middle, add a small amount of the secondary to the primary directly opposite. Then add a little of the primary to the secondary. Repeat this for each pair of complementaries.

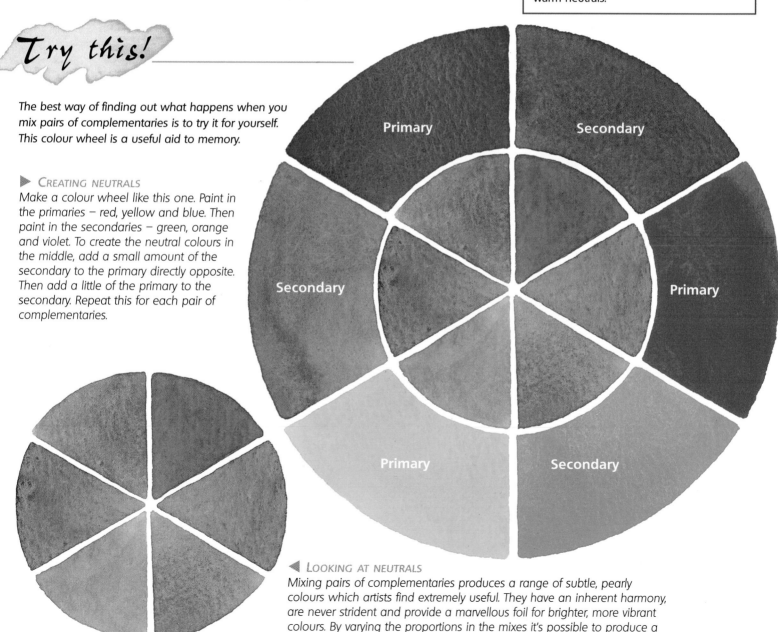

◀ LOOKING AT NEUTRALS
Mixing pairs of complementaries produces a range of subtle, pearly colours which artists find extremely useful. They have an inherent harmony, are never strident and provide a marvellous foil for brighter, more vibrant colours. By varying the proportions in the mixes it's possible to produce a wide range of subtle shades from each pair of complementaries.

Using complementary mixes

The neutrals mixed from the complementary pairs are indispensable to the artist. It is worth spending time experimenting with the mixes and becoming familiar with the range of colours produced.

Neutrals have many functions in paintings. Because they are naturally harmonious, artists often use coloured greys and neutrals as the basis of a painting – with small touches of brighter colour providing eye-catching focal points. Neutrals provide a foil for other brighter colours, so that a touch of an accent colour really sings out against a neutral background. Neutrals are also the colours of nature, so they are especially useful for landscape artists – giving the cool blue-greys and mauves of distant hills and the muted yellows and tawny tones of the countryside in autumn. They are also ideal for depicting rainy landscapes and stormy seas.

Tip

If a colour in your painting is too strident, you can knock it back by adding a touch of its complementary colour. If the hills on the horizon advance too much, add a touch of complementary yellow or orange to the blue or lilac washes.

In practice Painting from nature

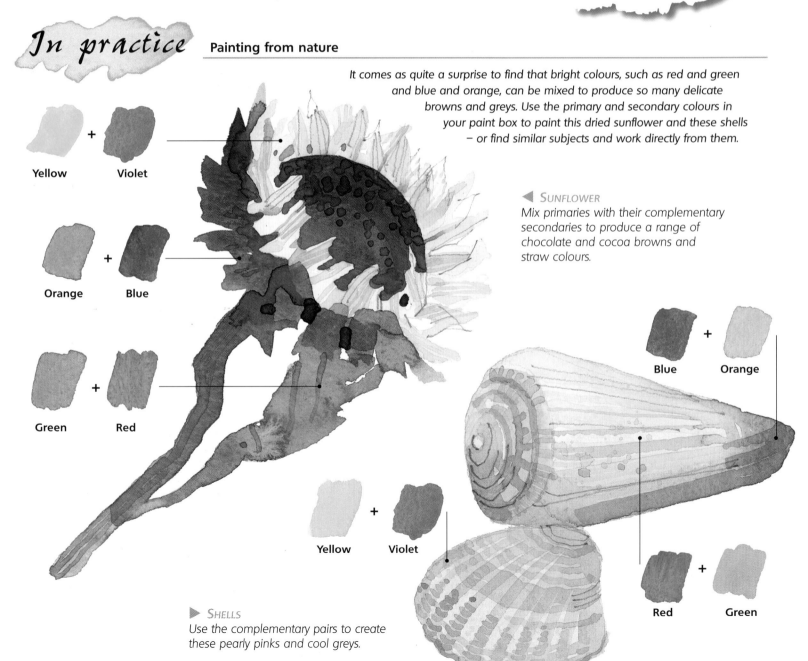

It comes as quite a surprise to find that bright colours, such as red and green and blue and orange, can be mixed to produce so many delicate browns and greys. Use the primary and secondary colours in your paint box to paint this dried sunflower and these shells – or find similar subjects and work directly from them.

Yellow + Violet

Orange + Blue

Green + Red

◀ SUNFLOWER
Mix primaries with their complementary secondaries to produce a range of chocolate and cocoa browns and straw colours.

Blue + Orange

Yellow + Violet

Red + Green

▶ SHELLS
Use the complementary pairs to create these pearly pinks and cool greys.

The six-primary wheel

The three-primary wheel is insufficient for colour mixing. In order to get a good basis, you need to have two versions of each primary – a warm and a cool – making the six-primary wheel.

The ability to manage colour underpins all good painting. You need to understand the basic principles, and combine patience with practice, to get to the point where you can mix exactly the colour you want.

BIAS OR UNDERTONE

In theory the only paints you need to mix a complete range of colours are the three primaries: red, yellow and blue. The practice is different. In paint form, all primaries have a bias, also called the 'undertone'. To assess the bias of a colour, look at it as a tint – mixed with white, or laid as a very dilute wash over white paper.

The undertone of a pigment is relative – all the reds in your palette have a slightly different bias. A red paint may have a blue or a yellow bias – alizarin crimson has a blue bias and cadmium red a yellow bias. Ultramarine blue has a red bias and cerulean blue a green bias. The six-primary wheel is based on pairs of primaries, each with a different bias.

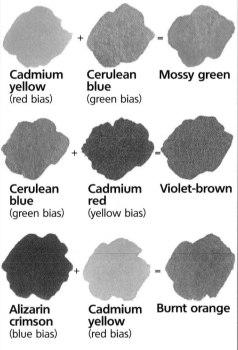

Muted secondaries

The six-primary system also produces a wonderful range of muted secondaries. Because of the undertone or bias of the constituent colours, these mixes actually have a little of all three primaries in their make-up. When all three paint primaries are mixed together they produce black or grey, and any mix that contains traces of all three will be greyed or neutralized. Look at the examples below and then experiment with your own selection.

Cadmium yellow (red bias) + **Cerulean blue** (green bias) = **Mossy green**

Cerulean blue (green bias) + **Cadmium red** (yellow bias) = **Violet-brown**

Alizarin crimson (blue bias) + **Cadmium yellow** (red bias) = **Burnt orange**

Warm & cool primaries

The six-primary system on this colour wheel gives a warm and a cool version of each primary. Mix the primary colours closest to each other to produce clear secondary colours.

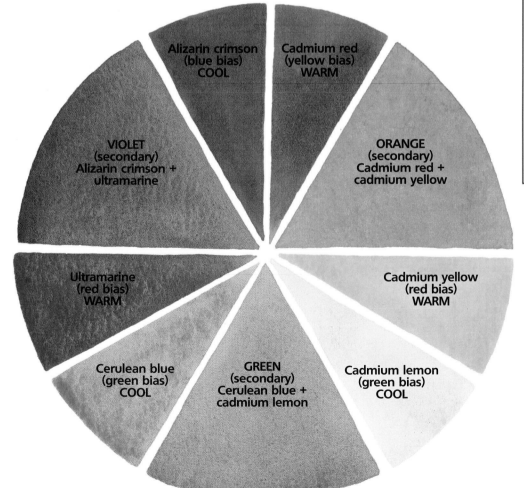

Alizarin crimson (blue bias) COOL

Cadmium red (yellow bias) WARM

VIOLET (secondary) Alizarin crimson + ultramarine

ORANGE (secondary) Cadmium red + cadmium yellow

Ultramarine (red bias) WARM

Cadmium yellow (red bias) WARM

Cerulean blue (green bias) COOL

GREEN (secondary) Cerulean blue + cadmium lemon

Cadmium lemon (green bias) COOL

◄ THE 'MIXING' COLOUR WHEEL
A single primary doesn't give enough of a range for colour mixing. Putting a warm and a cool primary on the colour wheel lets you produce the biggest range of colours from the smallest selection of paints.

For a good orange, mix cadmium yellow (red bias) and cadmium red (yellow bias). Cadmium lemon (green bias) and cerulean blue (green bias) give a fresh green. Alizarin crimson (blue bias) and ultramarine (red bias) make a good violet.

Using the six primaries

It's good practice to work with a restricted range of colours. This avoids confusion and helps you to become familiar with the colours in your box and the way they behave when mixed with each other. A restricted range of colours is called a limited palette.

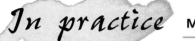

In practice **Mixing primaries**

This landscape was painted with the six primary colours from the six-primary wheel. With this flexible palette, mixing paints in different proportions produces a huge range of bright and subtle colours.

Ultramarine

Alizarin crimson

Cerulean blue

Ultramarine

Alizarin crimson

Cadmium yellow

Ultramarine

Cadmium yellow

Cerulean blue

Alizarin crimson

Ultramarine

Cadmium red

Cadmium lemon

Cadmium yellow

Cadmium red

Cerulean blue

Cadmium yellow

Cadmium red

Cerulean blue

Cadmium yellow

Cadmium red

Ultramarine

Looking at tone

Tone, or value, describes the lightness or darkness of a colour or an area of a subject. The ability to see and identify tone and match it in paint is an essential skill for the watercolourist.

Tonal variation is used in painting and drawing to create an illusion of solid form and three-dimensional space on a two-dimensional support. The areas of an object facing a light source will be light. Those on the side turned away from the source will be dark. On a curved surface there are smooth gradations of tone between the lightest and darkest areas. On a cube though, it is the sharp difference in tone between one plane and another that tells you immediately that it is a cube rather than a sphere.

Try this!

It is sometimes difficult to see tone because colours, patterns and different light sources confuse things. A black-and-white photograph makes it much easier.

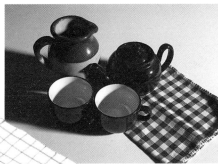

◄1 Study this monochrome set-up, then make an outline drawing. Don't put any tone on it. Notice that when the set-up is drawn in line only, the objects look flat and there is little sense of space.

►2 Now apply washes of tone to your drawing – use black or Payne's gray for this exercise. Half-close your eyes – this will help you identify areas of the same tone. If you judge the tones correctly, the objects will look three-dimensional, and you will be able to see the curved belly of the teapot and jug, and the hollow interiors of the cups and jug.

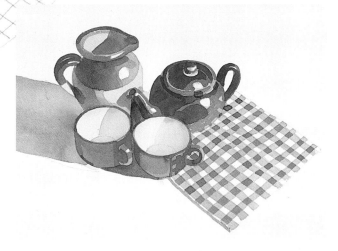

The tone of colour

Every colour has a tone – and the ability to judge the precise tone of a colour is fundamental to good painting.

If you compare the two photographs of the garden below, you will see that the camera has interpreted the light buff of the path as pale grey, while the bright green foliage is the same tone as the red roof. Some people have a natural ability to judge tones accurately – but most people can improve with practice. If you get these crucial assessments wrong, your image will look incoherent, and the spatial arrangements and forms will be difficult to read.

Try this!

Practise judging the tone of colours by making a series of tonal scales. You will find that some colours are naturally much lighter than others.

1. Achromatic or grey scale

Mix a black wash. Draw six rectangles and paint the one at the end black. Paint the rectangle at the other end a pale tint of grey. Now mix four evenly graduated shades of grey and put them in the rectangles between to make a scale which progresses evenly from pale grey to black.

2. The tone of yellow

Now mix an intense wash of cadmium yellow, dab a bit on scrap paper and see which of the grey steps it is closest to. Half-close your eyes to help you concentrate. Paint the yellow into the appropriate square. This yellow aligns with the third lightest grey.

3. The tone of blue

Repeat the exercise with Prussian blue. Blue is much darker in tone so the fully saturated colour aligns with a very dark grey.

▲ *GARDEN IN COLOUR*
In nature there are an infinite number of colours and tones. The artist has to simplify these in order to render them in paint.

Key points

- The term 'tonal key' describes the colour and tonal register of a particular painting or subject. If the colours are predominantly light, bright or pale, the painting is said to be in a 'high key'. If they are dark or muted, the painting is said to be in a 'low key'.

- The darker tones of colours are called shades.

- Lighter tones are called tints. In watercolour, they are made by diluting wash so the white of the paper 'tints' the colour – in other media such as gouache they are made by adding white paint.

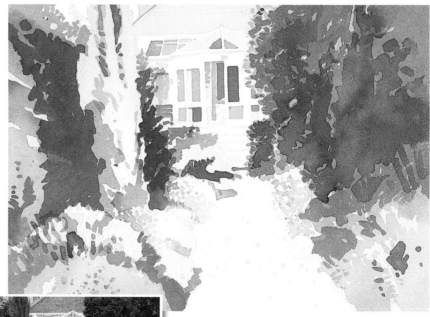

▲ *GARDEN IN BLACK AND WHITE*
The artist uses a more limited range of tones to depict the same scene. If you don't get the tonal relationships right, the painting will be confusing. This is equally important when you are working in colour.

Optical colour mixing

All colours and tones are influenced by those surrounding them. This effect can be exploited to create subtle shades.

If you apply small dots of two different colours to a surface you can see the individual colours clearly close up. But as you walk away it becomes more difficult to separate the colours, until, at a certain distance, they blend to create a third colour. If the patches of colour are small, 'colour mixing' happens at a short distance, but if they are large, it will occur at a much greater distance.

These optical or 'broken' mixes can be dots, dabs, strokes, stipples or hatching and cross-hatching, and can be used with watercolour, gouache or other media. (For details on stippling and hatching, see pages 143–144.)

Use a dry brush to drag one layer of broken colour over an underwash or tinted support, or use a large brush and loose 'brushy' marks for an uneven film, or try scumbling (see Key points, right). Broken effects can be rough, irregular and variable, or detailed and systematic.

Taking a closer look

The artist has used a meticulous stippling technique to capture the myriad subtle shades of green, the transparency of the sky and the warmth and sunlight which envelop the scene.

Ewes and lambs, Beckhole, North Yorkshire by *Norman Webster*

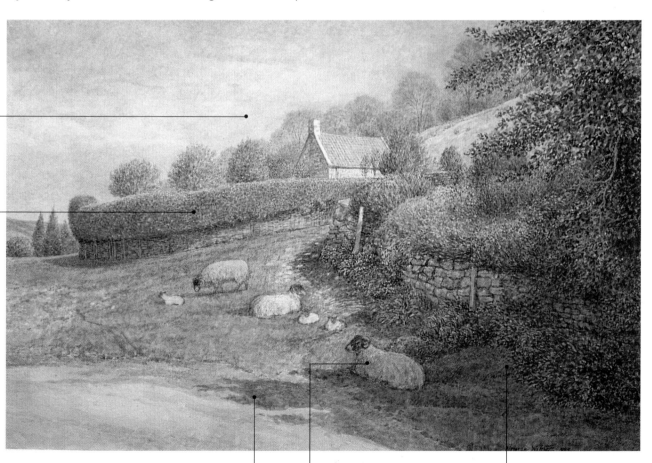

Stipples of pale blue and yellow laid over white paper capture the luminous quality of the sky.

Tiny dots of warm and cool green create a visual equivalent for the clipped foliage of the hedge – broken colour suggests its mass without making it look solid.

Larger brush marks depict light filtering through the foliage in the foreground.

Speckles of green, blue and brown capture the gradations of tone around the sheep's body, the texture and volumes of its fleece and the light that falls on to it.

Touches of broken colour depict the complexity and depth of the shadow.

Exploiting broken colour effects

Broken colour effects can be used to create luminous, shimmering colour and a lively, textured paint surface.

A painter has to contend with the limited tonal range of paint. The brightest colour in the palette is white (or in watercolour the white of the paper), but this can't match the intensity and brilliance of light. It's just as hard to match the depth of the darkest tones and colours. In a painting you must aim for a visual equivalent of the colours and tones in your subject. Broken colour allows you to achieve effects which can't be created with palette mixing. Viewed from a distance the individual dots, dashes and dabs of paint dissolve to produce a complex veil of colour that appears to shimmer just above the picture surface, mimicking the effect of light.

Key points

- Capture the depth and complexity of subjects such as foliage with optical mixes.

- Scumbling and dry brush techniques are ideal for depicting amorphous and luminous subjects such as skies and still and moving water.

- Use broken colour techniques to suggest the depth of shadows.

- Hatching and other broken colour effects can be used to achieve subtle nuances of tone and colour in dry media such as coloured pencil and pastel.

- Use optical mixing to produce a varied and lively paint surface.

- Introduce complementaries to make colours sparkle – touches of red in grass and foliage, and violet in shadows.

Try this!

Practise these broken-colour techniques, then pin your results on the wall or an easel and view them from different distances.

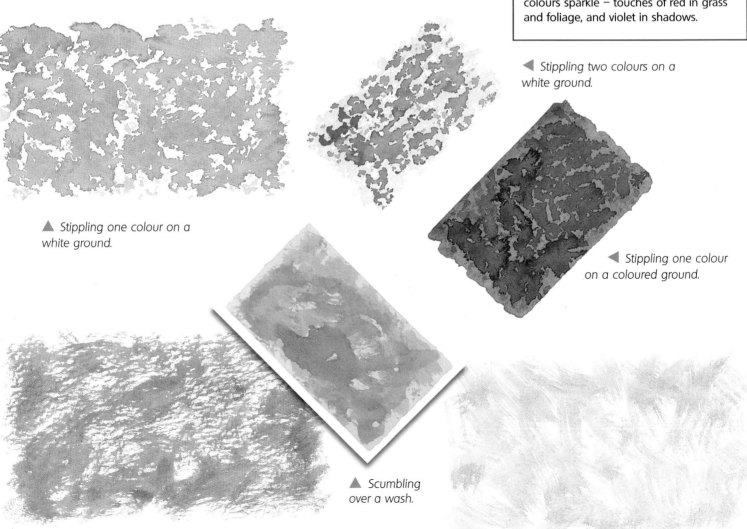

▲ Stippling one colour on a white ground.

◄ Stippling two colours on a white ground.

◄ Stippling one colour on a coloured ground.

▲ Scumbling over a wash.

▲ Dry brush on a white ground.

Colour moods

You can use colour in a painting to express different emotions and create a particular mood.

Colour performs many functions in a painting. It can be used very simply to depict the surface appearance of things – the blue of the sky, the red of poppies, and the yellow of sunflowers. Tonal gradations and warm and cool relationships can be orchestrated to represent volumes and spatial relationships – in aerial or atmospheric perspective, for example. Colour can also be used to set a mood, convey a feeling and evoke a particular response in a viewer. Some artists deliberately used heightened colour to

express their response to the subject, often abandoning the descriptive aspects of colour altogether.

The mood-altering influence of colour permeates our lives. The violet-blue of a drift of bluebells can fill us with delight; a grey, overcast day can plunge us into gloom; and brightly coloured clothes can lift our spirits. Advertisers use colour to influence us – blue, which suggests cleanliness and purity, is used on the packaging of soaps and washing powders, while red is used to signal power and strength.

Key points

- Cold and cool colours are restrained and contained, and sometimes sad.
- Hot and warm colours are bold, aggressive and vigorous.
- Pastel colours are soothing and pleasing.
- Colours from the same section of the colour wheel can be used to create a harmonious mood.
- Neutrals are naturally tranquil, but can also be used to create a sombre mood.
- Harsh contrasts of colour and tone suggest excitement and energy.
- Subtle gradations of tone and colour suggest peace and calm.

Taking a closer look

The artist has used a high-key palette to conjure up the light and warmth of a summer's day.

Quiet corner at Coombe Courtyard
by *Paul Riley*

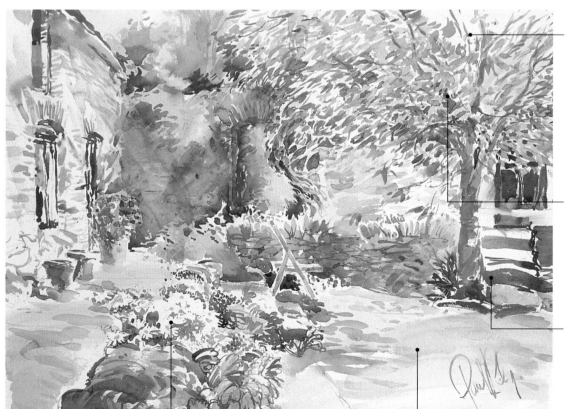

Contrasts of tone are kept to a minimum – this contributes to the serenity of the image.

Touches of complementary violets make the yellows appear to shimmer.

Violet shadows capture the warmth of the scene.

White paper showing between the patches of wash makes the colours sparkle.

The shadows are not very dark – this contributes to the happy mood.

The language of colour

Some colours make us feel happy, others create feelings of sadness, excitement or serenity. Familiarize yourself with the mood each evokes.

Colours can convey emotions – something artists can use to great effect.

Grey is a cool neutral associated with overcast days and cloudy skies.

Blue is calming, restful, serene and meditative, associated with seas, skies, space and distance.

Red is warm and advancing, associated with blood, fire, strength and passion. It's used to attract attention.

Yellow is bright and cheerful, the colour of sunshine and light, although it can appear strident, harsh or sickly.

Green symbolizes growth, fertility and yearly renewal.

Violet veers between warm and cool. It has been associated with royalty, and also with mysticism and fantasy.

Brown is a warm neutral. The colour of earth, it is associated with qualities such as timelessness and reliability.

Black is enigmatic. It can be negative, expressing darkness and nothingness. But black is also sumptuous, soothing and comforting.

White conveys light, goodness and cleanliness. It can be clinical or austere.

Tip

Study the paintings in this book and see what feelings they evoke in you. Are they precise or ambiguous, do they change with time, and do you think they express the feelings the artist meant to evoke? Then try the same exercise with some friends – are their responses the same as yours? You will be surprised by the degree of consensus – but the disagreements are interesting too.

In practice Landscape at twilight

Dark tones and a limited palette of blues and umbers capture the tranquillity of twilight. There are no jarring contrasts of colour or tone.

Silhouettes at dusk, Essex by Roy Hammond

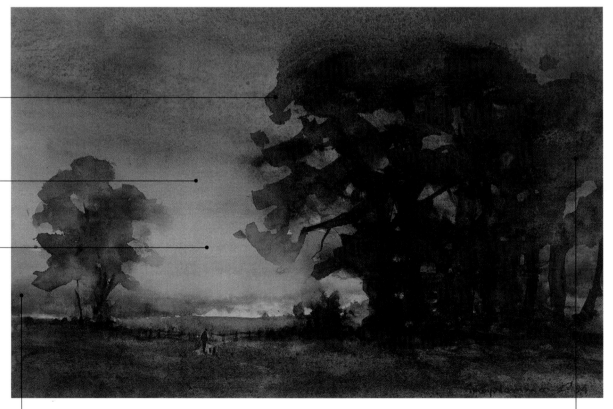

A mass of dark trees against the light evoke the stillness and quietness of the scene.

A gently blended wash captures the luminosity of the setting sun.

A pinkish glow suffuses the sky – there are no hard edges.

The tonal range is limited – variety is provided by setting the warm foreground against the cool background.

Washes of blues and raw umber have granulated, giving a soft, velvety texture to the clumps of trees.

Looking at tertiary colours

The tertiaries are a group of subtle and varied colours that occur between each primary and secondary on the colour wheel.

You create a tertiary colour by mixing a primary colour with an equal quantity of one of the secondaries next to it on the six-colour wheel. For example, if you combine primary red with secondary orange, you get the tertiary red-orange. If you mix red with its other neighbouring secondary you get red-violet.

By adjusting the proportions of primary and secondary colours, you can extend the range of 'intermediate' colours at your disposal – for example, a red-orange that is more red than orange.

Intermediate colours are more difficult to recognize and name than the primaries and secondaries because they appear to change colour depending on context. The tertiaries often have descriptive names from the natural world – for example, the yellow-green range gives us lime and apple greens.

Primary red
TERTIARY red-violet
TERTIARY red-orange
Secondary violet
Secondary orange
TERTIARY blue-violet
TERTIARY yellow-orange
Primary blue
Primary yellow
TERTIARY blue-green
TERTIARY yellow-green
Secondary green

The tertiaries

The basic wheel gives you three primaries, three secondaries and six tertiaries. These are all pure hues.

Mixing tertiaries

Primary yellow + secondary green = yellow-green
Primary yellow + secondary orange = yellow-orange
Primary red + secondary orange = red-orange
Primary red + secondary violet = red-violet
Primary blue + secondary violet = blue-violet
Primary blue + secondary green = blue-green

Exploiting the tertiaries

These are clear colours that extend the range of pure hues and provide a useful palette for the landscape painter.

You can use the tertiaries to create harmonious colour relationships, because the colours in one sector of the colour wheel are naturally compatible. For instance, the sector between blue and yellow has the sequence: primary blue; tertiary blue-green; secondary green; tertiary yellow-green; primary blue. Colours between any two primaries contain both, producing an analogous harmony. The primaries are strongly contrasted, but their secondaries and tertiaries link them visually.

Analogous harmonies often occur in nature – for example, in the blues and greens of the landscape and sky, and the blue-greens of the sea. Use them for high-key paintings with a sunny mood, and suggest space and form by playing warm colours against cool.

If your colours are too harmonious the painting may lack drama. You can counteract this by introducing a primary or complementary accent colour, or you can balance a range of cool colours with a range of warm colours.

Key points

● Primaries, secondaries and tertiaries from the same sector of the colour wheel produce analogous harmonies.

● Use the tertiaries to create bright colourful paintings or passages within a painting.

● Tertiary colours are common in nature – colours such as tangerine, apricot, lime, aquamarine and jade, for example.

● The tertiaries are less strident than the primaries.

● Enliven a tertiary palette with small touches of the related primaries.

Taking a closer look

This artist has used a high-key palette of primary and tertiary colours to capture the bright, clear light of a Venetian scene.

On the Grand Canal by Jenny Wheatley

The stucco is rendered in a range of yellows, orange-yellows and yellow-oranges.

Violets and mauves are used for the shadows between the buildings.

The reflective surface of the canal is a pale aquamarine, into which the reflections have been washed wet in wet.

Tertiary violets complement the tertiary yellows and suggest shade without using neutrals.

For the cool shadows within the arcading the artist has used blue-greens and greeny blues which balance the warmth of the façade.

Composing with colour

Skilful use of colour is an effective way of directing the viewer's eye around a painting and drawing attention to the focal points.

Colour helps to depict the form and surface appearance of objects, conjure the illusion of three dimensions on a flat surface, and create mood. Of equal importance, it has a compositional function – you can use colour to conduct the viewer on a journey into and around the painting, and to draw attention to key focal points. You can direct the gaze of the viewer by using strategically placed touches of a contrasting colour – the

eye follows the path of that colour into the painting.

Similarly, you can draw attention to the main focus of your subject by using colours that stand out – warm colours in a mainly cool field, for example. This aspect of composition often emerges as a painting progresses rather than being planned beforehand. It is all part of creating a successful composition and is a matter of exaggerating what is there to add emphasis at key points.

Taking a closer look

The artist's exuberant use of a vibrant palette concentrates the viewer's gaze on the façade of the château and the bridge across the moat.

Château de Carrouges by Bob Rudd

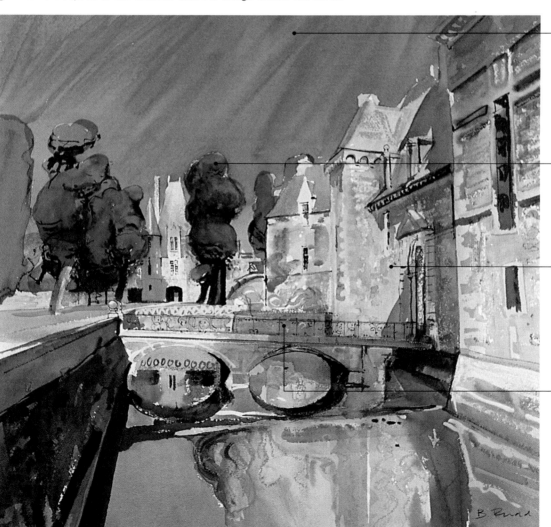

The brilliant blue sky and its reflection in the water create a 'frame' that holds the attention firmly on the centre of the image.

Bold green trees march across the centre of the painting and stop the eye from escaping into the distance.

Touches of brilliant yellow ensure your attention lingers on the château – try as you will, your eye can't wander away for more than a second.

The contrast between the warm and vibrant central area of the painting and the surrounding 'cool' sky and trees holds the viewer's attention on the bridge and buildings.

Making colour work

Be prepared to make any necessary colour adjustments to create the emphasis you want in a painting.

Assess your painting from time to time to see how the colours are working – you may need to knock back a colour that is too strident and drawing attention to the wrong place, or add an accent colour to attract the eye to an otherwise 'flat' area. You will find that even minute flecks of a contrasting colour are enough to engage the eye and lead it to the main focus of the painting. You can add this 'pathway' colour towards the end of the painting process – that way you know exactly what colour to use and where to put it. Often a slight adjustment is all it takes.

Creating pathways with colour

Here both artists have used restrained palettes of blues and greens. However, they have used colour in very different ways to lead the viewer's gaze to the main focal points.

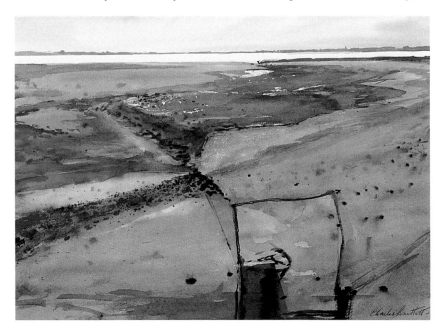

**Blue foreshore
by Charles Bartlett**

◀ *This artist used a limited palette, relying on tonal contrasts to create interest. Flecks of white attract the eye and lead it into the distance. There the viewer's gaze is halted by the gleaming horizontal strip of water.*

The dark areas in the muddy foreground start the eye on its zigzag path across the foreshore. In the middle distance the glassy patches of water lead the eye farther on its way.

**Italian Alps
by Mike Chaplin**

▶ *In this painting the artist exploited the striking quality of reds against complementary greens – even a small amount of red holds its own against cool green. Here the warm brown tones have the same effect.*

The eye is taken instantly into the painting, following the pathway created by the emphatic touches of warm red. The red reflection in the water centres the eye in the foreground, ready to start its journey.

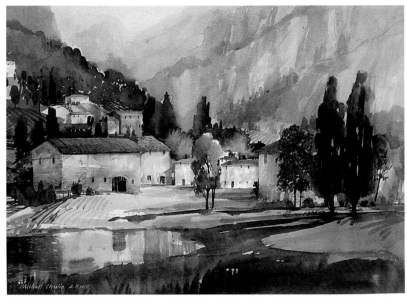

Painting in greens

The greens in a landscape are never simply green. They will look different depending on the time of day, the weather and the light.

Aknowledge of the paints in your box and the way they mix with each other gives you confidence and speeds things up. Bear in mind that on location the light and the weather change constantly. You need to make decisions all the time about what to put down – and your painting becomes subtler and more expressive as you start putting your decisions into practice.

In practice Mixing greens

A landscape such as this consists mainly of a huge range of different greens – everything from a dark blue-green to a green that's almost yellow. The main challenge is to assess the subtle difference between one green and another. Note that only two commercially available greens are used here – sap green and Hooker's green. All the rest are mixed.

1 Wash in the sky in cerulean with a No.10 brush. Leave to dry. Mix a blue-green (cobalt blue/cadmium yellow/a dash of Hooker's green) and lay in the broad hills. For the hill top use a mix of cadmium yellow/cobalt. Add more yellow for the yellowy green foreground. Allow to dry.

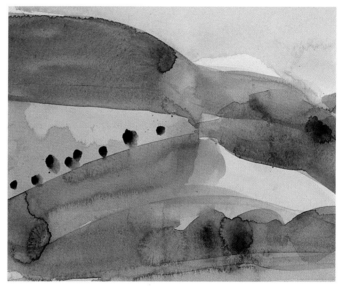

2 For the mid tones you need a variety of mixes: cobalt blue with some cadmium yellow; sap green with cobalt blue; and cobalt with Hooker's green. Lay broad swathes of intense colour along the hilltops and at the foot of the slope. Still with the No.10 brush, use sap green and cobalt blue for the bushes.

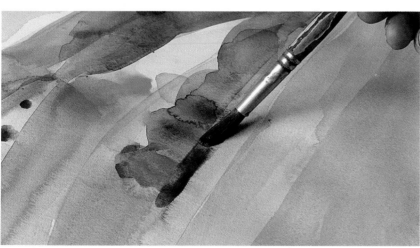

3 Lay a band of a rich yellowy green across the foreground to help strengthen that area and ensure it takes its correct position in space – use the No.10 brush for this. Use a rich mix of Hooker's green, cobalt blue and burnt sienna for the base of the distant hedgerow.

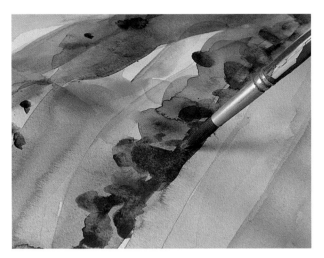

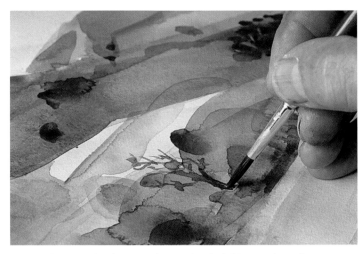

▲ **4** Continue putting in the hedgerow with the dark mix. Use the paint to depict the forms of the trees and bushes in the copse and hedge. Use the tip of the No.10 brush – it makes a neat point for fine details.

▲ **5** Add a touch of raw umber and cobalt blue to the yellowy green to create a dark tone and use it to draw the gaunt, branching tree which appears to be dead and leafless. Use the same mix and the No.9 brush for the trunk and branches of the small trees.

A range of greens

The beauty of mixing greens is that you can suit yourself. You don't have to copy the mixes shown here. Try a number of others – you will find you arrive at many of the same tones by using an entirely different palette.

Hooker's green

Burnt sienna · Cobalt blue

Use proprietary Hooker's green with varying amounts of cobalt blue and burnt sienna to make the dark greens you see here on the left.

Mix these dark greens by altering the amount of each contributory colour.

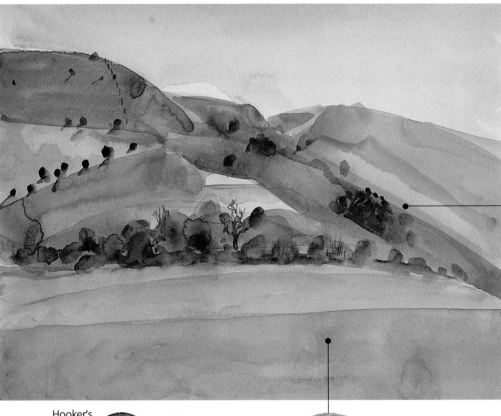

Hooker's green · Cadmium yellow

Cobalt blue

Cadmium yellow, Hooker's green and cobalt blue give the soft green of the hillside.

Hooker's green

Raw umber

Cadmium yellow

Cerulean blue

This yellowy green is mixed from cadmium yellow, Hooker's green, cerulean blue and raw umber.

CHAPTER 3
BRUSHSTROKES

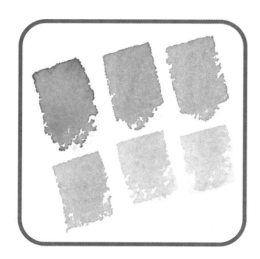

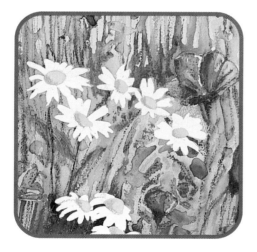

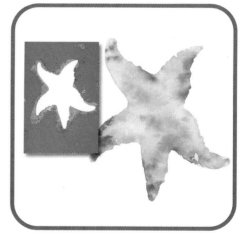

Brushes are the painter's basic tools so it is essential that you become familiar with their many qualities and capabilities. You will be amazed by the sheer variety of marks you can make with a single round brush, for example. Use its tip to create a range of fine lines and apply the entire length of the fibres to the paper's surface for broad washes and bold marks. Learning techniques such as stabbing, rolling, spattering and stippling will give you a whole repertoire of marks and textures.

But the brush isn't the only tool available to the watercolourist. This chapter introduces a large number of alternative mark makers, ranging from oriental brushes to sponges, pens, foam applicators and paint shapers. You will be shown how to use everyday household items such as cling film, bubble wrap, foil and string to create marks and textures, and encouraged to try stencilling. Watersoluble coloured pencils and crayons make a great addition to the watercolourist's kit, combining the control of a drawing tool with the blending qualities of paint. Experiment with the ideas and techniques detailed in this chapter – they are great fun and will stimulate your creativity.

Basic marks & brushstrokes

When the time comes to put brush to paper, you'll be surprised at how many different marks you can make with just a few basic brushes. This means you can build up your brush collection at your own pace.

When you're starting out with watercolours, it's best to begin with a few brushes – you'll find you can paint a wide range of marks with them. Over time, you can buy different brushes for various purposes, although many artists like to keep to the same favourites.

BASIC MARKS

Four basic brushes make a good starter kit – a 13mm (½in) flat brush, two round brushes (a No.9 and a No.6) and a mop for washes. Sable brushes are best, but a sable/synthetic or synthetic fibre type may be better for a beginner because it is cheaper. The flat brush and the mop are good for sweeping marks and for laying broad washes. The flat's edge is useful for making straight lines and blocks of colour with neat, hard edges.

Round brushes can be used in many ways to make lines in varying thicknesses. Handling the brushes in a different way gives a range of marks, from broken textures and patterns to sweeping calligraphic lines. The tip of a larger brush can be used to paint fine lines and details. (See page 267 for more details on brushes.)

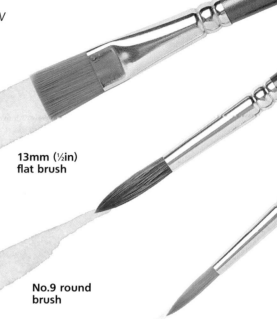

13mm (½in) flat brush

No.9 round brush

No.6 round brush

No.3 mop brush

Try this!

Why not try out some of the different marks you can make with your brushes? Experiment by painting the same marks on dry and on wet paper. Or try a thin wash and a stronger colour. And don't forget to label your results.

Blocks of colour laid with a flat brush.

Stabbing marks made with the tip of a flat brush.

Short sweeping strokes made with a round brush.

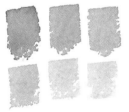

Blocks of colour laid with a round brush.

The bristles of a round brush laid flat on the paper.

The tip of a round brush used to make fine lines.

A mottled effect achieved by rolling a round brush loaded with plenty of paint across the paper.

Tip

Looking after your brushes properly will save money. When you've finished a painting session, clean them thoroughly under cold running water. Flick them to get rid of excess moisture and allow to dry flat. Store them bristle-end up in a jar.

Basic brushstrokes

Once you've investigated the various marks your basic brushes can make, you'll find them easier to use when you begin painting.

The marks you make with your brushes depend on you. How you hold the brush and the pressure you put on it play a big part in the effects you can achieve.

A MARKED INFLUENCE

What kind of brush you use has the greatest influence on the marks you make. The way you hold your brush and the type of gesture you make are important – a flicking action or a sweeping stroke of the brush produce very different effects.

The texture and absorbency of the paper also play their part, as they affect the way the paper takes the paint. Another factor is the paper's wetness.

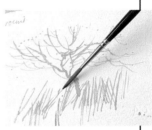
In practice

Using different brushes

You can see from the painting below how easy it can be to use different brushes to make a variety of marks. Dragging, dabbing and working in quick strokes are just a few of the possibilities open to you.

To suggest a hazy skyline, lay the first wash for the sky with the flat brush and leave it to dry. Then drag the dry flat brush dipped in a light blue wash across the same sky area.

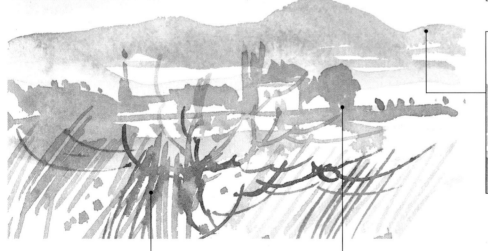

To draw in the distant hills, make short sweeping strokes using the No.9 round brush dipped in a wash of Payne's gray mixed with a small amount of ultramarine.

Drag a dry rigger brush dipped first in sage green and then burnt umber across the foreground to suggest grasses.

Lightly dab the No.6 round brush, dipped in sage green, on the paper to create tall, slender trees. Use the tip of the brush to suggest the bushes.

Using dry brush

You can use a dry brush with very little paint to create delicate, feathery brush marks. The technique is ideal for adding fine detail and building up areas of texture and broken colour.

Using a dry brush challenges the conventional watercolour painting technique. Instead of using washes of fluid paint, you apply a minimum amount of paint to make a mark.

Dry-brush techniques can be used to build a web of broken colour, which creates a wonderful luminous effect. If you apply the paint directly to the paper, the white of the support gives the dry brushed areas a special liveliness and vibrancy, but you can also use this technique to modify washes that have been laid previously.

Another way of using dry brush is to describe specific textures such as fur, feathers and hair or to paint precise details such as reeds and grasses.

Winter fields
by *John Harvey*

Taking a closer look

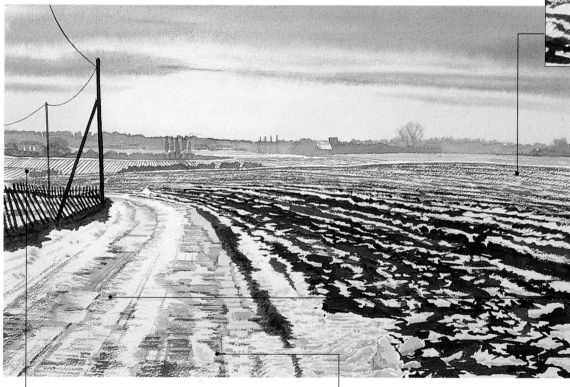

The entire length of the bristles of a No.4 brush are used to apply Vandyke brown to the furrows. The broken texture suggests the crumbly nature of the earth.

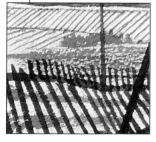

Vandyke brown is applied with the fine tip of a dry No.4 brush for the regular lines of furrows seen from a distance.

Davy's grey darkened with a little Vandyke brown gives depth to the tyre marks in the frozen mud. Brisk, horizontal lines are applied with a dryish No.6 brush.

Davy's grey dry-brushed over the grainy surface of the paper captures the rutted surface of the frosty track.

Dry brush in action

You need to practise the dry-brush technique in order to achieve a good effect, but it's worth the effort.

When painting with a dry brush you need to use it as soon as it is dry enough to make a mark. If you haven't got enough paint on the brush it simply won't cover the paper. And if there is too much paint on it you end up with a blotchy wash.

Experiment with various brushes and paper surfaces to find the range of marks you can make. Remember that colour applied with a dry brush is not the same as a wet wash – it doesn't lighten as it dries. With dry brush, what you see is what you get.

Tip

Create dry-brush effects by using the texture of Rough paper. Dip a brush in wash and remove excess paint by drawing the brush against the palette rim. Hold the brush at an acute angle so the bristles splay out and most of the head is in contact with the paper. Drag the brush lightly across the paper. The paint is laid down on the 'peaks' of the paper, leaving the 'valleys' untouched.

Starting to paint with a dry brush

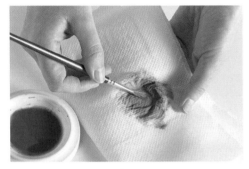

▲**1** Load a brush with wash and remove surplus paint by blotting off the excess on a piece of tissue.

▲**2** Or squeeze the brush between your thumb and forefinger, fanning the hairs out slightly as you do so. This separates the fibres so that you can create feathery marks.

▲**3** Hold the brush loosely, making sweeping gestures so the tip of the brush glances across the paper. Work in several directions to build up a web of broken colour.

In practice Interesting effects – sea, grasses and feathers

You can use dry brush to create a host of interesting painting effects, from a sparkling sea to reproducing faithfully the delicate texture of a feather.

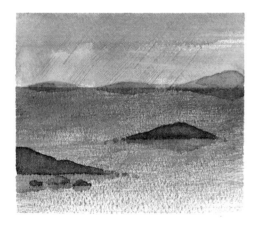

▲ Exploit the texture of Rough paper to create a sparkling sea. Apply a blue wash to a piece of scrap paper and leave to dry. Use a dry No.9 round brush to pick up the colour from the paper and apply it briskly, building up a paint layer that is thinner in the foreground.

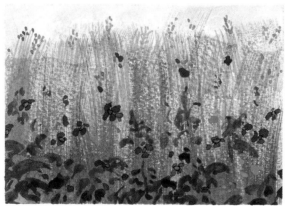

▲ Use the tip of a No.6 round brush to create a delicate fringe of grasses. Dip the brush in wash and blot it off on a piece of tissue. Hold the brush vertically with the tip just touching the paper. Apply rhythmic sweeping strokes, working away from you.

▼ Draw a feather and apply masking fluid to the outline and the shaft. This allows you to work freely and achieve a crisp edge. Dip a large flat brush in wash and dab it on tissue paper. Apply the dry brush marks following the direction of the filaments.

Using sponges

Sponges are not only good for dampening large areas of paper and applying blocks of masking fluid. They are also excellent for applying washes, lifting off patches of colour and creating texture.

You may think that the only way to paint in watercolours is with a brush. In fact both natural and synthetic sponges are extremely useful items of equipment no watercolourist should be without.

With a sponge you can create some highly successful and different painting effects. Use it to apply flat and graded washes over large areas and for various wet-on-dry and wet-in-wet effects.

A sponge is also an invaluable tool for creating a whole range of exciting textures – a woodland landscape, for example, or specifics such as bark and weathered rock. And dabbing on fairly dry colour with a sponge produces a wonderful mottled effect.

▼ **VARIED EFFECTS**
Sponges can be either natural or synthetic. Natural ones are the most popular, but synthetic ones are excellent for fine marks.

Try this

Experiment with the marks you can make with natural and synthetic sponges. Use either a single colour or several, and sponge wet on dry or wet in wet. Here are six striking effects that are easy to achieve.

Natural sponge – one colour dabbed on plain white paper.

Natural sponge – one colour on a dry, paler background wash of the same colour.

Natural sponge – one colour on a contrasting dry background wash.

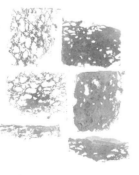

Natural sponge – two different colours blended together wet on dry.

Synthetic sponge – cut to shape and used to lay on distinct blocks of colour.

Synthetic sponge – a wet colour dabbed on to a different wet background wash.

A natural sponge with fairly widely spaced irregular holes creates loose, visually interesting textures.

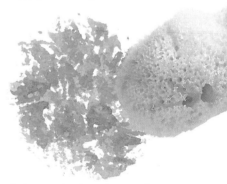

A dense natural sponge produces heavy marks with a close texture.

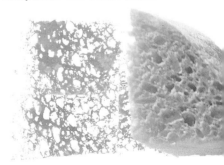

The even texture of a synthetic sponge leaves fine marks and the sponge can be cut to make definite shapes.

All-purpose tools

Sponges can create a variety of different paint effects – all of which can be used to create striking pictures.

The landscape exercise below is designed to help you become familiar with handling a variety of sponges. You need several natural and synthetic sponges in both finer and coarser textures. Any good art shop can supply small natural sponges, and an ordinary synthetic bath sponge can be cut into pieces of a suitable size.

Paint the background washes, then fill in details using both types of sponge. The combination of different sponging techniques creates freshness and immediacy in the finished landscape.

Tip

One method you can use to create a multicoloured, mottled effect is to select several colours and paint them on to the sponge with a brush. Then gently press down the sponge on to the paper.

In practice Field landscape

The highly absorbent natures of sponges makes them ideal for lifting colour from large areas. Here clouds have been suggested by gently blotting a blue wash while still wet with a clean, damp sponge, thus lifting out the colour.

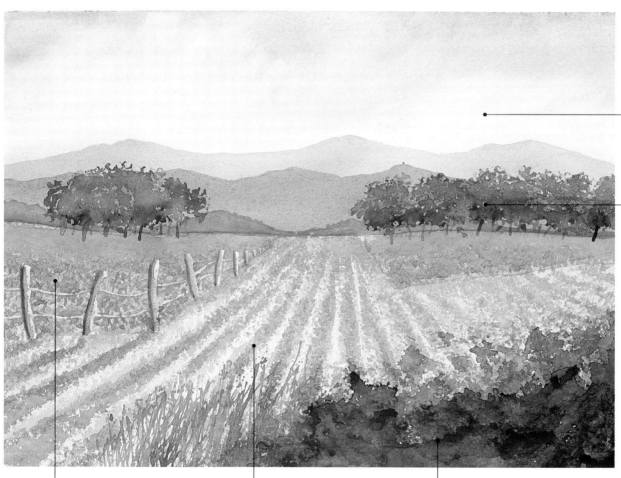

Summer vista
by *Kate Gwynn*

Cloud shapes are lifted out of the still-wet wash of sky using a slightly dampened fine natural sponge.

A small piece of natural sponge, used wet in wet, creates a softly mottled effect of dark green leaves in this row of trees. The tree shape was dabbed in first. Then more green was added – the artist using slightly increased pressure on the sponge – to create shadows under the tree.

Layers of paint laid on with a small natural sponge give a fine impression of grass.

Controlled dabs with a synthetic sponge give the furrows of the ploughed field texture and depth.

A large natural sponge produces dense, foreground foliage. Two layers of green are applied quickly, wet in wet.

Spattering effects

Spattering paint on to your paper surface is a quick and effective way to liven up an area of flat colour, or to suggest the texture of intricate surfaces such as sand, pebbles or foliage.

Spattering is the process of spraying or flicking paint on to paper from a loaded brush. The result is a speckled or mottled effect ideal for depicting surfaces too intricate to paint in any other way – a pebbled beach, dense foliage or the spray from a rough sea. You can spatter with a single colour, build up tonal interest with several colours, or spatter with clean water to provide subtle mottling on a dry wash. And you can spatter on pure white paper or an existing wash, and on dry or damp paper.

Use any type of brush. A toothbrush produces a fine spray, while a small decorator's brush gives a coarser effect. The stiffness of the bristles, the method of spattering the paint and the distance you hold the brush from the surface also affect the result. The paint shouldn't be too thick or it will cling to the brush – the more you dilute the mix, the lighter the effect.

Practice spattering on spare paper. And when you apply the technique to a painting, always remember to protect surrounding areas with scrap paper.

Try this!

Try spattering with a range of different brushes on spare paper, and experiment with building up the density and tone of the paint marks. You can achieve some amazingly subtle effects.

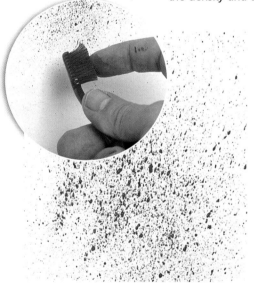

► **COARSE SPATTER**
Try a 1.2–2.5cm (½–1in) decorator's brush for a coarse spatter. Dip the bristles in the paint, then hold it a short distance away from the paper. Pull the bristles backwards and release them sharply to spatter the paper with colour. Or flick the brush sharply over the paper for larger spatters. Notice how quickly the density of the tone builds up with a coarse spatter.

◄ **FINE SPRAY**
A toothbrush produces a fine spray. Dip the bristles into the wash and shake off the excess paint – if the brush is overloaded it will drip. Hold the brush a short distance away from the paper and pull the bristles back carefully with a finger. Release them smoothly to deposit a fine spray of paint over the paper.

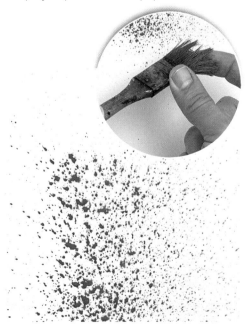

▲ **MULTI-COLOURED SPATTER**
A spatter of several colours or tones adds subtlety and realism. Sometimes the best effects are achieved with tonal values that are close together – on a sandy or pebbled beach, for example. Use the same technique as before, but make sure the first colour is dry before applying the next. A hair drier speeds things up if you are in a hurry or working in a damp atmosphere.

Spattering for light areas

You can spatter with clean water or masking fluid to create some light or white areas with interesting textures.

Spattering a dry wash with water lightens the paint to give a pale mottled effect, while flicking masking fluid on to the paper before you start leaves white highlights. Both methods introduce a variety of different tones and textures that are useful for expressing natural surfaces such as dappled sunlight on foliage, or sand and pebbles on a beach.

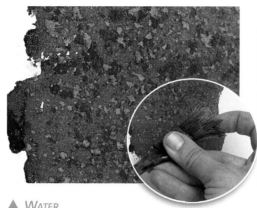

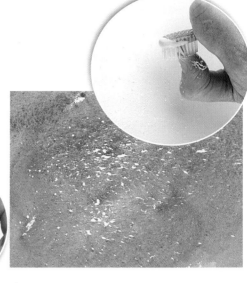

▲ **WATER**
Load a brush with clean water, then spatter it over a dry wash. The droplets loosen the wash, causing the pigment to separate, creating a light, mottled texture. Blot the wet spatter with a tissue for a more visible effect.

▲ **MASKING FLUID**
Spatter pristine paper with masking fluid. Leave it to dry, then apply a wash on top. When the paint is dry, rub off the masking fluid to reveal an area textured with fine white highlights.

 Painting a pebbled beach

Try out different spattering techniques on this beach scene – it's perfect for the textures of the stones and for adding tone to the cliff face. Paint the cliff and beach washes and let them dry before spattering. Use torn paper masks to isolate each area and to protect the rest of the painting.

**Beachy Head
by Ian Sidaway**

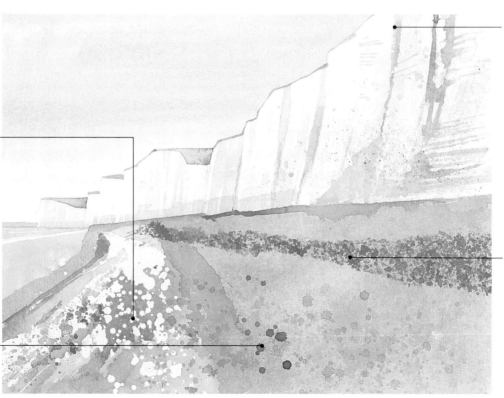

Mask around the entire picture area before you start to paint, so the washes and spatters leave a crisp edge.

Isolate the white pebbled area. Load a small round brush with masking fluid and tap it to flick drops on to the paper. Let it dry, then add the dark grey wash. Rub off the masking fluid when the wash is dry.

Spatter some mid grey-brown tones and a few dark grey drops to help advance the foreground.

Paint the cliff face and leave it to dry, then spatter clean water to mottle the washes. When this is dry, use a small decorator's brush to spatter light and mid-grey tones. To keep the spatter fine, hold the brush near the end of the bristles so they are confined and you can control the spatter.

Use torn paper masks to isolate the dark grey strand of stones. Spatter the wash with a small decorator's brush, holding it closer to the handle than you did before. Keep spattering to build up the tone.

Moving paint around

Blotting, blowing, tilting and pulling are all ways of moving wet paint around without using a brush. You can use these techniques for specific textures and images, or simply for their abstract effects.

Blot-painting and straw-blowing may seem like childish activities at first glance. But for the adult artist, these are valid ways of applying paint and moving it around for spontaneous 'no-hands' effects. They loosen up your approach and introduce a refreshing element of surprise into your work.

You can use blots for specific descriptive purposes – pebbles, for example. A random series of blots might suggest an image you can work up into a painting. If you blow them they might surprise you with a new way of depicting a texture such as foliage, twigs or flowers. Or you can use them purely for their decorative and abstract effects.

The shape of the blots is determined by how they are dropped, the thickness of the paint, whether the paper is wet or dry and how you move them around. Experiment to achieve different effects but allow yourself the freedom to be spontaneous and let a painting simply evolve.

Key points

- Pick up paint with a straw, then drop blots on to paper in a random way.
- Drop blots on to paper, then blow them around with the straw.
- Use a hair drier to blow very wet paint around the paper.
- Drop blots on to damp paper then allow them to spread at random.
- Tilt wet washes so the paint runs and flares in interesting ways.
- Use the handle of a brush to pull out strands of colour on the paper.

Try this!

Drop blots of paint on to wet and dry paper and see how they behave. Try blowing the paint around in different ways and notice the varied effects.

◀ BLOTS BLOWN WITH A STRAW
Drop blots on to the paper from a loaded straw, then blow through the straw to move the paint about. The results depend on how hard you blow. Here the blots were blown across the paper from a low angle, creating delicate, spidery marks that suggest bare twigs.

▲ BLOTS DROPPED FROM A STRAW
Suck up paint into a drinking straw, then drop blots of paint on to the paper. The size and shape of the blots depends on the height from which you drop the paint and on its consistency.

▶ BLOTS BLOWN WITH A HAIR DRIER
A hair drier gives a strong blast of air that is less controllable than a straw. Notice how the colour moves fast and spreads in bolder rivulets.

▶ BLOTS DROPPED ON TO DAMP PAPER
Wet your paper and drop on blots of colour. Watch them burst out and bleed in all directions. The blots are fringed with a tracery of feathery marks – a perfect way to represent flowers.

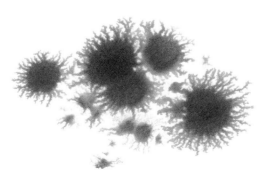

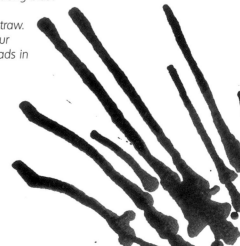

Tilting and pulling

Two more ways to manipulate paint without using a brush in the conventional way are tilting and pulling.

A wash runs if you tilt the board while the paint is still fluid. In this simple way you can create spontaneous and random colour blendings, marbling and trickles. The results are unpredictable, and the effects can be used to suggest natural images such as skies. The technique creates a more lively and textured general background than a flat wash. You can use a single colour, or apply bands of different colour washes and run them into each other. Create different effects by working on wet or dry paper, tilting it in one direction, or moving it around to spread the colour in all directions. Just tilt until you are happy with the effect, then lay the board flat so the paint stops moving.

You can also use the end of a brush handle to manipulate paint. In effect, you draw with the end of the handle, using it to 'pull' strands of colour out from the wet area.

Try this!

Try these suggestions and see how you can move the washes around. Then experiment for yourself to see what other effects you can create.

◄ **TILTING A SINGLE COLOUR WASH**
Apply a generous amount of wash to dry paper. While it's still fluid, tilt the board forwards and backwards so the paint runs. Notice the interesting flares and backruns that develop as the drying wash moves around.

▲ **TILTING SEVERAL COLOURS**
Apply three bands of wash in different colours. Tilt the board while the paint is still fluid so the colours run into each other. Different pigments behave differently. Here the yellow and red blend softly into each other, while the red bleeds into the blue in vertical streaks – perfect for a sunset.

▶ **TILTING A WASH INTO WET PAPER**
Wet your paper with a clean brush. Apply a loose wash just above the wet area then tilt the board. The wash runs into the damp paper in vertical streaks, creating a perfect rainy sky effect.

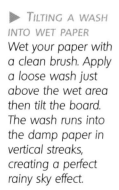

▶ **PULLING WITH A BRUSH HANDLE**
Apply a wash and let it dry. Then apply a band of a different coloured wash. While this is still wet, use a brush handle to pull out strands of colour. Try this technique to depict grass.

Alternative brushes

You can broaden your repertoire of brushmarks by using almost anything that has bristles and therefore holds paint.

Standard watercolour brushes are indispensable, but many other kinds of brushes can be useful too. Decorators' brushes, toothbrushes and blunt stippling brushes, for example, make a huge variety of different marks and create some expressive effects. They come in all shapes and sizes and vary in stiffness. You can use them loaded with paint for washy effects, or more sparingly for dry-brush techniques. Work wet on dry or wet in wet, spatter with them, make marks with different parts of the bristled head and apply broad sweeps of wash or small areas of texture. The possibilities are endless. Experiment to find out what they can do – but don't overdo things.

Toothbrush marks

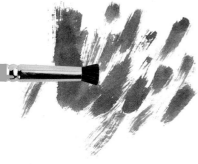

▲ *Use the brush to make a fine multi-coloured spatter.*

▲ *Lay a wash, then stipple wet on dry with the tips of the bristles.*

▲ *Streak colour on with a soft brush loaded with paint – experiment with different parts of the bristles.*

Decorators' brushes

◀ *Use a 2.5cm (1in) flat brush to apply colour with light stroking movements.*

▶ *Load the brush and make a heavy spatter, or stipple with the bristle tips.*

▲ *Use a 5cm (2in) decorators' brush to make sweeps of wash wet in wet.*

Stippling brush

▶ *Stroke a dry brush across the paper to spread the colour thinly. At its thinnest, the paint glances over the rough surface, creating a broken texture.*

▲ *Stroke a loaded brush across the paper. Lessen the pressure as you lift the brush off the paper.*

▲ *Hold the brush upright and stipple with several colours. Vary the amount of paint to create different textures.*

Other paint applicators

Brushes aren't the only items suitable for applying paint. Other non-bristle applicators provide a number of options.

Sponge applicators and sponge craft rollers hold watercolour well and are great for applying broad areas of wash. The way they deposit paint depends on how you manipulate the sponge – you can use firm or soft pressure, or vary the pressure and bend the sponge as you work. You can use sponge tools heavily loaded with colour for soft watery effects, or keep them quite dry for broken textures. Try single applications or apply multiple layers of colour wet on dry or wet in wet. Experiment with rollers in one direction, or move them back and forth and at different angles. Use the broad side or the tip of a sponge applicator to make very different marks.

Paint shapers are a modern, silicone-tipped artists' tool used for applying and removing colour. They have soft, medium or firm tips of various shapes, and they can create effects that aren't possible with a brush.

Paint shapers

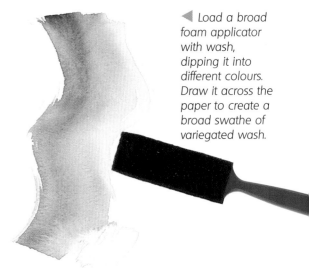

▲ If you mix your wash with gum arabic first, the paint shaper makes more emphatic marks. Create broad, light areas or fine highlight details with different sizes of shaper.

Foam applicators

▲ Make wide strokes with the broad edge of the applicator, or use the side for narrow lines of colour. Hold it upright and dab it on for a broken effect.

▲ Sweep the foam tip lightly across the paper – the wash covers it unevenly, creating a stripy effect.

◀ Load a broad foam applicator with wash, dipping it into different colours. Draw it across the paper to create a broad swathe of variegated wash.

Foam craft rollers

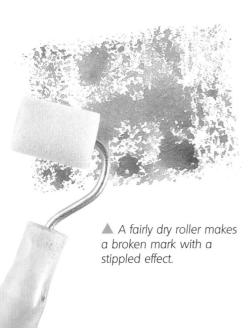

▲ A fairly dry roller makes a broken mark with a stippled effect.

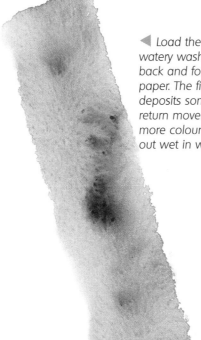

◀ Load the roller with a watery wash and roll it back and forth across the paper. The first movement deposits some water. The return movement applies more colour which flares out wet in wet.

▶ Roll on a wash and let it dry. Dip the roller in two colours and apply over the first wash. The colours mottle and flare wet in wet.

Texture makers

Everyday materials can produce a wide range of lively marks and textures that you can't achieve with a brush.

Cling film, aluminium foil, baking parchment and bubble wrap can be easily purchased from a supermarket or stationer, if you don't have a stock at home. They all make unexpected, but valuable, additions to the artist's box of tricks, since when you apply these materials to wet washes you get textures you can't achieve with a brush. The variety of effects possible is endless; the results depend on how the material is used, the type of wash, the amount of time the material stays in contact with the paint and the type of paper used. Such materials are worth trying – used sparingly, their effects can give the right texture to stonework, for example, or to the surface of water.

Tip

Remove the texture-making material very carefully. If you tear it off too quickly, you may lift off some of the paint with it, thus destroying the effect that you have tried to create.

In practice Light and shade in water

Two different texture makers have been used here to help depict the light and shade reflected in rippling water. Used selectively, the effects have impact and meaning.

Gondola
by *Ian Sidaway*

Baking parchment helps to depict the water surface. Use softly crumpled baking parchment first, applying it to a pale blue-green wash. Leave it on until the paint is dry.

Apply the darkest wash of all to the water in the foreground and beneath the bow of the boat. Then apply crumpled cling film and leave it until the paint is dry. The resulting texture perfectly creates a sense of depth in the water.

To depict the water convincingly you need to build up your washes. Start with a pale blue background wash. Then use darker blue and blue-green washes wet on dry to add the ripples in the middle distance.

Experimenting with texture makers

Before you incorporate the effects of these unusual texture makers in your work, experiment with them to see what each one can do.

Try this!

Lay fairly wet washes on spare pieces of paper, then apply the materials suggested here. Try your own experiments as well.

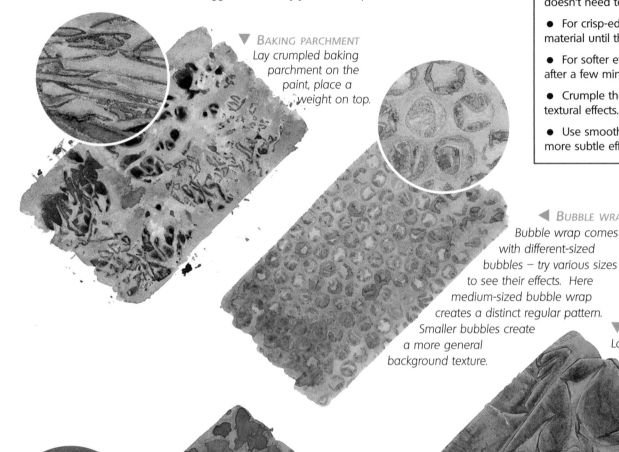

▼ BAKING PARCHMENT
Lay crumpled baking parchment on the paint, place a weight on top.

◀ BUBBLE WRAP
Bubble wrap comes with different-sized bubbles – try various sizes to see their effects. Here medium-sized bubble wrap creates a distinct regular pattern. Smaller bubbles create a more general background texture.

▼ CLING FILM
Lay crumpled cling film on top of a wet wash – the film sticks to the paint with no added pressure. Peel it off when the paint is dry. Or apply paint to crumpled cling film, then print with it (below).

◀ FOIL
Crumple the foil and place it on a wet wash. Place a weight on top to hold the foil in place. Leave the paint to dry before you remove the foil.

Oriental brushes

A traditional oriental brush is a sensitive and responsive implement that can introduce a refreshing energy and spontaneity to your work.

An oriental brush is almost a work of art in itself. Western brushes have hairs all the same length – the outer hairs are trimmed so the brush tapers. But the hairs of an oriental brush are tapered in layers from the inside, giving the characteristic conical shape with the longest hairs on the outside – this means the tip has a long, fine point, however large the brush. The result is a flexible, versatile brush which you can manipulate to create intricate textures; rhythmic, flowing lines that possess a calligraphic elegance; bold, sweeping brushstrokes; or broad washes. An entire painting can be executed with a single brush. Many painters use oriental brushes alongside ordinary brushes for their expressive, spontaneous and economical marks and textures.

▲ *Oriental brushes are available in many sizes. To start with, limit your choice to a small and a medium round, and a flat (hake) brush for background washes. Choose good-quality brushes with 'body' – avoid ones that are limp and lifeless.*

 In practice **Bamboo by a lake**

You can create this entire image using only the three brushes shown above, exploiting the different marks that each one can make.

Oriental landscape by Ian Sidaway

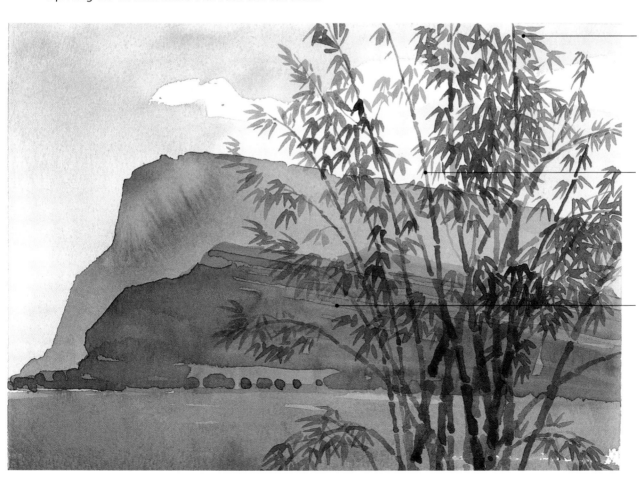

The fine round brush makes realistic leaf-shaped marks. Build up the density and texture of the foliage with successive layers of brushstrokes painted wet on dry.

The medium round brush is perfect for depicting bamboo. As the stem gets more slender, ease the pressure on the tip of the brush to create progressively thinner marks.

Use the hake brush to create broad background washes. You can work wet on dry and wet in wet in the usual way. As the hairs separate, several lines of wash are created with a single brushstroke.

Adaptable tool

An oriental brush responds to the slightest change in the way you hold and manipulate it.

You use different parts of the brush as you alter your grip and the angle, or change the amount of pressure you exert. Hold it upright to create delicate lines. Increase the pressure so more of the head makes contact with the paper for a broader mark – going from fine to broad and back again in a single stroke – or create broad painterly washes with the side of the brush head.

Try this!

Each of the three basic brushes can make a host of different marks. Here are just a few, but you'll discover many more.

Hake
Slant the brush and drag it lightly from side to side to create a broad wash.

Hold the brush upright and 'print' with the tip. Alter the angle of the marks to build up a texture.

Medium round
Move the brush back and forth, increasing the pressure until the whole head is in contact with the paper.

Hold the brush upright and flick with the tip to create a delicate open texture.

Small round
Hold the brush vertically with minimal pressure, and make light, fine strokes – perfect for delicate twigs or leaf veins.

Begin your brushstrokes lightly, then increase the pressure so the fibres splay and the line broadens.

▼ *HOLDING AN ORIENTAL BRUSH*
Holding the brush in the right way gives you maximum control so you can exploit the flexibility of the tip fully.

Upright position
To create linear marks, hold the brush vertically at right angles to the paper with a firm, but not tight, grip. In this position only the tip is used – the belly of the brush acts as a reservoir for the paint.

Slanting position
Hold the brush vertically, but this time more loosely. Rotate the hand slightly so your palm faces upwards and the brush slants. Vary the slant so the whole brush comes into play to create broad, bold strokes with gradations of tone.

Painting with pens

Pens give a wide range of quite specific marks that you can use to introduce a distinctive character into your painting.

Pens used with watercolour instead of ink add a different kind of surface interest to your painting. The familiar steel-nibbed dip pens, and the more exotic and unusual bamboo and reed pens, create a range of gestural marks and descriptive textures that are useful for depicting many natural surfaces. You can use them on top of dry washes to create generalized details for foliage, flowers or nearby grass, or to suggest textures such as bark, distant grass, fur or feathers. Or you can use a pen for a quick underdrawing in watercolour that will be absorbed later in the paint layers. You can use a pen with watercolour to create a containing line that you fill with wash – the line softens and bleeds in. This combination of detailed outline and soft wash is perfect for flower studies. In addition, a pen is a useful tool (instead of sacrificing a brush) for applying masking fluid.

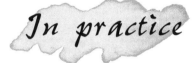 *In practice* **Natural textures**

In the painting below, various pens are used to add texture and detail to bark, foliage and grass. Try it yourself and see how they help you to capture the different textures.

**Olive trees
by Ian Sidaway**

Use both a dip pen with a broad steel nib and a bamboo pen to suggest the texture of the olive leaves. Work on top of dry washes, making short marks.

Use masking fluid with a broad steel nib to reserve the light areas on the foliage, then apply washes.

Make linear marks with a dip pen loaded with watercolour to depict the texture of the bark.

Scribble some marks with a fine mapping pen to depict the long grass at the foot of the trees.

Pens in action

Each type of pen has its own distinctive character and gives a range of marks that you can exploit in different ways.

You have more control over a pen than a brush because it is less floppy. This makes it easier to put down very precise marks in your work. Bear in mind, though, that a pen doesn't hold as much wash as a brush.

Dip pens are simple and inexpensive, with a large choice of nibs – from broad nibs for bold marks to fine mapping nibs for delicate details. The bamboo pen can be carved to give a range of pointed or blunt drawing tips, and may have a split down the middle for better ink flow. Reed pens are lighter and more springy than bamboo, and their crisp, sharp strokes make them the favourite tool of calligraphers. They can be cut and reshaped as required. (See pages 281–282 for more details on types of pens.)

Tip

If you paint and draw with your left hand, you don't have to struggle with a conventional reed or bamboo pen. Both of these pens can be reshaped by cutting and carving to cater to the requirements of a left-handed artist.

Try this!

Test all three types of pen with watercolour washes and see what marks you can make. Then experiment with masking fluid too.

▲ DIP PENS
A very fine mapping nib creates different marks from a broad nib. Both can create expressive textures and add telling detail to your work.

▲ BAMBOO PENS
Such tools are hard and tough. They can be broad or fine, and the marks they make are usually uniform in width. Try short, abrupt marks with a broad tip, or cross-hatching with a finer tip.

◄ REED PENS
These create flowing, calligraphic marks. Reed pens can be quite brittle, but if the tip collapses you can re-cut it. Try broad and fine tips.

◄ APPLYING MASKING FLUID
Here a dip pen and a bamboo pen have been used to apply masking fluid. Both pens make their own characteristic marks that create different kinds of textures.

Painting with knives

Painting knives – or any flexible knife-shaped object – extend the range of marks and effects you can make with watercolour.

Small plastic painting knife

Small metal painting knife

Medium metal painting knife

Painting knives are designed to apply and move paint around. They have flexible blades with a rounded or pointed tip and cranked handles to keep your hand clear of the surface. Flat, flexible, everyday objects make versatile 'painting knives' too. Try using an old credit card or cardboard.

Although painting knives are primarily designed for use with oil and acrylic paints, you can use them with watercolour for making marks, colour blending, and adding texture. Use the flat of the blade to spread paint, the tip to draw fine marks and the edges to draw lines. Edges and bendy tips are also useful for making marks in washes for a textured finish.

Knives are ideal for products that damage brushes such as acrylic. For textured effects mix washes with thickening mediums such as Aquapasto (see pages 225–226). Use very thick mediums for impasto effects (achieved by brush marks retained in thick paint).

Try this!

Experiment with the different effects you can achieve with conventional painting knives – use a metal or plastic painting knife, a chisel-shaped piece of card or an old credit card.

Painting knives

◀ Lay two colour washes side by side, then blend them with the flat of the blade.

▶ Trowel on paint mixed with Aquapasto, then press the tip of the knife into it repeatedly.

▼ Dip the edge of the blade into a wash. Pull the blade briskly across the support to create fine lines.

Card wedges

▶ Dip a wedge of card into paint and use it to scribble on the colour.

▶ Brush paint on to the cut edge of a card wedge and use it to print straight lines.

▼ Dip a 1cm (⅜in) wide piece of card into the paint and use this to print squares.

Textural effects

The marks and textures created with painting knives and card can suggest the forms of natural objects.

In practice — Rocky landscape

Try using painting knives and card to depict the many textures and surfaces found in a rocky, wooded landscape.

Tip

Painting knives are available in a wide variety of shapes and sizes and have a cranked handle. Plastic painting knives are less expensive and are kinder to your paper than metal. However, metal knives are more flexible and the blades are less likely to snap under pressure.

◀ **1** Apply a loose wash of phthalo blue/Payne's gray, leaving white for the clouds. Dilute the wash as you work down. Paint a line of yellow ochre wet in wet, about one-third up from the bottom. Allow to dry.

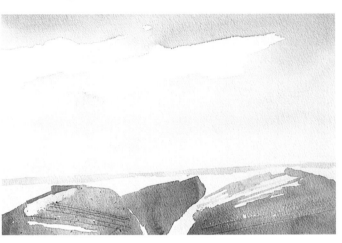

▲ **2** Cut a 2.5cm (1in) wide piece of card into a chisel shape. Dip it into a mix of Payne's gray/yellow ochre and spread it on for the rocks, leaving white areas. Darken the mix, paint it on to one cut edge of the card and print linear marks on the rocks.

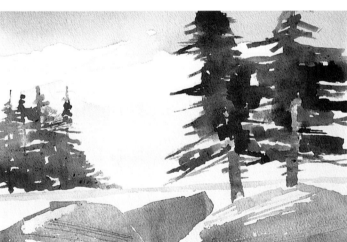

▲ **3** Paint the trees with chisel-shaped pieces of card. Tap the edge of the card on the paper to create slender branches. Use a darker yellow ochre for the trunks and sap green/sepia/Payne's gray for the foliage.

▶ **4** To finish, continue using card wedges to darken the foreground rocks and the tree foliage. Using a small painting knife, trowel a sap green/Aquapasto mix on to the foreground foliage, using the tip to scrape into the paint.

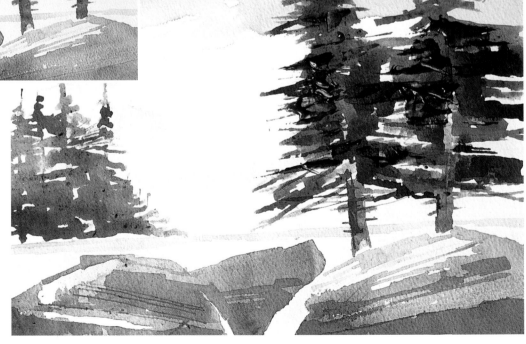

Watercolour pencils

Soluble watercolour pencils combine the control of pencils with the flexibility of paint – you can use them for details, washes and blending.

Watercolour pencils, or soluble coloured pencils, can be used on their own or combined with watercolour paints – to add detail to a wildlife study, for example. You can use them like standard coloured pencils, then wash over the marks with a wet brush or sponge to soften them or create washes. You can blend the laid colours with water, work into damp paper, wet the pencil lead, and build up layers of colour using wet-in-wet, dry-on-wet and wet-on-dry techniques.

There is a wide choice of watercolour pencils. The leads are usually fairly soft, but individual ranges vary. Softer leads give better coverage, while harder leads are good for detail and linear work. The choice of colours is huge, but you need only a few basics to blend your own colours. Some ranges offer quite muted colours, while other ranges have richer hues. For the softest leads and the richest colours, try colour sticks, which offer good coverage and dissolve very easily in water.

Key points

- Blend colours wet in wet, wet on dry, dry on dry or dry on wet.
- Build up layers of colour for a rich finish.
- Soften marks with a damp brush, sponge or moistened finger.
- Dissolve or lighten laid colour by working firmly with a wet brush.
- Develop tone by washing over laid colour with a wet brush.
- Create washes by lifting colour from scrap paper with a damp brush.
- Draw on to dampened paper to make soft, fluid marks.

Taking a closer look

In this riverside scene the artist has used watercolour pencils to capture the textures of rocks, plants and water, and to depict the play of light and shadow on the river.

Gardon River, Languedoc by *John Raynes*

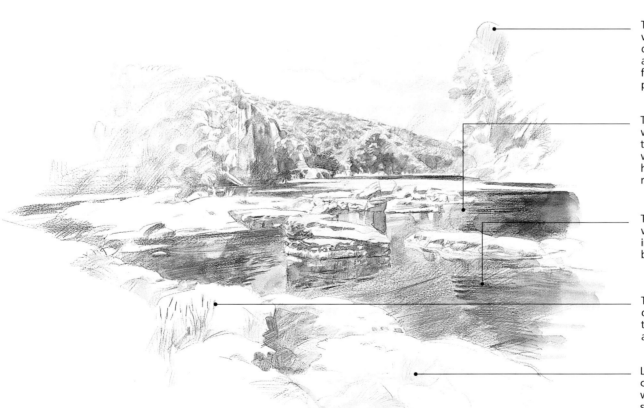

The trees were worked over with a damp brush, creating a wash that fills in the forms and softens the pencil marks.

The shimmering water was cross-hatched in two colours, brushed with water, then hatched again for a rich build-up of colour.

The broken reflections were tightly hatched in three colours, then blended with water.

The flowers were drawn dry on dry, then loosened with a damp brush.

Loose washes of colour, picked up with a wet brush, suggest patches of moss.

Versatile tools

Watercolour pencils can be used in the same way as standard coloured pencils, but adding water makes many painting effects possible.

Watercolour pencils are paint in the form of a pencil, making them highly versatile and very portable. Use them to sketch in the basic composition and to establish colour and tone with hatching, cross-hatching and layered colour. Then brush on water to blend and brighten the colours, soften marks and to create flat or graduated washes over laid colours. You can also make washes by scribbling on scrap paper, then lifting the colour with a wet brush and washing or spattering it over your painting. Continue to add layers of colour to build the desired intensity of tone and texture.

Many different techniques can be used in the same picture. For example, for looser lines, try wetting the point of the pencil first, or draw on to wet paper.

Tip

On rough textured paper, dry coloured pencil looks grainy – the colour 'sits' on the raised areas. But wetting the laid colour allows the pigment to flow into the indentations, creating a smoother, more even finish.

Try this!

Try out some of these watercolour pencil techniques using a brush and water. A sponge or damp finger works well too.

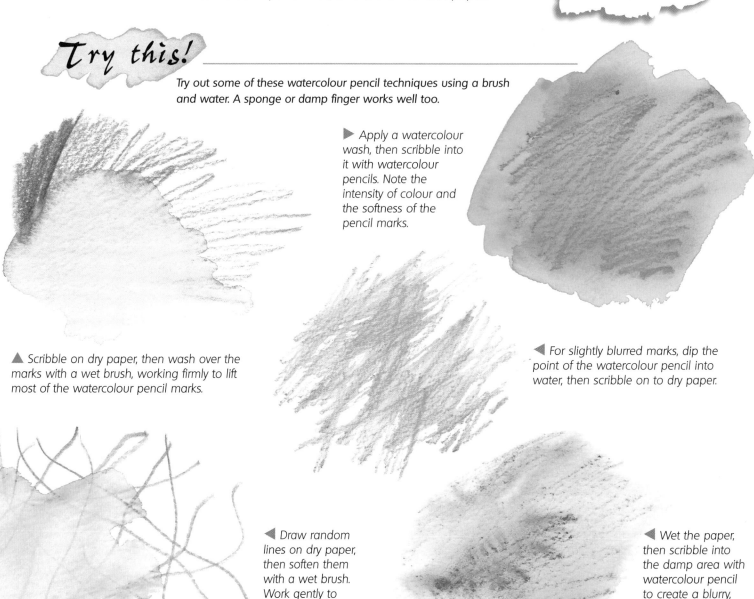

▶ *Apply a watercolour wash, then scribble into it with watercolour pencils. Note the intensity of colour and the softness of the pencil marks.*

▲ *Scribble on dry paper, then wash over the marks with a wet brush, working firmly to lift most of the watercolour pencil marks.*

◀ *For slightly blurred marks, dip the point of the watercolour pencil into water, then scribble on to dry paper.*

◀ *Draw random lines on dry paper, then soften them with a wet brush. Work gently to retain hints of the pencil marks beneath the wash.*

◀ *Wet the paper, then scribble into the damp area with watercolour pencil to create a blurry, slightly washy effect with greater colour intensity.*

Water-soluble crayons

Water-soluble artist's crayons can work well with watercolour to create spirited images that combine energetic linework with subtle washes.

You can use the calligraphic quality of water-soluble artist's crayons to add line and texture to water-colours, and exploit their colour-blending and line-softening possibilities in a number of ways to create washes. They are soft and easy to use, with good covering power and excellent lightfastness (resilience to the fading effects of light). Their high pigment content gives intense and vibrant colours, so they create bolder and more dramatic effects than watercolour pencils – this enables you to produce energetic and expressive images. They are not a substitute for watercolour, but the two mediums can work well together in mixed-media techniques. The possibilities are worth exploring, but ensure that the crayons you buy are water-soluble – most wax crayons can only be moistened with white spirit.

Key points

● Water-soluble crayons are richly pigmented with intense, vibrant colours.

● They create bold, linear effects and broad swathes of colour.

● Use water to soften lines and create subtle colour blendings and washes.

● Work on wet or dry paper to obtain different effects.

● Create impasto and scratched out textures with water-soluble crayons.

● Add line and texture to watercolours with water-soluble crayons.

In practice **Floral delight**

Water-soluble crayons were the ideal medium to create this richly textured image of vibrant wild flowers.

A field of wildflowers by *Kate Gywnn*

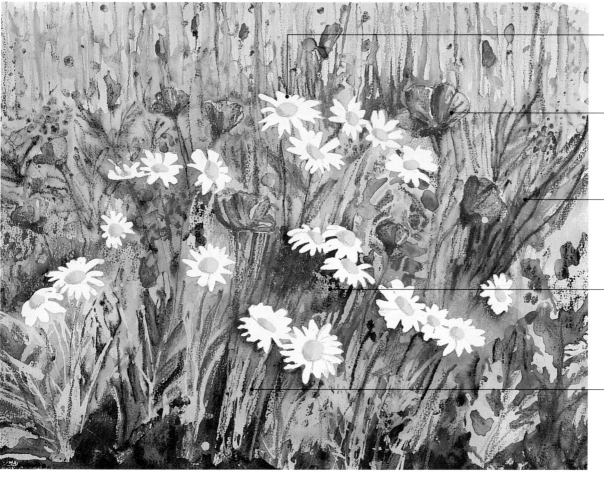

The artist reserved the daisies, then used a pale watercolour wash as a background to set the overall tone for the image.

A red water-soluble crayon creates delicate washes that express the papery texture of the poppy petals.

The use of vigorous linear marks creates energy and a sense of movement in the greenery.

The texture of the Rough paper creates broken colour in areas that remain unwetted.

Scratching back into wet crayon marks gives another kind of line that adds to the textural variety of the stems and grasses.

Colourful touches

You can use water-soluble crayons in conjunction with watercolour as well as on their own to create numerous expressive effects.

Water-soluble crayons are ideal tools for subjects that need emphatic touches of colour, such as flower gardens. You can create anything from quite delicate linear marks and fine details to bold swathes of intense colour or delicately graded washes. They have an energy and immediacy that can work well alongside watercolour. You can use them on dry paper and add water to blur lines and create washes and subtle colour blendings. Or you can create soft effects by working directly on to wet paper. You can dip the crayon in water first, and use it to make both linear marks and broad swathes of colour. The texture of the paper affects the results – a Rough surface creates more broken colour effects than NOT or HP.

Tip

There are some wax pastels available that you can moisten with water as well as white spirit. They are quite chunky and are useful for creating bold marks and broad swathes of colour.

Experiment with water-soluble crayons to see how you like them – the effects here are only a few of the possibilities.

◀ Scribble with a crayon on dry paper, then soften some of the lines with water.

▶ Wet the paper with clean water and scribble into it with a crayon.

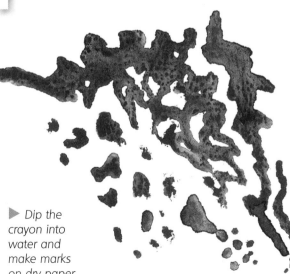

▲ Draw lines and dots and apply water gently to drag and merge the marks.

▼ Build up an impasto texture with two colours and then scratch back to reveal lines of the first colour.

▼ Make blocks of colour with three different crayons, and blend them with water.

▶ Dip the crayon into water and make marks on dry paper.

Backruns

Backruns are one of the unpredictable delights of watercolour. You can harness them to produce beautiful and expressive effects.

Backruns – also called 'cauliflowers' – occur when you apply fresh colour to a wash that isn't fully dry. The second colour runs back into the first wash, creating blotches with hard, pigmented edges – unlike the soft merging of wet in wet. Backruns are often accidental – and almost inevitable with unfamiliar paints, especially for beginners. The only remedy is to wash off the entire area. But you can treat an unintentional backrun as a 'happy accident' and use it in your image – the spreading paint may suggest a cloudy sky, for example. Indeed, backruns can be induced deliberately to create a range of landscape features, such as reflections, foliage and petals, or even the texture of weathered stone. The wetness of the first wash and the type of paper you use can both contribute to the formation of backruns.

Taking a closer look

The artist has made wonderful use of backruns throughout this lively and expressive image.

Pink grapes and quinces by *Shirley Trevena*

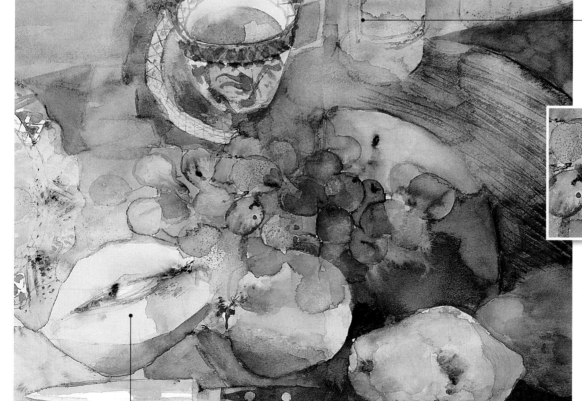

The artist used backruns to create soft tonal effects that enliven the background.

Soft backruns
Gentle backruns were used to help depict the grapes, creating a perfect impression without the need for great detail.

Subtly shaded backruns suggest perfectly the mellow skins of the quinces and the delicate colour of their flesh.

Granulation for texture
Granulation (see pages 235–236) adds texture to the purple backrun, contrasting dramatically in both colour and texture with the smooth yellow-skinned fruit.

Encouraging backruns

Backruns can be used to create unusual effects in your paintings that you cannot achieve with normal brushwork.

Many artists induce backruns deliberately to describe stormy skies or reflections in water or natural textures. To succeed you must judge the right moment. If the first wash is too wet the colours merge softly, wet in wet. You need to wait until it has lost its sheen before running in the second wash – or clean water – to produce a backrun. Backruns occur more easily on highly sized or HP papers than on more absorbent Rough papers. Adding ox gall or other tension-breaking mediums to your washes encourages backruns.

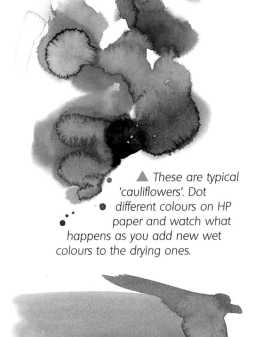

▲ These are typical 'cauliflowers'. Dot different colours on HP paper and watch what happens as you add new wet colours to the drying ones.

Try this!

Backruns are interesting, but you need to judge carefully if you want to add them deliberately. Practise on different papers so you can control the washes.

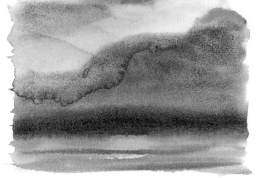

▶ Apply a cobalt blue wash to HP paper. When it's nearly dry, add a wash of burnt sienna/alizarin crimson. This invades the drying blue wash, stopping at the 'dry line' – the point where the first wash is completely dry.

▲ Here colours are softly merged wet in wet on HP paper. To create the storm cloud effect the 'sky' is re-wetted and tilted gently so it runs down to create a cloud-bank backrun.

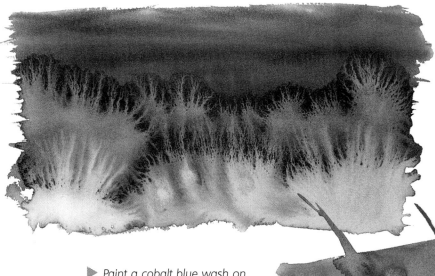

◀ This delicate effect is created on NOT paper with a strong wash of indigo with phthalo blue and green. Clean water creates the frond-shaped backruns. The addition of ox gall extends the spread and repels the colour farther.

Tip

You can use a hair drier or a straw to blow new colour back into a drying wash in specific directions and shapes, or tilt the paper to encourage the effect. This is especially helpful for provoking intentional backruns on Rough paper.

▶ Paint a cobalt blue wash on Rough paper. Then paint alizarin crimson straight through it and use a hair drier to provoke backruns in the cobalt blue wash. Add water to enlarge and lighten the backrun.

Stencilling

Stencils provide a versatile method of introducing specific shapes and patterns, as well as an easy way of repeating shapes.

One stencilling method involves applying paint through a cut-out shape while pressing down the edges to stop paint seepage. With another technique, you paint around a shape to leave a 'negative' image. Both methods are ideal for repeating shapes and adding pattern or texture to abstract or representational work.

You can use ready-made stencils or make your own – or use found objects, such as leaves. You can apply the colour with a brush, sponge or spray. A brush gives a washy image with uneven edges where the paint hasn't reached to the edges of the shape. Sponging provides a soft, neat image; spraying gives a more diffused colour.

Key points

- Stencils work best in images which are graphic or decorative or veer towards abstraction.

- Stencils may be 'found', bought or handmade.

- Hold the edges of the stencil firmly against the support to give the motif a neat, crisp edge.

- Apply colour using techniques such as sponging, stippling or spraying.

- Use a flat, single colour with a crisp edge to give a stencil a graphic quality.

- Apply variegated tones and colours for a more painterly feel.

Taking a closer look

Stencilling forces you to simplify, making it perfect for decorative purposes and representational or abstract images. The artist used gouache throughout this lively, multi-textured still life.

Still life on lace by Kate Gwynn

The background was washed in with rose madder.

Colour was applied with a sponge using a homemade fish stencil, then each fish was worked on separately.

For the fish scales, the artist taped an onion net firmly over each fish in turn, then sponged on several colours for a variegated effect.

The artist drew around a small lace doily with a pencil and filled in the shape with rose madder. When the wash was dry, she replaced the doily and sponged a darker colour through the cut-outs.

The foliage area was washed with a loose, pale green wash, then a darker green wash was sponged over geranium leaves for a soft, painterly effect.

The artist cut her own stencil for the vase, then sponged through the cut-outs with cobalt and ultramarine blue.

For the mat, colour was sprayed through the cut-outs on a large doily.

Varied stencils

Stencilling can be combined with other watercolour techniques to introduce soft or crisp shapes, patterns and images.

Try this!

Try stencilling techniques using a variety of stencils and equipment.

▲ **STARFISH**
A damp sponge dipped in two gouache colours was dabbed through a starfish stencil for a soft, organic effect. The stencil was taken from a child's stencil set.

▲ **LEAF**
Two colours were sponged over a leaf, leaving a negative image within a soft cloud of colour.

▼ **LETTERS**
These letters were taken from an alphabet and number stencil for office use. The artist used water-soluble coloured pencils through the cut-outs, then softened the lettering with water.

◀ **HAND**
The artist sprayed a strong wash over her hand to leave a perfect negative image.

◀ **NUMBERS**
Spattering with stencils gives interesting broken effects. Here, the alphabet and number stencil was laid over a wash, then a darker wash was spattered through the cut-outs using a spray bottle.

Printing with watercolour

Household and natural objects, such as string, corrugated card and leaves, can be used to print shapes and textures.

Almost any surface that will hold paint can be used effectively in watercolour. Printing with unusual objects adds another dimension to a painting – they remove the mark of the brush, and introduce an element of controlled serendipity. They also allow you to work quickly, giving the image a sense of spontaneity. You can use this technique in a literal way – a leaf to describe foliage or vegetation in a foreground, a cut lemon for a decorative fruit border. You can also find visual equivalents for motifs and textures – corrugated card for roof tiles or a ploughed field, bubble wrap or the end of a pen for knapped flint, for example. Print-off techniques are ideal for creating generalized textures for abstract and decorative images.

Taking a closer look

Printing with a selection of pens, card, foil and leaves provided this artist with a quick and easy way of creating the texture of flint, foliage and lichen-covered stone.

A flint church by Kate Gwynn

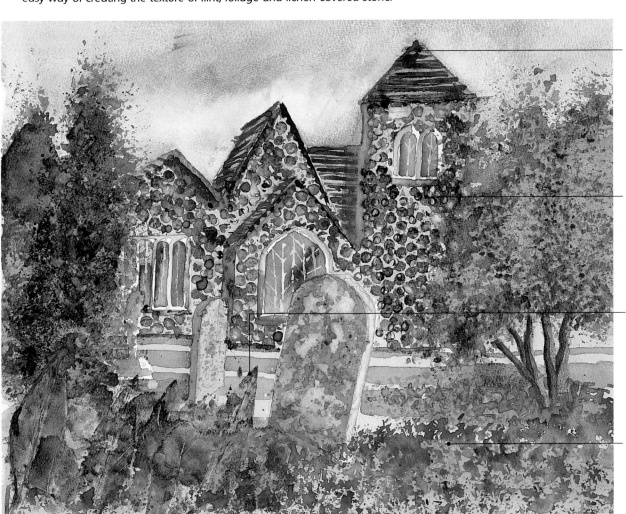

Parallel lines of roof tiles were printed on with brown wash brushed on to corrugated card.

A ball point dipped in paint was used to stamp the flints on to the church façade. The larger flint shapes were printed with the top of a chunky marker pen.

Foreground foliage was printed with a variety of leaves. Gum arabic (see page 233) mixed with paint helped the paint adhere to the leaf.

Textured vegetation was created with dark green wash on a piece of tinfoil, pressed down with the fingertips over a light green wash.

Exploring print-off methods

Use the print-off technique to create a wide range of stamped textures and marks, and to add interest to your painting.

Try printing with different objects on scrap paper first – single motifs, repetitions and over-printing in different colours. The paint should be fairly thick – gouache from the tube or diluted with a small quantity of water holds marks well. You can use Aquapasto medium, gum arabic or soap (see pages 225, 233 and 241) to thicken the paint. Depending on the type of mark maker, either dip it in the paint, or put on the paint with a brush. The character of the mark you print rests on both the amount of paint and the pressure you apply. Sometimes the second printing is better than the first.

225, 233 and 241

Tip

If you are using watercolour paint it's a good idea to apply a texture medium to it so that you have a slightly thicker consistency for printing Try adding Aquapasto medium, soap or gum arabic to your watercolour washes.

Try this!

Try printing with a range of items. Vary the consistency of the paint and the pressure you use.

▶ LEAVES
Use a brush to apply a mix of Hooker's green, indigo and gum arabic to a leaf. Lay the leaf on the paper, cover it with tissue and press firmly. Make a series of prints before applying more paint.

▲ LEMON
Cut a lemon in half and blot it with tissue to remove excess juice. Brush lemon yellow paint on to the cut surface and make a series of prints.

▼ STRING
Immerse a piece of string in a light brown wash or roll it on your palette. Press the string on the support. Mix a darker wash and repeat the process.

◀ CORRUGATED CARD
Brush paint on to narrow-gauge corrugated card, lay on a sheet of paper and press. Remove the card to reveal regular striations. Repeat with a broader gauge card. Then try printing in one direction, and turn the card through 90° and print again to create a grid.

CHAPTER 4

USING SKETCHES

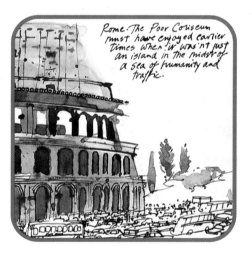

Rome. The Poor Coliseum
must have enjoyed earlier
times when it wasn't just
an island in the midst of
a sea of humanity and
traffic.

The sketchbook is an artist's most valuable resource – most artists would rather lose a finished painting than a full sketchbook. A working sketchbook is essentially a visual diary, a record of important events, places and experiences. Because your sketchbook is personal to you, you can use it to practise, explore ideas and make mistakes without exposing yourself to criticism.

Since sketching improves both the visual memory and manual dexterity, try to get into the habit of sketching regularly – every day if possible. Your drawing will become fluent and confident, enabling you to make quick, accurate studies of any subject that catches your eye. A sketchbook is also the best place to play around with compositions and experiment with materials.

This chapter looks at different types of sketch, from the tiny thumbnails used to explore compositional possibilities to tonal studies in which you record the distribution of lights and darks and the pattern of shadows within a subject. Holiday sketchbooks and travel journals are also featured and illustrated with material from the sketchbooks of practising artists – these very personal studies have a freshness and immediacy that will inspire you to start keeping you own sketchbook.

Why sketch?

Using a sketchbook to record what you see as you see it provides a wealth of reference material. Such a book is not only a visual diary, but also useful for trying out compositional ideas and techniques.

When you sketch, the drawings you create do not have to be highly resolved. Keep them spontaneous. They are an invaluable aid when, as sometimes happens, you can't return to a place, or if you want to record a passing incident or some trick of light and shade that may never occur in quite the same way again.

INVALUABLE SOURCE

Sketchbooks are a source of reference that you can use for years – either for entire pictures, or for specific details within them. For this reason you should try to include as much visual information as possible in your sketches and take comprehensive back-up notes as well. The latter can be useful reminders, especially as a record of light, shade and weather conditions.

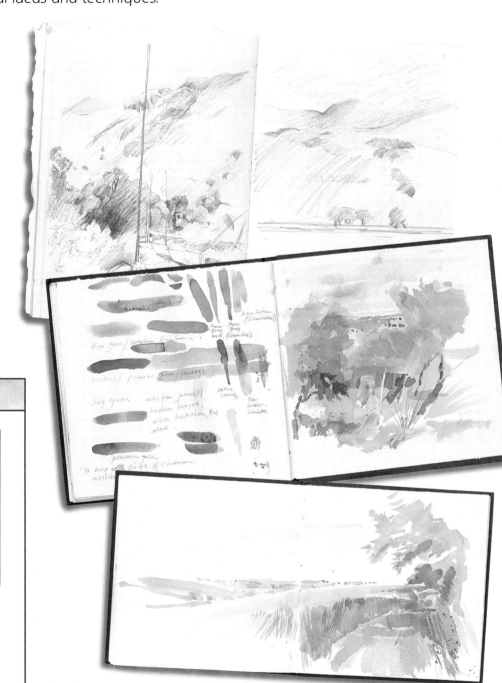

Key points

- It's always a good idea to carry a handy pocket-sized sketchbook and pencil, pen or ballpoint with you, since you never know when a good sketching opportunity might occur. If you are prepared, you'll be able to catch the moment on paper as it happens.

- Artists' pencils come in twenty grades, ranging from the softest (9B) to the hardest (9H). Soft pencils give a wide range of marks and can be used for laying graded tones.

▲ *All you need to get started is a small sketchbook with a hard backing for support, and a couple of artists' pencils. If you want to use colour in your sketches, a selection of water-soluble coloured pencils are a useful addition. Or you can sketch in watercolour, though pencils are often more convenient since they are easy to use and extremely versatile.*

Out and about

A sketchbook is an essential companion on any day out. You can capture scenes and details for use later − not just for one picture, but for any number of different paintings.

A trip to the zoo, safari park or a sea-life centre all provide an ideal opportunity for a satisfying day's sketching on a theme. A series of quick line drawings is a good way to record the rich variety of animals and all their quirks of personality. The idea is to make quick sketches, rather than detailed drawings, and to capture the spirit and character of the animals you see. Later, you'll find sketches like these indispensable for picture-making. All you need to start is a sketchpad, soft pencils, charcoal sticks, a putty rubber, and possibly pen and ink and some water-soluble coloured pencils.

A day at the zoo

▶ *Quick sketches, such as this penguin, help to capture an animal's individuality. A fluid line down the belly, a more considered silhouette over the head and beak, and an abrupt line down the back of the stubby, flipper-like wing are all that's needed to record this bird's basic dynamics. The scribbled tone adds bulk and form. The result is just the kind of scant but lively image that adds character and spirit to a carefully composed picture.*

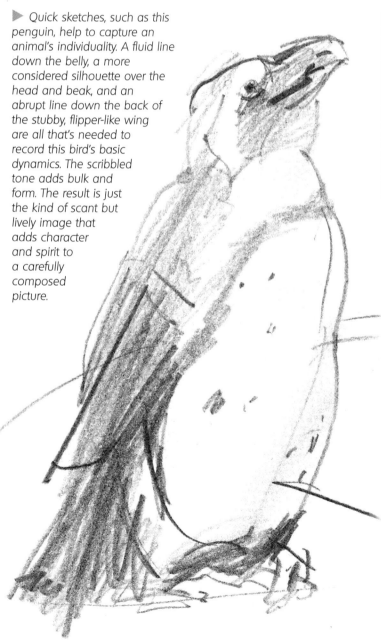

▲ *Take every opportunity to stop and make sketches. Just a few pencil marks quickly convey the life and vitality of these busy preening penguins. A handy railing or low wall makes an ideal support for a sketchbook.*

Expert advice

● Very soft pencils − such as a 7B or an 8B − are excellent for sketching because they provide a combination of soft tones for shading with very dark outlines.

● Make colour notes by adding scribbles of colour pencil. Here water-soluble coloured pencils are useful, since they can be used to create areas of wash, to indicate the base colour of an animal's coat, for example.

Using thumbnail sketches

Painting a pleasing landscape means taking important decisions even before you start work. Simple thumbnail sketches can help you formulate your ideas and resolve compositional questions.

Thumbnail sketches are quickly executed, small drawings that enable you to explore the different aspects of composition. The elements that go into the making of a picture include colour, tone, texture, light and space. Composition involves organizing these to create an image that grabs the attention of a viewer and hangs together well. Thumbnails are a simple and useful tool for exploring your subject in depth and experimenting with different ways of treating it.

FIND THE 'HOOK'

Decide what first drew your attention to the scene. This is the 'hook' for your painting. Then make a series of thumbnail sketches exploring various possible formats, crops and horizon positions. Choose the medium for these sketches to suit yourself and the subject matter.

Thumbnail-friendly media

▼ PENCIL
A pencil is the classic tool for drawing. Explore shapes in rapid sketches with a soft 4B pencil. Then shade in the shadow areas and darker tones.

▲ COLOURED PENCILS
You can use coloured pencils to explore the balance of colour and tone in your subject. Either work totally in colour, or add areas of colour to a pencil sketch.

▶ BALLPOINT PEN
A ballpoint slides easily over the paper leaving a definite fine line. It also makes emphatic dark marks. Consider the main shapes – keep the thumbnail simple and don't be tempted to use the pen's fine tip to add an excessive amount of detail. Use quick hatching to fill in areas of shadow.

◀ FELT-TIPPED PEN
A felt-tipped pen is a speedy drawing tool. You can manipulate it on paper to make different marks in a bold and energetic way. Use a felt-tip to block in the main shapes and explore areas of strong light and shade.

Selecting a composition

Once you have chosen a focus, use a series of thumbnails to explore different aspects of your composition and help you make the all-important initial decisions.

Decide on your focal point (see page 167), then explore the subject with a series of thumbnails. Look for repeated patterns, contrasts and similarities of shape, colour, texture and tone. Consider different formats – landscape, portrait or square – and which crop will work best. Explore different horizon positions and the division of the picture area. Observe the effects of aerial perspective and plan your washes. Keep the sketches small – aim to fit several on to a page of your sketchbook – so you can compare and contrast different approaches at a glance.

Series of sketchbook thumbnails of a road

The final choice
The artist has chosen a square format and a high horizon – a combination that provides a big foreground with a sweeping road that leads the eye of the viewer right into the picture.

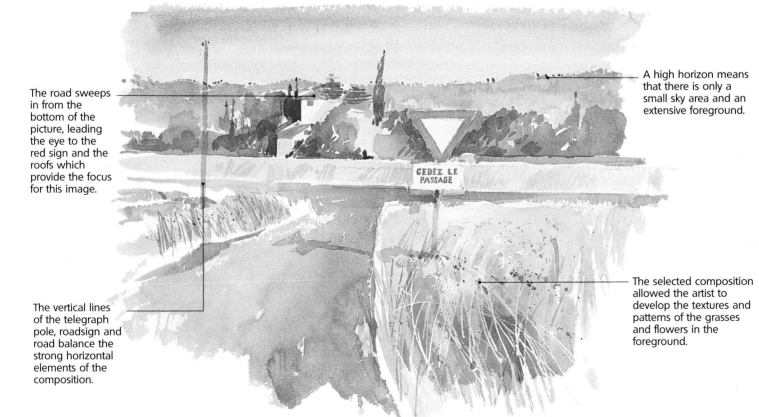

The road sweeps in from the bottom of the picture, leading the eye to the red sign and the roofs which provide the focus for this image.

A high horizon means that there is only a small sky area and an extensive foreground.

The vertical lines of the telegraph pole, roadsign and road balance the strong horizontal elements of the composition.

The selected composition allowed the artist to develop the textures and patterns of the grasses and flowers in the foreground.

CEDEZ LE PASSAGE

Making tonal sketches

In this type of sketch you dispense with line and simply record the areas of light and dark in a subject. It's a remarkably easy way to produce an accurate drawing, one that is ideal for beginners.

Outlines don't exist in nature – only edges – so drawing in tone only is more accurate and, surprisingly, much easier than line-only. When light shines on an object, the side facing the light is light in tone. The side turned away from the light source is in shadow and dark in tone. The areas between light and dark are called 'half-tones' or mid-tones. The contrast between the lights and darks and the distribution of the half-tones allow us to 'see' and understand form. By replicating these gradations you can create the illusion of three-dimensional form on a two dimensional support.

Tonal sketches help you understand the bulk and roundness of the forms you are drawing. Because drawing in tone only is unfamiliar, you're forced to use extra concentration, putting aside the assumptions you make in line drawing. You also make accurate assessments of tonal values – an invaluable skill.

Try this!

This topiary garden can be seen as light shapes against a dark background and dark shapes against a light background. If you sketch exactly what you see, the image emerges as if by magic. Here the paper gives the lightest tone for the sky and grass. The hedge and topiary are built up from three charcoal tones – light, mid and dark.

2 Work across the image, applying loosely hatched tone to the dark sides of the hedges but avoiding the top surfaces, which catch the light. Work freely, frequently changing the direction of your stroke.

1 Half-close your eyes and start to block in the hedge and the topiary in charcoal. Work lightly, in loosely scribbled hatching (see page 143). Blend the charcoal with your finger to create a light film. Don't get too dark too early.

3 Use the tip of the charcoal stick to apply texture to the hedges. Use a combination of short hatched marks and bold stippling to capture the texture of the dense clipped foliage. Don't try to be too precise, but look for an equivalent, a series of marks that provide a shorthand for what you are seeing.

Looking for balance

Tone is an important aspect of composition. If you ignore the colour and the subject matter, the tones in a well-designed picture should create a pleasing pattern in their own right.

Quick tonal sketches help you to assess the patterns of light and dark within a subject. In a successful painting light and dark areas will be arranged in a well balanced and harmonious way. Get into the habit of always making a tonal study before you paint a landscape. Scrutinize your subject through half-closed eyes and make a drawing using a limited range of tones. Look out for rhythms and patterns, and also for repeated shapes – these are the abstract qualities that underlie all good compositions.

In practice — Ways of emphasizing light and dark

In a tonal sketch you need to exaggerate the differences between the light and dark areas. You can use any drawing medium. Work quickly, using bold marks and simple shapes.

▶ WOODLAND FLOOR
Use a soft 5B pencil to analyze the pattern of light and darks in the subject. The tonal study reveals the underlying pattern. The wooded area occupies the top third of the picture area, the dark verticals of the tree trunks creating a rhythmic pattern that counterpoints the extensive light foreground.

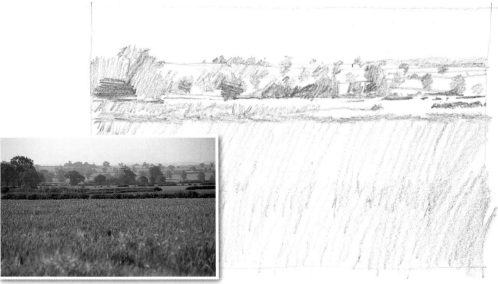

◀ FARMLAND LANDSCAPE
You can also use a sanguine (earthy red) coloured pencil or crayon for your tonal studies. Here the tonal study reveals that the composition splits into three horizontal bands: pale sky; dappled light and dark middle distance; and mid-tone foreground.

In search of rhythms

Drawing people or animals in movement can be daunting – the secret is to simplify the shapes and work as quickly as possible.

Drawing human – or animal – figures is difficult at the best of times, but figures in motion pose quite a special set of problems. To achieve a sense of movement you must capture the frozen gesture, while suggesting the continuation of the movement. Each sketch should hint that some part of the action has just occurred, and that something else is about to happen. The only way to acquire this skill is to work from life as often as possible. Dance classes or rehearsals are marvellous places to study figures in motion, but public playing fields, sports arenas and race tracks are equally rich sources of material, and more accessible. Look for the rhythms and use swift, fluid lines that sum up the movement.

Try this!

Work in a large sketchbook and study the scene before you start. In dance, particularly, certain gestures and poses are repeated.

◀ *Many movements and poses are adopted again and again. Take advantage of the repetition to observe them closely. Notice that redrawn lines suggest movement and vitality.*

Sketches of dancers by *Dennis Gilbert*

◀ *Look for the direction of the motion and the distribution of weight around the centre of gravity. The swirling lines of this dancer's skirt show the direction of movement.*

▶ *In ballet a series of movements often leads to an extreme pose which may be held for a few seconds – these are easier to sketch.*

▶ *Try to 'feel' the movement as you see it – notice the way compression in one area is balanced by stretching in another.*

Drawing quickly

Work fast – this forces you to reject non-essential information and focus on the key directions and movements.

A day at the racecourse requires you to draw quickly and capture the essence of a movement in a few fluid lines. Charcoal is an ideal medium because it has a natural fluency and skims across the paper. Don't worry if you make mistakes – simply redraw the lines. This repetition will enhance the sense of immediacy and motion. Work boldly with broad movements from the elbow and the shoulder – and avoid finicky 'wristy' gestures. With practice you will develop a shorthand that allows you to express movement with a few telling strokes. Avoid detail, looking instead for the rhythms and the lines that imply direction and movement.

In practice Sketching horses

The artist is a frequent visitor to stables and racecourses, where she studies horses at rest, grazing, being put through their paces, milling around in the paddock and hurtling along in the headlong mêlée of the race.

At full gallop
by *Charmian Egerton*

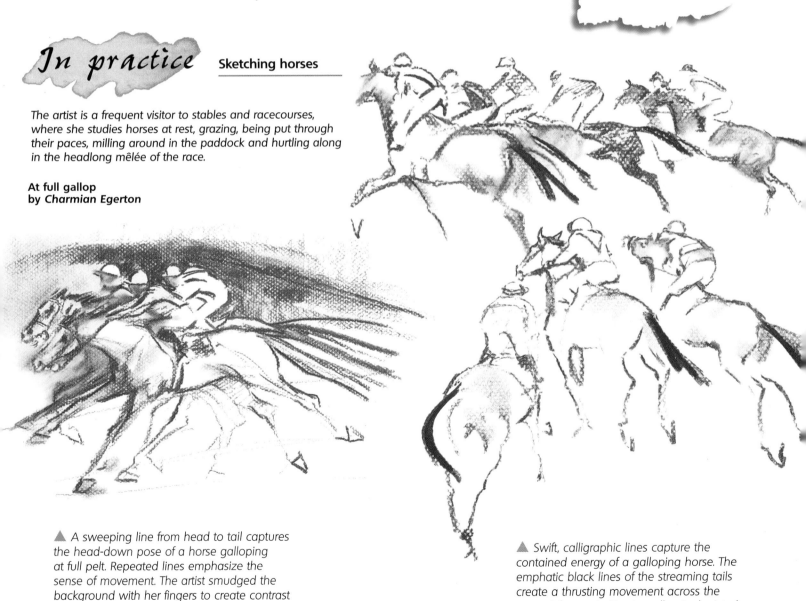

▲ A sweeping line from head to tail captures the head-down pose of a horse galloping at full pelt. Repeated lines emphasize the sense of movement. The artist smudged the background with her fingers to create contrast and drama. Rapidly smudged shadows suggest the bulk of the muscular body.

▲ Swift, calligraphic lines capture the contained energy of a galloping horse. The emphatic black lines of the streaming tails create a thrusting movement across the page. A horse starting to gallop is depicted with a few economical lines.

Colour information

The essence of using a sketchbook is speed, so you need a method of recording the colour in a scene that is accurate, effective and fast.

Sketchbooks are the artist's most important resource, an archive of visual experiences that can be plundered for ideas, images and details. Some of the most interesting landscape subjects involve the fleeting effects of light and weather, so you need to get your ideas down quickly.

To record colour on a sketch you need a portable, easy-to-use colour medium. Coloured pencils and pastels are convenient, while a small watercolour field box slips into a pocket. You can also scribble short colour notes on the sketch – a most effective way of pinning down the colours in a scene.

Pigeonnier at Pradère les Bourguets, near Ségourielle by *Albany Wiseman*

Taking a closer look

In this rapid sketch, made on location in France, the artist used watercolours, plus a blue pencil and a black pastel to record the muted tones of the autumn scene.

Black pastel gives an intense dark for the tree.

Loosely hatched blue pencil captures the pale sky.

The same blue pencil is used more solidly for the distant hills.

Pencil is used to modify the underlying wash.

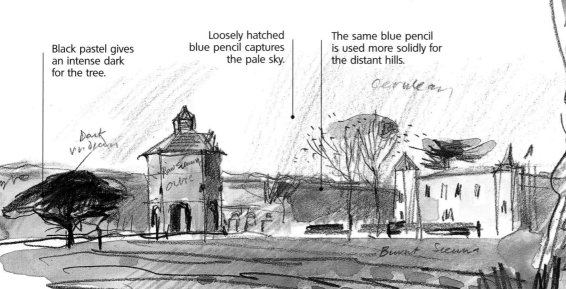

Key points

- Pencil is the simplest sketching tool: use it to annotate your drawing with colour notes.

- Dry media such as coloured pencil and pastel are convenient – you need only a handful of colours.

- Pastels allow you to smudge transparent colour over large areas very quickly.

- Describe colours with words that mean something to you – Wedgwood blue or Germolene pink, for example.

- A small field box of watercolours can be carried anywhere.

Rapidly applied washes mixed from a limited palette establish the colour key.

Combining sketches and photos

Photographs are a useful addition to sketchbook information. Used with discretion they help to conjure up a scene months, or even years, later.

Photographs are a useful aid for the artist, although they can never replace the sketch as a source of information and inspiration. While a photograph represents a moment in time, a sketch is a record of an experience. You can use photos for colour reference, although they tend to have a warm or a cold cast depending on the light conditions and the film used.

The sketching process acts as a filter. The finished sketch is an interpretation rather than a literal depiction of a scene. But the effort put into creating it means that years later you can conjure up the colours observed with great clarity.

▲ PHOTOGRAPH
This was taken while the artist was working on the sketch. The camera gives a rather crude version of the colours of the sky and the grass, but is more accurate on the purply neutrals of the trees and cottage.

In practice: **Late spring in Scotland**

This evocative watercolour was painted in the studio from a sketch made on the spot. The photo was taken at the same time.

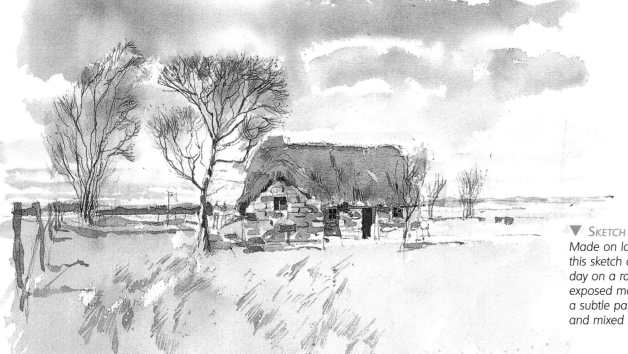

▼ SKETCH
Made on location in May 1994, this sketch depicts a bright, blustery day on a rather bleak and exposed moor. The artist has used a subtle palette of greens, ochres and mixed neutrals.

▲ FINISHED PICTURE
This image was painted six years after the original sketch was made, but the artist's memory of the scene was crystal clear. Here he has compressed the image into a squarer format, but retained the sense of an exposed landscape.

Sketching on holiday

While on holiday sketch anything that catches your eye. Your sketchbooks will provide a spontaneous, highly personal record.

Holidays may be the only time you can spend time doing some serious sketching, so make the most of every day. Keep your eyes open and record anything that takes your fancy. Unlike a photo, a sketch is selective – you choose what you want to record. It may be a busy market scene or a group of people, or it may be just a gesture, a hat or a doorway. Have your sketchbook always at the ready so you can make quick visual notes – even the simplest jottings will remind you of a scene and may provide you with enough information to create a finished painting.

It's essential to travel light when you go on holiday. Take a small sketchbook and your favourite pen, or a pencil or two. Include coloured pencils or a small field box of watercolours, if you want to add colour here and there.

▲ *The minimum number of pencil lines and the simplest of watercolour washes evoke a corner of the city the artist was exploring.*

Holiday sketchbook: Morocco

Keep your eyes open and you'll never be short of subjects to draw – you can start by looking out of your hotel window!

▶ *The view from a hotel terrace gave the artist an opportunity to absorb Moroccan culture. This shrine to lost sailors was sketched economically with sepia ink, and watercolour washes added.*

▼ *Even a tedious airport wait can be turned to the sketcher's advantage – at Tangier airport the artist's eye was caught by military personnel. Other sketches show local people in Moroccan costume.*

First find an ideal spot...

Sometimes you may want to record a complete scene. On holiday, you have the perfect opportunity to relax and enjoy the atmosphere, and to make a visual record of your feelings about the place.

A bustling market place is just the sort of subject you have time to enjoy while away on holiday. Use your sketchbook to gather information for a finished painting – an on-the-spot sketch provides perfect reference. If you back this up with quick studies of evocative details you won't have to rely on your memory later. You can 'edit' your final image, leaving some things out and including others from your sketchbook that work better.

A more complex subject takes longer to sketch than an incidental detail. Study the scene carefully so you can identify the essential elements. Then find a bar or café that makes a good base – there are usually plenty of people about so you can melt into the background, and refreshment is always on hand.

▲ *A place in the sun close to a café provides the perfect vantage point from which artists can sketch any scene that unfolds in front of their eyes. What better way to while away a pleasant few hours?*

Taking a closer look

The artist perfectly captured the atmosphere of this Moroccan market in this on-the-spot sketch.

**Open market in Asilah
by *Albany Wiseman***

▼ *Markets are invariably full of characters and interesting local atmosphere. The artist made a large sketch across two pages of his sketchbook so he could take in the full sweep of the scene. He made a visual note of the colours by adding a few watercolour washes to his pencil study.*

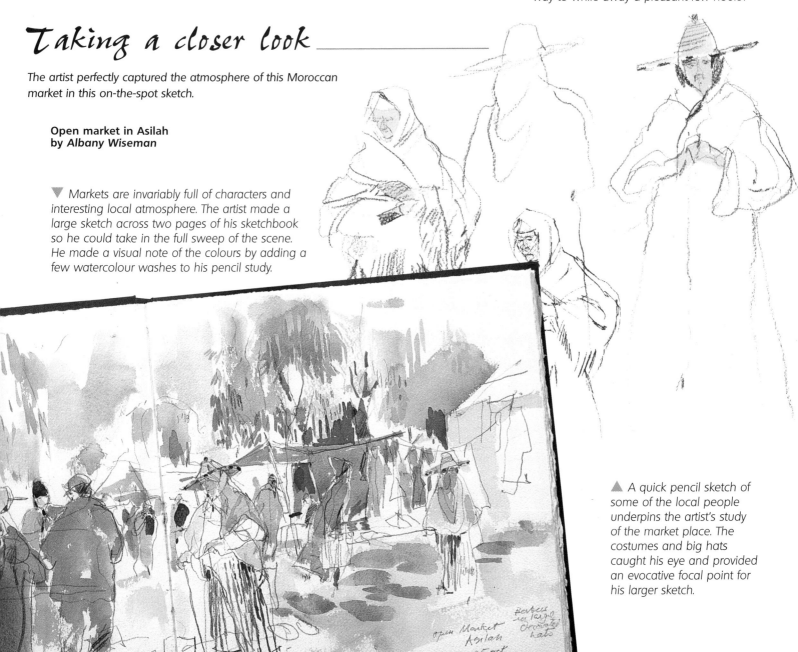

▲ *A quick pencil sketch of some of the local people underpins the artist's study of the market place. The costumes and big hats caught his eye and provided an evocative focal point for his larger sketch.*

Keeping a sketching journal

Combine sketches and handwritten text to create a complete and fascinating record of a journey or a noteworthy event.

An illustrated diary will become an evocative, treasured possession. The combination of text and images allows you to produce a complete record of the events that catch your eye. Use a journal to record a holiday or the key events in your children's lives. The text should be fitted around the images to produce pages that are visually interesting. Don't concentrate on the most spectacular scenes – out of the way corners and everyday encounters often have a more intimate quality. As the pages of the sketching journal begin to fill, you get a pleasing sense of continuity which will mirror the passage of time or the progress of your journey.

Taking a closer look

Artist and illustrator Anthony Matthews has been keeping illustrated journals since 1968 when he started working in London – to date he has produced about fifteen in various shapes and sizes.

◀ **Marseille madness**
Created in 1989, this tiny journal, which measures 10 x 15cm (4 x 6in), records the artist's response to Marseille. The sketches were produced at high speed and document his struggle to come to grips with another culture and a frenetically busy city.

Rome. The Poor Coliseum must have enjoyed earlier times when it was'nt just an island in the midst of a sea of humanity and traffic.

▲ **Train journey through Europe**
In 1967 Anthony Matthews travelled by train through France, Italy and Greece, then back to London. This journal, which measures 15 x 20cm (6 x 8in), records a repeat journey made twenty years later. He drew this sketch of the Coliseum in Rome in writing ink which he then softened with water.

Working methods

Choosing the right materials and developing a consistent style are the key to creating a pleasing journal.

Your sketching kit should be small enough to fit easily into a backpack. A small bound book of reasonable paper which will take line and watercolour is a good starting point.

Choose materials you are comfortable with: pencil, ballpoint, felt tip or fountain pen are all ideal for writing and line work, while watercolour is the medium of choice for many artists.

▲ The artist used a pad of recycled paper for this journal.

 Bicycle journey to remember

The artist's kit includes a watercolour box, two brushes, a dip pen, waterproof ink in sepia and black, and fountain pen ink. Created in 1992, this journal, measuring 22 x 17cm (8¾ x 6¾in), records a bicycle ride from Brive to Marseille.

◀ The artist used opaque white for the façade of the hotel – it tells against the warm neutral of the recycled paper.

▲ Calligraphic lines and blocks of pure colour capture all the excitement and colour of the circus.

Bonne route! by Anthony Matthews

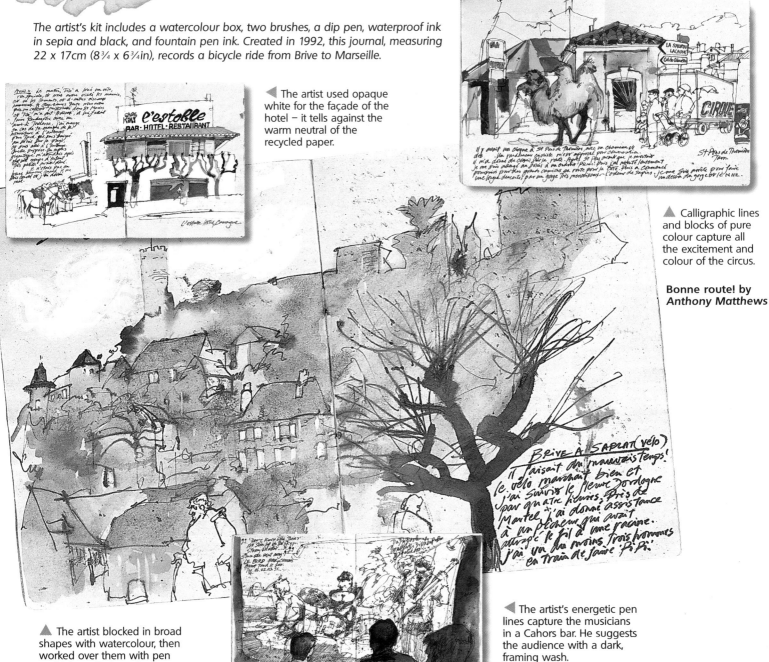

▲ The artist blocked in broad shapes with watercolour, then worked over them with pen and ink applied wet in wet or wet on dry.

◀ The artist's energetic pen lines capture the musicians in a Cahors bar. He suggests the audience with a dark, framing wash.

Sketching wildlife

Observing wildlife is both fascinating and absorbing. For the artist it provides a rewarding challenge.

Animals in the wild are an exciting subject to study. Sketching them for a later painting, however, requires patience and skill. They are often elusive and seldom remain still, so you must be prepared to spend time waiting and watching. And unless the animal is sleeping or grazing, you may have only a few moments to capture its character and form. It's vital to record what you see swiftly and confidently – even a few expressive lines can convey an accurate impression. Keep it simple – look for basic shapes and characteristic stances and indicate the texture of fur, hair or feathers with a few telling marks.

Taking a closer look

These quaint sea otters rested on their backs in the water for quite long periods. This gave the artist plenty of time to fill several pages of his sketchbook with quick studies, and to make a more considered colour sketch too.

**Sea Otter studies
by *Darren Rees***

Useful notes
Jot down visual notes so you can work up a more precise study later. Include hints of the habitat to give a sense of place and scale.

Sketching materials
Travel light when you're watching wildlife, and keep equipment to a minimum. Take materials you are familiar with – often a couple of pencils is all you need.

Quick and easy
Since wild animals move around a lot, you need to be quick. Often a rough outline is enough to provide invaluable reference for a more considered painting or drawing later on.

Keeping a wildlife sketchbook

Your wildlife sketchbook provides an enduring record that will help you create more detailed studies later.

Spend as much time as you can just watching your subject before you start to draw. Observe its behaviour and typical movements, watch how a group interacts – the more you watch and sketch, the more clues you'll get to an animal's character. Fill a page with lots of quick sketches, and start a new one when the animal moves – if it stays in view for long enough it may return to the same pose several times. Look for patterns and shapes and make thumbnails to try out potential compositions. Always use a medium you are comfortable with.

Pages from a wildlife artist's sketch book

Bird sketches by *Darren Rees*

Birds are a particular interest with this artist and his sketchbooks are filled with a wide variety of species.

◀ WADING BIRDS
These birds were resting so the artist had plenty of time to sketch their roosting poses – on one leg or with their bills tucked under a wing – as well as to take note of their plumage.

 SEABIRDS
This sketch captured the movement of the swooping birds and set them in their context of rock and swelling sea – a perfect record of a birdwatching session.

▼ DUCKS
A group of wild duck dozing together made an appealing study. The artist made lively and expressive use of his pencil to depict the varied feather textures.

 CRANES
These cranes were interesting to watch. The artist covered several pages with sketches of their intriguing dancing movements.

CHAPTER 5

DRAWING MEDIA

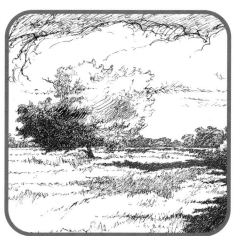

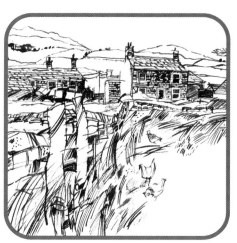

The 'lead' or graphite pencil is the most flexible, convenient and popular of all the many drawing tools available to the artist. It is perfect for the barely visible underdrawings that are needed in order to plot a watercolour. When preparing an underdrawing, work very lightly using a HB, B or 2B so that the minimum amount of graphite is deposited on the paper – this will avoid compromising the clarity of the watercolour washes.

Pencil is also a wonderfully expressive medium in its own right that can be used for rapid sketches made directly from the subject, or for more highly finished drawings. It is also worth exploring the other drawing media featured in this chapter. Charcoal in all its manifestations produces a marvellous velvety black line and encourages you to work broadly, boldly and quickly to produce drawings that have a wonderful immediacy. Of the coloured media, coloured pencil gives you maximum control while soft pastel can be blended and has a pleasing powdery bloom. Pen and ink can be used on its own or in combination with watercolour to produce line-and-wash effects, while a traditional quill pen gives a particularly pleasing range of marks and lines.

Drawing with lead pencils

Hard and soft pencils – the most inexpensive and versatile of all the drawing media – are an essential part of any watercolourist's kit.

Pencils are one of the most versatile tools for drawing, whether it's for quick sketches or working up more detailed studies. Lead pencils are actually made of graphite. Their subtle grey tones and the ease of erasing marks make them ideal for underdrawings (the line drawing made on the support before you start to paint).

Artists' pencils are available in twenty grades: the softest is a 9B, the hardest a 9H, with F and HB in the middle. The hardest produce a pale grey line, while the softest have a dark, velvety tone. Exactly how dark and how pale they are varies between manufacturers.

Hard pencils (H–9H) are ideal for drawing details. They can be sharpened to a fine point which lasts a long time and produces lines of constant thickness. Soft pencils (B–9B) are popular with artists because they are very flexible. Try this for yourself: sharpen a 2B pencil to a fine point and then draw a line in a sweeping movement while twisting the pencil from side to side. The resulting line varies from thin to thick along its length.

▼ FROM HARD TO SOFT
Choose the grade of pencil to suit the type of marks you intend to make.

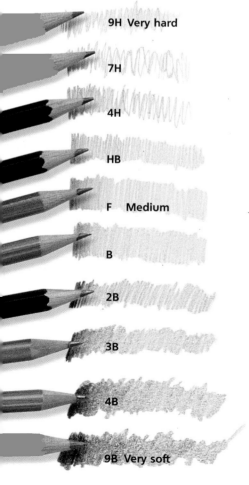

9H **Very hard**

7H

4H

HB

F **Medium**

B

2B

3B

4B

9B **Very soft**

▼ **Trasierra, near Seville by *Albany Wiseman***
With its range of descriptive marks, this sketch shows pencil drawing at its most expressive. The artist used a 9B pencil.

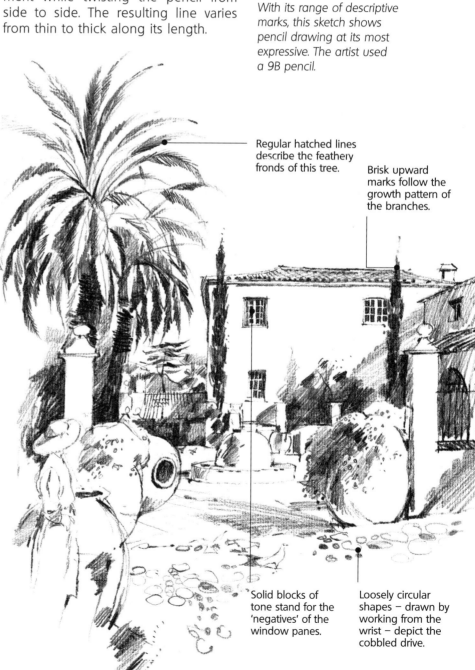

Regular hatched lines describe the feathery fronds of this tree.

Brisk upward marks follow the growth pattern of the branches.

Solid blocks of tone stand for the 'negatives' of the window panes.

Loosely circular shapes – drawn by working from the wrist – depict the cobbled drive.

One pencil for many marks

There's no need to carry a number of pencils around when you are sketching – just one can produce a wide range of differing marks.

You will be surprised how many different effects can be achieved with a single pencil. With a 2B pencil and a sheet of cartridge paper, try making as many different marks as you can. Experiment with sharp and blunt tips. Make bold sweeping marks working from your shoulder and elbow, and then make small marks with controlled wristy movements to build up new textures. Then, using the same pencil, try the exercise below, paying particular attention to the loops and curls of the handle and the wickerwork.

▲ BASKET OF LOGS
Study your subject through half-closed eyes, reducing it to a pattern of light, dark and mid tones. Also observe closely any difference in textures. In the case of this basket, for example, notice how the bark on the logs differs from the wicker. Plan your pencil marks with this in mind.

Experimenting with pencil marks

Sketching a basket of logs provides plenty of different textures and marks for you to explore. Use a 2B pencil and make your marks quite lightly to begin with. As with watercolour, you're working from light to dark. For most of the drawing, the pencil needs to be slightly blunted – sharpen it when you need to add the details.

Bark tone
Hold the pencil as you would when writing. Now draw short lines close together. Adjust the pressure to vary weights and direction.

Adding definition
Blunt the tip of the pencil on scrap paper, then make crisp black lines with it, exerting lots of pressure.

Bark texture
Hold the pencil on the paper and roll between the fingers. Alter the pressure to create a squiggly line which varies between thicks and thins.

Long grain of wood
Hold the pencil lightly and draw a series of long tremulous lines.

Dark shadows
Hold the pencil close to the tip, press hard and scribble. Work in several directions and build up layers to create dark tones for the shadows.

End-grain of logs
Rub the side of the pencil tip on scrap paper to flatten it. Lightly shade the end of the logs, letting the texture of the paper show through.

Water-soluble pencils

Water-soluble pencils are even more versatile than graphite pencils – manipulating the marks with water transforms them into washes.

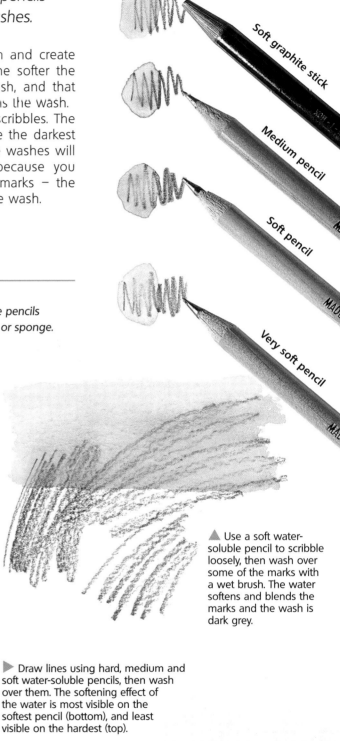

Soft graphite stick

Medium pencil

Soft pencil

Very soft pencil

Water-soluble pencils extend the range of tones and marks you can make with graphite pencil. You can wash over your marks with a clean, wet brush, or rub them with a dampened finger, to develop subtly blended and graduated tones.

Water-soluble pencils come in a range of grades. Try drawing lines with different grades, then use a wet brush to blend and soften them and create washes. You'll find that the softer the pencil, the darker the wash, and that adding more water lightens the wash.

Then try washing over scribbles. The softest pencil will produce the darkest wash, but this time all the washes will be darker than before because you have made more pencil marks – the more marks, the darker the wash.

Try this!

Compare the different tonal effects you can achieve with water-soluble pencils – use a range of grades, such as hard, medium and soft, and a brush or sponge.

◀ Scribble loosely with a hard water-soluble pencil, then brush half of it with water. In the dampened area, the marks are barely softened and the wash is pale grey.

▲ Use a soft water-soluble pencil to scribble loosely, then wash over some of the marks with a wet brush. The water softens and blends the marks and the wash is dark grey.

▶ Wet the paper with a sponge, then scribble loosely with a soft water-soluble pencil. The marks 'blur' more than on dry paper.

▶ Draw lines using hard, medium and soft water-soluble pencils, then wash over them. The softening effect of the water is most visible on the softest pencil (bottom), and least visible on the hardest (top).

Range of tones

The versatility of water-soluble pencils is a major benefit for tonal studies – it's easy to create a range of light, medium and dark tones.

Tonal studies can be worked up quickly with water-soluble graphite pencils. Start in the usual way with two or three grades of pencil. Use the hardest for fine detail and pale tones, the medium for mid-tones and the softest for dark tones. Make the most of your favourite shading techniques – hatching, cross-hatching, stippling and scribbling – to develop form and tone.

Once you've got the basic forms down, use a clean, wet brush to wash over paler tones to blend and soften your marks – the more water you use, the paler the wash. For deep shadow, work firmly and use less water – the harder you work the brush, the more tone it picks up, and the darker the wash. To lighten tones, lift the excess with the wet brush, and dab off.

You can add more pencil marks at any stage on dry or damp areas: marks made on damp paper will be softer than usual but harder to erase.

Taking a closer look

In this parkland study, the artist used hard, medium and soft water-soluble pencils. He then reworked certain areas with a wet brush to soften and blend the tones.

Hampton Court by Ian Sidaway

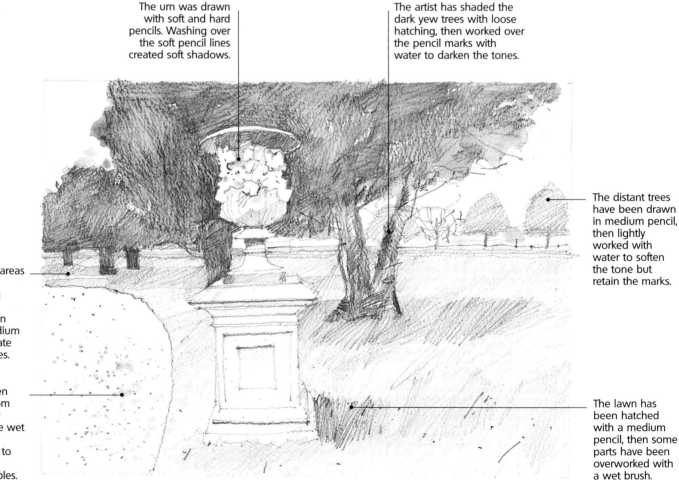

The urn was drawn with soft and hard pencils. Washing over the soft pencil lines created soft shadows.

The artist has shaded the dark yew trees with loose hatching, then worked over the pencil marks with water to darken the tones.

The distant trees have been drawn in medium pencil, then lightly worked with water to soften the tone but retain the marks.

The shadow areas have been brushed with water, then hatched again with the medium pencil to create darker patches.

Tone has been picked up from the dark yew trees with the wet brush and spattered on to the path to suggest pebbles.

The lawn has been hatched with a medium pencil, then some parts have been overworked with a wet brush.

Graphite sticks

If you enjoy drawing on a large scale, try using graphite sticks.
Their robust nature and soft, dark lines are pleasing to work with.

Round graphite sticks

Hexagonal graphite sticks

Putty rubber

Graphite sticks are similar to ordinary pencils – but pick one up and you'll find it's heavier than a pencil. It's made of compressed graphite (a form of carbon) and makes broader, bolder marks than pencils – perfect for large-scale work. They can make delicate marks, but not fine lines.

Graphite sticks range from hard to soft, and come as round sticks and hexagonal sticks. Round sticks are long and coated with thin plastic. They can be used for linear work as well as broader shaded areas. The hexagonal sticks are short and chunky – they give bold crunchy lines and rich dark tones.

Try this!

You can make a wide variety of marks with graphite sticks. Practise with both types to get the feel of them – they are particularly good for large-scale work.

◀ Hold the round graphite stick by its tip between your thumb and forefinger and drag it across the paper to create broad bands of shading.

▲ Using the side of the tip, draw the hexagonal stick towards you. Build up soft lines side by side for structured blocks of shading.

▶ Grip the hexagonal stick firmly near the top. Make fine scribbly marks with the point. Use light pressure and let the stick trace lightly over the paper.

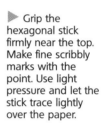

▼ Using the end of the hexagonal stick, draw a line with one of the side angles. This sharp line contrasts effectively against softer, shaded areas.

▶ Make cross-hatched marks with the hexagonal stick for strong, bold areas of shading. Hold the stick close to the point and apply heavy pressure.

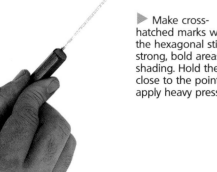

▲ Turn the hexagonal stick on its side and draw it down the paper towards you. You can draw over this varied tone with some line work.

▶ Using the tip of the hexagonal stick, pull it towards you, twisting it to make variations in the line.

Large-scale drawing

When drawing with graphite sticks, think big – they are excellent for exploratory work and bold sketches.

Graphite sticks are ideal for a big picture. The larger the sheet of paper you use, the more texture and detail you can include, using a range of cross-hatching, shading and linear techniques. The sheer weight of the graphite stick – both the chunky hexagonal type and the slimmer round one – encourages you to make the most of the soft, velvety dark marks and wide tonal range you can achieve with it.

Tip

If you make a mistake or an accidental smudge with graphite sticks, don't worry. You can use a putty rubber to take advantage of a smudge by turning it into a highlight. The same putty rubber will also take out any unwanted smudges or lines.

In practice · Olive grove

The artist drew the tiny leaves in the negative, working lightly round the outlines, then putting in the darks. He used three round graphite sticks – an HB, a 3B and a very soft 9B.

Olive trees II, Crete by Ian Sidaway

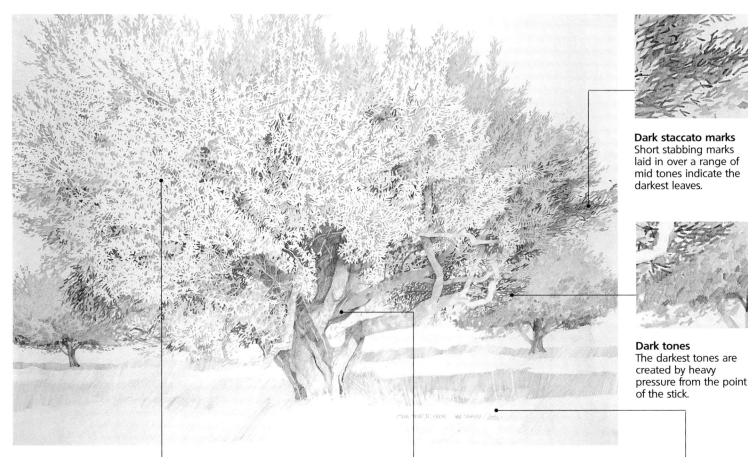

Dark staccato marks
Short stabbing marks laid in over a range of mid tones indicate the darkest leaves.

Dark tones
The darkest tones are created by heavy pressure from the point of the stick.

Drawing the negatives
The shimmering leaves of the olive are created by drawing in the negatives around them – first in light, then mid and dark tones.

Mid-tone shading
The mid tones on the boughs of the tree are built up with light pressure from the side of the stick.

Hatching effects
Loose hatching and scribbling give the effect of short grass, receding in light and dark bands under the spreading boughs of the olive.

Using charcoal

Charcoal is an ideal medium for the beginner because it forces you to simplify, and work boldly and spontaneously. It's cheap, simple to use and produces a variety of lines and blended shading.

You can use charcoal for quick sketches, tonal studies and thumbnails. It is a wonderfully expressive medium which skims across the paper, giving fluid black lines and areas of solid, velvety black tone. You need a paper with enough tooth (texture) to hold the powdery particles – cartridge and pastel papers, and NOT watercolour paper are all suitable. Charcoal smudges easily so protect your drawings with a sheet of tracing paper or spray them with fixative. If you don't have fixative to hand, hair lacquer will do the trick.

GETTING STARTED

Charcoal is made from burnt willow, vine or beech twigs and comes in several forms. The softest and most pleasing to use are sticks of natural charcoal. These vary in thickness depending on the size of the original twig. It is also available as compressed sticks and pencils which are harder and less inclined to break or smudge.

You will need a few sticks of willow charcoal in various thicknesses, paper and fixative. Buy fine glasspaper, or a craft knife, to sharpen the sticks plus a putty rubber to create highlights and erase mistakes. Fingers are ideal for blending, but you can use a torchon (a piece of paper rolled tightly to a point) to stop your hands from getting dirty.

Key points

- Charcoal works well on papers with a textured surface, but not on smooth or glossy ones.

- The marks produced vary, depending on the thickness of the charcoal being used.

- Spraying fixative over your work once you've finished protects it from smudging.

- You need minimal equipment to get started.

▶ **WILLOW CHARCOAL**
Here, you can see at a glance how different thicknesses of willow charcoal sticks produce varying types of mark. Regardless of the nature of the mark, the medium retains its bold, velvety black character throughout. If you are too heavy-handed thin sticks will snap, spattering crumbs of charcoal over your drawing.

Torchon used as an alternative to fingers for blending

Fixative

Kneadable putty rubber for creating highlights and correcting errors

Fine glasspaper

Coloured and white drawing paper

Charcoal pencils

Craft knife

Charcoal marks

It's well worth experimenting and seeing what types of marks charcoal can produce. They have great expressive potential.

Charcoal is a flexible medium. Use thick sticks for broad lines and bold marks and thin twigs for fine details. You can use the side of the stick to cover large areas quickly, and break off small pieces to make crisp dark marks and textures. And you can shape the tips of the sticks by rubbing them on paper. These chisel-shaped tips can be used for more controlled lines.

Charcoal pencils are compressed charcoal encased in wood. They are harder and less messy to use but they have a more limited range of marks and effects than traditional charcoal.

The colour of charcoal depends on the wood from which it is made: charcoal made from vine produces a brownish black, while willow and beech both make bluish-black marks.

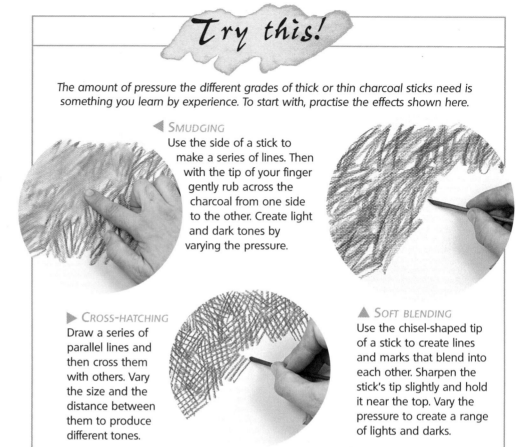

Try this!

The amount of pressure the different grades of thick or thin charcoal sticks need is something you learn by experience. To start with, practise the effects shown here.

◄ SMUDGING
Use the side of a stick to make a series of lines. Then with the tip of your finger gently rub across the charcoal from one side to the other. Create light and dark tones by varying the pressure.

► CROSS-HATCHING
Draw a series of parallel lines and then cross them with others. Vary the size and the distance between them to produce different tones.

▲ SOFT BLENDING
Use the chisel-shaped tip of a stick to create lines and marks that blend into each other. Sharpen the stick's tip slightly and hold it near the top. Vary the pressure to create a range of lights and darks.

Taking a closer look

This attractive drawing shows how the shaped tip of a charcoal stick produces fine lines, while a blunt, flat tip gives bold, expressive marks. The side was used to block in large areas.

Country afternoon by *Melvyn Petterson*

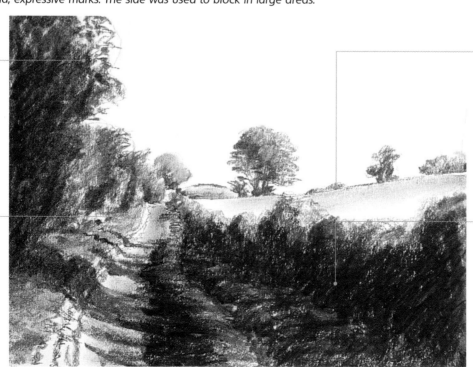

The tangles of foliage in the bushes were suggested by scribbling with the very tip of the charcoal stick.

The chisel-shaped end of the stick was ideal for laying in darker areas of tone which were to be knocked back later.

For the small bushes on the horizon, the blunt end of the stick was used to lay a fairly solid but small block of deep tone. The tree foliage was rendered with the stick's tip.

To throw dark shadows across the road and darken the hedge on the right, the blunt tip of the stick and the chisel-shaped end were used. The rough grass growing down the centre of the lane was also rendered with the stick's blunt tip.

Using coloured pencils

Coloured pencils are inexpensive, easy to use — and also small and portable. You can combine hard, sketchy lines with loosely worked patches of colour, so producing both linear and painterly effects.

Coloured pencils are suitable not only for small detailed drawings. You can also use them much more loosely for larger sketches. There are numerous visual effects you can create with them as well, especially if you work quickly and spontaneously. Simply scribbling one colour over another creates an enormous variety of different effects and tones. To get the most out of them, try to use as wide a range of strokes and marks as you can. These can be bold or delicate, free-flowing or tightly controlled. Controlled cross-hatching — overlaid criss-crossed lines — produces a crisp image, while layers of freehand scribble in two or more colours are effective for backgrounds. For small areas, use dense flecks or dots.

Expert advice

- To create a coloured area with a straight edge, mask the area using a sheet of paper and hatch briskly. Lift the paper to reveal a neat edge.

- Coloured pencil can be combined with watercolour for line and wash or mixed media techniques.

- Blend soft pencils with your finger. For harder pencils use some turpentine or white spirit.

Taking a closer look

In this lively drawing bold, loose scribbles, varied pressures and careful colour mixing combine to convey the bright sunny atmosphere of a French village.

**La Garde Frinet
by Ian Sidaway**

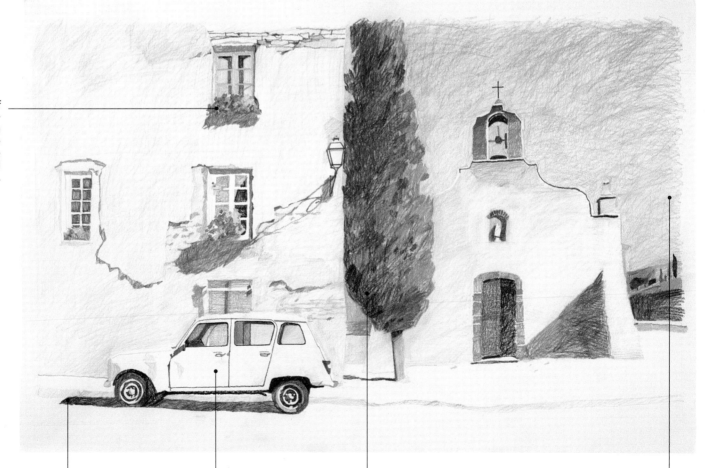

Tiny touches of pure colour — applied with medium pressure and the tip of the pencil — catch and hold the eye.

Solid black shadow, applied with heavy pressure, gives emphasis to the sunny scene.

The car is depicted in straightforward line drawing with a sharp pencil.

Carefully mixed blocks of colour, applied in the direction of growth, depict the tree's foliage.

Loosely scribbled hatching lets the white of the paper show through and gives the sky a luminous quality.

Pencil properties

Get to know your coloured pencils really well, and learn the tricks of blending and varying pressure for a wide range of effects.

Some coloured pencils are softer than others, depending on how much wax they contain – the higher the wax content, the harder the pencil. A hard pencil is ideal for delicate work since it produces a precise line; softer pencils are useful for laying areas of solid, bold colour. As with graphite pencils, you create different grades of tone by varying the pressure on the pencil.

Coloured pencil marks can be much harder to erase than those made by graphite pencils. Mixing colours, on the other hand, is easy. The marks made by the pencils are semi-transparent, so one colour laid over another makes a third. Combining the colours with different strokes produces various effects from regular and neat to loose and scrubby.

> ▶ *The beauty of coloured pencils is their range of hues – and the variety of papers you can use with them.*

Key points

Hard

Medium

Soft

● The amount of pressure you put on the pencil affects the tones it produces. Hard pressure gives a dark tone; medium pressure, a mid-tone; and light pressure, a light tone. Use the sharp point for fine lines, and the side of the core or a blunted tip for soft lines and broad blocking in.

Smooth paper **NOT paper**

◀ **THREE-COLOUR MIXING**
This brownish green was made by laying true blue and cadmium lemon over vermilion. The difference in tone between the two is due to different paper. NOT paper, with more tooth, gives a lighter tone.

1 2 3

▲ **TWO-COLOUR MIXING**
Just as with paints, overlaying two coloured pencil colours makes a third. Here 1 is made from light carmine and vermilion; 2 is made from Prussian blue and cadmium lemon; and 3 is made from vermilion and cadmium lemon.

Using pen and ink

With sensitive handling, a single pen can produce an eloquent drawing with a huge variety of expressive marks and carefully built up tones.

With pen and ink you can make a host of different marks, from fine and delicate to bold and energetic. You can produce drawings that are subtle or dramatic, and always full of character. With practice and confidence you can manipulate your pen to produce fluent, expressive work.

To start with, a simple dip pen is an inexpensive and versatile option. Choose a few nibs and get to know how they feel and what they can do.

A fountain pen is a good alternative, especially for sketching outdoors – the ink is on tap and can't spill; or invest in a special sketching pen. With waterproof ink you can apply washes and still retain the crispness of line. With water-soluble inks you can soften and merge lines with clean water or colour washes. You can dilute both types of ink with water to modify the tone. Choose smooth paper with a sized surface that won't absorb the ink or soften the line.

Taking a closer look

Pen and ink – here a dip pen and waterproof black Indian ink – is a lovely medium for landscapes. The infinite variety of marks you can make helps you to create a huge range of tones and textures.

Cobham, Surrey
by Melvyn Petterson

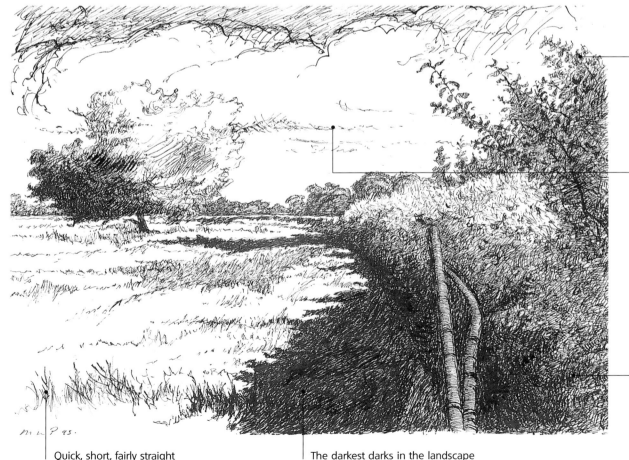

Individual leaves are carefully drawn, so they stand out from the more abstract scribbles and strokes that suggest texture rather than form.

Just a few lines and scribbles are enough to suggest the clouds. The range of strokes is huge – short, straight, dotted, tufted, slanted and scribbled.

Slightly less heavy scribbles produce a variety of subtle greys – increasing the range of tones in the landscape.

Quick, short, fairly straight strokes with the pen stand for clumps of grass.

The darkest darks in the landscape are built up with layer on layer of scribbled marks – bringing this area well to the fore.

A variety of marks

Fluency and liveliness in a pen-and-ink drawing come from using different marks that each perform a specific, expressive function.

Try this!

Make a range of different marks with dip and fountain pens and experiment with various ways of building up tone. Try waterproof and water soluble inks.

Fountain pen

▶ Try fine dotting and 'ticking' for a variety of tones and textures.

▲ You can get thicks and thins with a fountain pen if you twist the nib. Use a little more pressure so the nib splays slightly, producing a wider line.

▲ Open hatching creates a lighter tone. Close hatching makes a darker tone.

Dip pen

▶ You can make marks that are almost calligraphic if you vary the pressure on a medium dip pen.

▶ A mapping pen creates delicate marks. You can vary the density of cross-hatching for darker tones.

▲ Allow the dip pen to blot. You'll find the shellac-based sepia ink pools thickly and forms a glossy surface.

Water-soluble ink

▶ Make small, staccato marks with water-soluble sepia ink, then spatter clean water on top.

▶ Diluting the ink varies the tone. Notice how the darker cross-hatching advances in front of the lighter diluted marks.

▶ A different texture can be produced by washing clean water over shading lines. Notice how the pigment settles at the edges of the wet area.

Drawing with ballpoints

Ballpoint pens are perfect for quick sketches and you can use them to create detailed drawings with subtle tones and depth.

Ballpoints produce clear, consistent lines, and are extremely quick for jotting down sketches of small scenes or details. They come into their own when you want to draw smooth, consistent lines. The nibs are made of metal so they don't blunt or roughen in use. Try out a range of ballpoints to achieve a variety of line widths and weights – you can also exploit different point thicknesses and widths for a variety of textures. Ballpoints come with either water-soluble or non-soluble ink.

For detailed line work, use one of the finer ballpoint pens and light pressure. With medium and thick points, vary the pressure to give a range of tones.

Stippling with a ballpoint adds texture and tone – again different nib sizes give a range of effects. You can also build up a range of deeper tones with hatching and cross-hatching. If you are using pens containing water-soluble ink, you can create depth and tone by washing over lines with a wet brush or a moist finger.

Taking a closer look

Ballpoints can be used to suggest texture, depth and tone for detailed naturalistic studies.

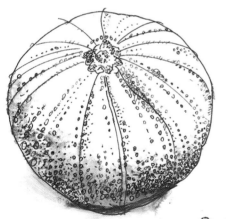

◄ SEA URCHIN SHELL
Water-soluble ink has been used for fine lines and stippling. At the base, the ink has been rubbed with a damp finger to create subtle shading. The toned area was then worked over again.

◄ HONESTY SEEDHEADS
Several different ballpoints have been used here to create a variety of textures, showing the different characteristics of the seedheads, stalks and vase. Traditional hatching and cross-hatching create deeper tones.

▶ SEASHELL
The finely detailed, complex contours of the shell have been drawn with a medium point. The same pen has been used to suggest the darker interior with some loose cross-hatching.

▶ CONKER
Stippling and fine line work in waterproof rollerball ballpoint add detail to a watercolour study of this conker in its prickly case.

Using ballpoints in line and wash

With a little practice, you can use water with ballpoint pens to develop an attractive wash-and-line technique.

Water-soluble inks add a whole new dimension to drawing with ballpoint pens. Once you have drawn your basic sketch, you can use water to blur and soften lines and to add tone and depth.

There are two ways of using water with ballpoint pens. In the first, you moisten a finger then rub over the lines to produce a blurry effect. Rubbing harder produces a smudged effect.

In the second method, you wash over the lines with a wet brush. The wetter the brush, the looser the wash. A broad sweep spreads the ink farther, while a gentle flick of the brush creates a cloud.

SHADES OF BLACK

Some water-soluble black ballpoint inks are bluish-purple; others are brown or greyish. Experiment with a range of water-soluble black ballpoints to discover their different effects – brownish ballpoints, for example, give an 'antique' look and a purplish ink produces a moody effect. Combining more than one 'black' gives a range of monochrome effects.

Tip

Ballpoint pens give you a great opportunity to mix media for some exciting effects. Here water-soluble ballpoint has been used to establish the main outlines of the starfish, while watercolour pencils applied on top provide colour and vibrancy.

In practice

Developing a sketch into a detailed drawing

The artist used two 'black' water-soluble ballpoints, one with bluish-purple ink and one with a brownish tint.

◀1 Use the bluish-purple water-soluble ballpoint to sketch the two bathers (see left and right) and to cross-hatch the shadows. Moisten your finger and smudge some areas of the cross-hatching for more tonal depth.

▶2 Extend the shadows by scribbling with the brownish ballpoint. Soften them with a wet brush – don't smudge the lines of the figures.

▶3 While the wash is still wet, use the same brownish ballpoint to cross-hatch areas that need extra depth, so that the ink blurs at the edges, softening the tone.

▲4 Still using the brownish ballpoint, hatch more shadows. To complete the sketch, wash over the ink with the wet brush to soften and emphasize the shadows.

Using erasers for drawing

Erasers produce dynamic shapes and highlights that can work wonders for your drawings alongside the dark lines and tones.

Artgum

Plastic eraser

Drawing well relies heavily on manipulating light and dark tones. But rather than leaving the light tones blank or applying them very softly, you can introduce an interesting new mood and surface quality by using an eraser: this rubs out lines and patterns to represent the lighter areas. The crisp, angular shapes create a great sense of clarity and energy.

You start by building up a mid tone with pencil, charcoal or graphite powder – then use an eraser to pull out light tones. You can then apply some darker marks for deeper tones.

You use the eraser itself to draw into the tone. For example, if you're creating a dark form, rather than imposing a dark line around the edge, try 'drawing' around it with an eraser. In effect, you're taking away the background around the form to show its edge, which is still sharp and clear, yet softer than the dark line of a pencil.

Each eraser is suited to different functions and supports. Some work better on hard, glossy papers; others are more efficient on a textured surface. Most are cheap, so buy a selection and try them out on different papers.

Plastic eraser

Pencil eraser

Putty rubber

Plastic eraser

MAGIC RUB

Ink rubber

Taking a closer look

Skilled use of erasers gives luminosity to this drawing. In light areas – the sky, the slopes, water and rocks – the drawing has been rubbed out. On the pebbles and on the grassy tufts, the artist used pencil to indicate form.

Mountain stream by Stan Smith

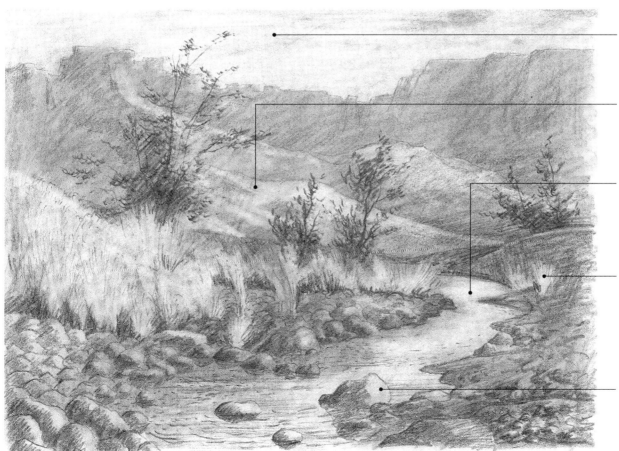

A broadly erased area creates a very light tone for the sky.

Sweeping erased lines indicate the light falling on the hillocks and rising ground behind and to the left of the stream.

Softly blurred sweeps of the eraser convey the movement of the water – this tone reflects the light sky.

Vertical, flicking strokes of the edge of the eraser depict tufts of pale grass.

Small touches of the eraser show where the light falls on boulders and pebbles.

Using several erasers

Using different erasers gives a wide range of vigorous, energetic effects. Here the artist used Artgum, a plastic eraser, an ink rubber and a putty rubber for this lively drawing of giraffes.

 Giraffes in grassland

Draw the giraffes and lay in a tonal background with charcoal pencil and graphite powder. Then use erasers for the pattern on the bodies, the background and to clarify the necks and legs.

▲ The corner of a putty rubber is sharp enough to get into small areas for general neatening of edges and sharpening of detail.

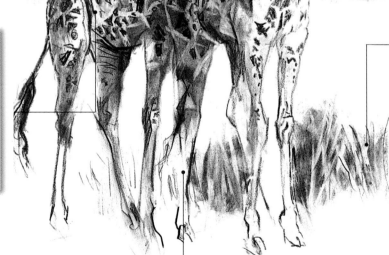

▲ Some random, general sweeps of an Artgum eraser indicate background foliage. The same eraser makes a few swift lines to suggest the patterns on the giraffe's neck.

▲ The softer end of the ink rubber is excellent for cleaning up areas and to get back to the white of the paper – such as the white marks on the bodies of both the giraffes.

▲ The sharp edge of a plastic eraser is ideal for rubbing out long, thin lines to suggest the tall, spiky grass. The same eraser makes clean, sharp criss-cross patterning on the bodies of the giraffes.

◀ A putty rubber is useful for defining the long, thin, bony legs of the giraffes – and to clean away finger marks and smudges.

Drawing with a quill pen

The traditional quill pen is flexible, responsive and creates drawings that are both vigorous and sensitive.

A quill pen is made from the large flight feathers of a goose, turkey or swan. It's light to hold, and highly responsive to the amount of pressure exerted on the tip. Thus a single line can flow from fine and delicate to broad and emphatic as you increase the pressure – unlike a steel nib that produces a more even line. You can't control it absolutely, but the occasional unpredicted mark adds visual interest to your drawing. It has a characteristic scratchy quality that suits smooth cartridge paper – try toned as well as white. Test out different inks – dilute them for better flow.

A quill pen can produce a number of expressive marks. Try emphatic, broad marks with a full pen and varied pressure – as the ink runs out and you lighten the pressure, your lines become finer. Make flowing calligraphic lines, and short, staccato marks, and blur lines by spreading blots with a finger. Try using the back of the pen too.

In practice **Landscape with a quill pen**

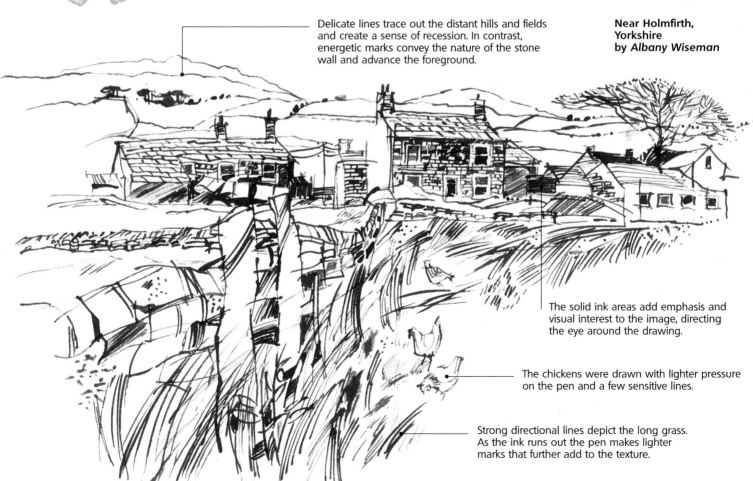

Delicate lines trace out the distant hills and fields and create a sense of recession. In contrast, energetic marks convey the nature of the stone wall and advance the foreground.

Near Holmfirth, Yorkshire by *Albany Wiseman*

The solid ink areas add emphasis and visual interest to the image, directing the eye around the drawing.

The chickens were drawn with lighter pressure on the pen and a few sensitive lines.

Strong directional lines depict the long grass. As the ink runs out the pen makes lighter marks that further add to the texture.

Cutting a quill pen

Quills are inexpensive and you can cut them to suit your subject and the way you work.

It's very satisfying to make your own drawing tool. With a little practice, a quill pen is quick to cut, and you can cut it according to the width of line you require for your own style of drawing. Turkey or goose quills are not expensive, while swan quills are the best and most costly. The cut tip of a quill pen is soft and flexible, so it loses its shape quickly. You need to trim it frequently to keep the line crisp and fine. If it breaks down completely, simply cut another one.

Tip

Curing the quill before cutting makes it harder and more durable. Remove all the barbs and rotate the quill for a minute over a hotplate to soften it. Then scrape the shaft with the back of a craft knife to remove the outer membrane. Let it cool then cut it to the right shape.

How to cut a quill pen

◀1 Pull off the barbs at the lower end of the shaft. Hold the quill so it curves towards you and insert a sharp craft knife into the stem at a 45° angle about 2.5cm (1in) from the tip. Cut a third of the way into the stem.

▲2 Level off the angle of the knife so you cut horizontally along the length of the shaft to the end. Work slowly for control – for safety, always make sure to cut away from you. Then, with the blade held vertical, cut off the tip of the quill.

◀4 Finally, lay the quill down on the work surface and cut a slit down the centre of the 'nib'. Be careful – the quill is quite delicate and can easily bend at this stage.

▲3 Now shape the tip by trimming away the sides to leave the end of the quill at the thickness you require.

Sketching with pastel sticks

Pastels – versatile and easy to work with – are wonderful for adding colour and texture to pencil and watercolour sketches.

Pastel painting is a technique in its own right, but you can use pastel sticks to bring a lively extra dimension to watercolour and pencil sketches, or to finished studies. A few sweeps of colour over dry washes add tone and texture; or you can use pastels to create highlights. Be careful not to overdo it, though, or you may deaden your drawing – a few light touches are all that's needed for some creative and interesting results.

Pastels are dry and powdery, so you need to use a paper that has enough tooth (texture) to accommodate the particles of pigment.

When you apply pastels lightly, the texture of the paper shows through. Heavy pressure forces more colour into the surface, so you make solid areas of colour. A fixative spray prevents smudging and stops the powder from falling off, but don't over-use it or it will change the tones.

In practice

Adding colour to a pencil sketch

Pastel sticks are ideal for adding colour quickly to pencil sketches made on the spot. You need only a few colours to bring the drawing to life.

Boat sketch by Albany Wiseman

This sketch was made on textured watercolour paper. This emphasizes the broken effect when the sides of pastel sticks are swept lightly across the sky. Three shades of blue imitate the effect of aerial perspective.

A few dashes of colour express sand and grass. They help to advance the foreground and suggest the textures of the ground plane.

The pastel strokes follow the curve of the hull and help to express the form. Pressing heavily creates solid area of colour. Dark shadows give a sense of strong light.

Pastel stick marks

Pastels make wonderful marks that vary from fine and detailed to broad and sweeping.

Soft pastels make an infinite variety of marks. You can use the blunt end of the stick for wide lines and stippled effects, or the edge for fine lines and details; scribble, cross-hatch, or make broad gestures with the side for large areas of colour and tone. You can mix and blend colours and grade tones by smudging with your finger or a torchon; and you can achieve the effect of a mixed colour by stippling, that is applying dots, in two or three colours close together.

Pastel marks and strokes

You can use pastels in many ways to create different types of mark, and to mix and blend colours. Investigate the possibilities on scraps of pastel paper.

▲ *HATCHING*
Create tonal areas by hatching with the sharpened edge of a pastel stick. Make parallel diagonal lines close together, or scribble without lifting the stick from the paper. Cross-hatching creates a more textured tonal effect.

◀ *SCUMBLING*
Rub a colour on to the paper with the side of the pastel stick. Work lightly so the texture of the paper shows through, then repeat with a second colour. This creates a fine stippled effect and the colours appear to blend – here dark blue and red create a rich purple.

Tip

Soft pastels are crumbly, so keep their wrappers on. If you take them off to use the side of the stick, replace them after use. Store loose sticks on corrugated card so they don't rub against each other. If they become dirty, shake them gently in a bag of rice to remove the dust.

◀ *BLENDING*
First try blending a single colour, rubbing it with your finger for a soft tonal gradation. Then blend two colours – here red and yellow make orange.

◀ *STIPPLING*
Create areas of broken colour by stippling with the blunt end of pastel stick. Stipple with a single colour, varying the spacing of the marks – the denser the marks the darker the tone. Then try two colours. At a distance, the eye blends them to create a third colour.

Drawing with pastel pencils

Pastel pencils have the immediacy of soft pastel sticks, but you can also sharpen the tips and use them for precision drawing.

Pastel pencils are simply soft pastels encased in wood. They combine the painterly softness of pastels with the linear possibilities of coloured pencils. You can use them for emphatic lines and bold areas of colour. And, since they are slightly harder than soft pastels, they hold a point for fine linework and details, delicate nuances of tone and broken colour effects. They have a scratchy, chalky feel in use, unlike the smoothness of coloured pencils. They are clean to work with and have the intensity of pigment and wide range of colours and tones associated with soft pastels, so the two work well together. You can use them in mixed-media techniques with watercolour or gouache but not with coloured pencils, since these create a waxy surface that resists the chalky pastel pigment. Pastel pencils are best used on paper with a slight tooth, and finished drawings need to be fixed.

Key points

- Pastel pencils are slightly harder than soft pastels, but with the same intense pigmentation.

- Sharpen pastel pencils to a point for detailed linework and delicate shading effects.

- Use a blunter tip for broad areas of colour and bold emphatic marks.

- Combine pastel pencils with watercolour and gouache in mixed-media techniques.

- Use a paper with a slight tooth that holds the particles of pigment.

- Blend colours on the paper with a finger or torchon, or use optical mixes.

Taking a closer look

In this fresh and lively sketch, the artist has exploited the versatility of pastel pencils to include accurate architectural detail as well as broadly described textures.

**Château Chamboureaux
by *John Raynes***

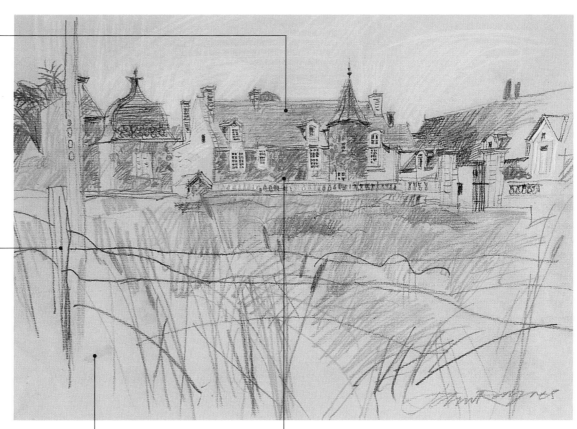

The artist rendered the buildings in considerable detail with a dark pastel pencil that he sharpened to a fine point. He used a thin veil of light blue to soften the lines of the roof tiles.

The bold lines of the fence and grasses in the foreground arrest the eye and return it to the main focus of the grand château.

The warm tone of the paper lends a sense of sunlight to the scene.

The artist used small descriptive marks to suggest foliage on the buildings. He used longer marks, and overlaid several greens, to convey the softer meadow grass texture.

Pastel pencil marks

From fine lines to shading, pastel pencils can be used in expressive ways.

You can sharpen pastel pencils for fine lines and details and delicate colour gradations. A blunter tip creates bold lines and broad areas of colour. You can mix colours on the page with a finger or a torchon, overlay a second thin veil of colour, or hatch and cross-hatch to build up tones. You can also create optical mixes with broken-colour techniques (see pages 57–58), and soften marks with clean water. But don't overlay too many layers or the colours will become muddy and the paper clogged. Emphatic marks are hard to erase, so outline the main forms very lightly to start with.

Try this!

You can create very sensitive shading effects and tonal variations with pastel pencils. Here are just a few techniques to try.

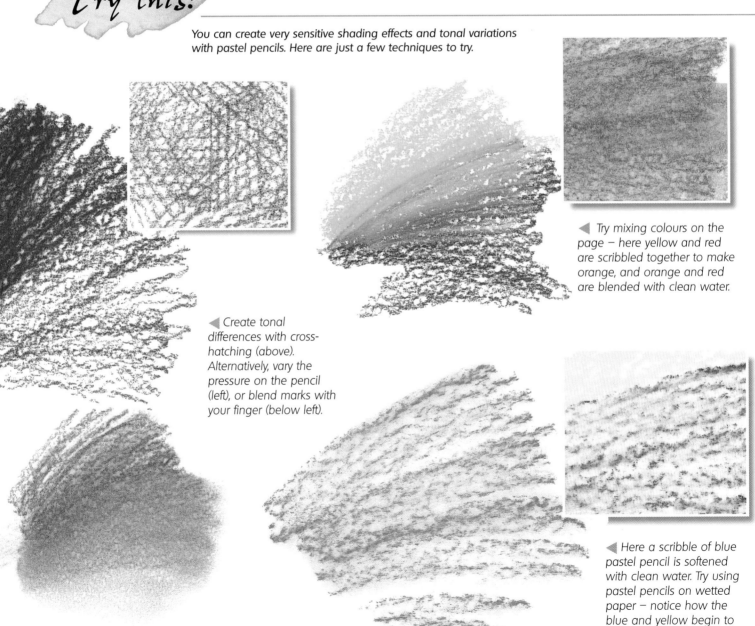

◀ Try mixing colours on the page – here yellow and red are scribbled together to make orange, and orange and red are blended with clean water.

◀ Create tonal differences with cross-hatching (above). Alternatively, vary the pressure on the pencil (left), or blend marks with your finger (below left).

◀ Here a scribble of blue pastel pencil is softened with clean water. Try using pastel pencils on wetted paper – notice how the blue and yellow begin to merge into a dark green.

CHAPTER 6
DRAWING TECHNIQUES

One essential skill needed by every watercolourist is the ability to draw. Not only are good drawing abilities the basis for convincing paintings, but they enable you to make records of ideas and things seen that can later be used in your work. This chapter deals with two vital elements: mark-making and methods of drawing accurately. The first skill, also known as rendering, is simply a matter of getting to know your drawing tools and practising until you can produce precisely the weight of line or the depth of tone that you require.

Learning how to draw accurately is more demanding since this involves translating what you see in a three-dimensional world into lines and tones on a two-dimensional surface. In order to do this successfully, you must first be able to see with an artist's eye. If you work through the exercises in this chapter, you will learn how to look at and analyze a subject so that you draw what you see rather than what you know to be there. Exercises such as measured drawing, drawing the negative, and using simple shapes are designed to help you learn to observe in this analytical way − practise them and you'll find your drawing skills improve immediately.

Hatching & stippling

Practise these quick, easy and flexible methods of adding tone and texture – they will lend character to your pencil drawings and allow you to make fast, accurate sketches.

A drawing made in line only allows you to record simple shapes and relationships and is ideal for watercolour underdrawings. But if you want to include information about the direction and intensity of light, and the location of shadows within a subject, you need to use shading.

Linear forms of shading, such as hatching and stippling, are ideal for landscape textures – foliage, grasses, rough ground or rocks and boulders.

Hatching is made up of pencil lines laid side by side – close together for dark tones, widely spaced for light tones. In cross-hatching, lines are laid at right angles to one another.

Stippling consists of dots – you create different tones by varying dot size and density. Regular dots and lines have a mechanical feel – the looser versions of hatching and stippling shown here are more versatile and easy to use. They are also suitable for freehand drawings.

Taking a closer look

The different hatching and stippling marks used here make a lively, varied drawing with lots of character. The artist used two pencils – 4B and B.

Well-head in Murs, Provence by *Albany Wiseman*

Some freely applied stippling is useful for portraying leaves – the artist has sharpened the 4B pencil to a chisel point to create the broad marks for the foliage.

Regular lines applied with a 4B pencil capture the dark tone of the conifers as well as their branching form.

Loose, random cross-hatching applied with a B pencil creates a mid-tone for the shadow in the foreground. This technique is ideal for covering large areas.

Loose cross-hatching with a B pencil has been used for the mid-tones on the roof of the building. Notice the way the curving lines follow the form of the dome.

Close, regular hatching with a 4B pencil gives crisp, emphatic shadows.

Using linear shading

Experiment with different methods of shading to discover the system that suits both you and the subject.

Practise building areas of loosely hatched and cross-hatched tone, allowing the pencil to make marks arbitrarily. You can use stippling to give a shaded effect by tapping the pencil in a rhythmic way on the paper. Hard pencils produce mid- to light greys, while soft pencils give a darker range – lines which are almost black to those which are mid-grey. For darker tones apply more pressure and increase the density of the dots.

Tip

Aim to shade a drawing as a whole, rather than working on a single area at a time. This enables you to check one area against another area to ensure that your tones are correctly distributed.

Try this!

This exercise uses four different pencils and shading systems to depict fruit and vegetables. It will expand your repertoire of marks and improve your handling skills.

▶ RANDOMLY HATCHED APPLE
Hold the pencil firmly, but not rigidly, close to the drawing point. Change the direction constantly, pivoting from the wrist. Apply more pressure for the dark tones where the apple curves under to meet the surface it sits on. The fruit is back-lit, so leave a 'halo' of light around the edge. This technique has a luminous quality.

Random hatching with an HB pencil.

▶ TIGHTLY SCRIBBLED ONION
You need a broad gesture, so grip the pencil halfway up the shaft and hold your hand off the surface. Feather the pencil over the light areas and apply denser marks in the darker areas. Use the tip of a sharp B pencil to draw the delicate contour lines. This combination of shading and line captures the volume and curving surface of the onion.

Tight scribble with a B pencil.

Dots with an H and a 2B pencil.

▶ ONION STIPPLED WITH DOTS
Hold the pencil firmly, resting your wrist on the drawing surface, and tap the paper with the pencil in a rhythmic way. Use widely spaced dots in the light areas and increase the density in the dark areas. Stippling permits fine gradations of tone. Add vertical contour lines to increase the three-dimensional effect.

▶ APPLE WITH CURVED HATCHING
This is similar to the hatching used for the other apple, but more controlled. Rest your hand on the paper as you work. Your lines should follow the curves of the apple – like the contours on a map.

Curved hatching with an HB pencil.

Measured drawing

Measuring is a simple and very effective way of producing accurate drawings, and a new pencil is the only piece of equipment you need.

Drawings can look wrong because incorrect assumptions are made about the size or the relative proportions of elements – we draw what we know rather than what we see. Take a few key measurements at the outset and check throughout to get these factors right.

MAKING A MEASURED DRAWING

You need precise measurements to make a convincing drawing of a building, but even in a landscape drawing such measurements are still useful.

Take a new pencil – an old pencil may be too short. Hold it out at arm's length, close one eye and line it up with the element to be measured. Also use the pencil to check the relative heights of objects, such as a figure in the foreground or a tree in the distance – you may be surprised by what you discover. Your pencil is also good for checking the slope of a hill or the angle of a roof.

You can use the information in two ways. Draw 'sight size' by transferring the measurements directly on to your paper, so you draw everything in the size that you see it. Or take a single key measurement and draw everything else in proportion to it. If you do this, you can draw to any size you prefer. Either way you will have an accurate and convincing drawing. Keep check of all the measurements as you work.

▲ CHOOSING A SUBJECT
This view of some mews cottages makes a good first exercise in measured drawing. The obvious verticals and horizontals are balanced by the strong perspective of the buildings on either side, and the whole subject is softened by the foliage.

Making a measured drawing

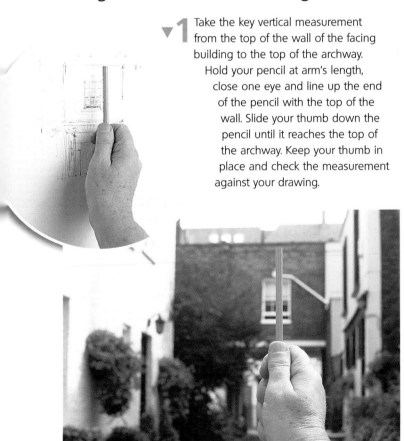

▼**1** Take the key vertical measurement from the top of the wall of the facing building to the top of the archway. Hold your pencil at arm's length, close one eye and line up the end of the pencil with the top of the wall. Slide your thumb down the pencil until it reaches the top of the archway. Keep your thumb in place and check the measurement against your drawing.

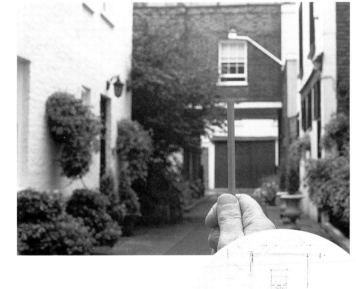

▲**2** Take a second vertical measurement from the top of the archway to the ground. To the eye, the distance seems to be the same as the first measurement. Careful checking proves this is correct. Measure the facing window and its position on the wall – observe the empty wall spaces to help place it correctly. Transfer these measurements to your drawing.

▶ **3** Turn your pencil through 90° and measure the facing wall horizontally from the right corner to the recess on the left of the window. Check this against your drawing. Notice that the measurement matches that of the two verticals – the central feature is composed of two equal squares.

▼ **4** Now lay the pencil along the sloping line of the paving. Keep the pencil at the same angle and transfer this sloping line to your drawing. Measure the angles of the top and bottom of the building and the windows and add these to your drawing. Transfer the angles of the cottages on the right side of the mews in the same way.

▲ **5** Check the accuracy of your sketch by measuring and comparing the key features again. Observe the empty spaces, such as the distances between the windows, and look at the relative heights of the window and archway facing you. Check the angles of the buildings at each side of the mews. Finally indicate the foliage and sketch the plant pots.

Looking at contour lines

Drawing in outline forces you to draw objectively by focusing attention on the outside edges and ignoring internal forms and edges.

A contour line is a long continuous line used to explore different aspects of form. There are many kinds of contour line, including the outline or silhouette which traces the outside edges of forms, ignoring their solidity and internal details. This type of drawing hones both your powers of observation and pencil skills. It makes you look at familiar objects in an unfamiliar way, engaging your total attention so your drawing becomes more searching – and more instructive. It's also an aid to composition. The silhouette drawing makes objects look more abstract, thus increasing your awareness of shapes. Use it to investigate a subject so you can select, emphasize and balance elements to create a pleasing arrangement.

Key points

● There are two important kinds of contour or continuous line drawing. Firstly, the outline or silhouette traces the outside edge of an object or a group of objects, ignoring internal detail. Secondly, cross-sections can be used to trace the undulations of a form. Just like the contours on a map, they can be seen as sections taken through the form.

Try this!

Try these exercises using a single continuous line. Don't worry if your drawings don't look very good – it is the experience that matters.

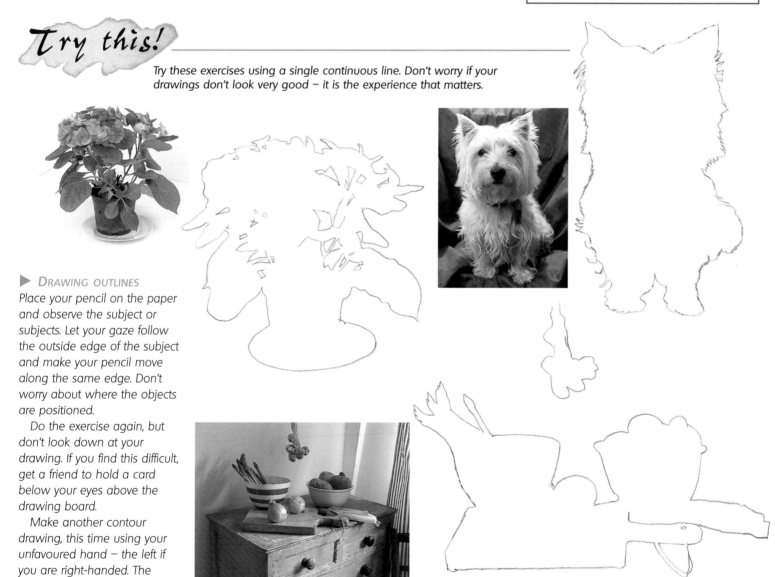

▶ **DRAWING OUTLINES**
Place your pencil on the paper and observe the subject or subjects. Let your gaze follow the outside edge of the subject and make your pencil move along the same edge. Don't worry about where the objects are positioned.

Do the exercise again, but don't look down at your drawing. If you find this difficult, get a friend to hold a card below your eyes above the drawing board.

Make another contour drawing, this time using your unfavoured hand – the left if you are right-handed. The movements of this hand are less rooted in habit and can be more expressive.

Using cross-sections

In order to make a complex object, such as a figure, work spatially in your drawing, you need to understand the volumes and surface undulations. Cross-sections are a useful aid to this process.

In order to draw a solid object convincingly, you need to get a feel for and describe its volume, and capture a sense of the surface continuing around to the other, unseen side. Visualizing the form as a series of segments or cylinders helps you understand how a three-dimensional object occupies space, and how the shapes appear to change as you alter your viewpoint. Cross-sections are a good aid to figure drawing – on the clothed figure these contours are evident at the cuff of the sleeve, the creases at the elbow and knee and the belt around the waist, for example.

Key points

● Natural contours are revealed in the creases of the clothed figure – at the wrist and elbow, for example.

● Lightly sketch the contour and cross-sections as you work. They can be erased when the drawing is finished.

● Drawing cross-sections allows you to understand the volumes of the form.

● Cross-sections are especially useful when drawing complex forms.

In practice

Visualizing figures

Look at the cross-sections in the studies below and notice the relationships between them.

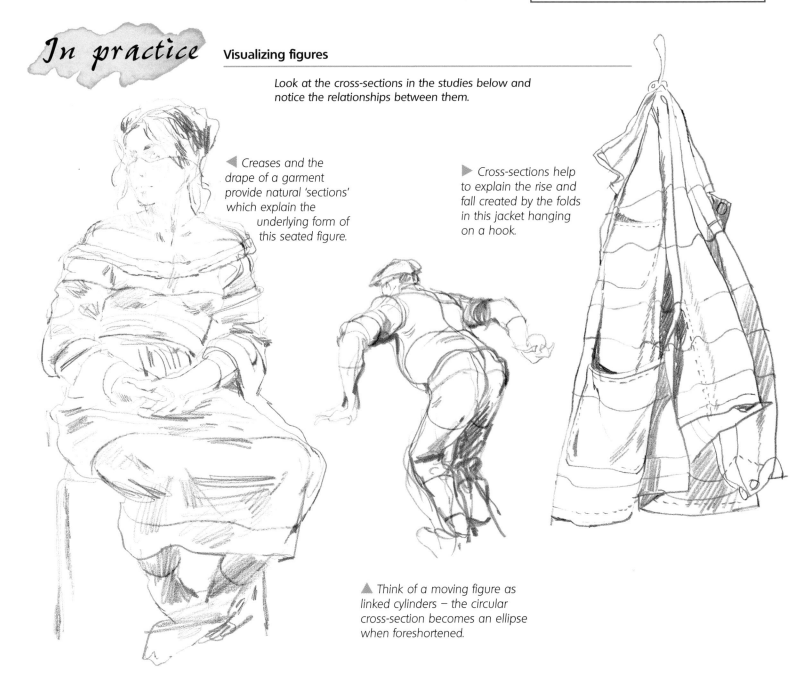

◀ Creases and the drape of a garment provide natural 'sections' which explain the underlying form of this seated figure.

▶ Cross-sections help to explain the rise and fall created by the folds in this jacket hanging on a hook.

▲ Think of a moving figure as linked cylinders – the circular cross-section becomes an ellipse when foreshortened.

Drawing accurately

Observation is the key to all objective drawing – systems, such as drawing from point to point, help you analyze a subject and draw it accurately.

One of the most effective ways of making an accurate drawing is to plot the vertical and horizontal alignments – a system which is sometimes called 'drawing point to point'. Let your eye travel over the subject, from 'point to point', looking for ways that different elements relate vertically and horizontally. Imagine you are looking through a sheet of glass with a square grid on it. If you were

drawing a house, for example, you'd see that the corners of the building and the sides of the windows are vertical and the ridge of the roof and the windowsills are horizontal. Using the point to point system you might also notice that a vertical through the chimneypot coincides with the plant pot on the lawn and that a horizontal through the plant pot also travels through a garden gnome.

Tip

Check for accuracy by looking at an image in a mirror – because the reversed image is unfamiliar, you will see any inconsistencies and inaccuracies immediately. Try observing the drawing in reverse by holding it up to the light so that you can see it through the paper or turn it upside down – mistakes will become apparent in both views.

Try this!

Use a pencil to find the horizontal and vertical relationships. Stand in front of the subject with your arm fully extended and lay the pencil alongside key alignments. Plot these on your drawing as lightly drawn lines and tick marks.

▲ *Choose a subject with some straight lines and regular curves – such as this toybox. This makes the job of recording edges, pinpointing intersections and estimating angles much easier.*

A vertical line dropped from the right corner of the blackboard passes down the right side of the front teddy bear.

Use a pencil to find a horizontal line which passes through the top of the drum, the bottom of the bucket and the corner of the chest.

A vertical line dropped from the top left corner of the board falls through the left side of the drum. The leg of the blackboard cuts the drum just right of centre.

Look for coincidences – the height of the front of the chest is roughly equal to that of the drum. Check negative shapes – the triangular space made by the drum, chest and shadow of the leg of the board.

Drawing negatives

Look for the negative spaces, or gaps, within and between objects. If you get these correct your drawing will be accurate.

 In practice

Drawing a camellia twig

▶1 Using a light pencil line, draw the negative shape between the bottom leaves and the stem.

▲2 Draw the small negative spaces farther up the stem. Sketch in the leaves.

▶3 Continue working up to the top of the twig, using a light line to draw the shapes of the leaves and the negative spaces. Constantly check the drawing against the subject.

 Tip

Counting is an important aspect of accurate drawing – count both the leaves and the spaces between the leaves. Also make sure that the 'negative' spaces between objects are the correct shape and in proportion (see page 201).

Negative space

Negative space

▶4 Once you have mapped out the entire drawing, check it against the subject. Then complete the outline using more emphatic lines. Concentrating on the negatives allows you to produce an accurate drawing of a relatively complex subject.

Using simple shapes

Reducing an object to its basic geometric shape helps you to understand what you see and gives you a solid, three-dimensional framework on which to hang the details of your drawing.

We seldom look very closely at objects. This means that when we need to analyze them in order to draw them convincingly, it can be hard to know where to start. The most effective solution is to reduce forms to simple geometric shapes. If you take a close look, you'll find that everything you see, both natural and manmade, can be reduced to a cylinder, sphere, cone or cube – or a combination of these. These shapes are all easy to visualize three-dimensionally and in perspective. A quick drawing of an object based on these shapes helps you understand its volume and solidity, and gives you a simple structure on which to base the details.

Key points

● It is easier to find underlying simple shapes by looking at familiar items.

● A cube, sphere, cylinder or cone can be seen in most objects.

● Even complex forms can be reduced to a combination of basic shapes.

● Practise drawing simple geometric shapes three-dimensionally and in perspective.

● Use the underlying shape as a framework on which to hang the details.

● Use basic shapes to understand groups as well as single objects.

Try this!

Fruit and vegetables can seem complex. Their underlying forms are often obscured by an irregular outer shape or a covering of leaves. But look carefully and you'll find the geometric shapes that help you draw what's really there.

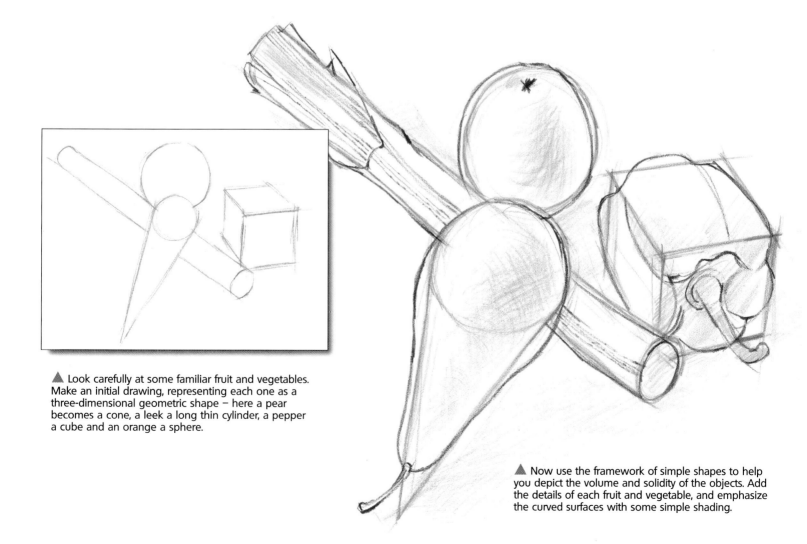

▲ Look carefully at some familiar fruit and vegetables. Make an initial drawing, representing each one as a three-dimensional geometric shape – here a pear becomes a cone, a leek a long thin cylinder, a pepper a cube and an orange a sphere.

▲ Now use the framework of simple shapes to help you depict the volume and solidity of the objects. Add the details of each fruit and vegetable, and emphasize the curved surfaces with some simple shading.

Drawing with simple shapes

*Looking for the simple, underlying geometric shapes will give
you the confidence to tackle all kinds of subjects.*

Even a complex still life responds to the simple-shape approach. The solidity of the objects and their relationship to each other is easier to understand and draw convincingly if you first simplify the group to a series of basic geometric shapes. When you have more experience, all you need to do is visualize the shapes in your mind as you work. But, to start, represent the group as a series of abstract shapes. This helps you depict the negative spaces between the objects as well as the objects themselves.

In practice **Kitchen utensils**

*Each of the kitchen items in the group below can be translated
easily into a simple geometric form. Try this exercise in pencil or
pencil with a tonal wash.*

◄**1** Don't be afraid to overlap the objects – it's easy to depict them if you start with the underlying forms. The teapot is basically a sphere, and the rolling pin a cylinder. The tall coffee pot fits neatly into a cone, while the canister is a cube. You need to get the angles right, so keep checking the relative positions of the objects.

►**2** Now add the main elements. Draw a shallow cylinder on top of the canister cube for the lid. Place the teapot lid on top of the sphere. Draw the spouts and 'feel' the curves of the coffee and teapot handles. Add the rolling-pin handles – draw a central axis through the cylinder to position them correctly. Finally, draw the coffee pot lid.

◄**3** When you are satisfied that your drawing is accurate, strengthen some of the lines. Emphasize the shadow cast by the coffee pot. Add some loosely hatched mid-tones to suggest the curves and indicate the source of light.

◄**4** Finally, add more shading, darkening some areas to give the objects a convincing solidity. Add tone to the table-top so the utensils sit firmly on the surface.

Analyzing flower forms

Flowers are a fascinating and infinitely varied subject to draw, but they can seem dauntingly complex. If you start by examining their basic shapes, this will make the task easier.

Flowers make enchanting subjects, but it's easy to be seduced by their colours and patterns and ignore the basic structures and forms. If you generalize too much you lose their character. But if you get too caught up with the details, the image can look laboured. All forms are easier to understand if they are simplified, and flowers are no exception. Even complex blooms can be reduced to simple geometric shapes – for example, a lily is basically cone-shaped, while daisies and chrysanthemums are circular. This makes it easier to understand their three-dimensional forms and visualize them in perspective – and means you can draw them more convincingly.

Try this!

Choose some familiar flowers and look at them closely to identify their simple shapes. Draw these shapes, then build the details of the flower within this framework.

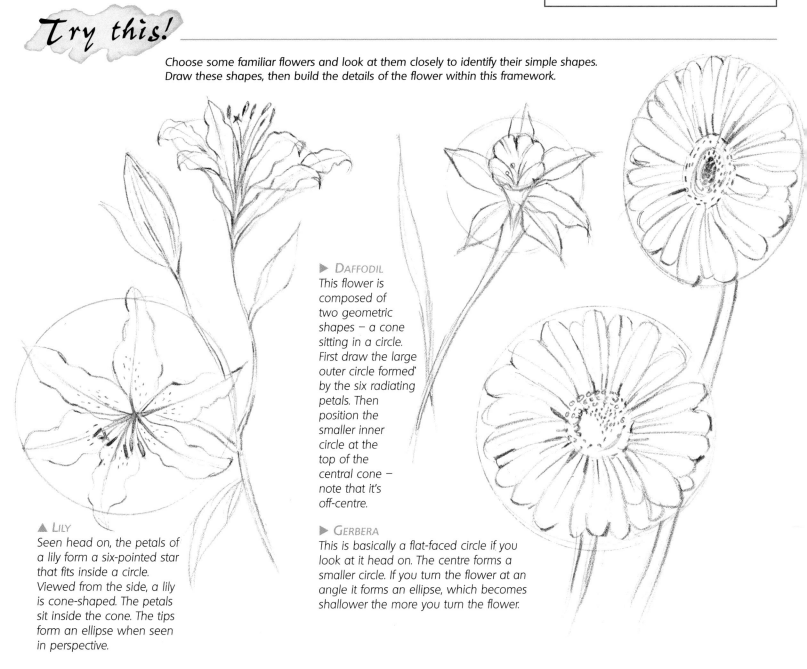

▶ DAFFODIL
This flower is composed of two geometric shapes – a cone sitting in a circle. First draw the large outer circle formed by the six radiating petals. Then position the smaller inner circle at the top of the central cone – note that it's off-centre.

▲ LILY
Seen head on, the petals of a lily form a six-pointed star that fits inside a circle. Viewed from the side, a lily is cone-shaped. The petals sit inside the cone. The tips form an ellipse when seen in perspective.

▶ GERBERA
This is basically a flat-faced circle if you look at it head on. The centre forms a smaller circle. If you turn the flower at an angle it forms an ellipse, which becomes shallower the more you turn the flower.

Making a detailed flower study

Make use of the simple shape technique to help you get started on some complicated flower exercises.

Many flowers can seem so complex that it's difficult to understand how they are constructed. But if you look carefully and analyze the basic geometric shapes involved, it all becomes clear. Notice the growth pattern, and study closely how the stem meets the flower. Many plants have several blooms springing from a single stem. Each bloom is the same basic shape, but seen from different perspectives. Most flowers are inherently graceful, and your drawing needs to reflect this quality. Even a vase of mixed flowers is approachable if you look carefully and analyze what you see.

Tip

When you start a drawing bear in mind that flowers do move, although this happens slowly. A flower head follows the sun as it moves across the sky, and some eventually close up if the sun goes behind a cloud. Select your subject cautiously and aim to complete your study in one session, before the flower changes its position.

In practice Iris

An iris is an elegant plant with a seemingly complex flower head. Follow the simple shape rule and you won't get lost in its voluptuous petals.

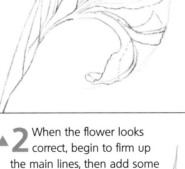

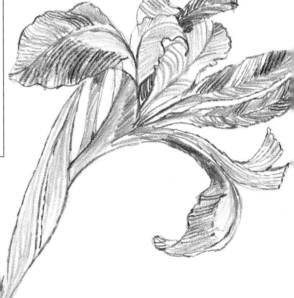

◄ **1** An iris forms an umbrella shape at the top of a curved stem. Sketch the stem first, then add the basic flower head with the radiating curves of the petals. Sketch in the shapes of the petals and stem.

▲ **2** When the flower looks correct, begin to firm up the main lines, then add some detail to the petal edges. As you draw, check the negative shapes between the petals.

▲ **3** Now you can begin to depict the character and texture of the petals. Add shading lines to give form and suggest tone.

▲ **4** Finally, bring the drawing to life by adding some colour. Use coloured pencils and work in the direction of growth to enhance the sense of movement in your drawing.

Drawing ellipses

Ellipses are smooth, regular curves that can be difficult to draw freehand – but plenty of practice will help.

Y ou can see ellipses on numerous objects – in fact, anything that is cylindrical. Look directly at the top of a can of beans, for example, and you see a circle. But lower your viewpoint, and you see a flattened circle. This is an ellipse, or a circle in perspective.

Ellipses present two problems. Firstly, like circles, they are smooth, regular curves which are difficult to draw well. Secondly, they change shape according to your viewpoint or eye level – the lower your viewpoint, the shallower (flatter) the ellipse.

Draw some ellipses freehand, aiming for a smooth curve (right). If you find this tricky, try the square-guide method (below) – it involves drawing a square in perspective, then drawing an ellipse inside it. Alternatively, draw the two true lines of symmetry (centrelines) first, then add the curve around them (overleaf).

◀ Draw a series of ellipses freehand. Keep your wrist and pencil fixed. Let your elbow provide the sideways movement and move your arm back and forth at the shoulder. This way the arm acts as a helpful restraint. Vary the movement to draw shallower or deeper ellipses.

Try this!

The square-guide method of drawing ellipses uses a square in perspective – you can erase the square afterwards.

A

▲ CONSTRUCTING A CIRCLE
Start by drawing a circle inside a square. Draw the square first, and add the diagonals. Then draw the circle inside it freehand so the curve just touches the square at the sides. Note that the square's diagonals meet at the centre of the circle This happens even when the circle is tilted (see B).

▶ CONSTRUCTING AN ELLIPSE
Draw a square in perspective and add the diagonals. Sketch the curve at the four points where it touches the square (A, B, C, D). Sketch the curve where it passes through the diagonals (E, F, G, H). Join the sections of curve to make an ellipse.

▶ CIRCLE IN PERSPECTIVE
Tilt the square away from you so you are looking at it in perspective. The circle inside is now in perspective and appears as an ellipse. Note that the near side of the ellipse is larger than the far side – the centreline (the broken red line) is closer to you than the circle's centreline.

▶ CYLINDER IN PERSPECTIVE
Practise drawing a cylinder in perspective. Begin by drawing a box in perspective. Draw the ellipses at each end and put in the sides of the cylinder. Remember that you see the top and bottom cylinders at different eye levels, so they won't sit properly if they are too deep or too shallow.

B

Ellipses in perspective

Ellipses appear in a host of everyday circular objects. Drawing them in perspective is a useful aid in composition.

The most important aspect of drawing ellipses is putting them in perspective, relative to your own viewpoint. Make a collection of objects featuring ellipses, such as cups and saucers, vases and bottles, or try a rooftop scene of chimney pots or felled trees at the edge of a forest.

Make a simple structural drawing, using charcoal or pencil so that it is easy to make adjustments. Look at the objects and draw the elliptical shapes – see how the ellipses become shallower as they recede. Try to use the repeating ellipses to lead the eye into the picture. Remember that you are not drawing to a mathematical formula, so give due consideration to light, tone, reflected light, shadow, negative shapes, texture and colour.

Tip

A frequent mistake is to make an ellipse pointed like a rugby ball. Remember that it is a continuous curve without ends. Another common error is to squash the ellipse to make it fit into the square. The result is a figure with curved ends and flat sides. Your ellipse should just touch the inside of the square.

In practice Decorating tools

This scene of paint tins, brush and roller, bottle jar, dust sheet and ladder has plenty of elliptical shapes and cylindrical forms.

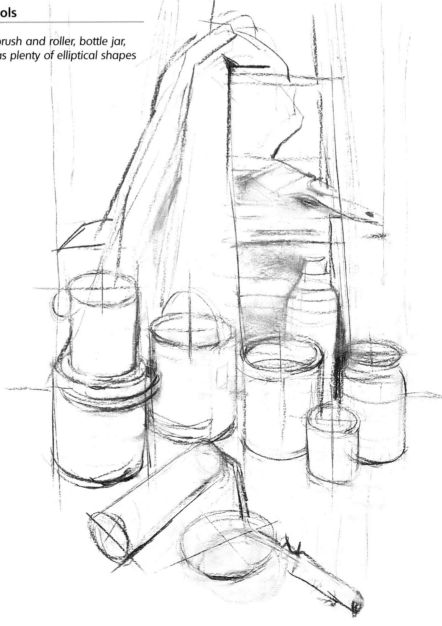

▶ *Make a careful analytical drawing using charcoal. Make sure your ellipses conform to the rules of perspective as they're seen from your own viewpoint. To draw the ellipses, use either the square construction method shown on the previous page, or the method used here. The artist sketched the centrelines for each ellipse and then drew the curve around these.*

Overdrawing for watercolour

The fluidity and unpredictability of watercolour can be brought under control by applying line over dry washes.

The term 'line and wash' usually describes watercolour washes over ink lines, but line can also be applied on top of a wash. A few crisp holding lines can salvage a ruined watercolour. If your wet-in-wet washes have melted into a fuzzy blur, a few pencil or pen lines can define an edge or clarify a detail. Pencil and coloured pencil are often used with watercolour when fine details or textures are required – as in wildlife, botanical and architectural studies. Some artists find dry media give more control than fluid paint.

Taking a closer look

The artist applied specific architectural details when the initial washes were dry. He used a fine brush and a 2B graphite stick, which gave him a variety of lines and great control.

Museum in the Parc Richelieu
by *Ian Sidaway*

Closely laid lines were used for the tiles on the cupola.

The shadow which defines the edge of this window reveal was applied with graphite stick.

Crisp graphite lines, applied last, pull the image into sharp focus.

The roof tiles were blocked in with a wash of Payne's gray. When this was dry the artist drew parallel lines with a graphite stick for the shadows under the edges of the tiles. He worked freehand to avoid a mechanical feel.

Graphite stick was used to depict the shadows between the coursed stonework on the façade.

A freehand graphite line was used for the joint between one area of concrete and the next.

Exploring linear media

Apply line over dry watercolour washes to create an outline, or add detail or texture. You can use almost any linear medium.

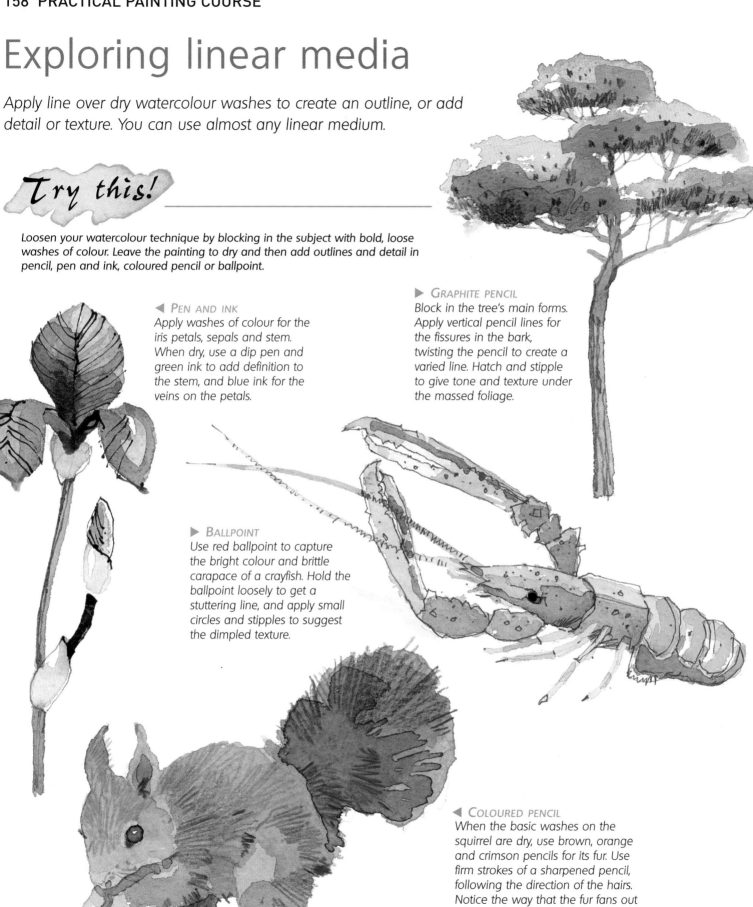

Try this!

Loosen your watercolour technique by blocking in the subject with bold, loose washes of colour. Leave the painting to dry and then add outlines and detail in pencil, pen and ink, coloured pencil or ballpoint.

◀ PEN AND INK
Apply washes of colour for the iris petals, sepals and stem. When dry, use a dip pen and green ink to add definition to the stem, and blue ink for the veins on the petals.

▶ GRAPHITE PENCIL
Block in the tree's main forms. Apply vertical pencil lines for the fissures in the bark, twisting the pencil to create a varied line. Hatch and stipple to give tone and texture under the massed foliage.

▶ BALLPOINT
Use red ballpoint to capture the bright colour and brittle carapace of a crayfish. Hold the ballpoint loosely to get a stuttering line, and apply small circles and stipples to suggest the dimpled texture.

◀ COLOURED PENCIL
When the basic washes on the squirrel are dry, use brown, orange and crimson pencils for its fur. Use firm strokes of a sharpened pencil, following the direction of the hairs. Notice the way that the fur fans out around the haunches and over the bushy tail.

Drawing with a brush

You can use a brush instead of a pencil to produce sensitive and expressive drawings with varied and fluent lines.

A good-quality round brush is a wonderfully sensitive drawing implement. It responds to the slightest change of pressure or angle – a single brush line can change from thick to thin and back again, giving a line which has a graceful and flowing calligraphic quality. You can also make shorter, more abrupt brushstrokes, creating descriptive marks that tell all in a single gesture. And you can use the tip of the brush for fine lines and delicately detailed drawing. You can also use a brush to make an initial underdrawing when you start a water-colour – the fluent line a brush gives is highly compatible with the fluidity of washes. If you want the brush lines to vanish under the painting, use the relevant colours for your basic drawing, or choose a recessive colour – try blue, for example.

Key points

● A brush gives a smooth, natural line that is compatible with watercolour.

● Alter the pressure and angle of the brush to create different, calligraphic lines.

● Use the tip of the brush for fine lines and delicate details.

● Make an underdrawing with a brush to begin a watercolour.

● A brush drawing with watercolour softens when washes are laid on top.

● Underdraw with waterproof ink if you want the brush lines to remain evident.

Taking a closer look

In this expressive painting, the artist has drawn a variety of eloquent marks with his brush that perfectly capture the different elements in the subject.

The hen run, Seillans by Glen Scouller

The background textures have a decorative quality – long marks contrast with the short, plump strokes used for the hens.

Minimal detail and a few descriptive brushstrokes convey the character of each bird. Every brushmark has a purpose.

Calligraphic thick-to-thin brushmarks depict the comb of the cockerel.

Sweeping brushmarks, both broad and fine, capture the cockerel's fine tail feathers.

Creating different lines

The way you hold a brush and the amount of pressure used will help determine the kinds of marks you make.

A round brush is a highly versatile drawing tool. The marks you can render depend on the size of the brush and the way you handle it. It's sensitive to the slightest change in pressure and direction, creating varied lines that become an important part of the finished image. You can make a fine line by holding the brush at right angles to the paper. If you lay the length of the bristles on the paper, you can make broad marks, while varying the pressure and angle creates classic, calligraphic thicks and thins.

Tip

One of the main advantages of drawing with a brush is that you can combine line and tone in a single brushstroke to suggest form.

In practice Two studies of a corn cob

A brush drawing forms the basis for both of these studies, but the finished effects are very different, as you can see clearly in the enlarged insets.

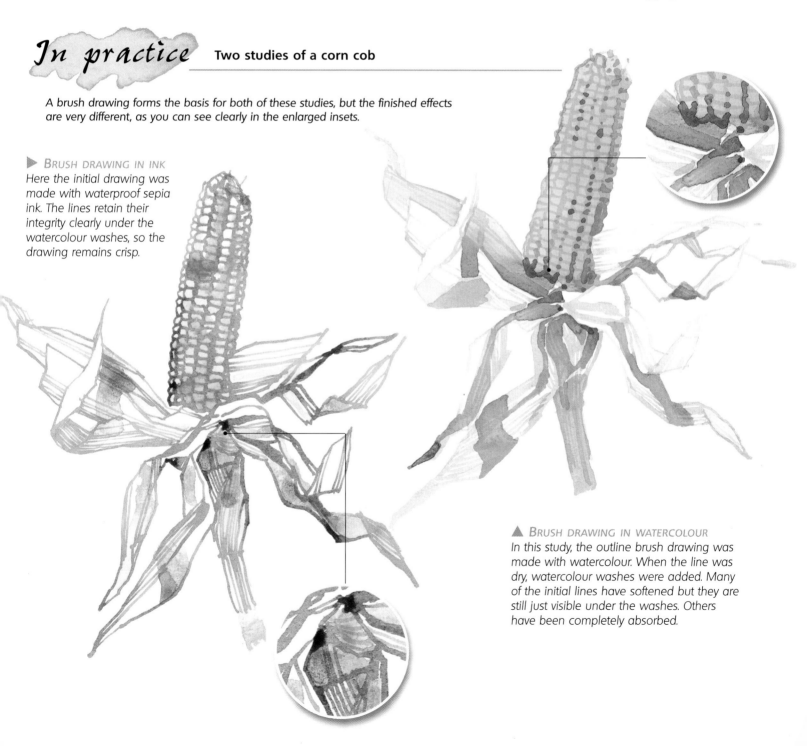

▶ BRUSH DRAWING IN INK
Here the initial drawing was made with waterproof sepia ink. The lines retain their integrity clearly under the watercolour washes, so the drawing remains crisp.

▲ BRUSH DRAWING IN WATERCOLOUR
In this study, the outline brush drawing was made with watercolour. When the line was dry, watercolour washes were added. Many of the initial lines have softened but they are still just visible under the washes. Others have been completely absorbed.

Transferring a drawing

You can use a grid system to transfer a working sketch on to watercolour paper, or to enlarge or reduce an image – and it's a good way to create an accurate drawing from a photograph.

Many artists use photographs or sketches as a basis for their paintings. The original image needs to be re-drawn or transferred on to the watercolour paper first. Use a grid system to do this .

You can make a re-usable grid on acetate or tracing paper. A 1cm (³⁄₈in) grid is an ideal size – make a smaller one for sketches or photographs with very small details. Then draw a grid with the same number of squares on the watercolour paper. For a larger image, make a grid with larger squares; for a smaller image, make a grid with smaller squares. Draw lightly so that you can erase the lines afterwards. With your finished grid you can start to transfer the image on to the paper square by square.

Tip

You can enlarge a sketch on a photocopier, and use transfer paper to transfer it to your watercolour paper. This type of paper has a graphite backing and works in the same way as carbon paper.

Taking a closer look

Using a grid system means that promising sketches from your sketchbook – including tonal sketches and those you have used to make colour notes – can be used as a basis for fully worked watercolour paintings.

San Gimignano, Tuscany by Ian Sidaway

The artist drew a larger grid with the same number of squares on to the watercolour paper.

The main shapes from the original sketch have been enlarged, using the squares of the grid.

Smaller details were added freehand.

The grid lines are still visible on the painting for the demonstration, but they would normally be erased once the sketch has been transferred.

The artist drew a grid directly on to his sketch – an alternative is an acetate grid which can be re-used.

Gridding up a photo

The easiest gridding method uses an acetate grid – you can use it again and again for transferring, enlarging and reducing images.

Try this!

Follow the steps to enlarge an image from a photograph or sketch. You will need a sheet of acetate, ruler, set square, fine liner, pencil, eraser and a sheet of watercolour paper.

1 Mark the top and one side edge of the acetate at 1cm (⅜in) intervals. At each mark along the top, rule a vertical line. Rule a horizontal line at each mark on the side edge to complete your 1cm (⅜in) grid.

2 Lay the acetate grid over the sketch or photo, aligning one corner of the grid with the corresponding corner of the image.

3 To double the size of the image, draw a rectangle twice the size of the image on the watercolour paper. Lightly draw a 2cm (¾in) grid on the rectangle; follow Step 1 but draw the lines 2cm (¾in) apart. To reduce the image, draw a smaller grid on the paper.

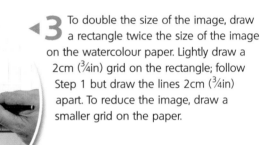

4 Choose a strong shape on the image, and find the corresponding square on the paper grid. Draw in the shape. Square by square, transfer the entire image to the paper. Work freely for a spontaneous effect.

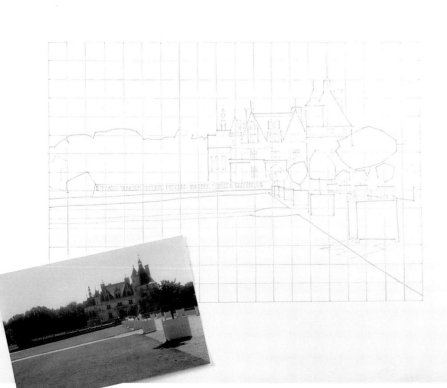

5 The finished image is double the size of the original – because the watercolour paper grid was twice the size of the acetate grid. Erase the grid lines on the watercolour paper before starting to apply your washes.

Rubbings for texture

Using rubbings to create texture in pictures is known as 'frottage' – the technique is the same as coin or brass rubbing.

Frottage, from the French word for 'rubbing', creates a visual image of texture. The technique is simple – place a sheet of paper over a rough surface and rub the paper with a soft pencil or crayon. The pencil or crayon picks up the raised areas of the surface, creating an image on the paper.

You can use frottage to reproduce textures – try wood rubbings to suggest tree trunks, for example It's ideal for textural equivalents – for example, paper doily rubbings could suggest lace. Frottage can also be used in watercolour and gouache paintings to add interesting textures.

Try this!

Try rubbing everyday objects, shading in various directions and on different faces of three-dimensional items. Use lightweight paper and a pencil, pastel or wax crayon.

▲ Here a wax rubbing was made of rough wood to create a resist, then watercolour was washed over the top.

▲ A pastel, rubbed over corrugated card, gives a soft, ribbed effect.

◀ A coloured-pencil rubbing of canvas board produces a regular pattern of tiny dots.

▲ A textured wallpaper rubbing made with Conté pencil creates an irregular pattern of spots and dots, reminiscent of pebbles on a path.

Frottage effects

Combining frottage with your usual drawing techniques can give your work an abstract quality or represent textures realistically.

Frottage can be used to create an range of textured effects, ideal for representational drawings. Some effects may trigger your imagination, and encourage you to try imaginary landscapes and abstract designs. You may find you can use frottage in some representational landscapes to explore themes, such as the patterns on fields.

Try to use frottage with discretion – too many areas filled in using this technique could make the finished picture look cluttered. Instead, confine yourself to one or two areas of frottage. If you are using frottage in a literal way, you need to make sure that the scale of the marks works with the scale of the subject.

Tip

It is useful to make a reference collection of frottage effects, keeping samples of the objects you've rubbed with the rubbings themselves. Make a note of the medium you've used as well.

Taking a closer look

In this expressive pencil drawing, frottage has been combined with linework, hatching and shading to convey the harshness of life on the edge of the Sahara.

Town and desert by Ian Sidaway

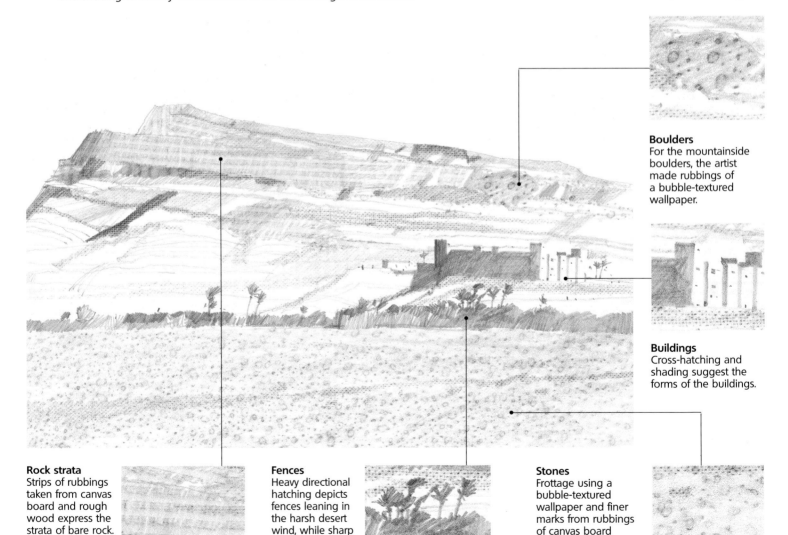

Boulders
For the mountainside boulders, the artist made rubbings of a bubble-textured wallpaper.

Buildings
Cross-hatching and shading suggest the forms of the buildings.

Rock strata
Strips of rubbings taken from canvas board and rough wood express the strata of bare rock.

Fences
Heavy directional hatching depicts fences leaning in the harsh desert wind, while sharp scribbles depict spiky, windswept palm trees.

Stones
Frottage using a bubble-textured wallpaper and finer marks from rubbings of canvas board suggest the stony desert floor.

CHAPTER 7

PLANNING PICTURES

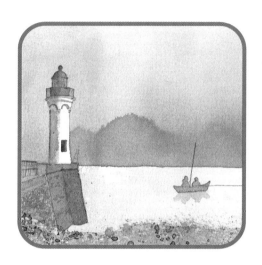

There is more to creating a picture than employing clever techniques. A successful painting holds the viewer's attention and lingers in the mind because the component elements combine together to create a satisfying whole. Good compositions are 'made' not chanced upon: the artist decides what to paint, what to put in and what to leave out.

This chapter offers a path through the complex decision-making process of putting together a picture – and offers plenty of practical advice, including how to use a viewfinder for tasks such as choosing a viewpoint, isolating a section of a view or deciding on a format. Also discussed are such topics as selecting focal points, how to crop images effectively and the value of compositional sketches. Tips on organizing the elements of the composition within the picture area, through using grids and the underlying geometry, show how even subtle adjustments can significantly vary the overall effect.

Formats & focal points

Choosing a format that suits the subject, deciding what the main focal point should be and fixing the position that suits it best are all vital steps in planning an effective composition.

Even before you get down to making preliminary sketches, you need to decide which shape, or format, suits the subject you want to paint. There are two traditional ones to choose from – portrait (upright) and landscape (horizontal). A viewfinder is an excellent tool for assessing formats.

USING A VIEWFINDER

A viewfinder is a piece of card with a rectangular hole in the middle that helps you frame and isolate an image. Turning it from landscape to portrait and looking through it, you can find the shape most suited to your subject and isolate what part of it you want to paint. Bringing the viewfinder towards you gives a wider view of your subject. Holding it farther away means that less will appear in the frame.

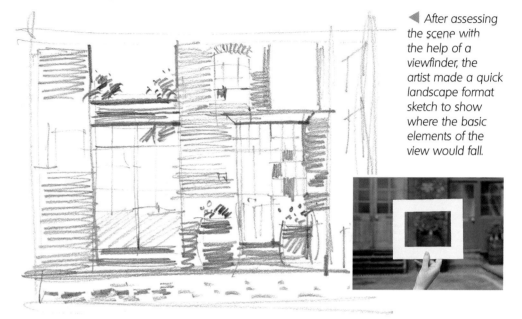

▲ *After assessing the scene with the help of a viewfinder, the artist made a quick landscape format sketch to show where the basic elements of the view would fall.*

▶ *Using the viewfinder again, the artist experimented with a portrait format. As a result, he decided he preferred the strong vertical element provided by the tall doorways, brick buttresses and flower tubs.*

Expert advice

● You can make a viewfinder by cutting a rectangular aperture in a piece of card.

● Allternatively, use your hands, thumbs and fingers to make a rectangular shape.

Finding the focus

All paintings need a strong focus, regardless of format. To achieve this, you need to plan and position an effective focal point right at the start.

Every picture needs at least one focal point – a point that draws the eye and provides a pivot for the whole image. Otherwise, the eye wanders from one spot to the next without knowing where to linger. You should be thinking about this right from the start. Try manipulating focal points, for example placing them in the centre first and then trying them off-centre.

MANIPULATING FOCUS

Beginners often position their main focal point in the middle of the paper. This can result in a composition that is static and boring. It's better to offset the focal point slightly – this gets round the visually distracting central 'cleavage' of the composition.

In general, asymmetric arrangements seem to work best. Place your main focal point off to one side to avoid positioning the horizon in the centre of the picture area. Make a quick series of compositional sketches exploring some different arrangements. Don't be afraid to shift your viewpoint or to move or remove any unwanted elements of the landscape. You can see how this works with these three sketches of urns.

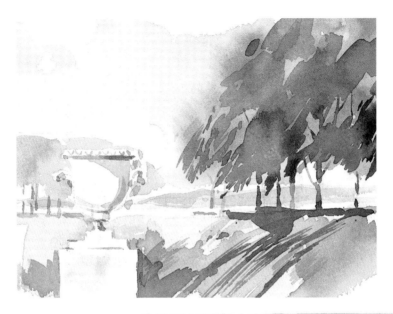

◀ *Placing the urn slightly off-centre to the left leads the eye into the composition. The light tone of the urn balances the dark mass of trees on the right.*

▶ *Placing two urns equidistant from the centre is risky. While the symmetry may work for some, others might find the result somewhat dull and lifeless.*

▶ *Placing the focal point too far over to the right means that the lighter left side of the composition risks being ignored. The answer is to try cropping out some of the left side of the painting to restore the balance.*

Tip

A general rule of composition is that odd numbers are visually more satisfying than even ones. One urn appears better than two, as the studies on this page demonstrate.

Dividing the picture area

You can simplify the composition process by subdividing the picture area into sections using the horizon or a grid based on thirds.

The relationships existing between the components of a picture and the edges of a rectangle, and between the elements in the picture, create the tensions that hold a picture together and keep the attention of the viewer. Over the years artists have used a variety of geometric devices to underpin their compositions, including the position of the horizon and grids based on the picture's division into thirds.

In a landscape painting the horizon provides a natural and important division of the picture area. This division is so dominant that if you draw a horizontal line across a sheet of paper most people will guess, if asked, that they are looking at a landscape. The location of the horizon line is crucial because it determines the balance of sky to land and sets the mood of the whole landscape.

The horizon line

Once you have decided on a format, make a series of thumbnail sketches exploring the effects you get when you place the horizon at different positions on the sheet of paper. The effects are remarkably varied in mood and impact.

◀ **HIGH HORIZON**
Only a sliver of sky is visible, limiting the opportunity to depict the effects of light and weather. This composition has an enclosed feeling. With a landscape format you can suggest recession with devices such as rivers that lead the eye into the picture.

▶ **HORIZON IN THE MIDDLE**
This is a risky solution because the half-and-half split of sky and land can be dull – an off-centre horizon is often better. A large cloud balances the land mass but this composition is less satisfying than the other solutions.

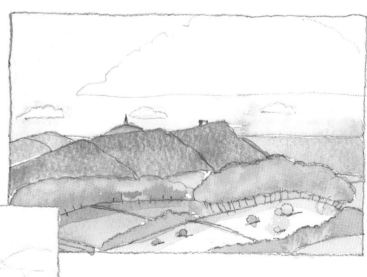

◀ **LOW HORIZON**
In this version the horizon is set low. Most of the picture area is devoted to sky, giving the image a light and airy feel. Low horizons allow plenty of scope for atmospheric sky effects or weather conditions, but there is little sense of recession.

Designing on a grid

One of the best ways of starting a composition is to divide the picture into an imaginary grid, into which the components can be organized.

In design, odd numbers are generally easier to work with than even. One of the most popular compositional devices is a grid based on thirds. This division has been found to be flexible and visually pleasing. Start by dividing your picture area into thirds vertically and horizontally. You can do this in your mind or use a pencil to draw the grid lightly on the paper. Then make an initial sketch, placing some of the key elements, such as the horizon and a tree or a building, along these lines. You may find it helpful to experiment with different arrangements in a series of thumbnail sketches. The grid is a guide only so don't stick to it rigidly. You can use all four grid lines or just some of them. The viewer should be unaware of the underlying structures.

Tip

Divide the aperture in a viewfinder into thirds and tape cotton thread across at these points to create a grid. Scan your subject through the viewfinder to see which elements fall on the grid.

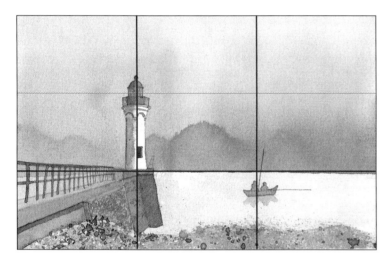

◀ The dominant horizontal of the sea and the vertical of the lighthouse fall on the grid – note that the little fishing boat is also located on a vertical grid line.

▶ The horizon and wall divide this picture into three equal bands. The important vertical of the tree on the left also falls on the grid.

◀ The far edge of the lake divides the image on a horizontal third. The nearest tree, which is also located on the grid, provides a balancing vertical thrust.

▶ Here the nearest telegraph post and the horizon fall on vertical and horizontal one-third divisions.

Being selective

Making compositional decisions is an integral part of becoming an effective artist. A pair of L-shaped brackets is a simple, useful and cheap device to help you in the selection process.

Any form of artistic composition involves you in making several important decisions right from the start. You need to determine what shape of support to use; what format your picture is going to be; what to include; and what to leave out. This selection process can be quite tricky, especially in a landscape where you are faced with a multitude of options. A viewfinder helps you 'find' a subject in a landscape. L-shaped brackets help you find a subject or subjects in a photograph or sketch.

L-shaped brackets – also called masks, croppers, corners or simply Ls – consist of two L-shaped pieces of card. Drop them over a photo or sketch and move them around to make an adjustable rectangle or square. This allows you to frame different areas and experiment with formats and compositions. You will need at least two pairs – a small one for working on photos and a larger one for sketches and paintings. If a painting doesn't seem to be working, drop the Ls over it to see if cropping more tightly or adjusting the format improves it.

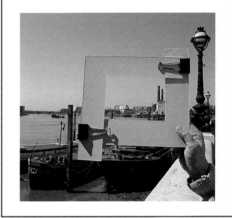
Making and using L-shaped brackets

It doesn't take long to make the Ls from card and not much longer to learn how to use them. A size of 25 x 25cm (10 x 10in) is a useful one to go for.

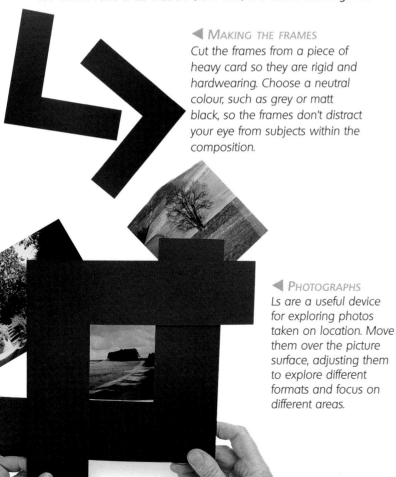

◀ **MAKING THE FRAMES**
Cut the frames from a piece of heavy card so they are rigid and hardwearing. Choose a neutral colour, such as grey or matt black, so the frames don't distract your eye from subjects within the composition.

◀ **PHOTOGRAPHS**
Ls are a useful device for exploring photos taken on location. Move them over the picture surface, adjusting them to explore different formats and focus on different areas.

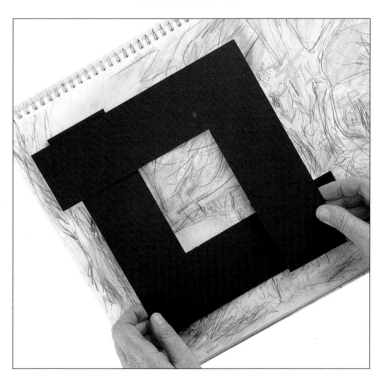

▲ **SKETCHBOOKS**
Use L-shaped brackets to edit your sketches before you work up a painting. In composition what you leave out is as important as what you leave in.

Using L-shaped brackets

These are the ideal tool for establishing the way an image fits within your support and for experimenting with picture formats. Try the exercise here and you'll see how useful they are.

A pair of L-shaped brackets has many uses. Use them in the field to check a sketch before you start a painting, or to make an adjustable viewfinder. In the studio they are a quick way of isolating different parts of a sketch or photo to see if they make a picture, and of trying different formats and crops. Dropping a large pair of Ls over a painting separates it from its surroundings so that you can judge colours and assess progress.

In practice — Four options from one landscape

A landscape is a vast subject and finding the pictures within it can be challenging. Photographs provide useful reference, and a panorama made up from two overlapping photos offers many pictorial possibilities. Try this exercise with your own photographs.

◀ A landscape format and a high horizon give a broad foreground. The eye is led past the wind-sculpted trees to the hills beyond.

◀ A tall format minimizes the sense of recession and draws attention to the pattern-making qualities of the group of trees and the fields.

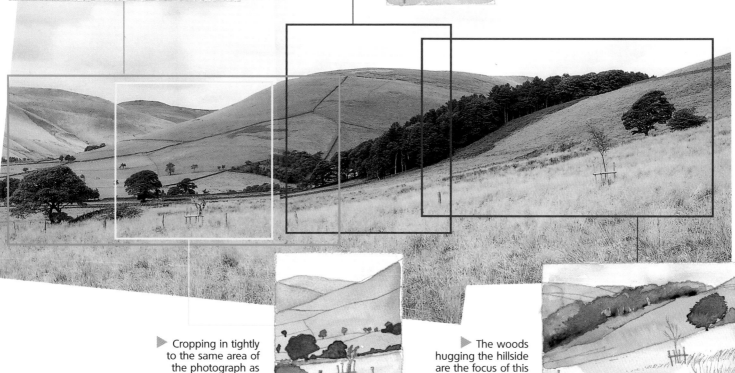

▶ Cropping in tightly to the same area of the photograph as above produces a more compact and contained image.

▶ The woods hugging the hillside are the focus of this composition. The isolated tree on the right draws the eye in.

Creative cropping

What you leave out of a picture is just as important as what you keep in, so think carefully about how you frame a subject.

The mood and impact of a painting can be dramatically affected by the way that you frame the main elements. Working from exactly the same subject and viewpoint, you can produce several different images by adjusting the relationship between the edges of the picture area and the subject. Take a single tree, for example. You could isolate it within a broad landscape, or crop in so that it fills and dominates the picture area. You can even crop the subject so that you include part of the tree only – going in close on a subject brings out its abstract and decorative qualities.

A sense of immediacy and movement is produced when subjects such as animals or people are cut by the edge of the picture.

Key points

● Place a small figure within a large background to create a sense of isolation and loneliness.

● Crop in tightly to a figure or object if you want it to dominate a composition.

● Create a sense of movement into or out of the picture area by allowing the figure to be cut off by the edges of the picture frame.

● You don't have to include an entire object – a bit of a tree, a figure or a building may make a better picture.

● Crop into a picture to fix a poor composition or create more drama.

Taking a closer look

Cropping into the tree's twisting trunk and excluding its leafy canopy both emphasizes the patterns within the composition and creates a dramatic, eye-catching image.

Rendezvous
by Peter Davey

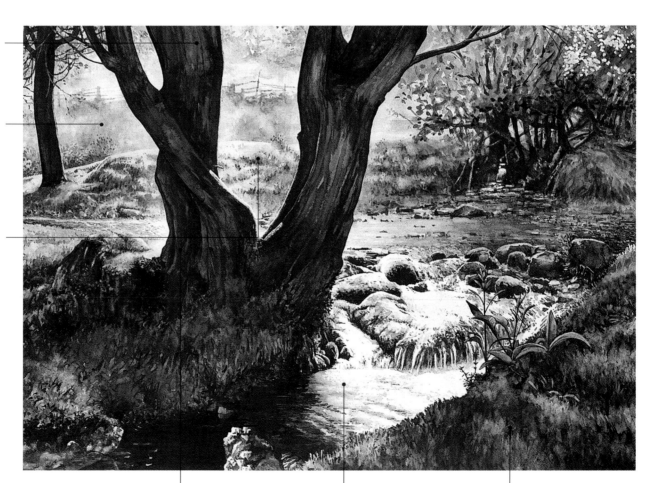

Cropping the tree, so that it breaks the top of the picture, places it towards the front of the picture space.

The contrast between the up-front tree and the distance framed by its branches encourages the eye to travel back into space.

Negative shapes trapped between the sinuous tree trunks and the edge of the picture area are an important aspect of the composition.

This trunk breaks the edge of the picture on the one-third division.

The pale, light-reflecting surface of the river is trapped between the dark tones of the tree and foreground.

The triangle of grass has been cropped to make a definite shape.

Effective choice

Cropping is an essential part of the picture-making process, whether you are working directly from the subject, or from photographs or sketches.

Part of the selection process is deciding where the outer edges of your image should be and how they should contain the subject. If you crop an object or figure, consider the way the edges of the picture rectangle cuts across them – if the cropping is awkward the composition can look casual and unplanned.

Use your L-shaped brackets as an adjustable viewfinder to scan the subject. When you have selected the key elements, try different formats and crops. Explore the varying options in a series of thumbnail sketches. Don't automatically choose the most obvious or picturesque view – an untidy corner of a field, a tangled hedgerow or a single tree may provide more drama and interest. Use the Ls to look for themes within photographs and sketches – you'll be surprised how often a small, overlooked section provides the basis of a fascinating study.

Cropping can also salvage a failure – taking a sliver off one side or the other can entirely change the balance of a painting. Of course, other occasions will arise where more radical surgery is necessary.

Try this!

Select a viewpoint and make a series of studies in which you crop in closer and closer to the subject.

▶**1** Make a quick sketch of the view in front of you. In this example the window in the background gives a sense of space and light, and the world outside.

▲**2** Now crop in more closely on the subject. Here a combination of a square format and an interior view creates an intimate, contained mood.

◀**3** Crop in even closer to isolate a 'found' still life within the setting. The window provides a natural frame for the objects.

High & low viewpoints

A change of viewpoint can reveal surprisingly different aspects in a landscape – it pays to look at your subject from various heights.

In a landscape painting, the height from which you view the subject greatly influences the composition and atmosphere of the finished image – so explore all the possibilities before you start. Look at the subject from both crouching and standing positions. Stand on a wall or climb a hill. Notice how things change when viewed from each position. With a high viewpoint you see farther, the horizon drops and the expanse of sky becomes an important element – the image feels spacious. A low viewpoint raises the horizon. There is less sky, and the foreground comes into focus – the view is more enclosed and intimate. If your eye-level is low, you can introduce texture in the foreground to draw attention to the picture plane and increase the sense of recession.

Explore your subject from different heights before you decide on your final angle. As you change your viewpoint you may well discover aspects of the subject and ways of cropping it that you hadn't noticed before.

Key points

- Explore different viewpoints before you decide on your final composition.

- Looking from different angles changes the relationship between objects.

- A high viewpoint enables you to see farther and creates an open, airy landscape with a large expanse of sky.

- A low viewpoint creates an intimate, enclosed landscape with less sky.

- Foreground details come into focus when you lower your eye-level.

Taking a closer look

The artist has chosen a bold viewpoint – looking down from a height – for his beach scene. The image is ambiguous, abstract. Only the figures give a clue to the subject.

Two figures on a beach by *Leslie Worth*

Without the figures, the image is abstract. Cover them with your finger and see how hard it is to make sense of the image. It dissolves into a series of textured colour fields.

Excluding the sky removes an important spatial clue.

The artist has created a decorative surface of textured spatters.

The figures are small in the picture area, but they provide vital information that enables us to 'read' the image. The shadows tell us the sun is shining, and that immediately makes sense of the dazzling white area in the centre.

The variety of broken colour techniques gives depth to the paint surface, so the eye seems to penetrate the picture plane.

Changing your viewpoint

Explore your subject from different angles and see how dramatically things change.

A change of viewpoint alters the dynamics of even the simplest still life set-up. Your eye-level changes what you can see, but looking at it from different sides also gives you radically different images. As you move around a subject, the spatial relationships between the different items change – two objects that overlapped from one angle may have space between them from another. Shadows come into view, and shapes change. Look at a subject from every angle to explore all the possibilities before you start a final painting.

Set up a simple still life and sketch it from different heights, then circle round it and look at it from different angles. Don't move anything.

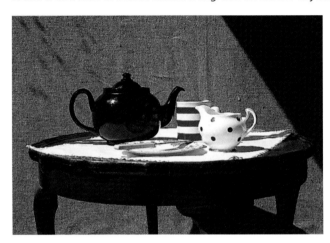

◀ *This still life set-up illustrates dramatically what happens when you view something from different angles. Notice how the relationships of one object to another change as the viewpoint is altered.*

Looking at the set-up from different heights

▲ *From a close, high angle the plate and knife are clearly visible, and you can just see into the mug and milk jug. The shadows are very apparent.*

▲ *From this viewpoint the arrangement is simple, with the largest objects at the back. All the objects are in full view but close enough to form an intimate group.*

▲ *From a low viewpoint the teapot, mug and milk jug are seen side-on and their silhouettes are clear and easy to draw. But the plate and the top of the table are virtually lost to view.*

Looking at the set-up from different angles

◀ *When you move round slightly the gaps between the objects open up, revealing some interesting negative spaces. And all the handles are now in view so their different shapes can be seen.*

◀ *From the opposite direction, the group becomes more closely packed. The objects overlap, creating some interesting shapes, and the shadows are much more important.*

Open & closed compositions

Understanding open and closed compositions helps you manipulate the viewer's attention and create the mood you want in your painting.

You can use the qualities of both open and closed compositions to control the way an image is perceived and experienced.

A closed composition creates an intimate, 'contained' image that holds the viewer's attention firmly within the picture The eye wanders around but never right out of the picture. An open composition gives a sense of space and distance, and implies the expanse beyond the picture area. The viewer's eye is free to roam without restraint.

Many subjects are naturally enclosed – an interior, for example, or a small garden. Conversely, beach scenes and landscapes are often expansive, with uninterrupted views – they are open compositions that perfectly convey the vastness of these subjects.

FINISHING TOUCHES

Study your composition carefully to check that it creates the mood you intended and holds the attention of the viewer. Often a very slight adjustment is all that's needed such as cropping a sliver of sky to close the composition in the distance. If you're unsure of the effect, lay some paper over the area to check the crop, or use scrap paper to represent items you want to add.

Try this!

A blanket of snow obliterates many of the features of a landscape and leaves the eye to wander. Try the examples below to see how both open and closed compositions focus the attention and arrest the eye.

▲ **CLOSED COMPOSITION**
Verticals such as trees are important in landscapes because they help to break up the strong horizontal aspects of the subject. These trees create a barrier across the back of the picture area and make a closed, intimate composition. The attention is anchored firmly in the foreground and middle distance.

▲ **OPEN COMPOSITION**
The flat, snow-covered ground and straight horizon create a very open, spacious composition. The trees provide a crucial focal point in an otherwise featureless landscape – without them the eye has nothing to hold on to, and easily strays out of the picture. With them, the composition is still open but the attention is held.

Manipulating a composition

Use the effects of open and closed compositions to enhance the mood of your painting and the way it is perceived.

You can edit your subject to create the best possible composition. A wide open seascape, for example, may convey a great sense of space but leave the eye to wander out of the picture – in such a case, try introducing side and foreground interest to 'close' the composition and focus the viewer's attention back into the image.

An open landscape can be contained by strong vertical elements, such as trees or gateposts. The same effect can be achieved by setting it within a frame of foreground vegetation.

Taking a closer look

These two artists have created closed compositions in very different ways.

Bellagio, Italy
by *Gerald Green*

◀ This narrow street scene naturally creates a closed composition. The artist took a high viewpoint – the eye being drawn down the length of the steep street. At the end there's a glimpse into the far distance, but the eye doesn't escape and quickly returns to the heart of the subject.

Kenwood House, Hampstead, London
by *Eliza Andrewes*

▼ The artist has enclosed an essentially open subject. The trees direct attention to the focal point – the house. The eye takes in the broad sweep of land on the left, but isn't allowed to wander out of the picture. The foreground trees are cropped top and bottom, placing them on the picture plane and establishing a sense of recession.

Unusual formats

Quaint or surprising at first glance, unusual formats can affect mood, and suggest new ideas for the composition of familiar subjects.

Most watercolour paintings have a rectangular format which may be portrait or landscape. You can exploit either shape to adjust elements such as focus, mood and emotion – and the same is true of unusual formats. But there are no rules about what effect a square, oval or circular shape has – it all depends on how you use it. A circular or oval painting, for example, can feel intimate and idealistic. A square format is often used for still lives because it seems to enclose its subject, as an interior does, encouraging the eye to sit at the centre of the frame. Formats such as octagons, which are unusual, tend to be more formal.

Taking a closer look

The conventional rectangular format can be stretched to make a wide, shallow shape or a tall, narrow shape. Look at how shapes like this can contribute to the composition of a landscape.

▲ **EXTRA-WIDE LANDSCAPE FORMAT**
Perfect for very large, open landscapes, this format is ideal for conveying a sense of grandeur and an atmosphere of peace and calm.

Loch Kinardochy by *Ronald Jesty*

◀ **TALL FORMAT**
This format is an imposing one – it forces the eye to travel upwards – in this case emphasized by the small figure of the man framed in the archway who is himself looking up.

Corfe Castle 2 by *Ronald Jesty*

▲ **TALL, NARROW FORMAT**
Here, the tall format emphasizes patterns – the rounded trees at the bottom giving way to the slender tree trunks at the centre and the clouds of rising smoke at the top.

Burning wood in Ninesprings by *Ronald Jesty*

Exploring alternative formats

The best way to explore the strengths of unusual shapes for paintings is to look at works already produced.

The choice of format is crucial to the success or failure of any composition. It is one of the first things an artist needs to think about when starting a painting. The main aim of any format is to attract the eye, contain it and help it move around all the elements in the picture. It influences the effect the picture achieves because different shapes bring their own qualities of intimacy, containment, pattern enhancement and sense of openness.

▶ SQUARE FORMAT
Calm and contained, the square format encourages the eye to settle in the centre, and at the front of the picture plane, rather than travel deep in – something reflected in the fact that this painting has a plain background.

Vase of flowers
by *Linda Birch*

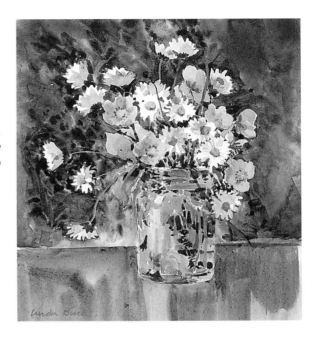

◀ OVAL FORMAT
An oval format, as well as giving an air of intimacy, carries the eye into and around the subject – emphasized in this charming painting by the turning stance and gaze of the child.

Gathering winter flowers, 1898
by *Emily Farmer*

▶ OCTAGONAL FORMAT
This is a highly specialized format. The artist was making a series of prints of octagonal follies – and chose to enhance them with an octagonal format.

Public weighbridge in France
by *Albany Wiseman*

Circles and vignettes

In a sense, circular formats and vignettes (where the edges are allowed to fade out in an irregular way) are opposites: a circle holds the eye within the frame, while a vignette allows the eye to wander freely.

◀ CIRCULAR FORMAT
In a rectangular format, the eye ricochets from the corners, moving in diagonals across the picture. But in a circular format the eye travels into and around the picture in a continuous movement. Here this movement is reinforced by the semi-circular pond and the rounded clumps of foliage.

**Barnes pond
by *Dennis Gilbert***

▲ UPRIGHT FORMAT
Here the format precisely echoes the subject: a highly patterned queue of people tailing away into the distance. The negative spaces around the figures are every bit as important as the figures themselves.

Crowd XXI by *Diana Ong*

◀ VIGNETTE FORMAT
With no corners or edges to hold the eye, this vignetted picture has a great sense of airiness, open space and freedom. The eye – and the imagination – are free to wander out beyond the picture area.

Cromarty lighthouse by *Albany Wiseman*

Experimenting with formats

The total effect a picture has on a viewer can be dramatically adjusted by changing the format. It alters the subject matter, composition and thus the perception of the finished painting.

▲ **PHOTO REFERENCE**
This photograph shows the original view the artist wanted to paint. As an exercise in exploring formats, he made five sketches using five different formats, adjusting his composition to suit the requirements of each.

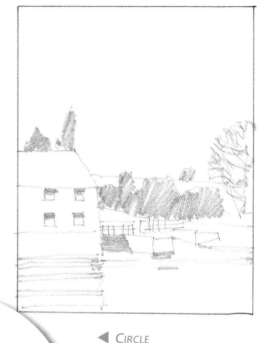

▶ **UPRIGHT RECTANGLE**
The artist has cropped the image to focus on the landscape and a large expanse of sky, rather than the building. Cropping out the arrow-like gable has resulted in a rather static, still image.

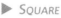

◀ **CIRCLE**
Here the artist has imposed stability by placing the main weight of the composition in a central band – the horizon and the reflections tether the image to the edges.

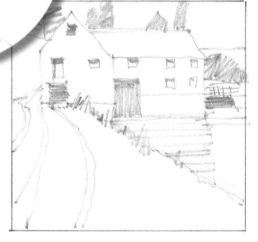

▶ **SQUARE**
A square format is inherently compact and stable. Here this tendency has been counteracted by placing the focus – the building – high up for greater impact.

▲ **LANDSCAPE FORMAT**
The landscape format is ideally suited to the landscape subject. Here the eye can wander from side to side in a leisurely manner. The dynamic thrust of the water's edge is continued by the angle of the gable.

▶ **EXTRA-WIDE LANDSCAPE FORMAT**
This format – sometimes known as a marine format – lends itself to certain landscape subjects. Here it accommodates the building and a balancing expanse of water.

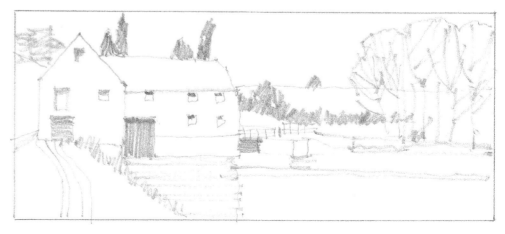

The geometry of pictures

Look for the lines that underpin a subject, then manipulate them to create a pleasing and effective composition.

There are three kinds of straight lines, directions or stresses in a composition: horizontal, vertical, slanting. They are important to the underlying geometry of a composition and have a profound effect on the mood and internal dynamics of an image. Horizontal lines express stability and calmness, reflecting the solidity of the ground we stand on, and the wide panorama of the sea or distant horizon. Verticals, more dynamic and imposing, have a soaring quality and imply growth. Slanting lines can express movement over the two-dimensional surface of an image, or into the three-dimensional picture space. Curves are softer and less thrusting than straight lines.

In practice

Horizontals and verticals

In this study of a majestic man-made structure set in a natural landscape, a tall format emphasizes the soaring verticals of the piers.

Landscape below Dent Fell by Ronald Maddox

The horizontal line of the viaduct curtails further upward movement very effectively.

Cropping in tightly and taking a flat-on view draws attention to the geometry of the structure.

The slanting line of the tumbling stream leads the eye into the central picture area and creates a sense of depth.

The curves of the arches are echoed in the curves of the hills.

The vertical piers draw the eye up through the picture area.

Pattern in landscape
The dominant verticals and horizontals of the viaduct are counterpointed by the curves of the arches and the rounded hills.

Exploiting directions and stresses

Use diagonals and zigzags to create a sense of energy and lead the eye into and around the picture area.

Slanting lines are invariably energetic – a quality you can exploit to conduct the viewer into and around the picture, and to generate a sense of movement. In the landscape, features like rivers, roads, walls, hedges and lines of cultivation provide diagonal stresses. By selecting your viewpoint you can emphasize or underplay these dynamic qualities.

Sometimes these stresses are implied rather than overt – they may be carried in the extension of a line, for instance, or in another line going in the same direction. Slanting lines that lead into the picture from the edges draw the eye into the picture area, while those that head towards the horizon create a natural sense of three-dimensional space and recession.

Tip

When composing with diagonals and slanting lines, you should try to balance them with verticals and horizontals – these will give some stability and key the picture to its frame.

Taking a closer look

Every aspect of this deceptively simple study has been carefully considered by the artist. The complex geometry creates a sense of order and dynamic tension.

The bridge at Burtaselt, Yorkshire by *Peter Folkes*

The vertical piers of the bridge stabilize the slanting lines, and echo the vertical sides of the picture.

The high horizon creates an enclosed composition.

The zigzag of the wall and the bridge is continued in the line of the horizon.

The cluster of houses stops the eye sliding out of the picture.

The lines of the river bank, wall and bridge radiating from the arch create a cartwheeling motion.

Diagonals and verticals
Here some key directions occur as strong diagonals and verticals. The bridge wall leads the eye into the picture area, while the verticals of the piers and house walls stop the eye careering out of the picture.

The slanting wall pulls the eye into the image and frames the bridge.

CHAPTER 8

COMPOSITION SKILLS

This chapter concentrates on more advanced compositional skills, particularly ways of creating the illusion of a three-dimensional space on a two-dimensional surface. Aerial or 'atmospheric' perspective, for example, is especially useful in watercolour landscape studies and very simple to use. It relies on gradations of colour, tone and texture to create a sense of recession.

Also clearly explained is the rather technical subject of linear perspective, pared down to its basic essentials. You can usually get your perspective right by combining observation with careful measurements of angles and sloping lines – use your pencil or spend a little time making yourself a set of angle-checking card scissors following the instructions provided. In addition, an understanding of the principles of perspective will enable you to see when a drawing has gone wrong and how to put it right.

A knowledge of basic one- and two-point perspective will help you draw buildings in landscapes and townscapes accurately, as well as solve more complex problems of perspective, such as drawing arches or a paved floor in recession. Other useful compositional topics covered include working from photographs and ways of incorporating figures in a composition.

What is aerial perspective?

Aerial or 'atmospheric' perspective refers to the way the atmosphere affects light as it travels through it, changing the appearance of colours and details with increasing distance.

Have you ever noticed the way distant hills tend to look blue with no visible details, while the landscape immediately in front of you is green with sharply defined features? These are some of the effects of aerial perspective. They are caused by the gases, moisture and tiny particles in the atmosphere which all affect the light as it passes through them. These effects vary according to location, time of day and time of year. By imitating aerial perspective you can create the illusion of space in paintings simply and quickly.

Aerial perspective has several effects which you can easily observe. With increasing distance, colours appear cooler and bluer. They also become less bright and there is less contrast between the lightest and darkest areas of an object. Details get less defined, and the outlines of things soften and become blurred as they recede into the distance.

Taking a closer look

Vineyard by Albany Wiseman

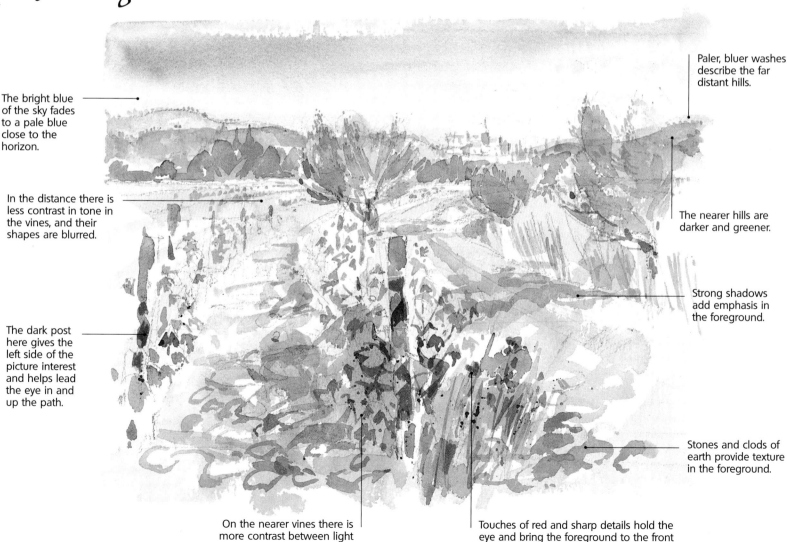

The bright blue of the sky fades to a pale blue close to the horizon.

In the distance there is less contrast in tone in the vines, and their shapes are blurred.

The dark post here gives the left side of the picture interest and helps lead the eye in and up the path.

Paler, bluer washes describe the far distant hills.

The nearer hills are darker and greener.

Strong shadows add emphasis in the foreground.

Stones and clods of earth provide texture in the foreground.

On the nearer vines there is more contrast between light and dark tones, and the details are more defined.

Touches of red and sharp details hold the eye and bring the foreground to the front of the picture.

Using aerial perspective

If you get into difficulties with your landscape painting, aerial perspective will help you to put things right. Adding a few dabs of red, or smudging the horizon may do the trick.

Sometimes a composition doesn't hang together in a pleasing way. Perhaps your eye doesn't travel through the picture plane and into the distance, but dances about on the surface; or maybe the painting is just a bit flat and boring with too little contrast between foreground and background.

Study your painting carefully and decide what is wrong. You can then overcome the problems with a few easy tricks of the trade. Use contrasts of texture, tone or colour temperature to create the illusion in your painting that some areas are closer than others.

Study the two examples on this page to see how the artist has used aerial perspective to rescue two compositions that lacked impact. Adding a little interest, texture and warmer colours in the foreground improved both of the compositions and created a convincing sense of recession.

Distant landscape

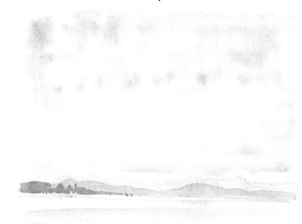

◀ BEFORE
The artist has suggested hills and mountains seen across a flat plain with a few simple washes of colour. But although the hills turn to blue as they recede, there is still a sketchy, rather insubstantial quality to the picture. There is nothing to link foreground to background and lead the eye in.

▶ AFTER
Here the artist has developed the foreground, adding patches of colour to imply clumps of vegetation. Dots of colour and the odd line imply individual plants, while washes of colour added to the sky and clouds add interest and a great sense of space and distance.

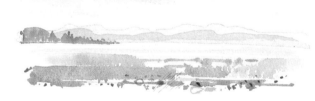

Crane and jetty

▲ BEFORE
The main visual interest here is concentrated in the top half of the picture. The foreground is uninteresting and spatially confusing – there is nothing for the eye to settle on.

◀ AFTER
The artist added the bold, dark jetty in the foreground – and changed the dynamics of the composition. A few definite brushmarks, contrasting tones and a touch of red place the jetty at the front of the picture and create a proper sense of recession.

Linear perspective

Linear perspective is a system that helps you to create the illusion of three dimensions on a two-dimensional surface.

Over the years many pictorial conventions have evolved for describing space and the relative location of objects in that space. This visual language varies from culture to culture. In oriental art, for example, position on the support is used to imply distance — the farther away an object is from the viewer, the higher in the visual field it will appear. Our visual language derives from the Italian Renaissance and depends on representing the appearance of things as seen from a single, fixed viewpoint — this system is called linear perspective.

You can draw images that conform to the rules of the system by observation. Use devices such as drawing the negative or measuring with your pencil to ensure objects are in proportion; verticals and horizontals are right; and the slope of receding lines is correct. However, a good grasp of linear perspective will help you to understand what you are seeing, and to rectify mistakes if the drawing goes adrift.

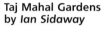

Key points

- Parallel lines converge on the horizon.
- Perspective lines above the horizon appear to go down.
- Perspective lines below the horizon appear to go up.
- Objects that are the same size appear smaller the farther away they are.
- Objects the same distance apart appear to come close together.
- Perspective distorts shapes and angles, so the façade of a house seen in perspective is no longer a rectangle.

Taj Mahal Gardens
by *Ian Sidaway*

CREATING RECESSION
This picture illustrates the principles of linear perspective. The front façade of the building is parallel to the picture plane, so there are no perspective distortions. The artist here was standing on a raised platform, so his eye-level was higher than that of the people in front of the building.

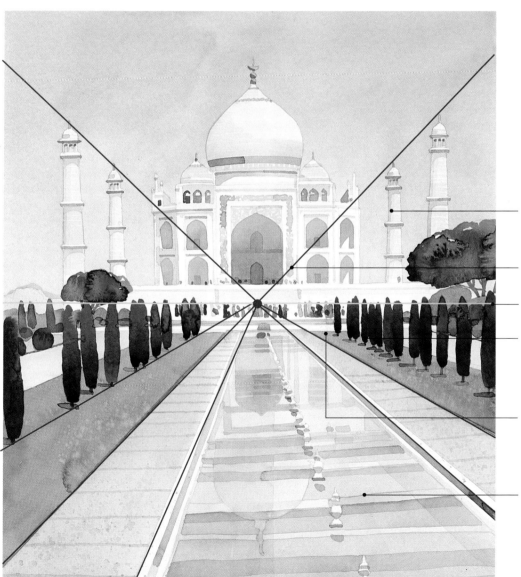

The towers – all the same height in reality – appear smaller.

Perspective line

Horizon (coincides with artist's eye-level)

The trees – all the same size – appear smaller the farther away they are.

The sides of the grass converge at an imaginary horizon.

The platforms in the water – again all the same size – appear smaller and closer together the farther away they are.

Defining terms

In order to grasp the theory behind linear perspective, you need to understand a few key terms and concepts.

Mastering the key concepts detailed here will help a great deal in all your paintings.

The picture plane is an imaginary vertical plane that coincides with the surface of the picture. Imagine it as a sheet of glass.

An imaginary horizontal plane, called the ground plane, is the plane on which you – the viewer – are standing. It's parallel to your eye-level and extends from your feet to the horizon. Eye-level is simply the height of your eyes above the ground, extending to right and left of the centre of vision.

The line at which the sky seems to meet the ground is the horizon line. At sea or on a flat plain it coincides with eye-level. In mountain or hilly country the horizon line and eye-level vary.

The vanishing point (VP) is the point on the eye-level line where receding parallel lines appear to converge. The point on the eye-level line directly in front of the viewer's eye is called the centre of vision (CV).

Perspective lines are parallel lines that in perspective appear to converge on the eye-level. In one-point perspective all parallel lines converge on a single VP on the horizon. Also known as single-point, central or parallel perspective, one-point perspective occurs in studies of city streets or interiors.

Two-point perspective occurs when there are two VPs on the horizon – the perspective lines on the right-hand side of a building will converge on the right-hand VP and vice versa. It is most often seen in landscape studies.

Perspective – sitting down

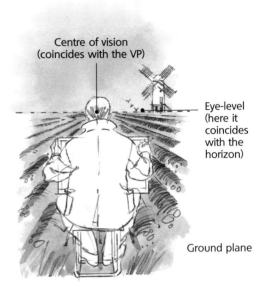

Centre of vision (coincides with the VP)

Eye-level (here it coincides with the horizon)

Ground plane

When you are sitting down the eye-level is nearer than when you are standing up.

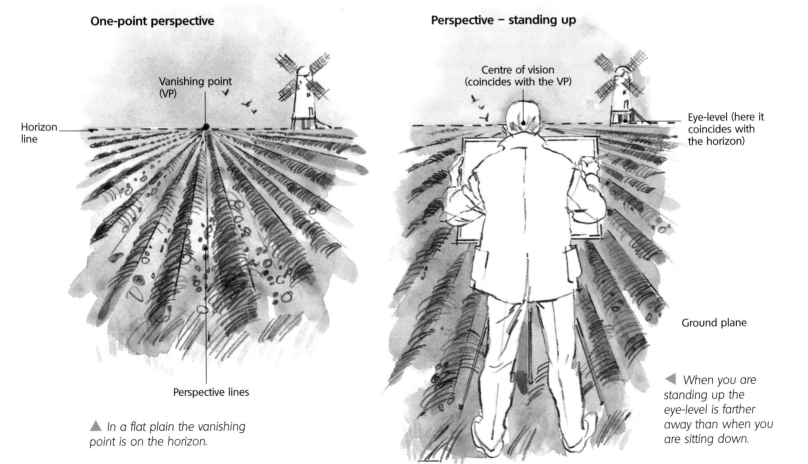

One-point perspective

Vanishing point (VP)

Horizon line

Perspective lines

▲ *In a flat plain the vanishing point is on the horizon.*

Perspective – standing up

Centre of vision (coincides with the VP)

Eye-level (here it coincides with the horizon)

Ground plane

◄ *When you are standing up the eye-level is farther away than when you are sitting down.*

One-point perspective

By applying the rules of one-point perspective you can ensure that any buildings in your paintings sit convincingly in the picture space.

The simplest version of linear perspective is one-point perspective. It occurs with subjects that are parallel to the picture plane – the imaginary vertical plane that coincides with the surface plane of your picture The most common examples of one-point perspective are a view down a village street or an avenue of trees, or an interior view in which you are facing the end wall.

Parallel lines, such as those at the top and bottom of the sides of a building, if extended by perspective lines, appear to converge at a single point on the horizon – the vanishing point. This point is the same as the artist's centre of vision and his eye-level, which is why it is also known as single-point perspective. Bear in mind that the lines of the front façade of the building always remain parallel to the picture plane because of the front-on viewpoint of the artist.

Taking a closer look

Establishing the horizon line, eye-level and vanishing point in the right place in a painting gives a consistent illusion of recession – the appearance of three dimensions on a two-dimensional surface. This doesn't have to be geometrically exact – as long as it works reasonably well, the picture will look convincing.

Elgin Terrace, Maida Vale, London 1937 by S.R. Bamin

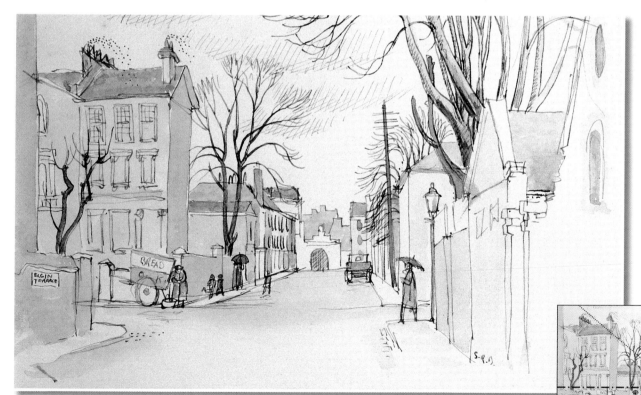

Eye-level
The artist was standing slightly higher up than the people in his painting – this is why his eye-level (and the horizon line) appears above the heads of the people themselves.

Vanishing point

Perspective lines
The perspective lines show that the sides of the road, the pavements and the receding houses all converge at the vanishing point – the parallel lines meet.

Vanishing point
The vanishing point occurs just above the green vehicle and slightly to the right of the building at the end of the road.

Eye-level and horizon line

Perspective lines

The picture plane & linear perspective

Once you've understood the concept of the picture plane, linear perspective becomes easier to put into practice.

Try this!

To see how one-point perspective works, first draw on a sheet of acetate that represents the picture plane – then go one step further and imagine the picture plane as a glass window.

Tip

To help you get a better idea of the concept of the picture plane, visualize it as a sheet of glass placed between you and the subject of your painting.

▼ Now imagine looking out of a window at a building, and drawing on the glass – the picture plane. The building is parallel to the window, its sides at right angles. The top of the side slopes down, while the bottom of the side slopes up.

Extend the sloping sides – these lines converge at the vanishing point. When you are painting a scene your picture plane coincides with the surface plane of your paper. Apply the same rules to render your subject convincingly in one-point perspective.

▲ To demonstrate linear perspective for yourself, you need to look through a window and trace what you see. Tape a sheet of acetate to the window – this is now your picture plane. Close one eye and trace what you see with a marker pen.

Select a particular line – the corner of a building, say. Establish this as the base point and keep checking that the drawn line is over the actual line (inset). Continue tracing. You'll find that parallel lines converge – the tops of the chimneys slope down. Your drawing obeys an important rule of perspective and is a convincing depiction of the scene.

Perspective lines converge

Horizon line (eye-level)

Side sloping down

Side sloping up

Centre of vision (vanishing point)

Two-point perspective

Two-point perspective comes into play when you want to depict a building that isn't parallel to the picture plane.

One-point perspective is used to depict a building in which one side only is parallel to the picture plane. The converging lines of the side of the building meet at the vanishing point. This point is the same as the artist's centre of vision and it's also at his or her eye-level and on the horizon line.

But if you are depicting a building which has two sides receding – that is, a building which isn't parallel to the picture plane – then you need to ensure that both sides have converging lines. And with two sets of converging lines, there also have to be two separate vanishing points – one on either side of the building. Both vanishing points are on exactly the same horizon line, which means they are also at the viewer's eye-level. This time, though, neither vanishing point coincides with the viewer's centre of vision.

Notice that all the vertical lines remain parallel with each other.

Try this!

Here's how two-point perspective works in practice. In the example below, both the vanishing points occur on the horizon line within the picture plane.

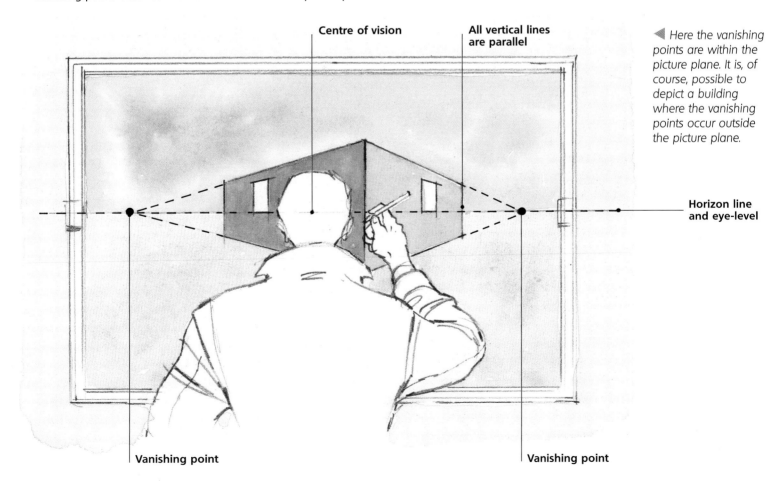

Centre of vision

All vertical lines are parallel

Horizon line and eye-level

Vanishing point

Vanishing point

◄ *Here the vanishing points are within the picture plane. It is, of course, possible to depict a building where the vanishing points occur outside the picture plane.*

Getting the angle right

A pair of angle-measuring scissors are invaluable when you want to achieve accurate two-point perspective.

Conveying perspective is often a matter of observing and drawing angles correctly.

In the case of a building viewed front on, this is quite straightforward because most of the angles are right angles (90°). But when you're looking at the same building in two-point perspective, it becomes more complicated because all the angles are either greater or less than 90°. This is where a device referred to as angle-measuring scissors is useful. It is simple to make and easy to use.

Tip

Another way of getting angles right is to hold a pencil up to the angle you want to measure, check it by eye, then move the pencil down at the same angle to your paper or sketchbook.

Making & using angle-measuring scissors

All you need is a piece of stiffish card and a small metal paper fastener that will help you move the arms of the scissors to and fro.

▶ **1** Cut the card into two strips about 5cm (2in) wide and 25cm (10in) long. Fix these two strips tightly together with the paper fastener. You're now ready for action.

◀ **2** Imagine there's a sheet of glass vertically in front of you – the picture plane. Hold out the scissors at arm's length – flat against the imaginary sheet of glass. Use your other hand to move the two arms of the scissors until they match the angle you're interested in. Here it's the line of the roof compared with a vertical line.

▶ **3** Holding the scissors tightly so you don't lose the angle you've just measured, transfer them to the right spot on your paper. Align the vertical scissor arm with the edge of the paper, then draw in the angle. There you have the correct angle for the rooftop.

Perspective problem solver

Drawing architecture in perspective can seem quite complicated for the beginner. But you don't have to regard it as impossible – there are some straightforward answers.

You are likely to encounter some difficulties in perspective every time you begin a drawing – arches, paved surfaces, lines of brick courses, sloping ground and so on.

There are some relatively simple solutions that can help you figure out perspective before you start and also to pinpoint any flaws if a drawing goes wrong.

Perspective is an important aid to drawing, and a good grasp of it helps you to analyze what you are looking at. But the most effective way of drawing is to use observation – put down what you actually see and employ your pencil to measure slopes and check one element against another. Once you have tackled perspective you can move on to the finer details.

Taking a closer look

This looks like a complex set of buildings – but look for a few perspective lines and you can see how the artist has created a dramatic and cohesive view of buildings of widely differing eras.

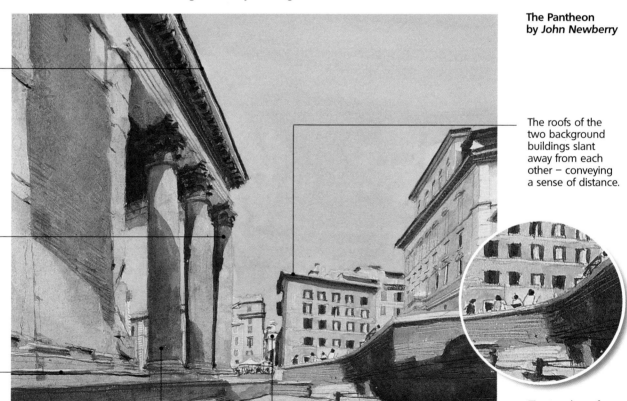

The Pantheon by *John Newberry*

The roofs of the two foreground buildings converge towards the vanishing point.

The pillars become closer together as they recede into the distance – the tiny slits of blue sky seen between them emphasize this point.

The steps and low walls converge towards the horizon.

The dramatically dark foreground shadows pull the main buildings forward in space.

The perspective lines draw the eye to the small white building just visible at the end of the narrow street in the centre.

The roofs of the two background buildings slant away from each other – conveying a sense of distance.

Tiny touches of colour on the clothes of the figures carry the eye around the curve of the right-hand wall – and lead it to the centre of the picture.

Architectural features in perspective

Here's some useful advice to help you draw arches, gable ends, paving and brick courses.

Taking a closer look

This watercolour of a walled town in the south of France combines several perspective problems in one image. It's drawn in one-point perspective throughout.

Tip

Shadows cast by buildings conform to perspective, receding to a vanishing point like the buildings themselves. Bear in mind that the direction of the shadow depends on the position of the sun. The length of the shadow, however, depends on the height of the sun – according to time of day and time of year.

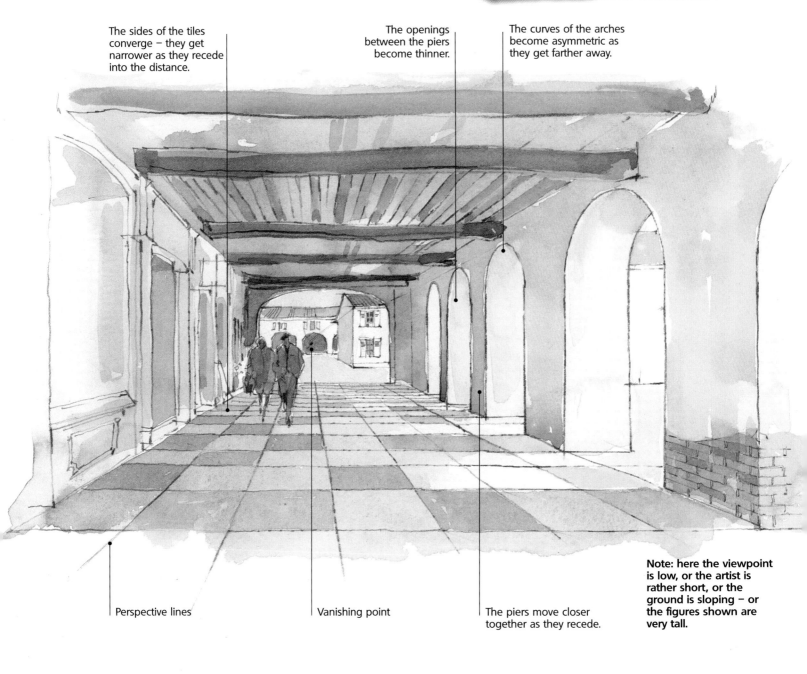

The sides of the tiles converge – they get narrower as they recede into the distance.

The openings between the piers become thinner.

The curves of the arches become asymmetric as they get farther away.

Perspective lines

Vanishing point

The piers move closer together as they recede.

Note: here the viewpoint is low, or the artist is rather short, or the ground is sloping – or the figures shown are very tall.

Exercises in perspective

Try these exercises – they will help you deal with some commonly occurring perspective complications.

Dealing with individual problems

▶ *GABLE END*
This often goes wrong because people forget that pitched roofs are affected by recession – so the apex isn't seen as being in the middle of the end wall. Start by drawing diagonals BF and CD within the parallel sides of the wall. This gives you centrepoint E. Apex G is always directly above this.

▶ *TILED SURFACE*
Draw the front of the first tile, AC, then add its converging sides to a vanishing point. Now draw the back, EG, parallel to the front. Find the centrepoint D by putting in diagonals EC and AG, then mark line BI to the vanishing point. For the second tile, draw line AFJ, then mark line HJ parallel to EG. For the third tile, draw a line from E through I and to the right-hand converging side, and then complete the tile as for the second tile and so on.

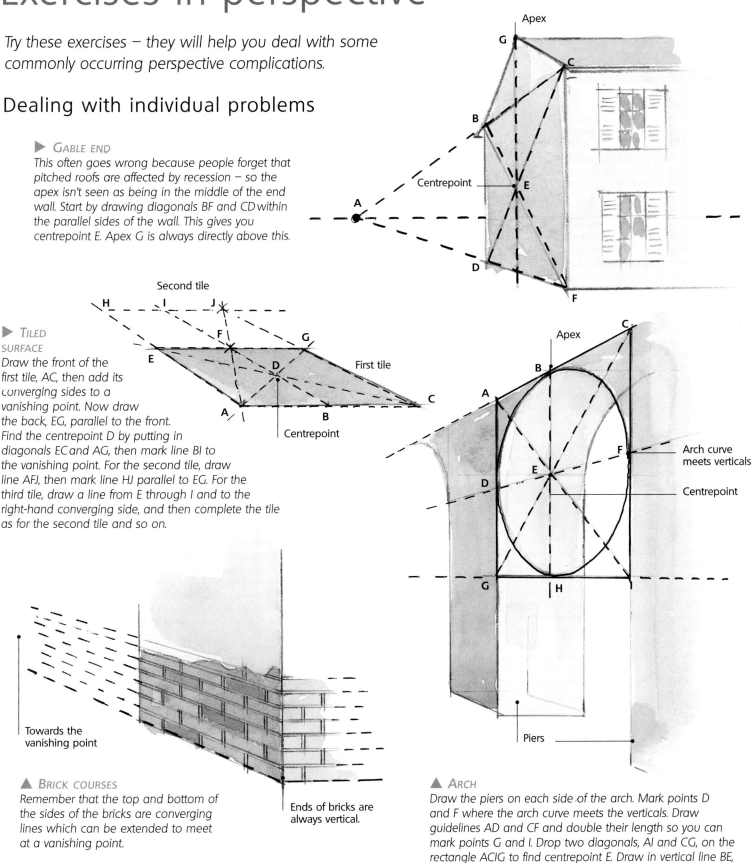

▲ *BRICK COURSES*
Remember that the top and bottom of the sides of the bricks are converging lines which can be extended to meet at a vanishing point.

▲ *ARCH*
Draw the piers on each side of the arch. Mark points D and F where the arch curve meets the verticals. Draw guidelines AD and CF and double their length so you can mark points G and I. Drop two diagonals, AI and CG, on the rectangle ACIG to find centrepoint E. Draw in vertical line BE, with B being the top apex of the arch. Lastly, draw smooth curved lines between DB and BF.

Coping with slopes

It's quite easy to deal with perspective when the ground is level – but what if the ground slopes? Whether the slope runs up or down, it has a different vanishing point from level ground.

 Making the ground plane slope

Here you can see how to handle perspective for ground slanting either up or down. Two new terms come into play: VPI – a vanishing point for the incline; and VPD – a vanishing point for the decline.

▶ GROUND SLOPING UP: PLOUGHED FIELD
This ploughed field starts flat, then rises up in the distance. The furrows on the flat converge at the artist's centre of vision, which is at his eye-level (in this case, the dotted line). When the ground slants up, there's a new vanishing point – the VPI. This is higher than that of the flat ground, since it is situated above eye-level. Observation will give you the direction of the slope.

Side and front view of house

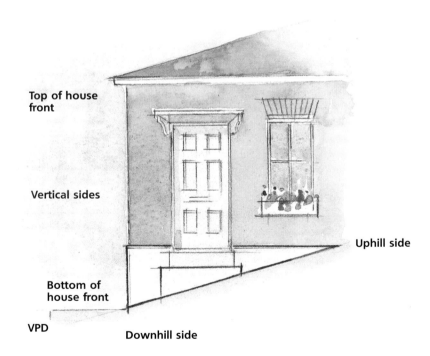

▲ GROUND SLOPING DOWN: SIDE VIEW
Like upward slopes, a downward slope has a different vanishing point from level ground. It's lower than the horizon line, making it a VPD. Add a house on this slope, and it becomes very complicated. As the ground slopes down, the house remains level – because floors, doors and windows all have to stay level.

▲ GROUND SLOPING DOWN: FRONT VIEW
The bottom of the front of the house follows the gradient down, so the continuation of this line leads to the VPD. The top of the house front, on the other hand, is level, so the continuation of this line goes to the vanishing point on the horizon line. The downhill side of the front of the house, as a consequence, looks taller than the uphill side. Although obvious, one other point is that the vertical sides of the house remain vertical, even on slanting ground.

The cone of vision

Understanding the way your eyes work when you look at something will help improve your compositional skills.

Your field of vision is the area you see if you look straight ahead. It funnels out from your eyes at an angle of 180°. But within this field you can only see clearly – in perfect focus – within a narrow range of about 60°. This narrow area of clear vision is called the cone of vision. It's important for artists because it dictates exactly what you can see clearly without moving your head – and therefore the area of the subject that can easily be included in a picture.

Each eye has its own cone of vision. The fusion of the two images, viewed from slightly different angles, means the field of vision is oval rather than circular – so a landscape format corresponds more accurately to the field of vision than any other. To see clearly beyond the range of your cone of vision, you must turn your head or move your eyes. This alters your centre of vision and changes the perspective of the object you are looking at.

Key points

● You can focus clearly only within a cone of vision of about 60°.

● To see clearly beyond 60°, you must turn your head and move your eyes – this makes for distortion in perspective.

● The area between the 60° cone of vision and the edges of your field of vision (180°) is called your peripheral vision – your visual field becomes increasingly vague towards the periphery.

● The main problem with the cone of vision comes when you want to draw tall buildings – if you're too close, you can't see the whole building; if you're too far away, you can't see details.

Details versus distance

▲ Because buildings are so big, it's difficult to find a position from which you can see the entire structure at a glance. This artist has set up his easel about 9m (30ft) from a chapel. He can see most of the façade without moving his head – and make out such details as the type of building material and the stonework carvings. But he can't see the top part of the tower.

▲ By moving his easel a long way back – 18m (60ft) or more – the artist can take in the whole façade at a glance, including the tower. But he's now too far away to see textures and details. With tall structures, you may find that perspective makes the verticals appear to converge. You may have to draw the sides of the building parallel for an acceptable image (see page 200).

Compensating for distortion

In certain cases the limitations imposed by your cone of vision can become a problem – with tall buildings or with long, low structures.

Draw a tall building from close up and you'll see that perspective makes the sides of the building appear to converge towards the roof. You must decide whether to draw what you see or compensate for the apparent distortion and draw the building with parallel sides. The decision depends on the degree of apparent convergence, the purpose of the drawing and what looks best. Artists often make these adjustments and nobody notices until the distortions are pointed out because the finished image looks right.

Tip

Bear in mind that a precisely drawn image conforming relentlessly to the rules of perspective is usually less convincing than one that is freer and more expressive. This is because we rarely stare fixedly along a single cone of vision. In reality our eyes dance over the scene, and we build up a composite of images.

In practice Drawing a terrace of houses

To draw a long building you must compile the image from several different viewpoints. Here you can see what the problem is when your subject is too long for your cone of vision to cope with in just one 'take'.

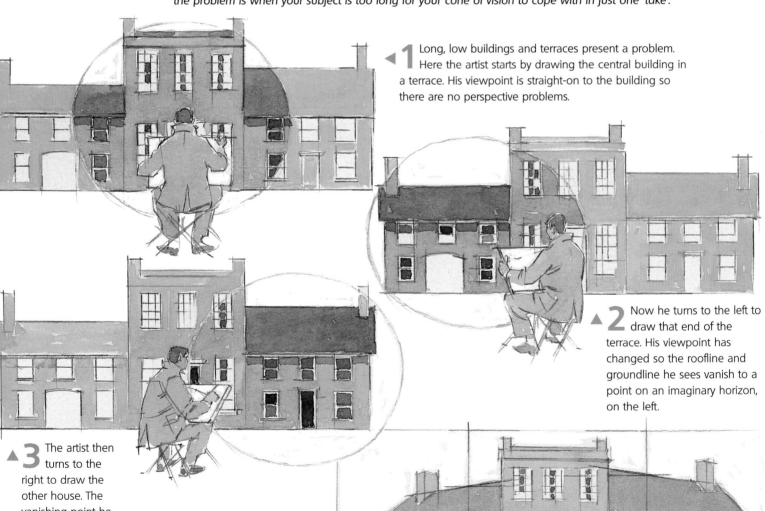

◀**1** Long, low buildings and terraces present a problem. Here the artist starts by drawing the central building in a terrace. His viewpoint is straight-on to the building so there are no perspective problems.

▲**2** Now he turns to the left to draw that end of the terrace. His viewpoint has changed so the roofline and groundline he sees vanish to a point on an imaginary horizon, on the left.

▲**3** The artist then turns to the right to draw the other house. The vanishing point he sees is now to the right.

▶ *When the artist's three viewpoints are spliced together the roofs appear to slope. For a more acceptable image, he must move farther away or 'fudge' the image by straightening up the roofs and ground level.*

Looking at negative shapes

The terms 'negative shape' and 'negative space' describe the gaps between the solid objects in a picture as well as the background space around the objects. They are important in every composition.

As soon as you draw something on paper you create positive and negative shapes. The object you have drawn is the positive and the area between it and the edge of the paper is the negative. The negative and positive elements slot together like the pieces in a jigsaw. In a good composition the patterns made by the negative spaces are carefully considered and balanced. Sometimes an artist adds interest to an image by emphasizing these shapes – by flattening the colour, or warming it so the negatives advance on to the picture plane, giving the painting an abstract or decorative quality.

Before you start a painting, make an exploratory sketch of the negative elements – start by drawing the shapes of the spaces around the subject. Look at the way these fit together, and the patterns they make on the sheet.

Taking a closer look

The artist here has deliberately simplified shapes and patterns in order to emphasize the abstract and decorative qualities of the subject and achieve a balanced composition. The image nevertheless remains an accurate description of a rural scene.

Towards Northington, Candover Valley by *Peter Folkes*

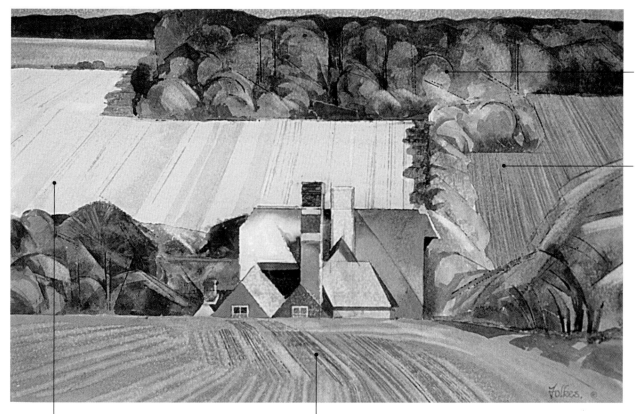

By simplifying the trees the artist draws attention to the geometric shape of the woodland.

Neatening the edges of the field and emphasizing its striped pattern make it an important shape in the composition.

The crisply defined stubble field can be seen as a pale negative shape against the dark positives of the woods and hedges.

Dry-brushed striations give the stubble a flat, patterned quality.

Drawing the negative

Drawing the spaces between objects can produce a more accurate result than drawing the objects themselves.

When you study an object such as a chair you immediately start to check it mentally against what you know about chairs – their shape, structure and size. There is a temptation to draw what you 'know' to be there. Drawing the negative spaces is one of the tricks that artists use to force themselves to look carefully at a subject.

▲ SEEING THINGS DIFFERENTLY

This well-known brain-teaser makes the point about negative shapes. When the two side areas are painted dark (left) you see two profiles, but when the central image is painted dark (right) you see a vase.

Try this!

As soon as you start drawing the spaces rather than the solids, you can put what you know about the object out of your mind and see it as an abstract pattern. This technique is useful with complex subjects such as chairs, trees and the human figure.

▶ POSITIVE
Here is a garden chair drawn in the normal way by outlining the positive elements – the back, arms, seat, legs and so on. It's quite a complicated subject.

▶ POSITIVE
Here's a winter tree, showing the pattern of branches in outline – note that it can be quite daunting to do this accurately for a particular species of tree.

◀ NEGATIVE
Now draw the chair, concentrating on the negative spaces trapped between the legs, struts and seat. The positive shapes emerge from the negatives. You'll find your drawing is not only easier – it's also very accurate.

◀ NEGATIVE
Now draw the tree, looking at the negative shapes as well as the solid shapes. You'll find it's quite easy to get the character of a particular tree right.

Leading the eye

Good composition involves guiding the eye. You can use colour, tone, shapes and internal elements to draw the viewer in.

In an effective composition, elements are connected in a pleasing and rhythmic way. When you view a picture your eye instinctively looks for a visual pathway – otherwise, the picture feels fragmented or incomplete. The eye looks for similarities, so repeating shapes – such as vertical tree trunks – can lead it round a picture. It also seeks out differences and makes comparisons, so contrasting shapes – for example, fallen logs in a sea of tree trunks – can create a balance that encourages your eye to travel round. Contrasts of tone or colour – for example a white farmhouse against dark winter fields – can act as visual magnets, while repeating tones and colours create internal connections.

Internal geometry can create visual pathways. Strong diagonal features that break in from the edge – for example, a wall set at an angle – can point the way in. Try changing position to find an angle of view from which the wall seems to lead to your focal point. You may even need to move the wall.

Taking a closer look

In this view of a woodland in early spring, repeating shapes and colour contrasts encourage the eye to explore the painting.

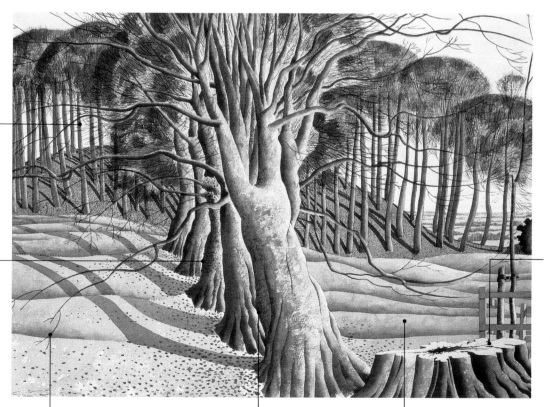

Early spring by Simon Palmer

The densely packed background trees act as a visual barrier, turning the eye back into the picture.

As with the central foreground slanting tree, the diagonal line of trunks creates a dynamic visual pathway through the picture plane.

The tree stump leads the eye to the foreground tree – this is a strong lead-in because the eye normally reads from left to right.

The horizontal contours at ground level balance the vertical emphasis, preventing the eye from 'floating' upwards.

The diagonal slant of the central foreground tree creates a dynamic movement into the picture plane.

The cool tones of the ground and shadows contrast with the warm tones of the trees.

Visual pathways

Careful selection of your subject matter and the manipulation of colour and internal elements are important tools in creating visual pathways.

Try this!

Experiment with different ways of using the internal elements of various landscapes to draw the eye to your focal point.

Tip

Deep shadows – especially directional shadows thrown by tall features such as trees – can be used as pointers to guide the eye round your composition. More generalized areas of shadow contrast with, and draw attention to, paler highlights.

▲ COLOUR
Several devices ensure the eye returns time and again to the house. The building falls on two intersections of the grid of thirds (see pages 169–170); its white walls contrast with the softer, warmer tones of the green fields; and the hedge leading in from the left acts as a direct visual pathway to the house.

▲ PATTERN
The pattern of stripes in the crops pulls the eye in from the bottom and right edges of the painting. The stripes change direction and tone at the boundary of the foreground field, drawing the eye up to the trees and back again.

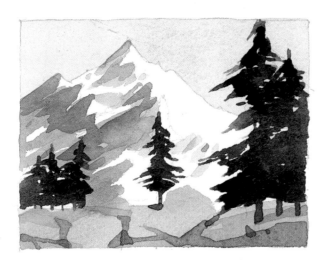

▶ HIERARCHY
The pointed tips and strong verticals of the foreground trees are repeated by the trees in the middle distance, drawing the eye upwards to the peaks of the mountain behind.

▲ LEADING FROM THE LEFT
The track is a visual pathway, drawing the eye diagonally from the left to the trees on the horizon. The trees are a visual barrier, forcing the eye back into the picture again.

The Golden Section

The ancient theory of the Golden Section provides a foundation that helps you unlock the secrets of a visually balanced composition.

An effective composition creates a harmonious balance in a painting so that the main subject takes centre stage effortlessly, and the eye is not distracted by discordant or uncomfortable elements. Achieving this can be a hit-and-miss affair. The Golden Section, believed by the ancient Greeks to be an 'ideal' proportion, has provided artists with a solution to this problem for centuries. Based on the proportion of three:five or roughly three-eighths to five-eighths, it gives you

a formula for creating visually satisfying compositions. The theory involves dividing a painting into two unequal sections, so that the smaller section is in the same proportion to the larger section as the larger section is to the whole. Once you are familiar with the Golden Section, look at paintings both classic and modern – notice how often its proportions occur. Many artists are naturally sensitive to perfect proportion and incorporate the Golden Section into their work quite unconsciously.

In practice **Three compositions based on Golden Section proportions**

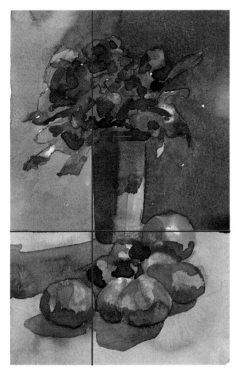

▲ VERTICAL FORMAT
In this sketch, the artist used a portrait format. He centred the vase in the width of the picture area, with the base roughly a third of the way up from the bottom. Notice how it sits neatly on the intersection of the Golden Section lines.

▶ HIGH HORIZON
Here the artist placed the horizon on a Golden Section line near the top, and the trees near the vertical division to the left. In a landscape format, the vertical division could just as easily be placed on the right, and the horizontal division near the bottom.

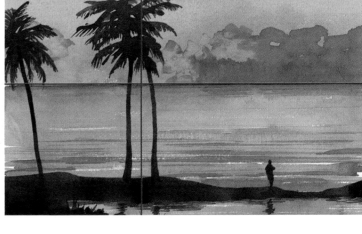

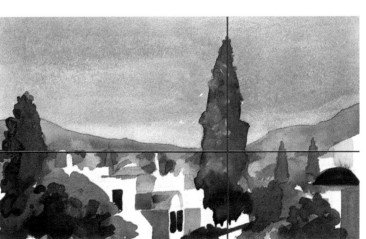

◀ LOW HORIZON
Here, the artist has reversed the Golden Section lines. He has placed the lowest line of hills on the low horizontal line, and the tall tree on the vertical division towards the right of the picture area.

Constructing the Golden Section

*Put the Golden Section into practice for yourself
with some sketches based on its principles.*

Try this!

*Follow the steps below to construct the Golden Section divisions
on your paper. You'll need a pencil and a large sheet of paper,
a compass, ruler and set square.*

1 Decide on the length of the longest
side of your picture area. Draw a line
this length (AB). This line marks the top of
your finished picture area. Put the point
of the compass on the paper at B and
rest the pencil halfway between A and B.
Draw an arc that stops above B at C.

2 Use the set square to draw a
line from B to C, checking the
angle at B is 90°. Draw a line joining
A and C. With the compass still at
the same setting, rest the point at C
and draw another arc from B that
bisects the line AC at point D.

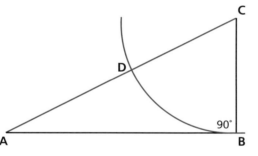

▲ **MAKING A GOLDEN SECTION VIEWFINDER**
*A viewfinder is a great aid to successful
composition, especially if you divide the
window along the Golden Section lines.
To make the viewfinder shown here, cut
a 30 x 23cm (12 x 9in) rectangle of card.
Draw a 5cm (2in) border all round, leaving
a 20 x 13cm (8 x 5in) window. Then tape
cotton or elastic bands at B and C,
13cm (5in) in from one outer corner (A) and
stretch them across the window.*

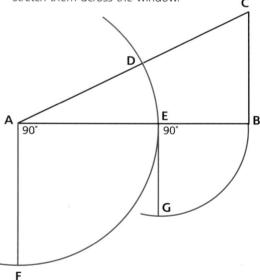

Key points

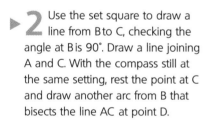

● The Golden Section theory is based
on a proportion of three:five. In the
human body, this means that the head
fits into the body roughly eight times –
three to the navel and five from navel
to floor. This is the ratio of three:five.
When composing a painting, the ratio
works slightly differently. When the
painting is divided into two unequal
sections, the smaller section is in
the same proportion to the larger
section as the larger is to the whole
(three:five:eight).

3 Now put the compass point at A
and position the pencil on D. Draw
an arc down from D to a point directly
below A at F. The line AF is the length of
the shortest side of your picture area.
Mark point E where this arc crosses AB.
Finally, put the compass point at E with
the pencil at B and draw an arc to G,
directly below E. Check with the set
square that the angles at A and E are 90°.

4 Now draw your Golden Section
rectangle. The line AB marks the top
edge, and the line AF is one of the sides.
Using the set square to check the angles,
draw in the point H at the final corner of
the rectangle. Point G marks the point
where the Golden Section divisions cross.

Shadows in landscape

Light and shadow can be used to create mood and manipulate or inform a landscape composition.

Shadows are an important aspect of the landscape. Even on the cloudiest days there are shadows, but the most interesting effects occur on sunny days. Early morning and late evening – especially in winter – give long shadows because the sun is low in the sky.

Clouds cast shadows as they pass between us and the sun. These are particularly evident in seascapes and on flat plains. They can add interest to a composition, creating darker toned shapes on the surface of the sea or land. They also create a pattern of lights and darks that becomes a tonal underpinning for the subject.

The landscape casts its own shadows – cliffs, mountains, ravines and so on. As the sun moves around, these can drastically change the appearance of the scene you are planning to paint. Tall objects – buildings, trees, people – cast shadows, too. When a bright sun is low in the sky, these shadows are dark and emphatic.

Key points

- Use shadows to inform empty spaces.
- Shadows emphasize the brightness of the sunshine.
- Repeated shadows give compositional emphasis and create rhythms.
- Shadows anchor objects in space and create interesting divisions.
- Shadows create silhouetted shapes, add dramatic effects and show the roundness and solidity of forms.
- Shadows show the direction of light and indicate its quality – bright, diffused, early or late in the day and so on.

Taking a closer look

In this highly dramatic picture the contrast between the light and dark areas is heightened by the slanting streaks of sunlight in the deepest shadow area.

Late sun, Corn Street, Bristol
by B.C. Lancaster

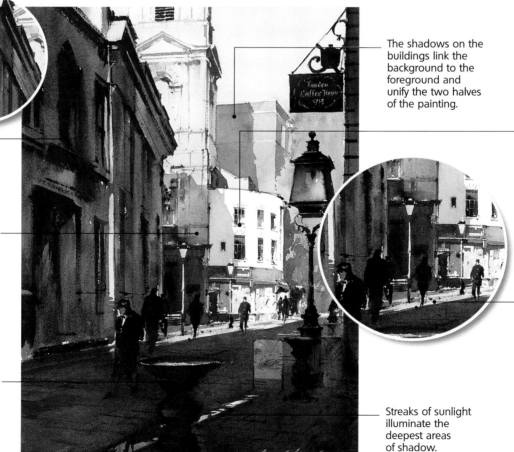

Doorways and windows appear as areas of deeper shadow on the shaded building.

Shadows falling on the buildings help to explain the direction of the light.

The strong contrast between the dark foreground and the brilliant background indicates that this is a bright, sunny day.

The shadows on the buildings link the background to the foreground and unify the two halves of the painting.

Shadows help to pick out and define the surface detail of the architecture.

The strong diagonal slant of the line on the ground where light meets dark leads the eye into the picture.

Streaks of sunlight illuminate the deepest areas of shadow.

Experimenting with shadows

You can achieve an amazing range of dramatic effects by the careful placing of shadows in your pictures.

In practice Avenue of trees

Attracted by the long tree trunk shadows, this artist made a series of thumbnail sketches, moving around to get different viewpoints and exploring the compositional possibilities.

◀ THUMBNAIL A
In this version, the group of chairs and their shadows provided a change of scale to the trees, but the artist felt the composition trailed away in the foreground.

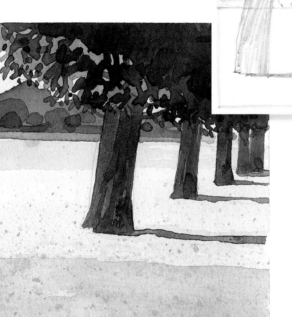

▲ THUMBNAIL B
Changing his viewpoint enabled the artist to include both sides of the avenue, but the foliage in the foreground was distracting and the eye was funnelled through the avenue and into the distance.

▲ THUMBNAIL C
Moving away from the avenue created an empty foreground, but the artist liked the way the cast shadows were cropped by the edge of the image.

Tuileries Gardens, Paris by *Ian Sidaway*

▲ FINISHED PICTURE

In this worked-up version, the artist has played up the simple geometry of the line of trees and their shadows. By putting in another tree and its shadow in the foreground, he filled the space, creating a strong diagonal that counterpointed the verticals and horizontals. Note that the extended gap between the extra tree and the next breaks the regular rhythm and splits the image into three almost equal vertical divisions. Including only one side of the avenue and allowing the cast shadows to break the frame highlighted the picture's abstract qualities.

Counterchange

Use contrasts of tone, known as counterchange, to introduce structure, pattern and rhythm into your compositions.

In a traditional counterchange textile pattern, a light motif is used against a dark ground, then the same motif is used dark against a light ground. In fine art, this switching of light against dark and dark against light is used in a less organized and rigorous way to inject structure, energy and sparkle into compositions.

To exploit counterchange you must first see your subject as an interlocking pattern of light and dark areas. Half-close your eyes and make a quick thumbnail pencil sketch in which you reduce the image to darks and shadows, and light and highlighted areas. This jigsaw of light and dark provides the abstract underpinning for a composition, which is deliberately manipulated to introduce pleasing patterns, and rhythms which pulse across the picture surface.

Taking a closer look

By painting this street scene 'contre jour' (against the light) the artist has greatly emphasized the drama, pattern and sense of movement in the image.

Venetian backstreet by *John Tookey*

The brilliantly white façade frames the dark archway.

The emphatically dark shadow within the archway draws attention to the decorative ogee-shaped opening.

Dark on dark
A dark figure seen against a dark background varies the rhythm.

The white ground makes the dark figures appear to shimmer.

Dark against light
Sketchy figures silhouetted against bright light create a rhythmic movement into the picture.

Using contrasts

By making subtle adjustments to highlight the tonal differences within a subject, you can add a new dimension to an image.

By adjusting the balance between light and dark – making the darks more punchy or knocking back the light areas – you can make more of the patterns and rhythms inherent in a subject. Counterchange is a useful way of implying movement, leading the eye backward and forward, into and out of the picture, letting air and space into the composition. It can be used to create a teasing ambiguity, reversing perceived tonal relationships, playing down some, emphasizing others – so the eye sees a recognizable shape then loses and finds it again. It can negate normal spatial relationships, flattening the picture space to draw attention to the shapes of objects – a process which can produce images that are highly decorative or move towards abstraction.

In practice Studies in counterchange

In these studies the artist explored the tonal patterns in a seascape seen under two very different light conditions.

Lighthouse studies by *Albany Wiseman*

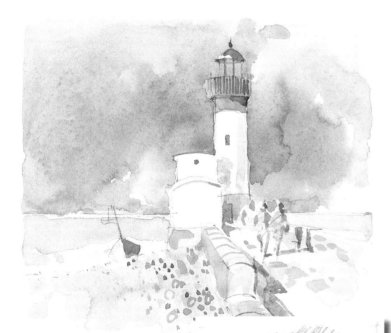

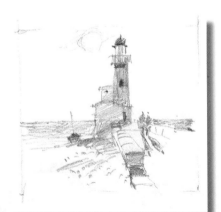

▼ CONTRE JOUR
Here the sky is the lightest part of the image. The lighthouse, boat and figures are seen dark against light. The image has an upward thrust – the eye dances from the shadow on the wall in the foreground, to the figures and up towards the turret of the lighthouse.

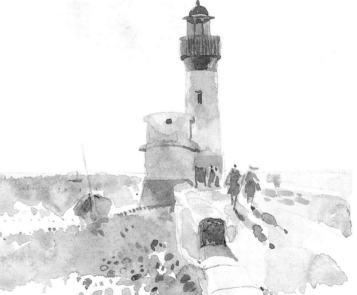

▲ AGAINST A DARK SKY
The white lighthouse is the lightest part of this study – and the pivot for the composition. The lighthouse is seen light against a dark sky, while the figures are dark against light.

Figures in composition

A figure is an immensely powerful element in a painting – and this is something that can be harnessed and exploited in your work

We recognize the human form and identify with it, no matter how sketchily drawn, because we are especially receptive to images of our own kind. Even a few straight lines and a circle read perfectly easily as a human form – a stick man.

Common mistakes in figure drawing are to forget about the composition and place the figure randomly, usually in the middle, and to make it very small. Yet composing with figures is the same as with other elements. Fundamental principles, such as the rule of thirds and the Golden Section (see pages 169 and 205), apply.

To create an effective image, consider the position of the figure and its relationship to the sides of the support. Look for and exploit rhythms and connections, symmetry and asymmetry, geometric structures, repeated forms and angles – all ways of giving your drawing unity, coherence and structure.

Mother and child

Study these mother and child drawings. In 1 mother and child are simply looking ahead, but in 2 the figures interact with each other; 3 and 4 focus attention on the intimate relationship between mother and baby.

◀ Mother and child stand squarely, facing the viewer. There's no depth of view – we are forced to concentrate on the figures themselves. Their stance is static and solid, forming a very stable asymmetric triangle.

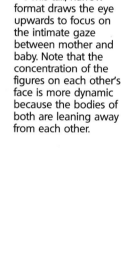

▶ Here the artist introduces a sense of movement – mother and child twist to face each other, the mother looking down, the child looking up to make eye contact. Note that both figures hold their free hands at waist level – a clever touch which links them together almost as much as their linked hands.

◀ This tall, narrow format draws the eye upwards to focus on the intimate gaze between mother and baby. Note that the concentration of the figures on each other's face is more dynamic because the bodies of both are leaning away from each other.

▶ Here part of the mother's head and legs are cropped out of the picture – creating an even greater sense of intimacy than in No.3. The negative spaces around the figures make interesting shapes.

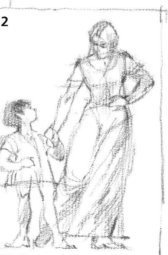

Studying different poses

What makes the figure exciting as a subject is its flexibility, the expressiveness of body language – and the gaze.

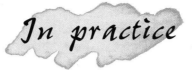

Using figures in alternative ways

Look for dynamic diagonals, stable triangles, movement, effective cropping, filling of the picture area, interaction between figures and interesting negative spaces.

The human body can adopt an almost infinite number of poses. It can bend to create a compact ball, stretch out in a star shape or stand straight with arms clasped to the sides in an elongated form. A seated figure gives a neat, still, compact form, while a dancing figure conveys movement, energy and drama.

Single or multiple figures on a page give intriguing negative shapes which can be important elements in the composition, creating a dynamic sense of movement, pulling the eye in or implying depth or a sense of space.

◀ The horizontal format, with the player's head and knees almost squeezed into the picture, helps focus the eye on the guitar – and on the man's concentration.

▲ The very strong diagonal from bottom left to top right corner, the twisting movement and creative cropping combine to make this an exceptionally strong, dynamic drawing.

▶ This drawing breaks the 'rule' of not siting a person in the centre of the page. The dancer lies on a central bench. The result is successful because the turned head, drooping arm and crossed legs create sufficient interest to offset the otherwise static position.

◀ Here too the figure is positioned centrally. This works well because the broad triangle shape is very strong and the vertical line formed by the figure's right arm and head is set off by the complicated interplay of shapes created by the left arm and the legs.

Using photographs

If the weather is changeable or you run out of time, a photograph provides valuable reference, especially when the scene you want to paint is complex or full of movement.

A camera is a worthwhile addition to an artist's kit; a photo can provide a useful reference. Light and weather change rapidly, altering a landscape in seconds – if you use a camera to capture a cloud formation or the effects of light and shade on water, you have a permanent record to refer to later. If the scene you're painting is constantly changing – a busy market place, say, or yachts on a rough sea – a photo freezes an instant in time so you can consider the subject and decide how best to capture it in your painting.

Photographs can help you compose a picture, but don't let the camera take over. It only records, it doesn't interpret and edit what it 'sees'. Remember that you are in control. A camera is a means to an end and you must decide on the focus of your composition and the details you want to include.

Taking a closer look

The artist photographed this shopfront so he could record the effects of the bright sunshine before the sun moved.

Food center, Little Italy, New York by Ian Sidaway

▶ *This reference photograph enabled the artist to study and capture the pattern of light and shade in the subject exactly – particularly the dominant diagonals of the shadow around the shop window.*

▶ *Notice that the camera hasn't picked up the details within the shadow area. The bread display in the window, for example, is obscured.*

▶ *In his final painting, the artist used information from his photographic reference, together with on-the-spot sketches which recorded details the camera didn't 'see'.*

Putting photos together

You can use several photos to create a balanced composition, and, if the scene isn't quite as you want it, make it up.

When you make a photographic record of a subject, include plenty of background so you can experiment with cropping it in different ways; or try putting together a panoramic view – stand in one spot and take a series of photos, moving your camera each time so each shot overlaps the last. When you put the photos together you can experiment with your composition and choose which part of the scene to paint.

A camera is perfect on holiday for taking visual notes of any scenes or details that interest you. A quick sketch backed up by a few photographs gives you plenty of information to use when painting at home later.

In practice **Making a composite picture**

If the image you're after doesn't exist, use photographs to make it up. You can be selective and isolate the images you want to include.

Pyramids at Giza by Ian Sidaway

◀ PHOTO 1
Looking at the pyramid on its own, you get no idea of its size. In addition, the monochrome tones of pyramid and sand are flat and uninteresting. Something else is required.

▲ PHOTO 2
This photo has a lot more going for it. The artist homed in on the standing camel – its complex shape would set off the hard, angular lines of the pyramid in the first photo.

◀ FINAL IMAGE
The man perched on his camel in the foreground now adds a vital sense of scale, plus exotic colour and detail that contrasts with the flat monotone of the pyramid.

CHAPTER 9

SPECIAL EFFECTS

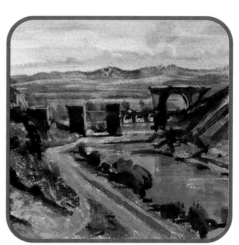

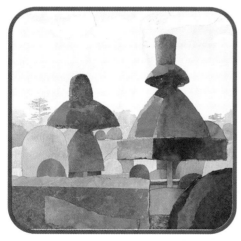

This chapter builds on the basic watercolour techniques outlined in Chapter 1. Ways of creating and using whites, for example, is supplemented with details of several techniques for reserving or masking the white areas in a painting including masking fluid, paper, fabric and masking tape. Paper, fabric and masking tape can also be used as masks to produce a fascinating range of useful edges. washes.

You will also find that there are many ways to create textures: wax resists, texture mediums, alcohol, pastel and salt are all demonstrated, as well as the effects that can be achieved with sprays and diffusers. Additives, such as gum arabic, wetting agents, and even soap and bleach change the way watercolour behaves and produce some fascinating results. The impact that different papers have on the finished image are discussed and there are sections on the effects that can be achieved with non-waterproof inks, a gouache base and collage.

Experiment with all these techniques – the process is extremely enjoyable, liberating even, and they will make useful additions to your repertoire.

Masking fluid

This is invaluable for creating details, sharp lines and hard edges, or blocking off large areas of paper to ensure they stay white. You can also use it creatively to make useful and interesting textures.

One of the great challenges of watercolour is reserving the white of the paper for white and light areas such as clouds, sheep, snow and highlights on water. Masking fluid provides a quick, simple and effective method of isolating specific areas of the paper surface. You simply apply the fluid to the paper – with a brush or pen, for example – and leave it to dry to a thin rubbery film. Because the paper under the mask is completely protected you can work with freedom, applying layers of wash over and around the masked area. When you have finished and the paint is dry, remove the mask by rubbing it with your fingertips or a putty rubber. It comes away to reveal a neatly defined area of pristine white paper.

Key points

- Masking fluid comes either tinted (yellow or grey) or colourless. With the tinted fluid you can see where you have applied it, but it may stain if left on paper for a long time.

- Colourless masking fluid does not stain.

Applying masking fluid

Practise using masking fluid on scrap paper. Make a variety of large and small marks – don't use your best brushes as the fluid can damage the bristles – paint over them and see how many different effects you produce.

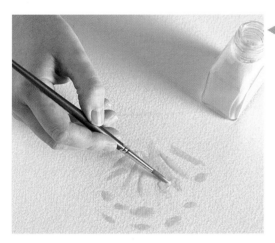

1 Dip the brush in the bottle and apply the fluid to the areas you want to protect. Leave the fluid to dry thoroughly before starting to paint.

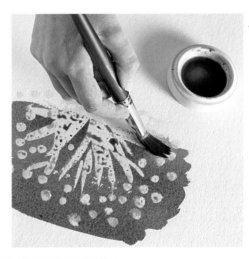

2 Using a different brush, apply a wash of colour over the area you have masked. Leave it to dry completely.

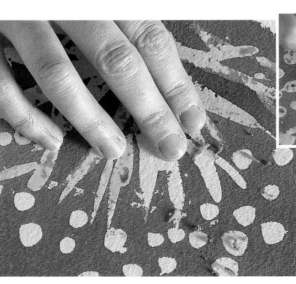

3 When the paint is completely dry, remove the mask by gently rubbing it with your fingertips until it forms crumbs. Large areas will sometimes peel away as complete sheets of film (above).

Tip

For large areas it is easier to remove masking fluid with a kneadable putty rubber rather than using your fingers.

Masking over a wash

This is another way of applying masking fluid which can be used to create dramatic visual effects.

The usual way of using masking fluid is to apply it directly to the paper so the natural colour of the paper is reserved, as described on page 217. You can also apply fluid over an underlying wash once the wash has dried, and then paint over it. Experiment to see what can be achieved by applying masking fluid in thin and thick lines, blobs, dots and so on.

as described on page 217.

Tip

Masking fluid resists wet paint, which forms droplets on its surface. The paint dries to create a stippled effect which can be incorporated in the final image. Here grey masking fluid captures the colour and texture of tree bark.

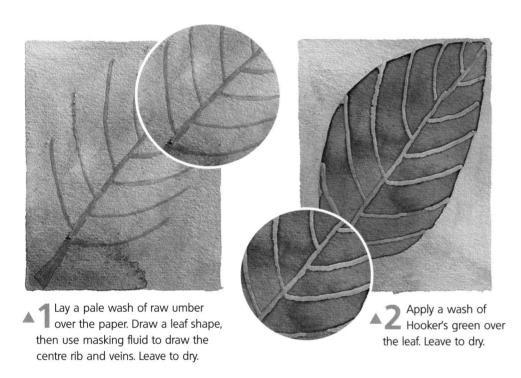

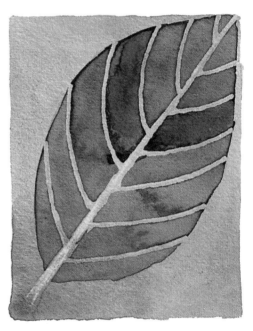

▲**1** Lay a pale wash of raw umber over the paper. Draw a leaf shape, then use masking fluid to draw the centre rib and veins. Leave to dry.

▲**2** Apply a wash of Hooker's green over the leaf. Leave to dry.

▲**3** Remove the masking fluid. Notice that the ribs and veins are not white – they are the colour of the background, although the mask has lifted a little of the pigment.

In practice

Using different applicators

You can apply masking fluid very precisely with a small brush or a dip pen. It is especially useful for reserving details, such as flowers in a hedgerow, or precise shapes, such as the veins on a leaf. It can also be applied with a sponge to create the texture of stonework.

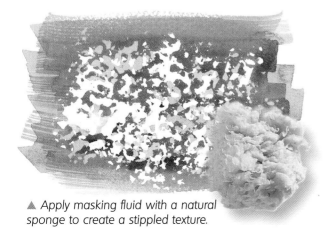

▲ Apply masking fluid with a natural sponge to create a stippled texture.

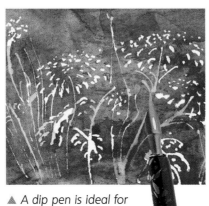

▲ A dip pen is ideal for the fine details of flowers.

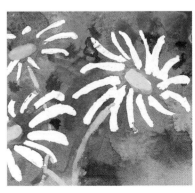

▲ Use a round brush to apply fluid for petals like these.

Masking with paper

Masks made of torn or cut paper are a versatile alternative to masking fluid for reserving white areas and creating edges.

Using paper to mask areas that you want to remain white or that have previousy laid washes is a quick and inexpensive option. It allows you to work freely, building up tones in one part of the picture while protecting adjacent areas; and it produces varied edges and graphic results you can't achieve with a brush.

You can cut paper to produce a crisp, sharp edge, or tear it to create a soft, irregular one. Papers tear in different ways, depending on their thickness and strength, so try different types. You can make a mask with a single edge. For example, tear paper to represent the line of a range of hills, then take a sky wash down to it – or use a torn edge to build up tones. You can also tear or cut a shape into the paper and use the mask to paint through like a stencil.

When your mask is in position, apply washes around it with a brush, or try sponging or spattering for softer effects. Attach the mask to the support with masking tape, then hold the edges down while you work to prevent paint seeping under it.

Taking a closer look

In this watercolour the artist has combined paper masking of the figure, wall and hills with a series of delicate washes. Touches of telling detail were applied wet on dry with the tip of a small brush.

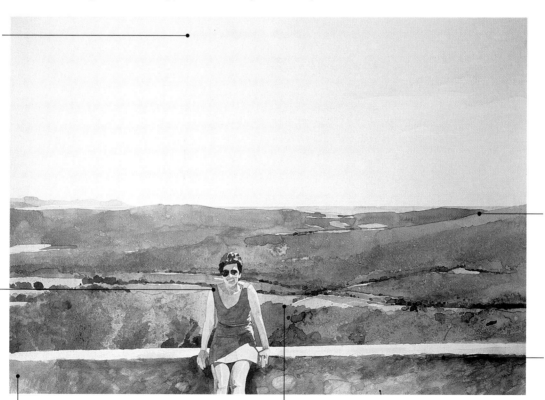

In the south of France
by *Ian Sidaway*

The sky, distant sea and general background washes were painted in after the wall and figure had been masked. The artist worked wet on dry, taking the green wash down to the edge of the mask.

When the paint was thoroughly dry, the figure and the dark hedgerows in the background were added.

The wall and figure in the foreground were masked off first.

The uneven line of the hedgerow directly behind the wall was masked with torn paper that gave a wiggly edge, then another mask with a straight edge was taped down to protect the wall. Colour was applied freely between.

Successive torn paper masks gave added texture to the receding hills.

The top edge of the wall was masked off with a torn and cut paper edge, then the stonework was painted in grey washes with some spattering.

Using masks

Cut or tear masks from pieces of spare paper, then use them with different paint techniques for a wide range of interesting effects.

When you come to choose paper for masking, try to use some that is fairly thick. Keep all your scraps and off-cuts – even small pieces may come in handy for creating instant masks while you are working on a painting. Start by laying your strip of torn paper in position across the support, then secure each side with masking tape so that it can't move and smudge the paint.

Try this!

▼ APPLYING A WASH

Apply a wash over a mask of torn paper, holding the edge down so the paint can't bleed under it. Lift the mask off gently. The resulting edge is crisp and precise.

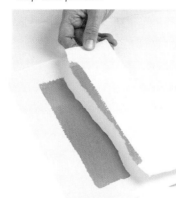

▼ SPATTERING

Spatter paint over another mask of torn paper, flicking it from a loaded brush in varying densities. Lift the mask. Notice how the spattering gives a soft, diffused edge.

In practice

Studies in fruit and vegetables

Paper masks can be used in all sorts of ways to describe natural forms and build up tones. Try these simple fruit and vegetable studies, experimenting with different techniques.

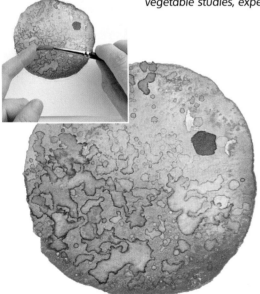

▶ Tear a lemon-shaped outline in watercolour paper and attach it to the support. Paint the fruit through the mask, using different washes and spattering in places. Lift the mask and see how the pigment migrates to the edge of the painted shape, creating a delicate outline.

▲ Paint the orange first, then cut a paper mask of the same shape. Lay it over the painted image and spatter clean water over it. The water modifies and dilutes the washes in small random shapes, perfectly depicting the texture of orange peel. Add the precise dark centre when the paint is dry.

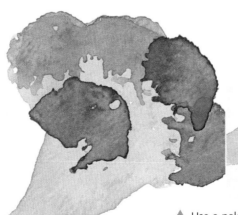

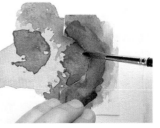

▲ Use a pale green wash to paint the shape of a broccoli floret. Tear a semi-circle mask and use it to build up successive tones of green, leaving each wash to dry before adding the next.

Masking tape

This can be used for reserving whites. It's quicker and more direct than masking fluid, and gives bold results.

Using masking tape helps you free up your technique and work with strong shapes. It stops you from fiddling and simplifies your approach so that you can enhance the abstract qualities of the image. Torn or cut edges create a variety of effects. You can mask off shapes so they retain the white of the paper, or mask off surrounding areas so you paint just the shape you have left – in other words, mask positive or negative shapes. Masking tape is also useful for protecting already painted areas from new washes. Use a low-tack tape that won't damage the paper or painted surface when you remove it, and choose a suitable width for your needs. The technique works well on HP and NOT papers and some highly sized Rough papers.

Key points

- Use masking tape to reserve whites as an alternative to masking fluid.

- Use a low-tack tape that won't damage the paper or painted surface.

- HP and NOT papers work best with masking tape.

- Create bold, graphic effects and crisp edges with cut masking tape.

- Tear the tape for softer edges.

- Mask negative or positive shapes.

In practice Aim for a striking landscape

The artist has use masking tape throughout this picture to create different effects. The resulting image has a graphic simplicity.

Seascape
by Ian Sidaway

The positive shapes of the clouds were torn from masking tape and applied to the paper to reserve the whites.

Successive applications of torn masking tape build up the shapes of the distant hills.

Masking tape around the picture area gives a crisp edge to the image.

For the sandy foreshore the masking tape was pressed down very lightly so the paint could creep underneath the tape.

Thin strips of tape cut with a knife create the cloud reflections in the water and indicate the rippled surface.

Creating effects with masking tape

Use masking tape to express a wide range of natural elements and to achieve various decorative and graphic effects.

You can exploit cut or torn edges, or a combination, for different effects. For more intricate shapes, cut the tape on the paper with a sharp craft knife – make sure you cut only the tape and not the paper too. Pencil lines are visible through the tape, so you can cut on the lines. Once the masking tape is in place you can safely paint over it, and the covered area will be reserved. However, if you stick the tape down less firmly, some of the paint may seep underneath – this can create interesting effects, too.

▲ A grid of thin strips of tape creates a crisp, graphic pattern – this is on HP paper.

There are a number of ways to use masking tape for different results – try them and think about your subject to decide which may be appropriate.

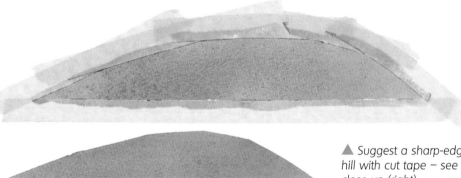

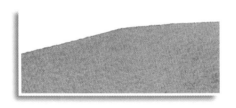

▲ Suggest a sharp-edged hill with cut tape – see close-up (right).

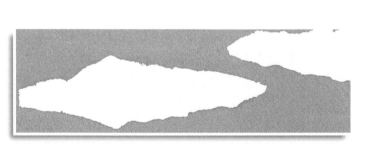

▲ Here torn masking tape on NOT paper masks out strong positive cloud shapes.

▲ Cut shapes directly on the paper. Paint them, then remove the tape. HP paper helps create very sharply defined outlines (left).

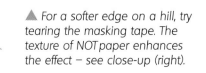

▲ For a softer edge on a hill, try tearing the masking tape. The texture of NOT paper enhances the effect – see close-up (right).

Masking with fabric

Masks made from torn, cut or frayed fabric create a variety of interesting edges that you can't achieve easily with a brush.

Fabrics can be used for reserving white areas and building tones and textures. The artist's studio provides a variety of material for generalized textures and descriptive edges. Primed and unprimed canvas, scrim (used for upholstery and in bookbinding), even an old, torn towel, are all useful. Cut heavy, closely woven fabrics, such as cotton duck or canvas, with smooth curves or angular edges to suggest a receding range of hills. Fray or pull the threads to give irregular, shaggy fringes for grass and foliage textures. Primed canvas can't be fringed but provides crisp, precise edges, while some fabrics, such as unprimed linen canvas, can be torn to give a straight but softer edge. Lightweight, openweave fabrics such as scrim or muslin allow the paint through. Use these to depict textures such as the surface of weathered masonry.

In practice — Landscape from fabric

Several different fabric masks have been used in this simple landscape to give descriptive edges and textures.

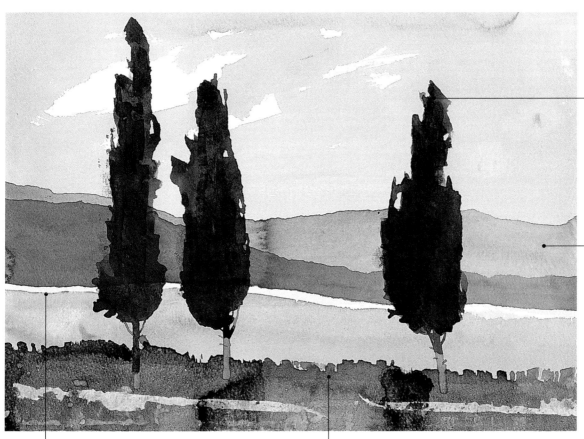

Poplars
by *Ian Sidaway*

Successive washes applied over a mask of ragged towelling build up the texture of the trees. Afterwards, the paint-sodden fabric has been used to 'print' the shadows.

The cut edge of cotton duck gives a crisp but jagged line that suggests distant mountains in silhouette.

Primed canvas creates a hard, precise edge.

Frayed unprimed canvas creates a broken edge that suggests long grass.

Key points

● Different fabrics give a wide range of different edges.

● Tear, cut or fray fabrics to achieve different edges.

● Reserve whites with fabric masks.

● Use successive fabric masks to build up a series of tones.

● Closely woven, heavyweight fabrics protect the masked off area.

● Openweave fabrics allow the paint through to the support to create a variety of loose textures.

Achieving different effects

Use cut fabric for sharply defined edges, or fray it for soft, irregular effects.

Closely woven, heavy fabrics protect the masked-off area. Use them freshly cut to create crisp edges, or pull threads and tease out the cut edge for softer, uneven lines. Place the mask in position on the support and secure it with masking tape. As you paint over it, hold the edge down to prevent unwanted seepage, and stop it moving and smudging. The finer the fabric and the more open the weave, the more the paint will seep through to the paper. For generalized textures with scrim, say, stipple with the brush to coax the paint through the fabric – the wetter the wash the more the colour will go through.

Try this!

Primed and unprimed canvas give several different kinds of masked edges. Try other fabrics for varied results.

◀ Cut a piece of unprimed canvas. Fray the edge to make a fringe. Attach the mask to the support and apply a wash. The threads separate and clump as you paint to give an uneven edge – suitable for grass and foliage textures.

▲ The canvas selvedge has a narrow fringed finish. This creates a ready-made broken edge. Parallel lines masked in this way could suggest a ploughed field.

▶ Cut cotton duck can give a hard edge that you can tease out to give a slightly ragged effect.

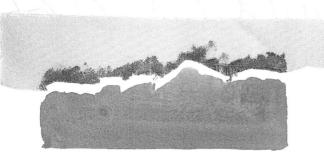

▲ Cut a piece of primed canvas – here the curve suggests a distant hilly skyline. Secure it to the support and apply a wash over the mask. Primed canvas won't fray, so the edge is crisp and precise.

◀ A piece of old towel gives a very rough and hairy edge. Towelling is absorbent – notice how some of the paint has soaked into the fabric and created a 'ghost' image in places.

▶ Scrim has an open weave which lets paint through. Notice that when the brush is drier the texture of the weave is more obvious.

Texture mediums

Additives that change the way washes behave can help you produce effects that are not possible with watercolour on its own.

Texture mediums change the nature of watercolour and allow you to produce unusual paint effects and textures that you can't achieve in the conventional way. Some contain fine particles that mix with the paint to create texture in a single wash, or build up an impasto-like effect with multiple washes. There are mediums specifically for use with watercolour. These remain water-soluble so you can always rewet them to produce further effects. You can use acrylic mediums with watercolour, but remember that once these are dry, they can't be rewetted.

These additives increase the versatility of watercolour, but don't overuse them or the effects lose their impact.

Try this!

The only way to find out if you like the effects of texture mediums is to try them out. Experiment to see what textures and surfaces they suggest.

◀ **AQUAPASTO**
This watercolour gel thickens washes so you can work wet in wet without the usual flaring and bleeding. Apply the thickened wash to the paper, then dip a brush into several washes to make multicoloured brush marks. Notice that the colours don't spread out.

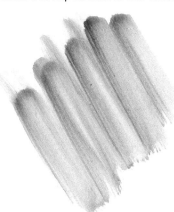

▼ **TEXTURE MEDIUM**
More fluid than Aquapasto, this gives a little more texture. It contains particles that give a slight low-relief effect. Apply it directly on to the paper, then apply a wash, or mix it with watercolour first. Try working into the wash with paint shapers.

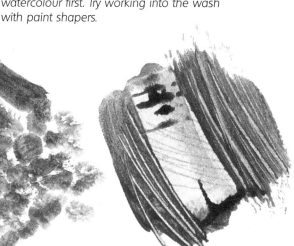

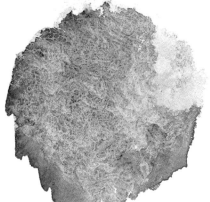

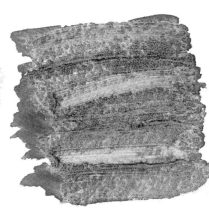

▲ **MEDIUM TEXTURE GEL FOR ACRYLIC**
This contains coarser particles than the watercolour texture medium. These pick up the light and create a bolder effect, with a three-dimensional surface texture you can almost mould. Experiment with the medium by applying it directly on to the paper or mixing it with a wash first.

Using texture mediums

Texture mediums add a variety of unusual and lively textures to watercolour, but be careful not to overuse them.

These additives are interesting to work with and extend the range of effects you can achieve with watercolour. But, like all special effects, they are useful only if they answer your needs and you are comfortable using them. They may create exactly the expressive texture or descriptive detail that you need in a painting. Remember to be selective – they can produce stunning effects but if you overuse them your work will become mannered and stylized. Don't use them as substitutes for careful observation. Apply them where they really count – to give texture to a distant field, or to add expressive detail to a thick tangle of rough grasses in the foreground. Experiment first on scrap paper if you're unsure of the effect you're after.

Tip

Don't forget to wash your brushes in water as soon as you've used acrylic texture mediums. If you don't, they go hard and you can't resurrect them for future use.

In practice Conveying natural textures in a landscape

Texture mediums can help you give the feel of the countryside. Try the scene below and familiarize yourself with the various effects they create.

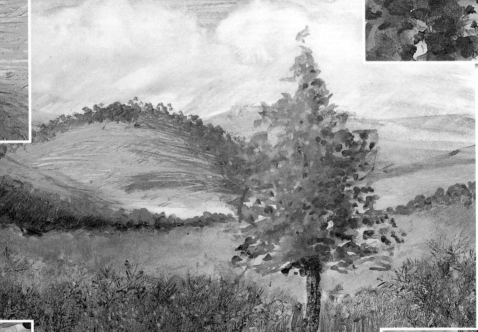

▲ *To enliven the grassy hill, work back into washes mixed with watercolour texture medium. Then use medium acrylic texture gel for the ploughed field.*

▲ *Aquapasto mixed with the leaf washes enables you to work wet in wet to build up the pattern of the foliage and give a sense of depth.*

Over the hills by *Kate Gwynn*

◀ *Mix fine acrylic texture gel with the grass wash so you can draw back into it with paint shapers. Then print with a conifer sprig, using a darker wash mixed with the same gel.*

▶ *Medium acrylic texture gel gives a realistic three dimensional roughness to the tree bark.*

Wax resists

Using wax enables you to introduce expressive, spontaneous textures into your painting and is perfect for depicting natural surfaces.

This technique is based on the principle that wax and water don't mix. When you draw with wax, then apply a wash on top, the wax repels the wash so the paint runs off or settles in droplets on the surface. The technique, which is less precise than using masking fluid, is an excellent way to add some lively, descriptive textures to your painting.

You can use an ordinary household candle on pristine paper to reserve whites – or rub the wax over a dry wash, adding more washes to create coloured textures The results vary according to how heavily you apply the wax, the kind of marks you make and the type of paper you use. A candle rubbed over textured Rough paper produces a speckled pattern with the white of the paper showing through, and if the paper is laid over a textured surface, you can produce a frottage resist (see page 163).

(see page 163)

Try this!

Try these exercises to see what effects are possible with wax resists. Then experiment with different papers and different wax marks to see how the results vary.

◀ Scribble randomly on Rough paper with a candle, then flood in a blue wash. Watch how the paint behaves on the waxed areas, and notice that the texture of the paper causes broken lines and a speckled texture.

◀ Lay a blue wash and allow it to dry completely. Scribble on top with a candle, then flood in a stronger blue wash to a create coloured texture.

▶ This time try scribbling with a green wax crayon and then apply a green wash. Again the paint deserts the waxed areas – but you can never predict exactly how the wash will behave. Here droplets of colour have formed in places.

▶ Try building up textures with different colours. Scribble with a coloured wax crayon, then overpaint with a wash of a different colour.

Using wax resists

Use this technique to imitate natural textures and create patterns by building up layers of wax and paint.

Wax resists can be used to create a whole variety of generalized textures and patterns in your painting, or to help depict specific surfaces such as foliage, bark, rocks or ripples on water.

You can build up layers of wax and watercolour to 'mould' the picture surface and create descriptive effects. For instance, make sweeping strokes with the side of a candle to mask a broad band, or use a sharpened candle or wax crayon to make more controlled marks and patterns. Experiment with random scribbles, flowing lines or regular stripes. Coloured wax crayons and oil pastels add a lively range of colours to the technique.

Note that with ordinary white candle wax, you may find it difficult to spot the scribbles you've made on white paper. Hold it up to a light source to check.

Tip

Coloured wax crayons and oil pastels both resist watercolour paint, exactly like an ordinary household candle. They add another dimension to the technique – there are lots of different colours to choose from. Note that, unlike masking fluid, the wax resist is permanent – it remains on the paper.

In practice A chalk landscape

Wax resists are a useful addition to your artistic repertoire. This study shows how both candle wax and coloured wax crayons can be used in a variety of ways to add textures to sky, grass meadows, ploughed fields and waving grasses.

**Cornfields
by Kate Gwynn**

Broad sweeps with the side of a candle, overlaid with very wet washes of cobalt blue and Prussian blue, depict a blustery summer sky.

Green candle wax overpainted with a variegated green wash combine to suggest a wooded hillside.

The impression of waving corn is created with a yellow ochre wash, overdrawn with vigorous curving strokes of a wax candle. Further layers of wash and candlewax advance the foreground and add an energetic sense of movement.

Overpainted wax on Rough paper creates stippling that conveys the grassy texture of distant meadows. The green wash is applied over green wax crayon, and the pale yellow wash over natural candlewax.

A wash laid over parallel lines drawn with a sharpened candle is a perfect shorthand way of rendering a stubble field.

Using salt for texture

Sprinkling salt into a wet wash creates distinctive results that can't be achieved in any other way. Use it to express specific effects or for generalized textural interest.

Applying salt to a wet wash has a magical effect. The salt soaks up the paint, leaving a scattered pattern of light spots with a delicate, crystalline appearance. The density of the resulting texture depends on how thickly you sprinkle the salt. Like all special effects techniques, salting loses its impact if you over-use it. Keep it for depicting a snow storm, a starry sky, a daisy meadow, the sparkle of sun on water or frost on an icy puddle.

Results are dictated by the wetness of the wash, the type of pigment and paper, the kind of salt and the way you sprinkle it. Use a single application, or apply further washes and more salt to build up elaborate textures.

Key points

● Sprinkle salt on to wet washes.

● Salt creates a crystalline pattern as it absorbs the wet paint.

● Different salts have different effects.

● Different papers create different results.

● Washes take longer to dry after salting.

● Brush the salt off when the wash is dry.

● Build up elaborate textures with layers of washes and salt.

Taking a closer look

Salt is used to add sparkle to the water in this river scene and to introduce surface texture in the foreground.

**Guadalupe River, Texas
by Shirley Felts**

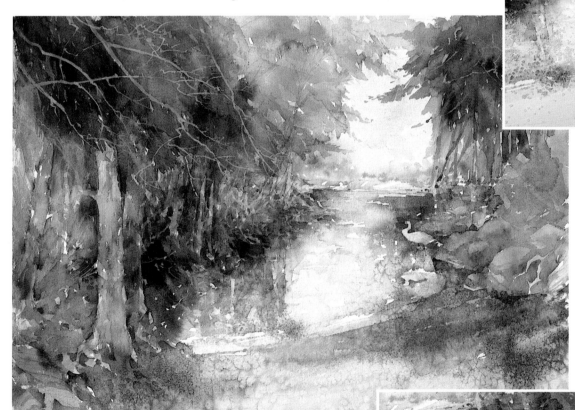

▲ *The artist added more washes and salt to create a rich, mottled texture. She confined the sparkling salt effects to the foreground water. This provided maximum impact and gave a strong sense of recession.*

▲ *The artist wanted to depict the intense light reflected in the surface of the water. To achieve this, coarse sea salt was scattered on to the wet wash in the foreground.*

◀ *The salt was left to absorb the colour while the wash dried. The artist sprinkled it more thickly in some places than others to capture the light filtering through the overhanging trees and catching the water unevenly.*

Salt effects

You can achieve a wide variety of textures and effects with salt, depending on how you use it and the type of salt you choose.

When you use salt, the wetness of the wash is crucial. If it is very wet, some of the salt dissolves, creating large star-bursts that run into each other. If the wash is too dry, the salt has no effect. For the best effects, scatter the salt when the wash is just beginning to lose its shine. You can apply the salt straight from a shaker or carton, but for more control, pinch a few grains between thumb and forefinger and sprinkle it exactly where you want it to go. Different densities of texture are achieved by scattering the salt more or less thickly.

Different salts create different effects. Try coarsely crushed rock or sea salt, or use fine table salt. The paper also influences the effect – try HP and NOT surfaces. Different pigments respond in different ways, too. Wait until the wash is completely dry before you brush off the salt – remember drying takes longer than normal. Always allow the first wash to dry and brush off the salt before you repeat the process.

Try this!

Experiment with salt on washes of varying strengths and different pigments. Try the effect on different papers.

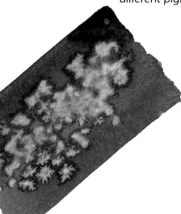

◀ **STRONG WASH**
Apply a concentrated wash of Prussian blue, and sprinkle salt on it. The pattern is fairly contained, and the light marks tend to be separate and distinct.

▲ **HP PAPER**
Scatter salt on to a wash applied to an HP surface. The pattern retains its delicate detail but the pigment migrates to the edges.

▼ **DILUTE WASH**
Add more water to the Prussian blue wash and sprinkle salt on it again. This time the salt crystals start to dissolve in the very wet wash, and the star-bursts flare out into one another more.

◀ **ROUGH PAPER**
On a Rough paper the edges of the salt pattern are less delicate and the texture created is bolder.

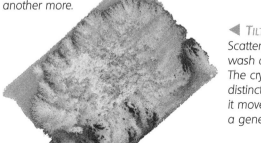

◀ **TILTING THE PAPER**
Scatter plenty of salt on to a fluid wash and tilt the paper while it dries. The crystalline pattern is no longer distinct. The salt absorbs the wash as it moves down the page and creates a general mottled texture.

Sprayed effects

You can use diffusers and sprayers to send a fine spattering of paint across your support – ideal for broken colour and textural effects.

Diffusers and spray bottles offer more control and finer effects than spattering or flicking. Use them for large areas and decorative backgrounds, or try spraying against a paper mask or through a stencil.

Diffusers, sold in art shops, look like jointed tubes – you dip one end into the wash, then blow the paint across the surface. The spray is easier to control than spray from a spray bottle. Diffusers are economical – you can use them with washes mixed in a palette.

Small spray bottles from chemists and hardware shops are ideal for bold, uneven effects. They tend to clog easily, so avoid granulating pigments.

Sprayed effects work best with strong colours, so use lots of pigment in your wash – or try liquid watercolour or ink.

Taking a closer look

In this semi-abstract painting the artist has applied watercolour with a diffuser and spray bottle to depict the grainy textures of sand and stone.

**Desert palms
by Ian Sidaway**

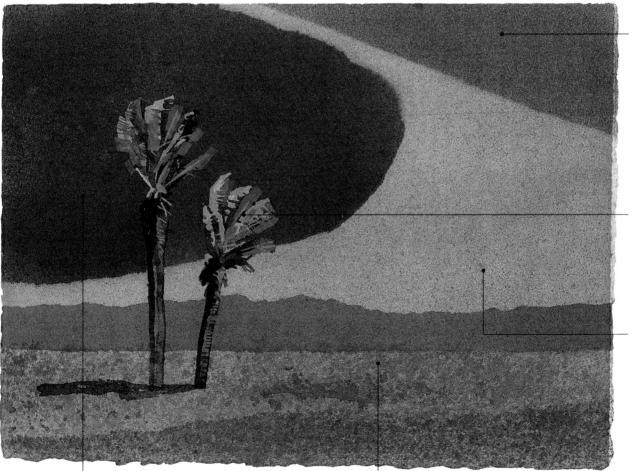

The diffuser was used to apply a heavy spray of deep orange over the paler orange ground.

The artist masked out the trees with masking fluid and painted them last using gouache and watercolour.

Deep orange was used with the diffuser to give a fine stippled effect.

A heavy spray was applied with the diffuser – paler areas were masked off with torn paper.

Several layers of colour, applied wet on dry with a spray bottle, suggest a gravelly texture.

Using diffusers and sprayers

Experiment with the many effects you can create with diffusers and sprayers – from fine and heavy spattering to two-tone mixes and stencilling.

Try this!

These devices can be used for a variety of naturalistic and abstract effects. Try out these different techniques to enhance your work.

Spray bottles

◀ USING A HAND SPRAY
Mix a strong wash, making enough to cover the bottom of the uptake tube in the bottle. Spray the colour across the surface.

▲ With the support at an angle, spray on the colour, then lay the board flat to control the colour runs.

◀ Spray on one colour, tilting the support so the colour runs. Allow to dry. RInse out the spray bottle then spray on a second colour.

Diffusers

◀ Spray one colour, building up the layers as required (bottom left). For a two-colour effect, allow the first colour to dry, rinse out the diffuser, and spray on the second colour (top left).

▲ Spray over a shape such as a leaf, feather or shell using the diffuser.

◀ Paint a wash on to the support, then spray water along one edge to soften it.

◀ Spray the colour through a stencil, such as a paper doily.

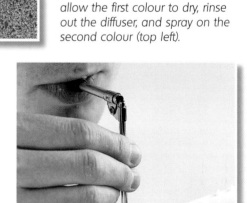

▲ USING A DIFFUSER
Dip the diffuser into a strong wash. Blow a fine spray across the support – you'll need to blow quite hard. Build up the colour in layers.

Introducing gum arabic

Gum arabic is an additive that increases the versatility of watercolours – it allows you to keep the paint fluid on the surface for longer so you can work into it and scrape away for different textural effects.

Gum arabic, derived from the sap of tropical acacia trees, can be bought as small lumps, in crystals, or as a liquid. In its liquid form it is transparent and slightly glutinous. You may find it called 'gum arabic', or 'gum water' – this is gum diluted with water. Gum arabic is the binder which holds the pigments together in transparent watercolour and gouache, and helps the paint to adhere to the paper. It is also used as a 'painting medium' – a substance added to the paint to change the way it behaves.

Adding gum arabic to watercolour paint changes its quality dramatically, making it thicker and much more responsive. The gum helps the paint flow, holds the pigment in suspension and adds a translucent quality that gives brilliance to the picture surface. It also slows down drying, so you have more time to play around with the paint as you go along.

Key points

Gum arabic has a range of effects:

● Paint is thicker and more responsive.

● Drying times are slowed down.

● Colours are more translucent and more brilliant.

● Paint becomes glossy, with a sheen.

● You can re-wet washes so you can lift colour and create textures.

● You can apply a gloss glaze to unify a picture if the elements become too disparate.

Taking a closer look

In this autumnal study the artist has used gum arabic to change the consistency of the paint film, so creating an image full of fluid lines and descriptive textures.

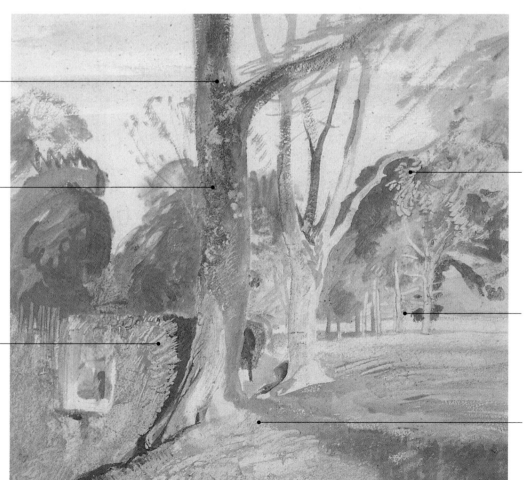

Woods
by Charles Knight

Blotting the wet paint creates the effect of lichen.

Fine scratched lines suggest the texture of bark.

Sgraffitoed marks (see page 234) capture the texture of a beech hedge in autumn.

In places the paint has an almost treacly appearance. Gum arabic has allowed the artist to work into the colour vigorously and freely.

Fluid lines drawn into gum-thickened paint with the tip of a brush handle depict the sinuous trunks and branches of distant trees.

Broad marks made with a fingernail suggest the broken ground beneath the tree.

Gum arabic effects

Experiment by adding gum arabic to your washes – you'll find it transforms the way the paint behaves.

Gum arabic is easy to use. Simply pour some into a mixing saucer. Dip a clean brush into the gum, carry it over to the wash and mix it well.

Mixing paints with gum arabic gives washes more body, making the fluid paint less runny, more viscous and easier to manipulate. Paint becomes glossy and more transparent. With paint mixed with gum arabic, every brushstroke remains visible unless you go over it. Swirling, circular motions with the brush create a lively, busy texture.

You can also draw into a damp wash with the end of your brush. If the paint is thick enough, you can scratch right back to the paper to leave a white line. You can do the same with your fingernail, a comb or a piece of card, creating random or squiggly lines (sgraffito). If you scrub into a gum-water wash with a brush or piece of tissue, you make little air bubbles. These burst, creating a speckled effect that remains on the surface of the paper when the paint dries, making a highly textured surface.

Try this!

Mix gum arabic with the colours in your paintbox and you will see that each responds in a slightly different way. Try out various techniques to see what effects you can achieve.

▲ WITHOUT GUM ARABIC
Load a brush with cadmium red and lay a band on the paper. It is a relatively opaque, matt colour.

▲ WITH GUM ARABIC
When gum is added to cadmium red the paint becomes more transparent and brilliant and dries with a glossy sheen.

▲ SPATTERING WITH WATER
Lay a wash of paint mixed with gum arabic. When it is dry, spatter clean water over it. It dries to give a randomly dappled effect.

▲ DRAWING WITH WATER
Lay a wash mixed with gum arabic and allow to dry. Load a brush with water, paint a grid of lines and blot with tissue.

▲ SGRAFFITO
Use a painting knife to scratch into a still-wet wash. The gum arabic adds definition and holds the mark.

▲ SMEARING WITH A KNIFE
Mix gum arabic with two colours, then apply them to the surface with a painting knife, smearing them to give a marbled effect.

Looking at granulation

When specific pigments separate from the water in a wet wash, the result is a grainy, mottled texture that you can exploit to add expressive surface interest.

Certain pigments separate in a wet wash, causing granulation. This results in grainy, speckled textures. The effects may be somewhat unpredictable but they can produce some of the happy accidents in water-colour. Using this technique is often more effective than painting an area in a flat colour – for example, shadow areas, which otherwise may be dull, can benefit from granulation.

Pigments that granulate include ultramarine and cerulean blue, and earth colours such as burnt umber, raw umber, burnt sienna and sepia. In order to produce the same range of effects with non-granulating colours, mix in some granulation medium.

The choice of paper affects the granulation – for maximum effect use Rough, and for a less pronounced result use a NOT surface. Ultimately, the only way to discover how pigments granulate is by trial and error, especially as the characteristics of pigments vary according to the manufacturer.

Key points

- Granulation occurs when a pigment separates from the water in a wet wash.

- Granulation causes a grainy, speckled texture that gives added surface detail.

- Only certain pigments granulate.

- Add granulation medium to other pigments to create a similar effect.

- Some pigments granulate only if they are applied over an earlier dry wash.

- If washes are too wet, the granulation effect may be unnoticeable.

- Different papers influence the degree of granulation.

Taking a closer look

In this dramatic evening scene, the artist has exploited the granulation effect of certain pigments to enhance the moody atmosphere of the stormy sunset.

Sunset, Chatham waterfront by Roy Hammond

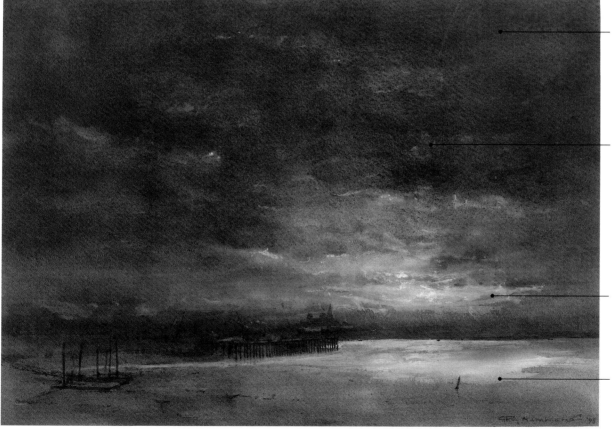

The granulation of the sky washes helps to convey the luminosity of the night sky and adds to the glowering mood of the storm clouds.

The reflections of the setting sun in the water are smooth and glassy, while granulation adds to the sense of turbulence in the sky.

The strong use of colour and tone make the light from the sun, and its watery reflections, positively dazzling.

The artist reintroduced granulation effects in the foreground washes. The grainy effect captures the texture of the foreshore.

Exploiting the effects

The best way to find out about granulation is to experiment with a whole range of different pigments.

Look at manufacturers' colour charts to find out which colours granulate, then experiment to see how the pigments behave. Some granulate on their own, others respond more strongly in a mix. A number of them granulate only when laid over a previous, dry wash. If you apply too much water the effect may be slight. Experiment with mixing non-granulating colours with granulation medium. For maximum effect, mix the colours with the medium alone – if you dilute them further with water you get different results again. You can also mix granulation medium with granulating pigments for an enhanced effect.

When you're familiar with the effects of granulation, decide how best to exploit them in your work. Be selective – it isn't desirable to use granulation effects over the entire picture area.

Tip

Help the granulation process along by tapping or shaking the board while the wash is still wet. This encourages the pigment to settle in the indentations of the paper.

Try this!

Granulation effects vary considerably – it depends on how loose the wash is, the pigments you use and the paper you work on. Try the examples below, then experiment with other permutations.

Granulation mixes

▲ **CERULEAN BLUE WITH BURNT SIENNA**
Both these pigments granulate on their own. Mixed together, the effect is pronounced.

▲ **PHTHALO BLUE WITH RAW UMBER**
Raw umber granulates strongly. Mixed with phthalo blue it produces a rough texture.

▲ **ULTRAMARINE WITH SEPIA**
This mix creates a subtle, rather gently mottled texture.

Using granulation medium

▲ **PURPLE MADDER**
Mixed with granulation medium, the result is a softer, somewhat more mottled texture.

▲ **INDIAN RED**
With granulation medium, this separates into distinct particles, creating a very grainy effect.

▲ **HOOKER'S GREEN DEEP**
Adding granulation medium results in very mottled and grainy textures.

Exploring wetting agents

Wetting agents are used with watercolour to increase its flow. They can also create a host of unusual textures in wet washes.

Wetting agents are additives that increase the natural flow of watercolour. You can add them to your washes or apply them directly on to the paper. Water has a high surface tension – in other words it tends to form droplets rather than spread out to wet the surface. Also, some surfaces, such as very hard, sized papers, are less 'wettable' than others. A wetting agent applied to such papers reduces the surface tension. This makes the paint flow more easily and evenly across the surface.

Ox gall is the traditional wetting agent. You can use it to make washes flow more freely, or you can apply it to give interesting, unexpected textures to wet washes. The results are unpredictable, but if you are prepared to experiment, the unusual effects can bring an exciting spontaneity to your work.

Taking a closer look

The artist has captured the stillness of this moonlit scene. Ox gall helped him to manipulate his sky washes to depict the eerie luminosity of the night sky.

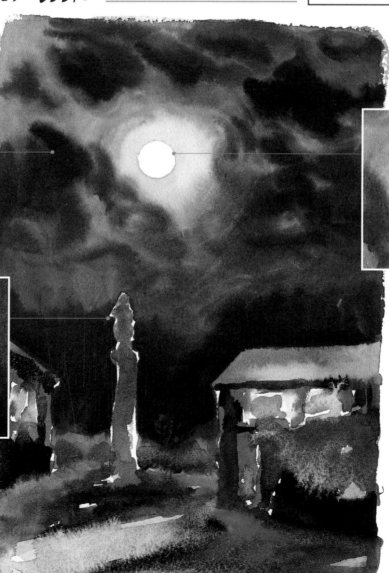

St George Memorial, Burton Latimer by *Richard Allen*

Cloud formations
Working wet in wet, the artist added a darker mix of the sky wash. The ox gall in the first wash allows the paint to flow freely to suggest cloud formations.

Moon and halo
After reserving the white of the moon, the artist applied a wash of water with a little ox gall to the entire sky area. Then he painted the halo around the moon before flooding in the first sky wash. The ox gall enabled the wash to flow freely.

Reflections
Touches of reserved white stand for the stark reflections of the moonlight, adding to the theatrical mood of the dramatically lit scene.

Using ox gall

Used imaginatively, ox gall helps you to produce lively and interesting textures and effects in wet washes.

Add a drop of ox gall to a wash to enhance its flow, or, for the same effect, mix it with clear water and apply it to the paper first. Used straight from the bottle, it reacts instantly with wet washes, creating many surprising effects that continue to develop as the wash dries. It's fun to use in this less traditional way if you are willing to experiment and adapt – the results might give you just the texture you need in a painting.

Tip

Watercolour medium is an additive that enhances the flow of washes in a similar way to ox gall. You can use it to achieve a whole range of special effects.

Try this!

Try ox gall in wet washes. Drop it, spatter it, vary the wetness, use staining and non-staining pigments. Apply an ox gall wash and add colour to it while still wet. Try Rough and HP surfaces as well as NOT.

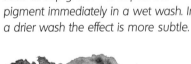

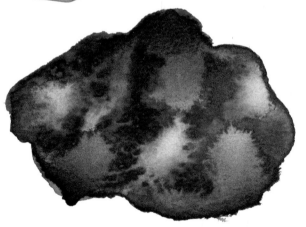

▲ Drop ox gall into a staining pigment such as sap green – it dispels the pigment immediately in a wet wash. In a drier wash the effect is more subtle.

▲ In an earth colour such as burnt sienna, ox gall reacts quite slowly, creating more subtle gradations of tone.

▶ Touch the tip of the brush into wet ox gall – even widely spaced marks spread until they merge together.

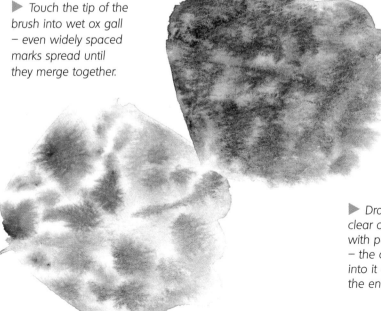

▶ Draw into a clear ox gall wash with pen and brush – the colour seeps into it and stains the entire area.

How to use alcohol

Alcohol has dramatic, if unpredictable, effects on wet washes. Used with discretion, it provides another useful string to the artist's bow.

The pure alcohol you buy from the chemist can be applied to wet washes to create a whole range of special effects. Because its chemical make-up is completely different from that of watercolour, it rapidly dispels the pigment in a wash. The resulting effects depend on the wetness of the wash, the pigment you use and how you apply the alcohol. You can create generalized textures, or produce larger bursts or trails of modified colour.

You can use the effects for specific descriptive purposes – to depict the texture of weathered stone or street lights in the rain, for example – or apply them to your work in a purely abstract way. As with watercolour itself, the unpredictability of alcohol is part of its charm and it's worth investigating the effects you can achieve. However, use it with restraint – as always, overuse of a particular technique dilutes the impact you are trying to create.

Key points

- Use pure alcohol, bought from a chemist – not the sort you drink!
- Alcohol dispels pigment In wet washes
- If the wash is too wet the colour fills back in as it dries.
- In a dry wash the alcohol has no effect.
- Spatter alcohol for generalized textures.
- Drop or trail it for larger areas of modified colour.
- Granulating and non-granulating pigments respond differently to alcohol.

Taking a closer look

In this painting, alcohol has been used in several different ways, each one to depict a different surface.

**View of Venice
by Ian Sidaway**

A dropper and a brush were both used to apply alcohol to the wet sky wash, creating softly muted cloud effects.

A dip pen loaded with alcohol adds telling textural detail to the weathered wooden posts.

The rippling water has been depicted with the help of alcohol, used under and over wet washes. A spattering of alcohol added the touches of light glistening on the surface.

Painting with alcohol

You can apply alcohol to your painting in many ways – and each one gives a very different result.

The way you choose to apply alcohol depends on the subject you are painting. Spatter or flick it from a brush to create broad textural effects – useful for a pebbly beach, weathered masonry or a night sky. Drop, dribble or trail it into the wash for more specific results – light effects on water, flowers in a field or a cloudy sky perhaps. Apply it a little at a time with a brush, a pen or a dropper. The wetness of the wash is crucial. If it is too wet, the reaction is immediate and dramatic as it dispels the pigment, but a second later the colour floods back and the effect is lost. If it's too dry, the alcohol has no effect at all. Also, the reaction varies according to the pigment. You need to test it for yourself to see what happens.

> ## Tip
>
> **You can use surgical methylated spirits instead of alcohol. The effects are similar, but the marks are softer – it's not strong enough to hold back the pigment completely, so the effects diminish and edges blur as the wash dries.**

Try this!

You can see from these examples that it's possible to create a wide range of different effects with alcohol. Try these for yourself to get the feel of this useful additive.

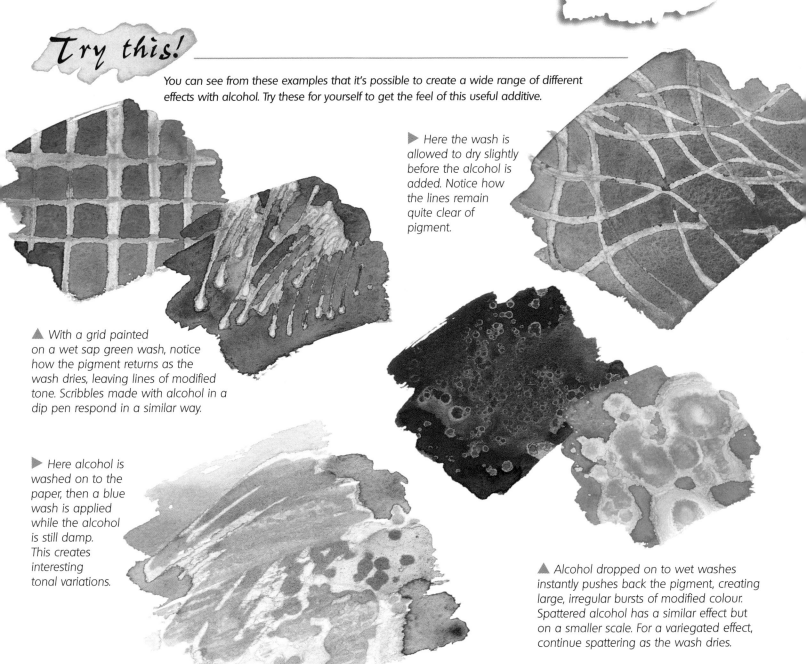

▶ Here the wash is allowed to dry slightly before the alcohol is added. Notice how the lines remain quite clear of pigment.

▲ With a grid painted on a wet sap green wash, notice how the pigment returns as the wash dries, leaving lines of modified tone. Scribbles made with alcohol in a dip pen respond in a similar way.

▶ Here alcohol is washed on to the paper, then a blue wash is applied while the alcohol is still damp. This creates interesting tonal variations.

▲ Alcohol dropped on to wet washes instantly pushes back the pigment, creating large, irregular bursts of modified colour. Spattered alcohol has a similar effect but on a smaller scale. For a variegated effect, continue spattering as the wash dries.

Soap effects

Mixing soap with watercolour changes the way the paint behaves so you can create marks and build up textures wet in wet.

Soap gives body to watercolour and prevents it from spreading, so it can hold brushmarks. Overlaid strokes retain definition – usually they merge into each other. This means you can build up textures wet in wet with layers of distinct marks – useful for grass, foliage or fur. In broader areas of colour, you can manipulate the paint for more general textures that dry with a mottled effect to suggest weathered wood, stone or bark. Sometimes bubbles break, causing pinpricks in the paint that add surface interest – mix gently if you want to avoid this. Soap disperses colour when you spatter or brush it on to wet washes. Just a small amount prevents paint from running and separating on a glossy or greasy surface. Use white, unperfumed household soap only, and either mix it with the paint or apply soapy water to the paper first.

Try this!

With soap you can work wet in wet without the colours merging. Try these examples to see the effect it has.

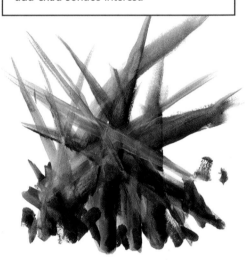

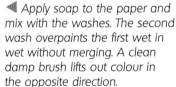

▶ *Load a brush with two soapy mixtures – here lemon yellow and indigo – and overlay brushmarks. They retain their integrity and the colours remain distinct.*

▲ *Load a brush with colour, then rub it in the soap. Paint a spiral working from the centre out. The brushmark covers its track each time it crosses, creating an effective sense of recession.*

◀ *Overlay brushmarks in the same way with a single green. This perfectly suggests the texture of long grass. Notice the sense of depth as the later marks advance.*

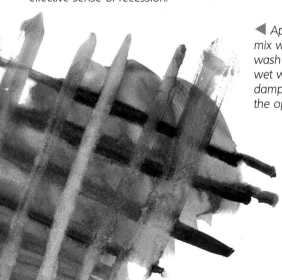

◀ *Apply soap to the paper and mix with the washes. The second wash overpaints the first wet in wet without merging. A clean damp brush lifts out colour in the opposite direction.*

▶ *Drop soapy water on to a wash and paint across it with a brush. The soap disperses the pigment and also stops the colour returning.*

Using soap

Try it out on scrap paper first, so you know how it feels before you embark on a full-scale painting.

In practice — River scene

Here soap was used before and during the painting. This kept the washes controllable so they could be worked without letting them dry at any stage.

Tip

Masking fluid can damage your brush. Put soap on the bristles first to form a protective layer. When you have finished, simply wash off the soap and masking fluid residue.

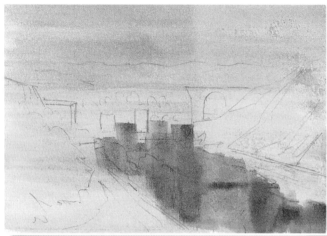

1 Wet the paper with plenty of soapy water. Apply a raw sienna wash over the whole picture area, then add cobalt blue for the sky and water. Darken the water with yellow ochre. Keep the work damp and keep adding soap.

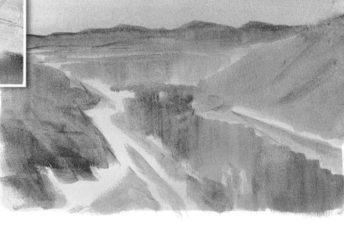

2 Paint the distant hills with ultramarine. Brush across the far fields and the slopes on either side of the river with Hooker's green. Brush in light red to advance the foreground.

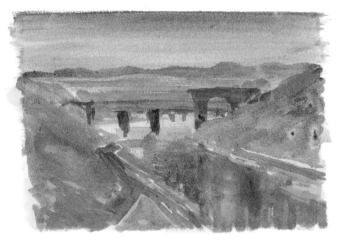

3 Strengthen the tracks with light red. Roughly block in the near and far bridges with raw umber. The painting is still wet so colours can be strengthened, lifted, and overpainted with lighter or darker colours.

4 Paint clouds in Chinese white/raw sienna, with cobalt blue/raw sienna shadows. Work in more raw sienna/yellow ochre, darkened with cobalt blue on the river. Brighten reflections with cobalt blue/white. Brush light red into the river and lift out colour in horizontal streaks. Add white highlights. Darken the bridge, and add white to earth colours for bridge highlights.

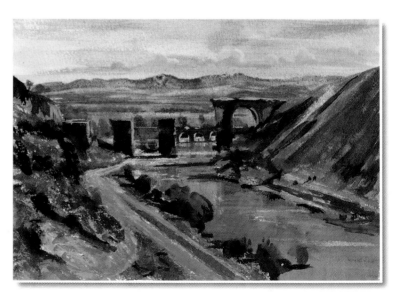

Bleach effects

Using bleach in your paintings may seem unusual, but it lifts pigment to reveal white paper – perfect for highlights and textural interest.

Whether applied with a brush, sprayed, spattered or sponged, household bleach can be used to create highlights in painted areas and to lighten or manipulate laid colour. Its effect on liquid watercolour is dramatic – with ordinary pan or tube watercolour the action of bleach is less pronounced, but you can nevertheless create fascinating surface textures and soft-edged pale areas.

Bleach has an instant effect on wet washes; with dry washes you should work it into the paint and then wait a while. Semi-dry washes often give the best results.

Bleach affects some pigments more than others, so test on scrap paper before using on a painting. Washes laid over bleached areas tend to dry darker than usual. Always use an old brush since bleach damages the bristles.

Key points

- Bleach burns out colour and creates textural effects.

- Apply bleach with a brush, pen or spray bottle or spatter it with a toothbrush.

- Results vary for different pigments.

- Bleach works best on semi-dry washes. Results are slow on dry washes, and unpredictable on wet.

- Bleach leaves soft edges on watercolour. On inks and liquid watercolour the edges are harder.

- Bleach alters the paper surface, so later washes may be darker than normal.

Taking a closer look

In this colourful painting, the artist has used bleach in a variety of ways to describe the different surfaces and textures of an industrial plant in the countryside.

Industrial landscape by Kate Gwynn

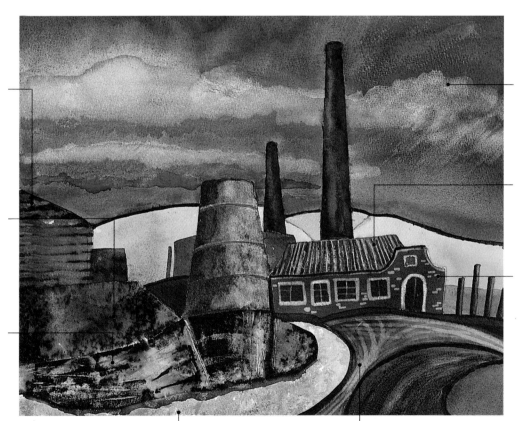

For the wood cladding, the artist brushed bleach over a watercolour wash, then lifted out colour with corrugated card.

Here the mottled surface of old concrete is created by lifting out colour with a brush dipped in dilute bleach.

Indian ink laid over dry watercolour, then brushed with bleach and scratched with the end of the brush, suggests the texture of a deteriorating concrete wall.

Bleach lifts out colour and kitchen paper dragged over the top creates the effect of clouds in the sky.

The roof ridges were drawn into an almost dry wash using a bamboo pen dipped in bleach.

The artist painted the house with liquid watercolour and 'drew' the features of the house using bleach with a brush and bamboo pen.

For the grainy surface of tarmac, bleach was brushed over the road and colour lifted out with crumpled kitchen paper.

Bleach applied with a wet brush creates clear crop lines. Dry brushed bleach makes soft stripes, suggesting a ploughed field.

Different ways with bleach

Bleach can have unpredictable results, so experiment first with different pigments and create a portfolio of samples to refer to.

Try this!

Use a brush, spray bottle and pen to create a range of effects. Try a variety of pigments, too – different colours give different results.

◄ *Bleach spattered on to a wet wash immediately burns off colour, creating bursts and speckles of white. It's easier to control on a semi-dry wash (inset left), where it spreads less readily and leaves finer, less distinct pale areas. On a dry wash (inset below) the pigment is only partially lifted.*

◄ *Alizarin crimson watercolour responds well to bleach – here bleach makes soft-edged highlights on the apple. Green was mixed with crimson for the darker tones.*

► *Bleach dropped into black ink with a brush creates soft, sepia-toned areas.*

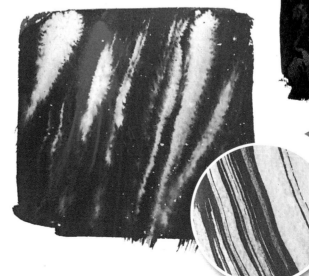

▲ *This spidery, cloudy effect was achieved by spattering bleach over a wash and then drawing in it with a pen. A second wash laid on top gives a purplish hue over the bleached areas; where the bleach was thickest the pigment forms a grey haze.*

◄ *Here bleach is brushed into a wet wash to create soft-edged pale streaks and interesting tonal variations. On a dry wash (inset) the same technique leaves distinct, sharp-edged stripes.*

Non-waterproof inks

Try out some non-waterproof inks to introduce an element of serendipity into your line and wash work.

Most inks are shellac-based and waterproof when dry. Once you have made a line drawing in ink you can apply watercolour washes over it without disturbing the lines or contaminating the wash. Non-waterproof inks are entirely different.

The dry line can be re-wetted to soften it, knock it back or create a wash. The ease with which you can do this depends on the character of the ink and the nature of the support – the best way of familiarizing yourself with the possibilities is to experiment.

Try this!

You can create water-soluble lines with a range of non-waterproof inks, liquid watercolours and fineliners. The permanence of the line and the intensity of the washes made by re-wetting the line vary between products.

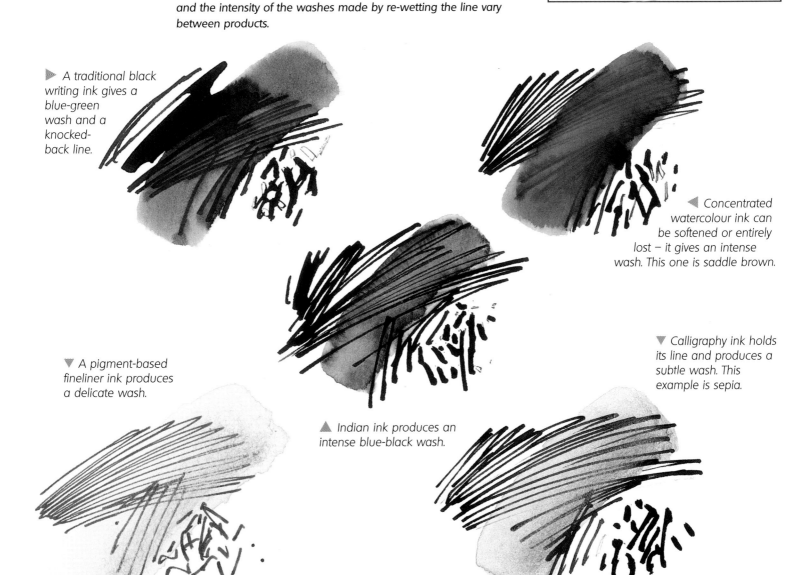

▶ *A traditional black writing ink gives a blue-green wash and a knocked-back line.*

◀ *Concentrated watercolour ink can be softened or entirely lost – it gives an intense wash. This one is saddle brown.*

▼ *A pigment-based fineliner ink produces a delicate wash.*

▲ *Indian ink produces an intense blue-black wash.*

▼ *Calligraphy ink holds its line and produces a subtle wash. This example is sepia.*

Line-and-wash effects

Use non-waterproof inks to achieve unusual effects quickly and with minimal equipment.

Non-waterproof inks allow you to draw with a solid line and then soften it with water. The most soluble inks are liquid watercolours and ordinary writing ink. Both produce intense washes and the dry line flares as soon as water or a wash is applied over it. Liquid watercolours come in glorious colours, while black writing ink splits into variegated washes. Non-waterproof Indian ink and some fineliners are more controllable. (See page 245.)

(See page 245.)

(See page 245.)

Plant study

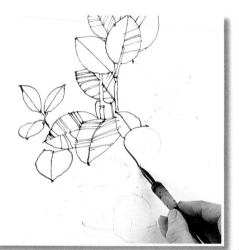

▸**1** Make a light pencil drawing of the subject. Using a dip pen and non-waterproof Indian ink, lay in the main lines. Use dark, emphatic lines for the edges that are in shadow and a lighter line for the veins and the leaves that are catching the light.

▸**2** Continue inking in the main lines, twisting the pen and varying the pressure to produce a range of thick, thin, light and dark lines. Don't apply any shading – this will be provided by the wash from the re-wetted ink. Finish the ink drawing and leave it to dry.

▸**3** Dip a brush in water and work it over the leaves to dissolve the ink and produce a delicate wash. Use this wash for the mid tones, leaving the white of the paper to stand for light areas, and the highlights on the leaves. Note that the ink continues to seep into adjacent wet areas, creating a subtle blurring of the lines.

▸**4** Continue until all the mid tones and most of the darks are established. Study the subject through half-closed eyes, noting the areas of deepest shadow. If the wash from the painting isn't dark enough, take a little more ink from the bottle.

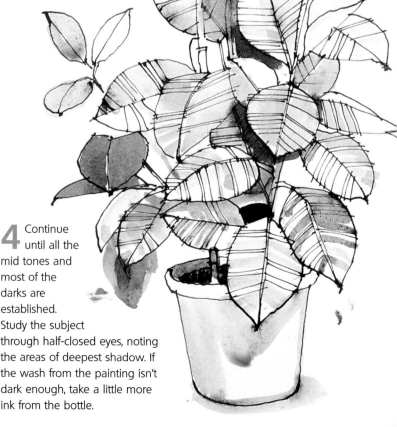

Tip

A fountain pen and black writing ink allow you to combine line with hatched, stippled or smudged tone. The medium comes into its own when you work back into the drawing with a brush loaded with water. The line softens instantly to give subtly variegated washes.

Watercolour & pastel

The interplay between the transparency of watercolour and the vibrant opacity of soft pastel produces images with great freshness and spontaneity.

Soft pastel is both a painting and a drawing medium, which makes it ideal to use with watercolour. You can use pastels simply to add an extra dimension to a watercolour sketch – to create highlights or add tone and texture to dry washes; or you can incorporate them fully into the painting process, using them more broadly, and in wet or damp washes as well as dry. You can build up layers of wash and pastel to create a final image that has great depth and vivacity.

This approach works especially well with gouache. Pastel and gouache have much in common. Both mediums are intensely pigmented, and have a matt opacity with a gentle bloom. They can create areas of solid colour, or be used thinly to give semi-transparent mists of colour in scumbles (where opaque, dry paint is brushed over a darker colour for a broken texture) and optical mixes – perfect for depicting the shimmering quality of light on a landscape or giving a sense of depth and movement to water.

Taking a closer look

The artist has combined gouache and pastel in a layered technique that captures the depth and turbulence of the sea.

Breakers at Kynance Cove, Cornwall by James Bartholomew

Broad washes of gouache establish the underlying tone of the seascape. A combination of dry brushed gouache and thinly smudged pastel depicts the luminosity of the misty sky.

Layers of broken colour create optical mixes that express the effects of light on the shifting surface of the sea and allow the viewer to see into the depths of the water.

Spatterings and scumblings depict the flying surf so effectively that the viewer can really 'feel' the wind and the spray.

Vigorous linear marks with white pastel express the swirling motion of the sea and the light glancing off the turbulent surface.

Layers of pastel and gouache depict the shifting sea, each wash or pastel mark informing the next. Areas of scumbled and broken colour create a sense of depth and movement.

Combining two mediums

You can use soft pastels with watercolour in a number of ways that exploit and enhance the qualities of both mediums.

On dry washes, you can make crisp pastel marks for added definition or to create textural effects; or scumble pastel pigment to achieve subtle swathes of colour. You can also use pastels in damp or wet washes to create more diffused marks and colours. Alternatively, use pastel first and apply washes on top – the washes pick up particles of pastel that modify the colour and cause random blendings. A combination of all of these methods gives a layered approach. You can even scrape back to rediscover earlier layers of colour.

This animated, 'finding and losing' way of working produces spirited and expressive images.

Tip

You can achieve subtle variety in your whites by using a combination of pastel, gouache and the white of the paper. This is perfect for depicting cloud or capturing broken water effects, for example.

Try this!

Follow the suggestions below to see how you can combine pastel and watercolour; then try building up layers of wash and pastel.

▶ *Here pastel marks are blended with clean water, creating varied tonal effects.*

▲ *On a dry wash, pastel retains crisp marks so you can create outlines to add definition and introduce texture with hatching or stippling. You can blend pastel with a cotton bud or tissue for diffused colour.*

▶ *Pastel lines on a wettish wash create an interesting effect – the lines 'ghost' slightly, softening the marks.*

▲ *This is a yellowish wash applied over red pastel – the particles of pastel pigment mix with the wash, creating a variegated orange.*

Chinese white as a base

This method, known as blottesque, allows you to create effects that are more subtle and delicate than can be achieved with ordinary lifting-out techniques.

The blottesque technique involves using Chinese white as a release mechanism for watercolour. Using Chinese white as a base makes it easier to lift and manipulate applied colour to create hazy, misty effects, and soft-edged, subtly blended areas of tone.

In blottesque, you apply a thin layer of Chinese white to your support, leave it to dry and then paint over it with layers of transparent watercolour in the normal way. At any stage, you can lift, scrub or rub off colour to achieve the effect you want.

You can use the technique all over your painting, but if you don't want Chinese white to mix with transparent colour, confine it to one or two appropriate areas – such as the sky to create naturalistic cloud effects.

Key points

● Blottesque makes it easier to manipulate colour to create soft, misty effects and subtle colour blends.

● Apply a layer of Chinese white over the support before starting to paint.

● Mix Chinese white with watercolour to make a warmer or cooler base for your painting.

● Paint over the Chinese white with layers of transparent watercolour.

● Manipulate laid colours by lifting, rubbing and scrubbing.

Taking a closer look

Here the artist worked over a base of Chinese white to depict a stormy, sand-filled sky and hot desert sunlight on the trees – hazy effects and subtle gradations of tone are typical of blottesque.

Approaching sandstorm by Adrian Smith

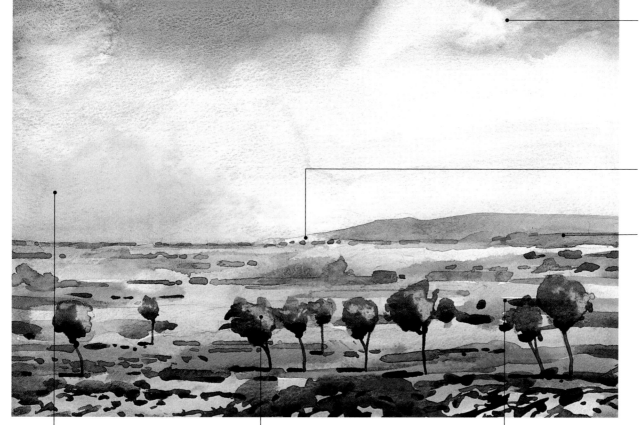

The artist lifted out colour from the sky wash to make fluffy-edged clouds that blend into the blue.

Colour lifted from the hillside creates a brilliant but soft-edged area of sunlight.

Working wet on dry on the hill makes for a crisp line that contrasts with the soft forms of the clouds, sandstorm and trees.

A transparent yellow ochre wash depicts the sandstorm. A second layer, blended at the edges, depicts the heart of the storm.

The crowns of the trees have been painted with Hooker's green. Colour has been lifted off to create bright highlights.

Areas of white left as highlights are crisper than highlights made by lifting colour.

Blottesque techniques

When you lift colour laid on a base of Chinese white, the edges are soft and merge into neighbouring washes. Exploit these effects for naturalistic skies, and hazy, moisture-drenched weather effects.

Try this!

Painting a misty scene

These steps show you how to lift off and lighten colours laid over a base of Chinese white to create a subtle and naturalistic misty sky.

▲**1** Paint the support with a thin layer of Chinese white mixed with ultramarine and allow to dry. Lightly pencil in the distant hills, the trees and hedges at the edge of the field, the cows, their shadows and the contours of the field itself.

▲**2** Darken the sky with Payne's gray. Apply raw sienna/yellow ochre for the far hills, and yellow ochre/Hooker's green for the nearer hills. Use Hooker's green and lemon yellow for the field. Blend the washes where they meet. Paint the hedges with Prussian blue/raw sienna.

▲**3** Using a clean, damp tissue, lift off areas of the sky and hill washes to leave white areas for the clouds, softening the colour at the edges for a damp, misty effect. Lift out areas of colour on the hedges and the field to create highlights.

▲**4** Vary the green wash to make several greens, using ultramarine, lemon yellow and indigo. Use darker mixes to add form to the distant hills, the hedges and the field. Use the tip of the brush for a few blades of grass in the foreground. Use burnt sienna and Payne's gray for the cows, darkening the mix for the shadows.

Impressions in paper

You can use various implements to apply indentations to paper in order to add decorative or descriptive details to a painting.

This subtle technique involves using a hard tool to make indentations in dry paper. When you apply a wash, the paint gathers in the hollows, creating lines or marks that are darker than the surrounding wash. You can use almost anything that makes an impression in the paper without leaving a pigmented mark. You can use the effects they create to help you describe natural textures such as foliage, long grass, roof tiles or the pitted surface of old stone. The results can be quite understated on a textured Rough or NOT surface. On smooth, highly sized surfaces, the indentations are more obvious once the paper is wet from a subsequent wash – the paint gathers in the 'valleys', making the textural marks more visible.

Key points

● Try creating impressions in a wash that has been allowed to dry as well as on dry paper.

● Use sharp, pointed drawing implements if you want to make thin, precise lines, and chunky items to give thick, distinct lines.

● Experiment with using different household items and tools to create a range of effects.

● If you are using paper with a hard surface, the results will be more pronounced.

In practice A château landscape

In this painting, impressions in the paper have been used to suggest the textures of trees, grass and stonework.

Château on the Loire by *Ian Sidaway*

Parallel lines scored with the back of a scalpel blade depict the rows of roof tiles.

Indentations
These are made with a screwdriver to add texture to the ancient masonry.

Stabbing marks
Made with a large nail, these marks produce the texture of clipped foliage.

Linear marks
These marks, made using a chisel, help to suggest the long grass in the foreground. The paint tends to collect in the indentations so the effect is enhanced.

Making indentations

Here are some of the effects which can be achieved using household objects and do-it-yourself tools.

Always work on paper that has dried – you can make impressions before applying a wash, or deepen a texture by making marks in a dry wash and then applying more paint. For crisp, fine lines, 'draw' into the paper using an engraving tool or the back of a scalpel blade – these marks can suggest roof tiles, or brickwork perhaps. Use a knitting needle, a large nail or the tip of a chisel or screwdriver to make stabbing indentations and staccato marks for more generalized textures such as foliage or weathered masonry. The paper and paint you use and the pressure you exert on the implement all affect the result. If the weight of the impression breaks down the surface of the support, the paint soaks into the paper and creates darker marks.

Tip

To add depth and surface interest to an image, make impressions on a variety of different papers. Then use these to build up an almost three-dimensional effect with a textured collage.

Try this!

The technique is largely a matter of trial and error, so you need to test it out. Use different papers and a variety of suitable tools.

◀ *The back of a scalpel creates a conspicuous, crisp texture on HP paper. The handle of the scalpel creates softer impressions.*

▲ *The tip of a screwdriver produces short linear indentations that show up strongly in a wash.*

▲ *The end of a brush handle stabbed into the support creates a generalized speckled effect.*

▲ *A chisel makes sharp indentations that create highly visible textures even on NOT paper.*

▶ *On a NOT surface a large nail makes a crisper dotted texture than the effect created with the brush handle. The pigment gathers in the indentations to make dark speckles.*

Using collage

Collage is an exciting technique that uses assorted materials including found objects to create pictures with impact.

Composing a watercolour collage forces you to be bold rather than precise, which can be liberating. The materials can be moved and changed as often as you like until you're ready to glue them down.

Collages can be worked up quickly to give them a spontaneous look, and their three-dimensional quality adds drama. The materials and techniques can be combined to create interesting patterns and textures, leading you towards abstract images.

The materials used should be flat and lightweight – paper, string and feathers are all ideal – to complement the luminous quality of the paint. Try painting paper to create a variety of finishes, and use bought or found items, such as bus tickets and stamps, for their various textures, colours and edges. Printed papers such as packaging labels can evoke a sense of time and place.

Collage materials can also be used to suggest other surfaces – for example rectangles of newsprint could suggest a row of buildings.

Key points

- Direct, spontaneous effects are a key feature of collages.
- Test ideas by moving materials around.
- Use collage to free yourself from precise imagery.
- Use the shapes and textures of the materials to develop abstract images.
- Combine found and bought materials.
- Prepare you own materials, such as painted and torn papers.
- Include areas of collage in a conventional painting, or use collage to complete a basic painted sketch.

Taking a closer look

In this watercolour collage from an artist's sketchbook, found papers lend a French food theme to a simple image of a jug on a tricolour background.

A taste of Normandy by *Michael Clark*

The colours beneath are visible through the crumpled paper, echoing the transparency of watercolour.

A shop logo cut from a food wrapper, gives a sense of place. The text is French, repeating the theme of the tricolour background.

The French flag and the jug were painted in watercolour before the collage pieces were added.

The uneven surface of the museum ticket adds a fresh quality, while its red strip echoes the reds of the shop logo and background, giving the entire image colour harmony.

A ticket for a cheese museum reveals more about the jug, suggesting that it might contain milk.

Prepared papers

A watercolour collage can use lightweight materials such as labels, newsprint and giftwrap, or papers you've painted yourself.

In practice

These landscapes combine conventional watercolour techniques with layers of painted, torn and cut papers to create perspective, pattern and texture.

Namibia
by Ian Sidaway

Brushmarks in the paint suggest the strata of the rock.

The sky has been left as watercolour, increasing the sense of recession.

The bush was cut from painted paper, making a bright accent.

Torn strips of textured paper represent bands of coarse sand.

The animals were drawn with candle wax, and then overpainted. The wax resists the paint.

The rocks were painted, then worked over using painted and cut papers for a startlingly realistic effect.

The cut edges of the paper suggest the hard contours of the rocks.

The rock with the cave paintings was rendered separately, then cut out and glued in place, bringing it boldly to the foreground.

Topiary garden, Cumbria
by Ian Sidaway

The sky and the distant trees have been left as flat watercolour for a greater sense of recession.

The trees, bushes and hedges have been worked using painted and torn papers.

The artist has used the collage to highlight the pattern of shapes in the topiary trees, creating a more abstract image.

The collage has been worked in layers, starting with the most distant objects. Building up collage from the background to the foreground in this way gives a strong sense of perspective.

The torn edges suggest the slightly rough outline of the bushes.

Tip

When you're painting papers for collage, experiment with all sorts of brushes – try stippling brushes, toothbrushes and decorators' brushes.

The coarse textured effects you can achieve with some brushes are difficult to work in small areas of a painting, but you can tear off scraps of your prepared papers and use them to loosen up your image.

A landscape collage

Preparing your own papers allows you to use loose or bold paint effects in very small areas – and to mix a variety of effects and textures in the same picture.

In practice **Tuscan landscape**

This collage uses watercolour and papers prepared with a variety of paint effects to depict the textures and colours of a pattern of fields in a Tuscan landscape.

▶ **1** Block in the sky with a blue wash, leaving some areas white for the clouds. Darken the wash for the hills, working wet on dry in three layers to build perspective. Paint the foreground in various greens, covering all of the paper.

▲ **2** Tear pieces of textured watercolour paper into cloud shapes, aiming for very soft edges. Fix them in place with acrylic gel medium.

▲ **3** Mix warm and cool greens, yellows, russets, browns and reds, adding gum arabic to some mixes. For the greens use a sap green/viridian base. Using a variety of brushes and brushstrokes, paint the papers for the collage. Leave some unpainted, including the brown paper.

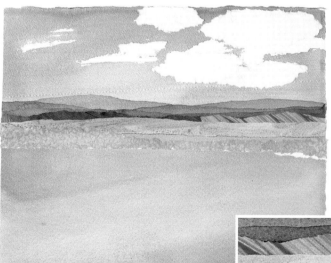

◀ **4** For the distant hills, tear narrow strips of the cooler green and yellow prepared papers (inset below). Arrange them in layers, working from the background to the foreground, then glue them in place.

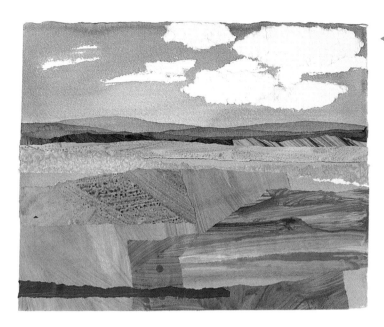

5 For the middle and foreground fields, select a range of prepared and plain papers. Tear shapes for the fields and arrange them in layers, using the stronger, warmer colours nearer the front of the picture plane. Glue them in place.

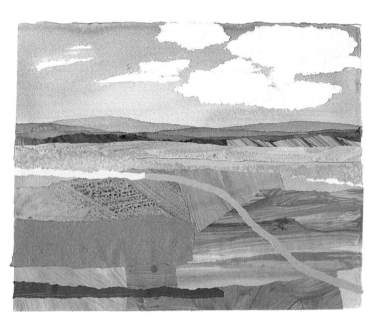

6 Add the trackway leading in from the left edge and curving towards the bottom right. Use narrow strips of unpainted white and pastel-coloured watercolour paper. Screw up an oblong of brown wrapping paper, smooth it out and glue it in place to make a ploughed field.

◀ FINISHED PICTURE
To complete the picture, draw rows of simple trees. Leave some as outlines and paint or collage the crowns and trunks of others.

The mixing of collage and watercolour creates a picture that is both semi-abstract and semi-figurative. The path, which is presented flat rather than in perspective, leads the eye across the fields, breaking up the perspective, and enhancing the pattern of the torn papers.

Choosing paper for effect

In watercolour the quality and character of the paper directly affects how you use the paint and the appearance of the finished painting.

The texture of the paper and the amount of size affects the movement of washes, the quality of line and detail, and the luminosity of the colours. Watercolour papers vary from bright white to cream. The whiteness affects the brilliance of the colours. Tinted watercolour papers are a fairly new product – they modify colours and tones.

Rough paper suits bold, expressive work. It creates mottled and speckled textures as wet washes settle on and soak into the uneven surface. HP paper has a hard, smooth finish, suitable for a tight, detailed approach and for creating flat washes that don't soak in, while medium-textured NOT papers enable you to combine broad washes with some detail.

Taking a closer look

The artist here chose a heavily sized paper with a very smooth surface, and made the most of the effects a hard surface has on washes.

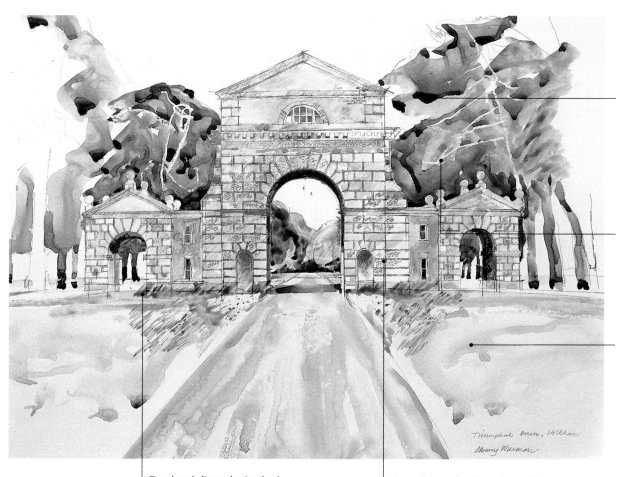

Triumphal arch, Holkham by *Albany Wiseman*

The paint doesn't soak into the heavily sized paper. It 'pools' on the surface and the colour dries darker than usual. Here the paint has collected in dark puddles that depict the masses of foliage.

Thin lines of wax resist are used for branches among the foliage.

The grass is suggested with a loose, pale wash. The artist pushed the wash around on the hard surface, leaving areas of thin colour to suggest bright light. Darker pools of wash add surface interest.

Fine brush lines depict the long grass. On heavily sized paper the marks stay crisp and sharp.

The artist used coloured pencils to draw the stonework and add textural detail. He softened the lines with washes applied on top.

Test out surfaces

Consider your style of working and experiment with different papers to see which suits you best. Keep your experiments for future reference.

There are watercolour papers to suit every need. Before you buy, think about how you prefer to work and the effects you want to achieve.

For layered washes, a NOT or HP paper gives a fresh, bright appearance. For textures and expressive gestures, choose a good quality Rough or NOT paper. A well-sized Rough or NOT paper is suitable for techniques such as scraping back, abrading and lifting out.

If you want to make detailed images and favour a tight approach, look for a good HP paper, especially for architectural or botanical studies. With some types of this paper, you can work on both sides.

Heavily sized HP papers are best for line-and-wash work. To achieve flat, even washes with line, use a well-sized NOT surface. A pale tinted surface gives an underlying harmony so choose a colour – warm or cool – to suit the mood of the painting.

Tip

Cut small pieces from each paper you choose. Experiment to see how they react to washes, scraping back, lifting out, abrading. Explore both sides of the paper – some have a different quality on each side. Label your experiments.

Comparing different papers

Apply washes to a variety of surfaces, from highly textured Rough paper to heavily sized, smooth HP paper. Include a tinted paper to see how the colour modifies the tones and colours.

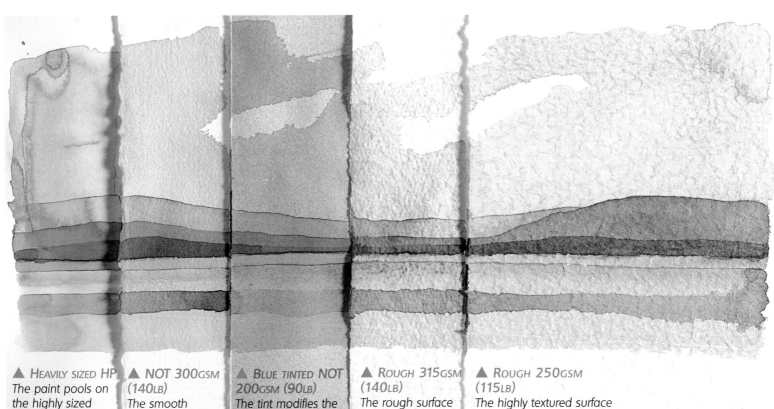

▲ HEAVILY SIZED HP
The paint pools on the highly sized surface and dries with crisp edges.

▲ NOT 300GSM (140LB)
The smooth surface creates flat, even washes.

▲ BLUE TINTED NOT 200GSM (90LB)
The tint modifies the colours and thus influences the mood.

▲ ROUGH 315GSM (140LB)
The rough surface causes a stippled effect.

▲ ROUGH 250GSM (115LB)
The highly textured surface creates a mottled effect.

Discovering Khadi papers

The varied and unusual textures of Khadi papers show through even thick and creamy colours, adding an extra dimension to your paintings.

Khadi papers are made in India from cotton rag; some contain other ingredients, such as jute sacking, which give additional textural effects to paintings. Cold-pressed papers are called 'smooth', but have a medium texture, while the Rough Khadi papers can be very highly textured. They are all absorbent. They come in many colours and are handmade with four deckle (irregular) edges. There's a range of weights, from 210gsm (grams per square metre) to the heaviest 1,000gsm which is like thick card. Sheet sizes are large – Indian Atlas measures 140 x 100cm (54 x 40in), for example – but smaller sizes are also sold.

Khadi papers are perfect for loose, bold and highly textured paintings. They are available from paper specialists, large art suppliers, and by mail order.

Try this!

Test the techniques shown here to see the variety of effects you can achieve on Khadi papers. Use a range of weights, surfaces and colours and keep them as samples for future reference.

▲ SMOOTH 640GSM
The canvas-like texture shows through these gouache colours, although the artist mixed them to a thick consistency.

▲ BUFF GUNNY (ROUGH) 210GSM
Here water has been dropped into a dry wash mixed with gum arabic, then colour was blotted off to reveal the ground colour.

▲ ROUGH 210GSM
The wash was applied over masking fluid – removing the fluid has damaged the paper. Use this feature when you're exploiting texture.

▲ ROUGH 320GSM
A wash applied with a sponge leaves an impression of the sponge shape on this paper which is suitable for fairly fine work.

▲ ROUGH INDIAN ATLAS 480GSM
This bold mottled finish used a wax resist, which was picked up by the peaks of the very rough paper. The wash settled only in the pits.

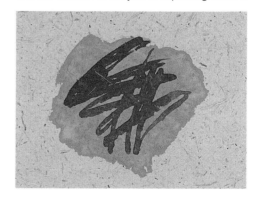

▲ BAGASSE 310GSM
This paper has extra ingredients, and washes dry unevenly, leaving a mottled effect. The orange wash was worked wet on dry.

Using Khadi papers

The unusual properties of Khadi papers can lead you towards looser, freer techniques, and more textured or abstract images.

The rough surface and the generous size of many Khadi papers are useful for large-scale paintings where detail is less important than the overall effect. The smoother papers can be used for finer work, but the very textured types are ideal for broken or mottled colour effects. The absorbent surface gives washes loose edges and a softly diffused appearance – perfect for wet in wet.

Coloured papers can add a interest to your work, but ensure that the colour is suitable. Some of the paper colours are strong, so subtle washes will be lost; instead use intense, bright, strong mixes. Try gum arabic to intensify the colour and retain luminosity – this is also useful if you want to work back into your colours without damaging the delicate surface of the paper. Alternatively, mix Chinese white into your washes, or use gouache.

Tip

The lighter-weight Khadi papers are likely to cockle when they dry – to prevent this, stretch them in the usual way before starting to paint. Gummed brown tape may come away from the deckled edges, so make sure you trim off the deckles before you start.

Taking a closer look

This study on a very heavyweight, pale-coloured Khadi paper explores the textures of stone and rock in the Yemen desert.

Yemen tower house by Ian Sidaway

The bubbly surface of the cream-coloured paper suggests the soft masses of cumulus clouds.

The distant mountain was worked wet in wet. The second wash spread rapidly into the first, creating softly diffused edges – one colour changes into another almost imperceptibly.

The artist used paint over a wax resist for a heavily mottled finish that depicts the stony desert floor.

A soft graphite stick scribbled over the white of the paper depicts a thin layer of scrubby vegetation.

Spattered colour spreads and diffuses rapidly, forming large speckles looking like rough, eroded desert rock.

Paint applied with a sponge suggests patterns on the rocky outcrops.

A torn paper mask created an uneven edge without damaging the delicate surface of the paper.

CHAPTER 10
EQUIPMENT

The materials required for watercolour painting are simple – paints, paper, brushes and water – but the choices available can be bewildering. This chapter provides a concise introduction and practical advice as to what to buy. There is an introduction to brush shapes, sizes and materials and advice on cleaning and caring for them. The different types of watercolour paper and their qualities are described, as is how to stretch paper to prevent it cockling. Watercolour paint is available as pans, half-pans and tubes – in students' quality colours or the more expensive artists' version. You can buy a filled box, or choose an empty box and make your own selection of colours. Advice is also given on goache paints.

Other materials discussed include the essential tools of the watercolourist's trade: pastels, coloured pencils, watercolour pencils and pens. Easels are also covered – a sketching easel with telescopic legs, for example, makes a good choice for a beginner because you can use it on location or at home, and it can be folded neatly away when not in use.

Watercolour paints

Watercolour paints come in a wide variety of forms, packages and qualities. It's a sensible idea to find out what suits your requirements before you spend your money.

First, equip yourself with some information to help you decide what to purchase. Visit art shops to explore different options, and study a selection of paint leaflets and catalogues to identify your needs and preferences. Cost will undoubtedly be an important factor.

STUDENTS' OR ARTISTS'?

There are generally two decisions you can make when it comes to choosing paints. If you are a beginner, students' quality colours are an ideal starting point. They are attractively priced, easy to handle and the results you can achieve are perfectly acceptable. The drawback is that their colour range is somewhat limited.

As you gain experience in handling watercolour, switching to artists' quality colours is a consideration. These paints are available in a wider range of colours than students' quality paints and they are made with higher-grade pigments. In addition, their colour is more intense.

However, artists' quality paints are much more expensive than students' quality, and you will discover that prices vary depending on the type and cost of pigment used in their manufacture.

Tip

When you've removed the labels from new pans they can be difficult to identify, so make yourself a colour chart. As you take off each label, dab a blob of colour on a sheet of paper and label it. Then when you encounter a pan you can't identify, simply paint a small blob on to spare paper and match it to one of the chart colours.

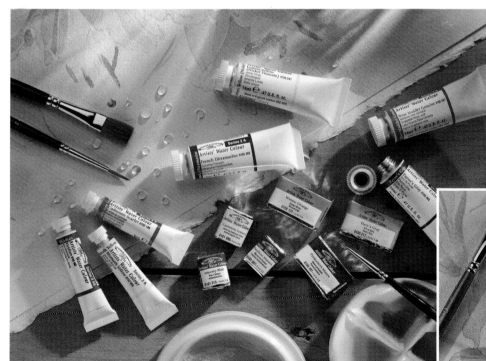

◀ ARTISTS' QUALITY PAINTS
Premium quality artists' colours are price-coded in series according to the cost of pigment used in their manufacture. Some are expensive in all ranges – cobalt blue, for example – so always check the price before you buy.

▶ STUDENTS' QUALITY PAINTS
Students' quality paints tend to have a uniform consistency, which means they are more predictable than artists' quality and easier for the less experienced watercolourist to handle. They are moderately priced and all the colours in the range cost the same, which makes budgeting simpler.

Pans or tubes?

Watercolour paints are available in two main forms – pans or tubes. Each has its advantages and disadvantages.

Pans – whole, half and quarter – contain semi-moist cakes of paint. They are available in assorted boxes and tins containing twelve, eighteen or twenty-four colours, or you can buy them separately. Watercolour in this form is convenient, especially for working outdoors – the colours are instantly accessible because they don't have fiddly caps.

The other option is tubes containing very soft colour. These are generally available in two sizes, and are useful when you need to mix large quantities of wash – for skies, for example – or work on a big scale. The choice of pans or tubes is a matter of personal taste. You could use a combination of both, with tubes of the colours you use most and pans for the rest.

START SMALL – AND BUILD UP

When you start painting, a basic palette of no more than a dozen colours gives you enough scope to mix most of the colours and tones that you'll need. As you progress, you can add more, but many professional artists choose to work with a limited palette. Tubes also come in boxed sets, or you can buy them individually to make up your own personal selection.

BOXED SETS

Watercolours are available in boxed sets containing pre-selected ranges of colours in tubes or pans. You can buy them in cardboard boxes, but metal or plastic boxes are better. They protect the paints and prevent them from drying out, and there is usually space for a brush or two. The lids of metal and plastic boxes provide palettes for mixing colours – some have a second leaf that folds out to provide yet more mixing space – and most wooden boxes include a ceramic or plastic palette.

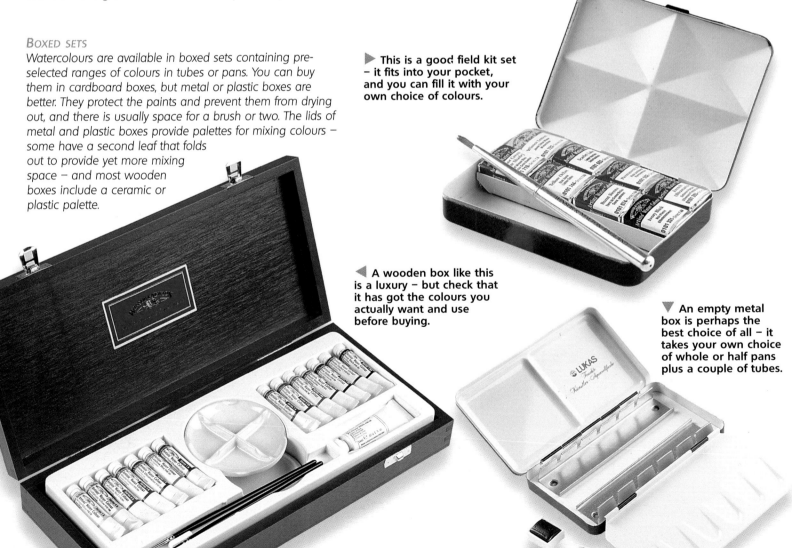

▶ **This is a good field kit set – it fits into your pocket, and you can fill it with your own choice of colours.**

◀ **A wooden box like this is a luxury – but check that it has got the colours you actually want and use before buying.**

▼ **An empty metal box is perhaps the best choice of all – it takes your own choice of whole or half pans plus a couple of tubes.**

Gouache paints

You can buy gouache paints not only in tubes or pans, but pots too. All of these come in a number of different sizes and a vast range of colours.

Gouache is opaque watercolour paint, known for its rich, deep colours. It is at its most opaque when used thick, but it can be diluted with water for thin, semi-transparent washes. You can use gouache with a brush – but you can also apply it using a tissue, sponge, card or toothbrush, or even your fingers. Also you can use it thickly to create raised textural areas. Because of its opacity, gouache has great covering power and can be used to paint light colours over dark.

Gouache colours are normally sold in tubes, although the more popular colours also come in pots. Pans of solid colour are an alternative. The number of colours is huge, although those in pans are somewhat limited. But a small variety of well chosen colours can produce almost every hue imaginable. You can buy tubes separately, but most manufacturers produce beginners' sets containing a few basic colours. These are excellent value for money and can easily be added to.

Tip

Watercolour brushes work well with gouache. Round brushes are the most useful, so collect a few different sizes. For smaller sizes, stick to soft hair brushes, since these are better for fine detail. With larger sizes, choose both soft hair and bristle brushes. Bristles allow you to apply paint thickly for textural effects.

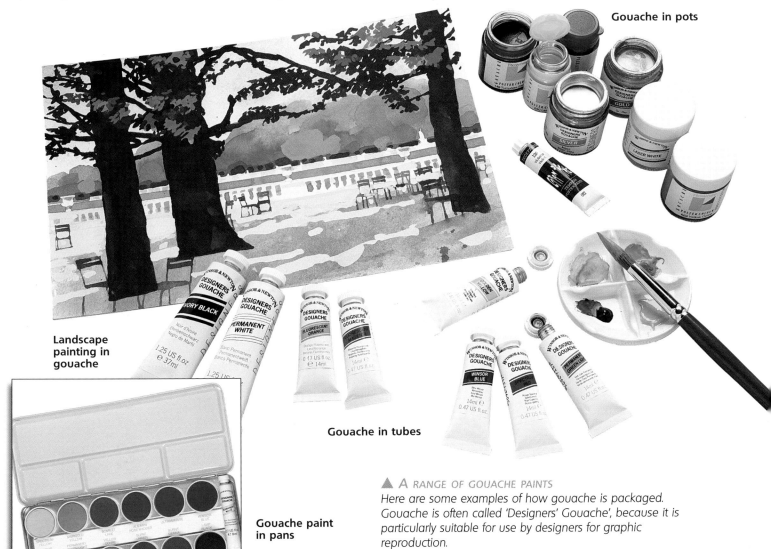

Gouache in pots

Landscape painting in gouache

Gouache in tubes

Gouache paint in pans

▲ A RANGE OF GOUACHE PAINTS
Here are some examples of how gouache is packaged. Gouache is often called 'Designers' Gouache', because it is particularly suitable for use by designers for graphic reproduction.

Papers for gouache

With gouache you have a large choice of papers – choose from plain watercolour paper, tinted paper or special handmade oriental papers.

You can use a greater variety of supports for gouache than for any other medium. Paper, card, board, wood and even fabric are all good – as long as the surface is free from grease. As with watercolour, though, the most usual support for gouache is paper. There is a huge assortment available in numerous sizes, weights, colours and textures. Weights range from the lightest at 190gsm (90lb) to the heaviest at 640gsm (300lb). All papers up to 300gsm (140lb) need to be stretched before use, but heavier papers shouldn't need stretching unless you drench them with very wet washes. The most useful are NOT papers which have a good all-purpose surface.

COLOURED PAPERS

Since gouache is opaque, you'll find you can use tinted papers to great effect – especially grey papers which provide a good middle tone. Because the paint contains white pigment, the colours stand out better on a tinted background. But take care to select coloured papers that are sympathetic to, or appropriate for, your subject matter. Applying the opaque paint in thin washes allows the paper colour to show through in places, adding warmth or coolness to your work.

HANDMADE PAPERS

There is a wide range of handmade papers available, for which gouache is particularly suitable. You can apply the paint quite thickly, so encouraging particles of pigment to stay on the surface. These papers usually come from India, Japan or China, and are made with rice, mulberry-tree bark, straw, tea leaves, wool and dried flower petals. Many of them are no thicker than tissue.

A

▼ *HANDMADE PAPERS*
There are thousands of different kinds of oriental papers, varying hugely in quality and price. This small selection gives you some idea of the many different colours, weights and texture types you can buy through specialist paper retailers.

KEY
A is made with straw; **B** with tea leaves; **C** with wool; **D** with algae; and **E** includes marigold petals.

B

D

E

C

▲ *COLOURED PAPERS*
Watercolours are usually painted on white paper, which is left blank for white areas or highlights, but with gouache, where you can use white paint, you have the option of using some of the wonderful tinted papers available. Those shown above are just a small selection.

Choosing & stretching paper

There are many different kinds of watercolour paper. Each has different qualities, which make an important contribution to the appearance of a picture. Some need to be stretched before use.

Your choice of paper affects the way your paint behaves. For instance, paint applied to Rough paper collects in the indentations and gives a more broken finish while paint applied to a smooth surface displays a cleaner coat of colour. So if you are painting a scene full of crisp detail, a smooth paper is best.

SIZE AND ITS BENEFITS

The absorbency of the paper greatly influences the quality of the marks that can be made on it. This also affects how the paper handles and what washes look like once they have dried. For best results, use paper that has been treated with size, a kind of glue which is either added to the pulp during the paper-making process or applied to the surface of the sheet. The more heavily sized the paper, the more water resistant it is. This means that it is easier to lift off colour, if necessary.

HP (hot pressed), or smooth, paper has a very smooth surface. It suits fine line and details.

NOT, or cold pressed, paper (NOT literally means 'not hot pressed') has slightly more texture than HP paper. Its medium surface is the best choice for beginners.

Rough paper is an ideal surface for bold, expressive watercolour.

Key points

● Watercolour paper is categorized by weight, measured either in grams per square metre or pounds per ream (500 sheets). You will generally find weights of 190gsm (90lb), 300gsm (140lb), 425gsm (200lb) and 640gsm (300lb).

● Ideally, paper which is lighter than 425gsm should be stretched before use (see overleaf). You can probably get away without stretching small sheets of 300gsm paper, but 190gsm paper will certainly need stretching.

How to stretch paper

Lightweight watercolour paper needs to be stretched before you begin painting, or it will cockle as the paint dries.

Stretching is done by wetting the paper completely and then taping it tightly to a board. You can use a special drawing board or simply a piece of chipboard, plywood or MDF.

DRYING OUT

Stretching may seem a chore, but it will save you money because lightweight papers are cheaper than heavier ones. Stretched paper is easy to work with because it dries flat even if you use very wet washes. Don't worry if the stretched paper wrinkles slightly while you are painting – it will flatten as it dries.

You can use a hair drier to speed up the drying time. If you do, keep moving the drier around so the paper dries evenly. Don't allow the drier too close to the paper surface – the gummed strip will get too hot and come unstuck.

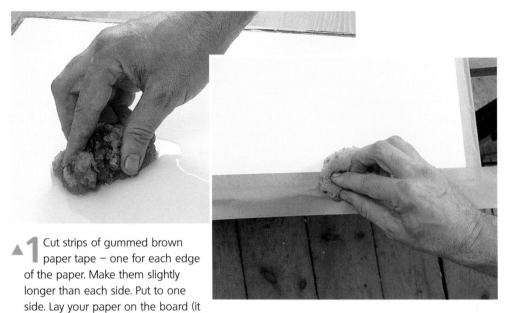

1 Cut strips of gummed brown paper tape – one for each edge of the paper. Make them slightly longer than each side. Put to one side. Lay your paper on the board (it needs to be slightly smaller than the board). Dip your sponge into cold water and wet the paper thoroughly.

2 Moisten the gummed strips, then stick them down around the edges. Wipe all around the strips with the damp sponge to press them firmly to the board.

In practice

Discover the different qualities of HP, NOT and Rough paper by experimenting on them first with a dry brush and then with a wet one. The results are surprisingly varied.

Using a dry brush ...

... on HP paper
Charge a dry brush with plenty of paint and drag it across a sheet of HP paper. The result is a block of smooth colour.

... on NOT paper
Load the brush as above. Painting on this paper causes the paint to break up slightly, with the edges starting to become rather ragged.

... on Rough paper
Drag a dry brush over Rough paper and the indentations in the paper are left untouched by the paint. The result is a broken finish.

Using a wet brush ...

... on HP paper
Wet the brush before charging with paint and lay a band of colour on the paper. This produces a smooth colour that dries somewhat lighter.

... on NOT paper
Applying the same amount of paint, again with a wet brush, to NOT paper gives a darker colour. It may break up a little on the slightly textured surface.

... on Rough paper
On Rough paper the paint collects in the indentations, leaving darker patches of colour within the paint. The edges are very ragged.

Tip

If you haven't got time to stretch your paper in the usual way, then invest in a block of watercolour paper. A block of paper contains sheets gummed on all four sides – with a small gap in the middle of one side – and is therefore strong and stable enough to use without stretching it first. These blocks can be used perfectly well for even the wettest washes. When your painting is dry you gently ease the sheet off the block, leaving the next sheet ready to work on.

Brushes for watercolour

A selection of good-quality brushes is a vital purchase. It pays to buy the best you can afford, but remember you can limit yourself to just a few – and produce great paintings with them.

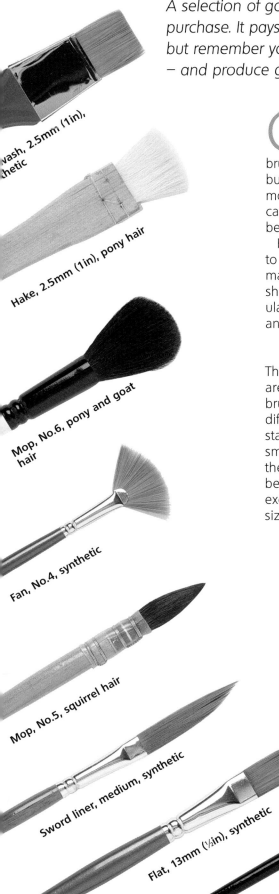

Wash, 2.5mm (1in), synthetic

Hake, 2.5mm (1in), pony hair

Mop, No.6, pony and goat hair

Fan, No.4, synthetic

Mop, No.5, squirrel hair

Sword liner, medium, synthetic

Flat, 13mm (½in), synthetic

Round, No.6, Kolinsky sable

Oriental, goat hair

Round, No.9, sable/synthetic blend

Rigger, No.3, synthetic

Choosing a basic range of brushes is a top priority for anyone starting to paint with watercolour. Lots of brushes and brush types are available, but, to begin with, it's unnecessary to buy more than a few different brushes – you can easily expand your collection as you become more experienced.

Remember, it takes just a single brush to create a surprisingly large repertoire of marks and effects. These depend on the shape, size and fibre length of the particular brush – as well as the way you hold and handle it.

ROUNDS, FLATS AND MOPS

The most versatile brushes you can buy are rounds, followed by flats, flat wash brushes, mops and riggers. They come in different sizes – a brush's size is normally stamped on its handle. No.0000 is the smallest and No.24 the largest (although the sizes are not completely consistent between manufacturers). Flats are the exceptions to this rule, since they are sized by width.

The way to tell whether a brush is of high quality or not is to see if it holds a good amount of paint and whether it releases the paint gradually to make a consistent mark. In terms of quality, the best brushes are made of pure sable. These are also the most expensive, so sable/synthetic – brushes that are a mixture of synthetic fibre and sable – or pure synthetics are an acceptable alternative. Squirrel is softer and less resilient than sable, but makes excellent mop and wash brushes. Also, ox hair can be used for flat brushes and goat or pony hair for wash, mop and oriental brushes.

Expert advice

● **Rounds** – these are useful general-purpose brushes for creating fine lines, broad sweeping strokes, and laying washes. A No.9 and a No.6 should cover most requirements.

● **Flat or one-stroke brushes** – extremely adaptable brushes that can be used for crisp lines, wedge shapes and to lay large areas of wash.

● **Flat wash brushes** – broad, soft and holding large amounts of water, these are suitable for painting large areas of wash quickly.

● **Mops** – large, soft, dome-tipped brushes, mops hold generous amounts of watercolour. They are ideal for laying washes. A No.3 mop is a useful one to start with.

Extending your collection

As your artistic skills develop, you may want a few specialist brushes to help you create some striking effects.

When the time comes for you to consider increasing your number of brushes, you may feel spoilt for choice by the sheer range and variety available. Hakes, for instance – flexible Japanese brushes made of pony hair – can produce an excellent range of marks and textures. They are also useful for flat washes.

Most other oriental brushes are round. Even the largest sizes have fine points, which means they can be used for delicate work. Other brushes worth considering include quill sables – soft-hair brushes made by tying the hairs together and then inserting them into quills. Fan blenders and sword liners are also useful.

Keeping brushes clean

Treat brushes with care, since they are costly to replace if they get damaged. Although watercolour, unlike oil paints and acrylics, is relatively easy on brushes, you still need to clean them thoroughly after every painting session.

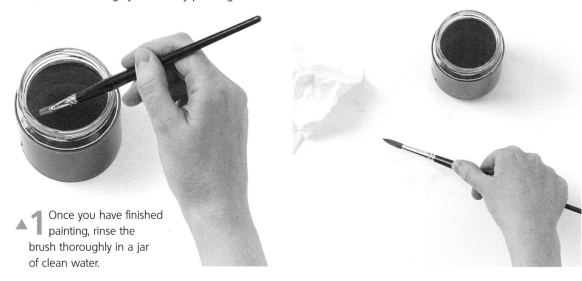

◄2 Shake the brush briskly by flicking your wrist. This will get rid of excess water and help bring the bristles back into shape.

▲1 Once you have finished painting, rinse the brush thoroughly in a jar of clean water.

▼3 If there are any stray fibres still sticking out, smooth them back into place between finger and thumb.

▼4 A brush can become heavily stained by some pigments – such as alizarin crimson which doesn't rinse off easily. Wet the brush and work it in special brush cleaner. Make sure the lather gets up into the heel, near the ferrule. Rinse under a tap.

▶5 Leave the brush to dry flat – if it is dries upright, any surplus water may seep down inside the ferrule, thus spreading out the fibres or bristles. When dry, store the brush bristle-end-up in a jar.

Watercolour palettes

Watercolour palettes come in a range of shapes and sizes, so you can be guided almost entirely by your own personal likes and dislikes when it comes to buying one.

Whether they are ceramic, enamelled metal, plastic or polystyrene, the one property all watercolour palettes share in common is their colour – white. This allows you to see the true colour of a wash with minimum distortion.

The design you choose depends on how you intend to use your paints. For large, expansive washes, you need a palette with deep recesses so you can mix the paint with generous amounts of water. For tighter, more detailed work you may want smaller recesses, but more of them, so you can make use of many different colours. If you select a hold-in-one-hand, thumbhole-style of palette, be careful not to tip it at an angle – if you do your washes could run together or spill out.

Watercolour palettes are designed with quite specific uses in mind. The more popular designs – shown below – give you a good cross-section.

A wide range to choose from

Buying watercolour palettes can be quite confusing when you look at the many different designs available. Just keep your own painting requirements firmly in mind and choose your palette – or palettes – accordingly. In particular, bear in mind the weight of large ceramic palettes when it comes to spending a whole day painting outdoors.

KEY
1 Folding field palette with thumbhole
2 Lightweight plastic palette **3** Ceramic palettes with deep recesses **4** Cabinet saucer **5** Divided slant and slant well tiles
6 Tinting saucers **7** Compact plastic palette

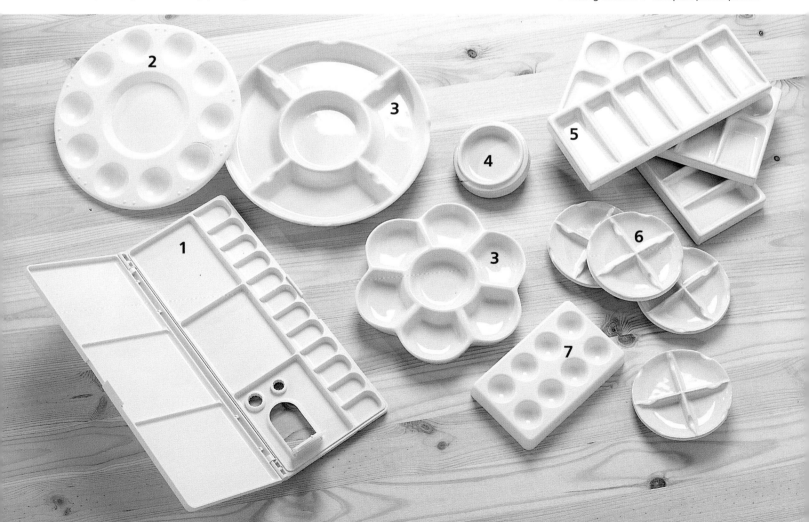

Types of palettes

Slant tile or tinting saucer? Plastic or ceramic? It's your choice, but the way you work will ultimately affect your decision.

Some artists aren't happy unless they're surrounded by lots of different palettes, while others find just one ample for all requirements. As you progress you'll discover which ones suit you.

SLANT TILES & TINTING SAUCERS

Slant tiles are available in two styles – divided slant tiles and slant well tiles. The first type has six compartments, each sloping to a deep recess at one end for mixing a fairly large wash. Use the top end of the slope for small, dry mixes, or for transporting some paint from the deep end to assess its tone. Slant well tiles are the same basic shape, but have a pool-shaped well at the top of the deep end of each recess. You squeeze tube paint into these, then move a little into the slant to dilute or mix it.

Tinting saucers are small circular saucers divided into four shallow compartments, each with a useful brush-rest on the edge. Because of their size they are great for small washes – but you might find it useful to purchase several. A variation on the tinting saucer is the cabinet saucer. It has a similar design but without divisions. You need a separate one for each wash, and space on your table for them all. They come in stacks of five with a lid. The idea is to stack saucers with unused washes overnight, covering them with the lid so the wash doesn't evaporate, then use the washes next day.

Slant tiles, tinting saucers and cabinet saucers are made of white ceramic. The smooth, slippery surface is excellent for mixing watercolours.

PLASTIC PALETTES

Plastic palettes have deep wells with room to carry a lot of fluid paint. Remember that a colour seen in a deep pool in your palette appears much darker than it does when you spread it thinly on paper. Plastic palettes are lightweight and inexpensive, perfect for when you are painting outdoors. But, they do stain much more than ceramic palettes.

◄ **TINTING SAUCERS**
With their compact triangular recesses, these are perfect for small-scale mixing.

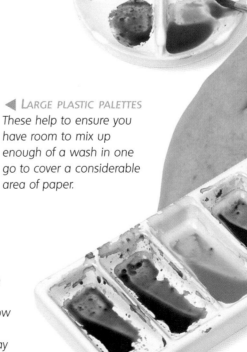

◄ **LARGE PLASTIC PALETTES**
These help to ensure you have room to mix up enough of a wash in one go to cover a considerable area of paper.

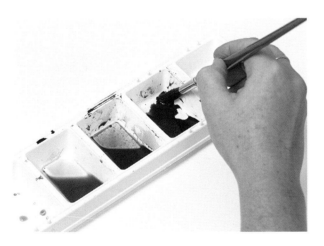

▶ **DIVIDED SLANT TILES**
This type of palette is very popular because it's so versatile. You mix your wash in the deep end, then test the colour at the shallow end. They can be quite heavy, so are not generally suitable for carrying around all day on outdoor painting sessions.

Watercolour field kits

Watercolour is a portable medium, perfect for outdoor use. Make sure you don't spoil your trip by carrying too much cumbersome and unnecessary equipment.

If you decide to paint outdoors, take only the basic necessities, so that when you find a scene you want to paint, you spend the minimum amount of time setting up. A compact, portable watercolour field kit makes things easy and provides everything you need to capture the scenes that inspire you – whether you're aiming to paint a series of simple sketches or finished paintings.

READY-MADE PAINTBOX KITS

Some manufacturers produce light, compact, ready-prepared watercolour boxes that contain everything you require for painting outdoors – the smallest boxes fit easily into a pocket. Whole or half pans are more convenient than tubes – the colours are quickly accessible and there are no caps which can get lost.

Field sets contain between six and twenty-four half or whole pans of artist's or student's quality paints and include palette flaps for mixing paints. Some have storage compartments for brushes (although these generally hold only small brushes). Certain kits also have a sable brush and a water bottle, the top of which can become a clip-on trough for water, and some boxes even include a sponge for large washes.

▲ FIELD BOX
Lightweight plastic boxes like this are cheap and extremely handy. This set contains an integral water bottle, fold-out palettes, a sponge and twelve student's quality half pans.

▼ WHOLE PANS, HALF PANS
This pocket-sized field box can hold both whole pans and half pans and one 8ml tube. It also features a clip-on water dish.

▼ COMPACT METAL BOX
Conveniently sized to fit in the smallest of pockets, this kit has eight artists' quality half pans and a sable brush.

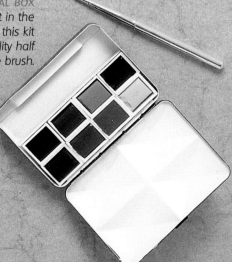

Key points

● If you plan to work outside regularly, you may want to buy a small portable easel. These have an adjustable work height and telescopic legs. There are several versions available at varying prices. An easel is not essential – a thin piece of plywood makes a perfectly good work surface. It is light and rigid and can be held in any position. Secure your paper to it with drawing pins or bulldog clips – or stretch it beforehand (see page 268).

● An alternative to an easel or board is a watercolour block or ring-bound pad. These are firm enough to be used upright and are ideal for working outdoors. You can buy them in a variety of surfaces.

Hand-picked colours and brushes

Instead of buying a box filled with colours you may not use, you can make your own personal selection.

A useful palette for watercolour landscapes could include cobalt blue, lemon yellow, Hooker's green, yellow ochre, burnt umber, burnt sienna, Payne's gray and cadmium red. These can be mixed to create a wealth of natural colours. Most art suppliers sell empty paint boxes with spaces for your own choice of colours. Fill them with whole pans or half pans.

Brushes sold in ready-made field kits are very small and suitable only for fine details, so equip yourself with a basic selection of four brushes: a 13mm (½in) flat for washes and broad marks, a No.9 and a No.6 round brush for washes and details, and a mop for large areas. If you like, add a No.2 round for very fine details and a small, natural sponge for large washes. You will have your own preferences, but these brushes cover most eventualities. A specially made plastic tube can protect your brushes. Alternatively, you can save money and improvise with a piece of cardboard tubing.

◀ **POCKET BOX**
This is a good box for a beginner. It has twelve student's quality half pans, a brush holder and a three-compartment mixing palette.

Expert advice

● It's always a good idea to carry extra water. Buy a specialist water bottle or economize with a small plastic mineral water bottle. Small yoghurt pots are ideal for washing your brushes.

● If your box doesn't have built-in mixing palettes, buy a couple of cheap, lightweight plastic mixing palettes – these are sold in any art shop. Even less expensive are wax-coated paper picnic plates – you can just throw them away at the end of the day's painting. Large folding palettes are ideal if you use tube colours – save the squeezed-out paint blobs for another session.

● A lightweight folding chair or stool is a good buy, but shop around. Try looking in fishing shops as well as art shops and compare styles and prices. Or if you are happy to sit on the ground, simply take a rug, a plastic bag or a coat to keep the damp at bay.

● To complete your field kit, take a pencil or fountain pen for sketching, a rag for wiping brushes, a polythene sheet to protect your work in case of rain, and waterproof clothing to protect yourself. Finally, take a cardboard tube with you for carrying your dry, finished paintings home at the end of the day.

▼ **METAL SKETCHERS' BOX**
Containing twenty-four half pans, this metal box has two palettes – one with divided slant tiles. Metal palettes are easy to clean and durable.

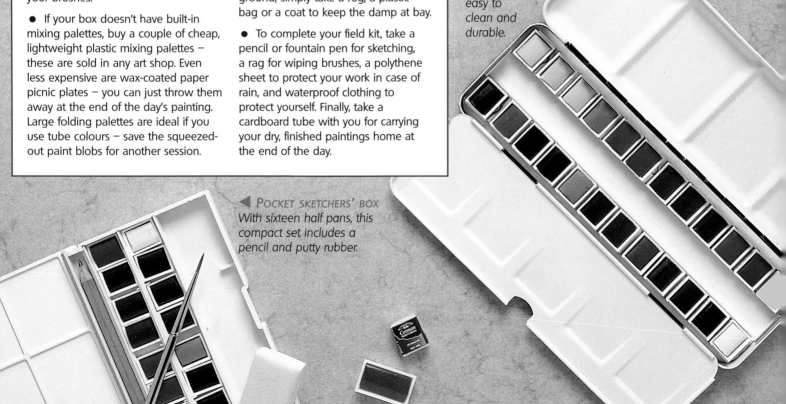

◀ **POCKET SKETCHERS' BOX**
With sixteen half pans, this compact set includes a pencil and putty rubber.

Drawing pens

Pens made from natural materials – quills, reeds and bamboos – were for centuries the only types available. Today there's a wide range of metal-nibbed pens to choose from as well.

All types of pen take a bit of practice before you can use them with confidence, but once you've bought a few and tried them out, you'll be able to produce a wide range of drawings. The choice is vast – from traditional drawing pens in quill, reed or bamboo, through dip pens with various nibs to cartridge pens, fountain pens and technical pens.

DIP PENS

There is a very large assortment of nibs and holders for dip pens. Detachable steel nibs are flexible and come in a myriad of shapes and sizes.

Brush pens have nibs made from two wide, spatula-like plates of metal. They are good for making wide, bold lines and heavy shading.

Mapping pens have fine, pin-point nibs, these are excellent for drawing precise detail and extremely fine lines for maps and technical artwork.

Script pens have pointed, round or square nibs, these are mainly used for calligraphy, but you can use them for drawing too. Round nibs are the most suitable types for very thick work, while square ones give a fluid, ribbon-like line. Both come in various sizes. Script nibs are split into sections so that you can change the width of a line as you draw it. Some nibs have two slits and some three for even broader work.

Tip

You may have bad memories of getting ink everywhere when you were at school. To overcome this, make sure you select the right sort of paper. To begin with, choose smooth, sized papers to prevent the ink from bleeding. When you have more experience, you can move on to NOT papers.

▶ *DIP PENS*
These come in a very wide range of holders and nibs. Experiment with a selection of mapping, round and square nibs to find out what works best for you.

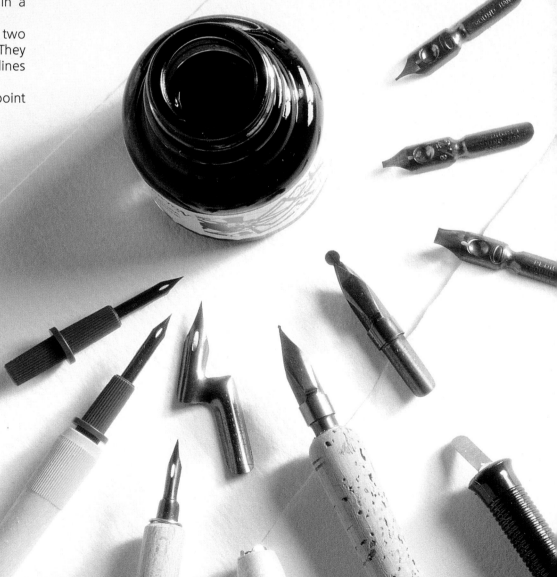

Ancient and modern

Pens that have remained unchanged for hundreds of years work just as well as those of contemporary design.

TRADITIONAL PENS

These pens all produce their own characteristic marks and handle well. They are cheap and widely available. Look after them and they will last a long time.

Quill pens are made of the large flight feathers of birds such as swans, crows or turkeys These pens are light, flexible and responsive. Swan quills are the most expensive. Quills are soft, so you need to trim their points frequently to keep them sharp enough to make a fine line. Use a craft knife for this, or purchase a traditional quill knife from a specialist art shop.

Reed pens are superb for producing short, chunky strokes and have flexible nibs. They are fragile, however, and chip easily.

Bamboo pens are the toughest of all the natural material pens. The nibs aren't flexible at all, so they work best for thick, short lines. They need little care – just wash after use.

CARTRIDGE PENS

Instead of dipping the pen into an inkwell every few minutes, try pens with ready-flow cartridges for convenience and ease of use.

Technical pens have tubular stainless steel nibs in many sizes. They produce a line of even width – giving a rather mechanical feel. Use them for stippling and shading, but not for freehand artworks.

Refill fountain pens are good for drawing – some are sold as sketching pens. They have a pump action for drawing ink into a reservoir within the pen, and come with a fairly wide range of nibs.

A page from the sketchbook by Anne Wright

▲ FINE NIBS
These are ideal for drawing thin lines and precise details – notice the balconies and windows here. After the forms were mapped in, thin washes were added for tonal contrast.

◄ FOUNTAIN PENS
Portable and easy to use, these come with quite a wide range of nibs. They're an ideal choice for sketching outdoors.

◄ TURKEY QUILL PENS
With this pen the point needs frequent trimming to keep it in shape.

▼ REED PENS
Here is a pen that is very responsive and a pleasure to use, allowing you to draw smooth, fluid lines.

◄ MECHANICAL PENS
With an assortment of nibs used for engineering and architectural drawings; you can also use these pens for hatching and stippling.

Coloured pencils

Available in a wide choice of high-quality ranges, coloured pencils are cheap and portable, and make marks that don't fade or smudge.

The leads in coloured pencils contain clay, pigment and wax. They vary in thickness, and are usually protected by a round or hexagonal wooden sleeve, although some have triangular sleeves. Colour sticks have thicker leads and some have plastic or paper coatings instead of wooden sleeves. Round pencils turn easily, and are ideal for curved lines; angled shapes can be gripped firmly, making them best for straight lines.

The leads are not graded so you need to experiment to find the best pencil for the effects you want to achieve. Hard leads are good for fine work; soft leads are better for bold colour and pastel effects.

There is a huge choice of colours, but just twelve are enough to mix your own selection – the marks are transparent, so you can lay one colour over another to make a third hue, and then adapt it with yet another colour. Some ranges offer stronger tones, but you can darken or lighten the tone yourself by applying more pressure or less.

▶ Hexagonal coloured pencils (below); triangular coloured pencils (right); hexagonal coloured pencils with erasers (far right); and putty erasers (below centre).

▲ Round coloured pencils.

Watercolour pencils

Watercolour pencils – or water-soluble coloured pencils – make marks that you can blend and dissolve with water to create washes.

Watercolour pencils look like standard coloured pencils – the only difference is their water-soluble leads. The leads are not graded, but hardness varies from range to range. For the very softest and thickest leads, try watercolour crayons.

Before you buy a watercolour pencil, check for solubility – with the softest leads, you can quickly eradicate the original mark by brushing lightly with water or a moistened finger, leaving just a colour wash. Harder leads need more attention, make weaker washes and leave traces of the original mark. Make sure that you use the right type of watercolour pencil for the effect you want to achieve.

There's a large choice of colours – some ranges offer bright, rich tones, and others more subdued colours. The biggest ranges have up to 100 colours. However, with soluble marks, it's easy to blend two colours to make a third, so you can mix numerous colours yourself from a small basic collection.

▲ *Watercolour pencils with round wooden sleeves (top); and watercolour crayons.*

Expert advice

● When a coloured pencil has been sharpened so much that it's too short to handle, extend its life with a stub holder. Just insert the end of the pencil into the holder to give the pencil barrel extra length.

▲ *You can build up your own basic set of watercolour pencils, mixing them from your favourite ranges.*

Pastels

There is a large number of pastels to choose from and all types provide wonderful effects for sketching and drawing, and can be used in conjunction with watercolours.

A major factor to consider when selecting pastels is hardness and softness. Pastels are made with powder pigment and a binder. The higher the binder content, the harder the pastel. Hard and soft pastels feel different in use, and give contrasting effects.

With soft pastels the colour crumbles smoothly and easily, covering the paper rapidly and sinking into the tiny pits of the paper. Put the same amount of pressure on a hard pastel and you'll find it has a slightly scratchy feel and covers the paper less readily. It also catches the tooth of the paper and creates quite a grainy effect.

Generally there are three main groups of pastels – soft pastels, which are generally (but not always) round, hard pastels, which are more often than not square in shape, and pastel pencils.

SOFT PASTELS

Artists' soft pastels come in various widths and sizes. Some ranges are softer than others, and some pigments will be softer than others. Their softness makes them less suitable for linear work. You can use a sharpened corner for details, but this wears down quickly.

Round pastels are particularly good for creating broad areas of brilliant colour. You can work with the side of the pastel, laying wide bands of colour, or use broken bits to make marks. Using the tip gives you more control.

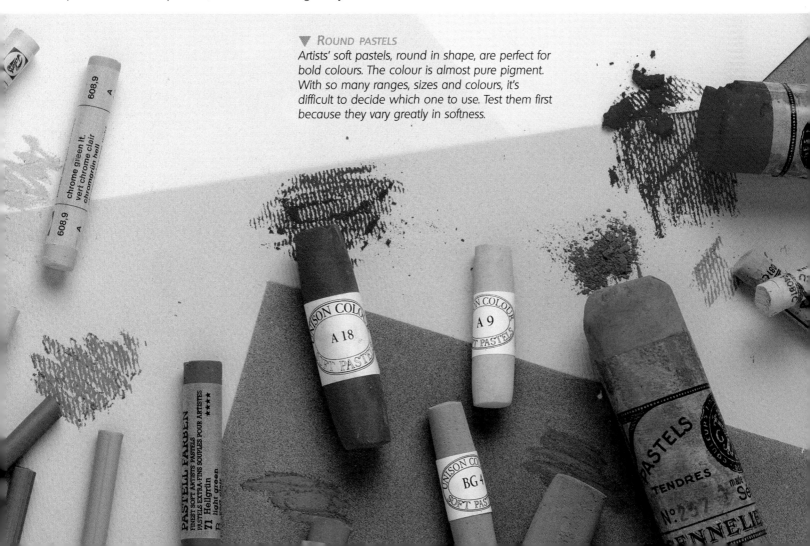

▼ *ROUND PASTELS*
Artists' soft pastels, round in shape, are perfect for bold colours. The colour is almost pure pigment. With so many ranges, sizes and colours, it's difficult to decide which one to use. Test them first because they vary greatly in softness.

Hard pastels & pastel pencils

*Both these types of pastel are harder than soft pastels and are
ideal for linework as well as for sketching.*

Hard pastels are also known as chalks, chalk pastels or Conté crayons. They contain less pigment and more binder than soft pastels, feel more chalky and cover paper less rapidly. Hard pastels are excellent for drawings and sketches in line and tone, and for adding details to soft pastel paintings. They can be sharpened to a point for line drawing, and you can hatch and smudge with them to create blended tones. The pastel line is soft and expressive, with a powdery texture and intensity of colour.

PASTEL PENCILS

These are pastels in pencil form. They tend to be harder than round or square pastels and are good for complex line work, detail and shading. In use they have a somewhat scratchy, chalk-like quality, quite unlike the smooth flow of coloured pencils.

Pastel pencils have all the depth of colour associated with soft pastels and are a marvellously expressive medium. Use them for direct, bold sketches or for dense, detailed drawings with subtle nuances of tone.

You can use all pastels – soft, hard and pencil – in combination with watercolours. They work particularly well over dry washes to enhance colour and texture, and can also be used for highlights. The trick is not to overuse them – a few telling marks rendered in pastel will have a far greater impact than vast blocks of colour.

◀ *HARD PASTELS AND PASTEL PENCILS*
*Hard pastels make versatile drawing tools – you can use the
tip, the flat of the tip, the side or a side corner. Hard pastels
traditionally came in a range of earth colours, with names
such as sepia and sanguine, as well as black, white and greys.
They are now available in a full range of colours.*

*The clean-hand alternative to hard and soft pastels
is the pastel pencil. You can use pencils with other pastels to
add fine marks, or by themselves for loose drawings.*

Easels

Easels come in many styles, ranging from lightweight, portable models ideal for outdoor watercolour painting and sketching, to more solid, heavy-duty studio types.

In the field an easel can be very useful. It can hold your board or canvas securely at the right height and in the correct position, leaving both hands free – you don't have to try to balance the board on your knees. It also allows you to walk away from your work to view progress at a distance.

CHOOSING AN EASEL

For watercolour painting – with very wet washes – it's essential to purchase an easel that can convert to a full horizontal position.

While cost will certainly be a strong factor when choosing an easel, you need to select one that is both easy to carry and assemble if you intend to work outdoors.

Adjustable, collapsible sketching easels are available in wood (usually beech as this is less likely to warp) and metal. An ideal choice is aluminium which is both lightweight and sturdy.

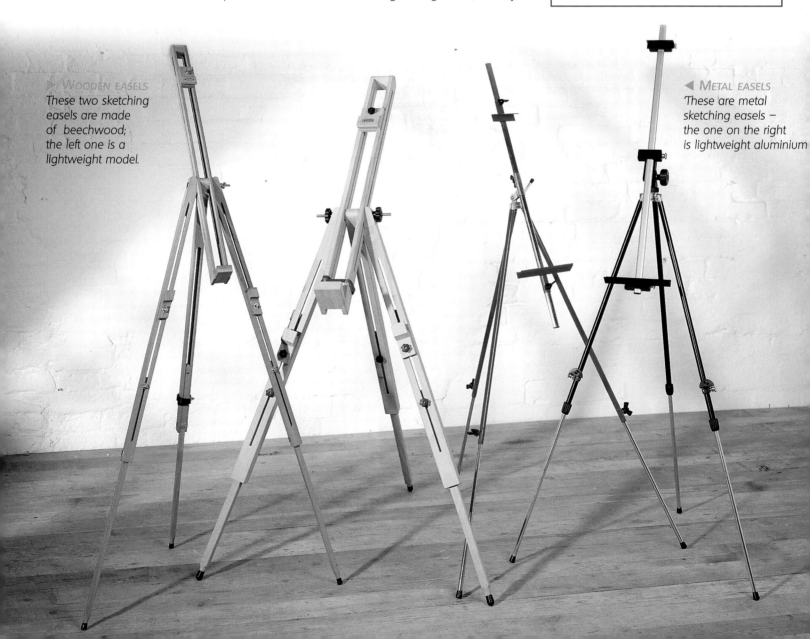

WOODEN EASELS
These two sketching easels are made of beechwood; the left one is a lightweight model.

◄ **METAL EASELS**
These are metal sketching easels – the one on the right is lightweight aluminium

Studio easels

As their name suggests, studio easels are designed for use indoors. They feature various levels of tilting and adjustment.

Most studio easels are designed for oil painting and are quite heavy and rigid. This means that although many are adjustable in height and the size of canvas they can hold, few of them adjust to the full horizontal position needed for most watercolour painting. The tilting radial easel, however, is one studio model that does. It features a central joint that allows the canvas or board to be angled securely in any position between the vertical and horizontal. These can be weighty – approximately 7.5kg (16.5lb) – and are unsuitable for outdoor use, but a good choice for a studio.

Donkey easels – also known as 'horses' or 'platforms' – are another possibility. These are wooden benches that allow the artist to sit astride while painting. They offer several heights and angle adjustments for the canvas or drawing board, together with a spacious well for materials. The lid of the well lifts to form a canvas rest. Again, this type of easel is perfect for use in the studio.

TABLE EASELS

Table easels are versatile for working at home or in a studio. Some – but not all – can be adjusted to lie flat, and all can be set to a variety of angles. Check before you buy, since some can be altered only to very steep angles, which are unsuitable for watercolour work. Most fold up to quite a small size, which makes them convenient for carrying, and some feature rubber feet. They are available in beechwood, steel or aluminium.

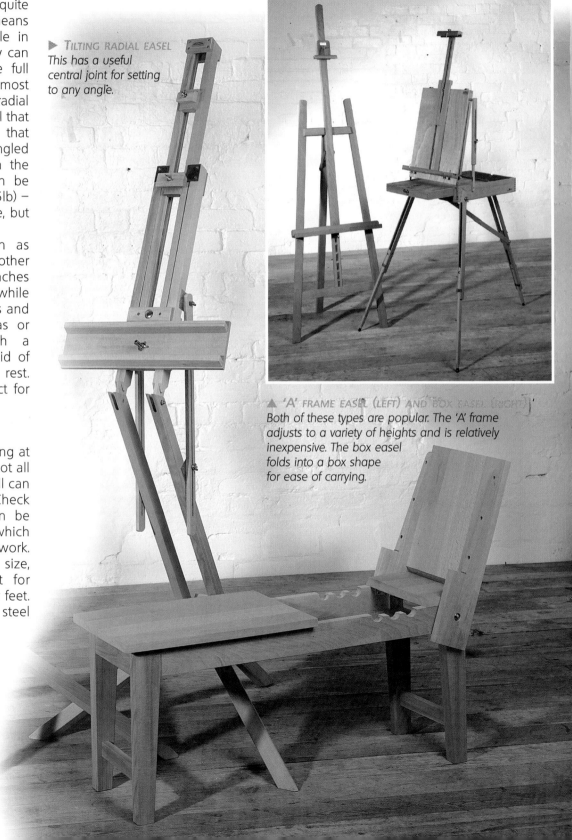

▶ *TILTING RADIAL EASEL*
This has a useful central joint for setting to any angle.

▲ *'A' FRAME EASEL (LEFT) AND BOX EASEL (RIGHT)*
Both of these types are popular. The 'A' frame adjusts to a variety of heights and is relatively inexpensive. The box easel folds into a box shape for ease of carrying.

▶ *DONKEY EASEL*
An artist can sit astride this easel while working.

Handmade sketchbooks

Many artists have a stash of paper offcuts and slightly damaged papers that might be useful in the future. These papers are ideal for making a customized sketchbook.

Sketchbooks regularly use paper of minimum quality – and all of the same type and grade. In addition to restricting your options, some of these can be outrageously expensive. However, if you choose to make your own sketchbook, you can design it to your own requirements – and save money in the process.

For reasons of economy, it's best to work mainly with paper leftovers – you can even use scraps cut from the ends of unsuccessful drawings. But if you prefer, you can cut up larger sheets of paper to the size you want.

The easiest way to bind a handmade sketchbook together is to use a hole punch and string. For a more durable result, a high-street photocopying shop often has spiral binding equipment that will give a professional look and finish to your sketchbook.

Tip

If you know the weight and finish of the various papers you are putting into your sketchbook, make a note of them in pencil in the corner of the sheet. You will find this information is particularly useful at a later stage if you are very keen on the effect of the surface, weight or texture of any one paper.

▼ **MAKE YOUR OWN SELECTION**
If you make your own sketchbook, you aren't tied to the traditional paper sizes or just one type of paper. Offcuts, including tinted and handmade ones, can bring inspiration to your sketches.

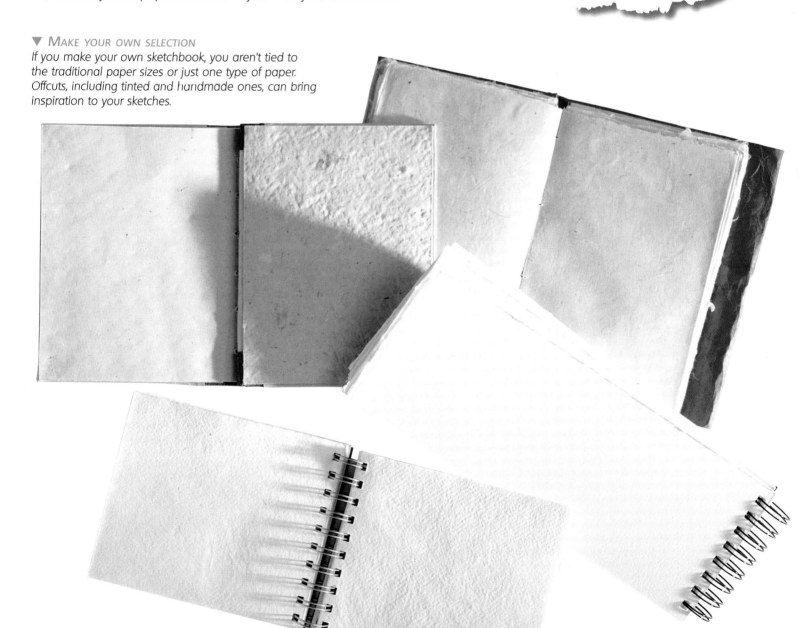

Making a sketchbook

Insert different types of paper in your sketchbook to make sure that you're prepared for every eventuality.

It's a good idea to make your sketchbook using a few sheets of cartridge paper for sketching in pencil, coloured pencil or charcoal; a couple of sheets of your favourite style or weight of watercolour paper; and some coloured papers or papers with a special surface.

If you also want to include some pastel papers, add a sheet of tracing or tissue paper in front of each pastel sheet for protection, so you won't have to worry about smudging the soft, powdery colours.

A multi-paper book means that you're better equipped for sketching outdoors.

Key points

Equipment needed for making your own sketchbook:

- The back of an old A3 sketchbook or a 29.7 x 42cm (11¾ x 16½in) sheet of cardboard (this will make two books)
- Paper scraps
- Decorative papers (optional)
- Ruler and craft knife
- 90mm hole punch and eyelet punch or bradawl
- Scissors and length of string

▲**1** Cut the cardboard in half lengthways. Measure and mark 1.5cm (½in) and 3.5cm (1⅓in) either side of the centre of both long edges. Draw vertical lines down from these points. Score the lines with the knife, but don't cut through. Fold along these lines.

▲**2** Punch holes 3.5cm (1⅓in) from the top and bottom edges of the two outer 2cm (¾in) wide panels. Use the eyelet punch or the bradawl. If you use a bradawl, work from the outside inwards so the excess card is pushed to the inside for neatness.

▲**3** Cut the paper sheets into 13.5 x 19cm (5 x 7½in) rectangles. Punch two holes in the short edge of each. Pass the string from the top hole in the front cover flap, through the top holes in the papers and the back cover flap, and then through all the bottom holes.

▲**4** Loosely tie together the ends of the string on the front of the sketchbook. Open out the book and check that there is enough slack in the string for the pages to lie flat. Adjust to the correct tension, then knot it tightly and trim the ends.

▲ *FINISHING*
You can decorate your sketchbook in all sorts of ways to make it look more attractive and personal. Cover the card before you fill the book, using colourful papers on the cover and spine. Add endpapers to line the front and back flaps, and try out decorative ties.

Index

Page numbers in *italic* indicate illustrations

Illustrations

Richard Allen 15,19, 20, 237; James Bartholomew 247, Charles Bartlett 18(b); Linda Birch 180(t); Chris Beetles (S.R Bamin) 191, (Roy Hammond) 60, 235, (Charles Knight) 233, (Tony Porter) 27; Bridgeman (Eliza Andrewes/Noel Oddy Fine Art) 178(b), (Emily Farmer) 180(bl), (Simon Palmer) 203, (Glen Scouller) 159; Mike Clark 253; Peter Davey 173; Joe Francis Dowden 94, 242, Eaglemoss Publications 49, 53, 123, 130, 133(t), 192(t), 202, 230, 241, 259, 265–266; Charmian Edgerton 108; Shirley Felts 229; Peter Folkes 24, 184, 201; Dennis Gilbert 107, 181(t); Gerald Green 178(t); Kate Gwynn 14, 16, 21–22, 26, 34(b), 39–40, 72(b), 73(l), 74, 79–80, 91–92, 95–98, 169–170, 172, 217(b), 218, 225(b), 227–228, 243–244; Frank Halliday/Search Press 13; John Harvey 71; Ronald Jesty 179; Sophie Knight 43–44; Brian Lancaster 207; Mall Galleries

(Ronald Maddox) 23(b), (Aubrey Phillips) 23(c), (Bob Rudd) 63; Anthony Matthews 37, 113–114, 246(tr), Susan Pontefract 101(t); Melvyn Petterson 126(t), 129; John Raynes 89, 139; Darren Rees 115–116; Paul Riley 59; Jacqueline Rizvi 33; Royal Watercolour Society (Charles Bartlett) 64(t), (Mike Chaplin) 64(b), (John Newberry) 195; Ian Sidaway 18(t), 28, 31–32, 38, 47, 51–52, 54–56, 58, 61, 75–78, 81–83(b), 84(l), 85–86, 87(b), 88, 90, 105–106, 122, 124, 126(t), 127, 138, 140, 144, 157–158, 160–162, 164, 177, 182, 189, 204, 208, 213–214, 219, 221–224, 226, 231–232, 234, 236, 238(b), 239–240, 245, 246(b), 248, 251–252, 254,–256, 260, 268; Adrian Smith 176, 205–206, 249–250; Stan Smith 29, 65–66, 102(cl), 131–133(b), 134(b), 149, 155–156; Superstock/Diana Ong 181(tr); Tig Sutton 120(b);

John Tookey 50, 209; Shirley Trevena 93; Norman Webster 57; Jenny Wheatley 48, 62; Winsor & Newton 87(t), 263, 281–282; Albany Wiseman 30, 35–36, 41–42, 70(b), 101(c,br), 103–104, 109–112, 119(r), 135, 137, 145–146, 148, 150, 151–154, 167(tc,br), 168, 174, 180(br) 181(b), 187–188, 190, 192(b), 193–194, 196–200, 210–212, 257–258; Leslie Worth 175; Anne Wright 276(tr)

Thanks to the following photographers:
Edward J Allwright, Simon Anning, Paul Bricknell, Mike Busselle, Mark Gatehouse, Brian Hatton, Patrick Llewellyn Davies, Peter Marshall, Graham Rae, Nigel Robertson, Steve Shott, John Suett, Steve Tanner, George Taylor & Mark Wood